RIGHT PLACE, RIGHT TIME

THE LIFE OF A ROCK & ROLL PHOTOGRAPHER

RIGHT PLACE, RIGHT TIME

THE LIFE OF A ROCK & ROLL PHOTOGRAPHER

BOB GRUEN

WITH DAVE THOMPSON

Abrams Press, New York

Library of Congress Control Number: 2020932352

ISBN: 978-1-4197-4213-2
eISBN: 978-1-64700-013-4

Printed and bound in the United States
10 9 8 7 6 5 4 3 2 1

ABRAMS The Art of Books
195 Broadway, New York, NY 10007
abramsbooks.com

For my grandchildren, in the hope that they enjoy the freedom of rock and roll

CONTENTS

Introduction ix

Chapter 1: Where It All Began I
Chapter 2: Growing Up 7
Chapter 3: The Emerald City I3
Chapter 4: Where There's Smoke 24
Chapter 5: The Rise and Fall of Glitterhouse 35
Chapter 6: The Ike and Tina Express 48
Chapter 7: 1971—It's All Happening 68
Chapter 8: Elephant's Memory 83
Chapter 9: Coast to Coast 94
Chapter 10: Some Time in New York City I03
Chapter 11: In the Thick of It II5
Chapter 12: Surreal Days I30
Chapter 13: New York to LA and Back Again I39
Chapter 14: Airborne! I50
Chapter 15: New York Clubs I59
Chapter 16: Central Park to Byblos I69
Chapter 17: Whatever Gets You Through the Night I80
Chapter 18: Right Place, Right Time I9I
Chapter 19: Money Honey I98
Chapter 20: Trouble in Japan 205
Chapter 21: The Club Scene 2I3
Chapter 22: London Calling 225
Chapter 23: Everything Will Be Alright 236
Chapter 24: Anarchy in the UK 248

Chapter 25: Anarchy in the USA 258

Chapter 26: All-Access Pass 269

Chapter 27: Full Moon Rising 287

Chapter 28: The Record Plant 294

Chapter 29: Now He Is Everywhere 309

Chapter 30: The View from Here 324

Chapter 31: See You in Jamaica 333

Chapter 32: Stars in My Eyes 344

Chapter 33: Happy Birthday to Me 358

Epilogue 368

Acknowledgments 379

INTRODUCTION

Bob had the ultimate backstage pass. He was backstage with all these bands.

Can you imagine the stories he's got?

—Alice Cooper

ONE SUNNY DAY IN 1979, I WAS CRAMMED INTO A small rental car with a young heavy-metal band called Riot. We were driving across Texas from one show to another.

I was telling them stories about my life as a rock photographer, and the driver was listening so intently that he missed our exit. The next exit was now fifty miles away, so that little mistake added a hundred miles, and ninety minutes, to our drive. But nobody in the car seemed to mind. They just said, "Tell us more stories, Bob."

Until then, I had never realized just how many great stories I had, and how interested people were in hearing them.

I took my first concert photos at the 1965 Newport Folk Festival when Bob Dylan famously shocked the world by going electric; camped at the Woodstock Music Festival; met John and Yoko at an Aretha Franklin concert and became their friend and personal photographer; drove Tina Turner's Jaguar down the Pacific Coast Highway in a fog so thick that I couldn't see the road; was at CBGB for the birth of the New York punk scene.

I documented Salvador Dalí making the world's first moving hologram of Alice Cooper; became friends with the notoriously wild Keith Moon, drummer for the Who; toured with the ever-colorful New York Dolls; rode the bus with the Sex Pistols for their ill-fated American tour; and took the picture of Led Zeppelin members posing like rock gods in front of their jet plane.

And those were just some of my stories up to that day in Texas in 1979. Since then I've collected a lot more—having a long and hopeful conversation with John Lennon just two nights before he was murdered; living for close to a year in Japan and connecting with the rock scene there; flying with Green Day in their private plane; and hosting Joe Strummer on my couch.

Just about every music fan knows my photos. They've seen them for years on album covers and posters, in books and magazines, in art galleries and museums. Some of them are iconic: the picture of John Lennon in the New York City T-shirt, the Clash on a rooftop with the Empire State Building behind them, the Ramones in front of CBGB, Tina Turner whirling across the stage. The history of rock and roll is captured in my archive of many thousands of images, more than half a century of rock culture told in one classic image after another.

Those photographs, however, show you only what I saw. *Right Place, Right Time* is about how I grew as a person—from a young kid with no particular agenda, with a camera and a passion for capturing the moment, to a professional photographer witnessing the evolution of generations of musicians who have come and gone, never quite made it, or succeeded beyond their wildest dreams.

For me, this book is not just about rock and roll. It is about freedom . . . the freedom to express your feelings, out loud. My focus has always been to communicate that sense of freedom, the passion and desire to be fully in the moment.

Tommy Ramone once said that in order to create a successful rock band, "The image and the sound must gel." Punk author Legs McNeil (*Please Kill Me*) concurred, "You have to have a great song, and you also have to have a great image to go with it."

There's the style, the swagger, the show, the song. But rock and roll also needs an image—as much as it needs a guitar and a mic. And this was even more true before the YouTube era, before the Internet existed, even before *Rolling Stone* published its first issue. In small broadsheets and fanzines, on album covers and concert posters, the image has always been what helps draw the fans to the concerts.

To me, my photos aren't just pictures, and the artists in them aren't just acts. I wasn't visiting the rock lifestyle as a journalist, I was living it. I've been lucky enough to work, travel, and become friends with many of the greatest artists in music. They became my extended family—my wonderful, crazy, wildly creative, and sometimes dysfunctional extended family.

Like any family, we've had our ups and downs, experienced one another's triumphs and tragedies, and attended one another's weddings, birthday parties, and funerals.

I've lost some of my most inspiring friends—John Lennon, Joe Strummer, Giorgio Gomelsky, Joey Ramone, so many . . . too many! But I've made new ones, as well—Billie Joe Armstrong, Supla, and Jesse Malin, unofficial mayor of the Lower East Side.

Because these people are my family, my stories about them aren't the usual ones. I know them as wildly talented, three-dimensional, and often perfectly ordinary people. My career has given me an intimate perspective that I hope comes through in these pages.

I reflect on taking the first photos of John and Yoko's baby, Sean. Going shopping with Tina Turner, and watching her cook dinner for her kids. Sitting at the bar in CBGB with Johnny Rotten, right after the Sex Pistols had broken up. And I'll never forget Debbie Harry kissing me on New Year's Eve 1979 in Glasgow.

All the time I hear from young people, "I want to follow my dream." In *Right Place, Right Time*, I'll share what following one's dream means to me: It means believing in yourself, giving up security, and taking chances. It means getting out there and living your life—loudly.

My own dream was simple. I wanted to take good pictures, go to interesting places, and meet fascinating people. Someone once asked

me and Malcolm McLaren, the manager of the Sex Pistols, how we had planned for our success. We both said, "Plan?"

Malcolm summarized this attitude well: "When you go to sleep at night, you have plans for the next day. The next morning you wake up, the phone rings, and your plans change. You make the best of the day, every day."

It takes courage to live like that, every day unplanned, with unexpected turns. But you have to do it if you want to follow your dreams. It's a matter of being in the right place at the right time, and then you have to do the right thing. That isn't something you can plan. You have to follow your instincts and try to not second-guess yourself.

That is how I've always lived my life.

Growing up in a typical suburban home on Long Island in the 1950s, I saw Elvis on television and listened to rock and roll on Murray the K's *Swingin' Soiree*, an all-night radio show that I tuned into under the covers in bed, with my parents sound asleep in their room next door.

My twin passions, music and photography, were born at the same time: By the age of five I was spending hours in the darkroom with my mother, an attorney who was an amateur photographer. I got my first camera when I was eight and had my first picture published in a local newspaper when I was thirteen.

Still, in my house, photography was considered a hobby—and in the wider world, rock photography didn't exist. My parents expected me to graduate from college, get a secure job as a businessman, start a family, and live the American Dream. Instead I dropped out of college at nineteen and moved to Greenwich Village in 1965.

I did not have a career plan. My plan was to turn on, tune in, drop out, and live with a rock band—so that's what I did.

I arrived in New York City as a naive young man, ready to start having adventures and learning the ways of the city. There were some very lean years, but I could survive on twenty-five-cent hot dogs and a one-dollar bottle of wine.

At the time I started—and really for most of my career—photographers were servants to the music business, merely there to

provide adequate images of an event, their identities inconsequential. If I wasn't there to pick up the phone when someone called, then they just called the next photographer on their list. The competition was fierce.

My career advanced one contact and opportunity at a time. I'd go to a concert, then to a few clubs to check out what was going on there, then to an after-party or perhaps another late-night club. But I took my camera with me everywhere.

Then I'd go home driving along the Hudson River at sunrise, and head straight to the darkroom to develop my rolls of film. After a short lie-down, I'd make prints and take them around to the magazines and record companies. And then, that night, I'd go out again and repeat the whole cycle. I did that for decades. Following your dream is hard work.

I owe a lot of my success to the fact that many of the musicians I met and photographed considered me a friend. As Yoko Ono said of me: "John and I felt he was sensitive. In those days, photographers were all so pushy, and he wasn't. His photography shows what his character was, and that's what's so beautiful about it." I put my camera down when someone didn't want their picture taken, and I never gave much direction.

Some of my best pictures are of musicians in a dressing room or at a party, in the back seat of a car or on the street. I got those pictures because I was out there, all the time, open to chance, to the moment, to letting things unfold. And they were relaxed enough around me to be themselves.

"Bob's best pictures are the ones offstage," Iggy Pop said. "They're important for what they document about the interaction between the people in them. You get a lot of information about either what these people were really like or what games they were playing."

My passion for the music and for the people who make it comes through in my pictures. They're not always technically perfect. Sometimes the focus is soft, or the figure is blurred, but the feelings are clear. I want to capture the spirit and passion of the moment.

I'm in my early seventies now, and I still go out most nights, happy to be sober, to hang out with and photograph old friends and new. I know I've changed over the years. But the passion that I started with

for capturing the moment is as alive within me as it ever was, and the drive to keep going, keep photographing, keep documenting the world in which I live my life—that remains undiminished.

I still get as excited looking at a newly taken photograph as I did when I was younger; I still feel a shot of adrenaline when I look at a particular image and think, "That's the one!"

WHERE IT ALL BEGAN

Donovan and Joan Baez • Bob Dylan

I N JULY 1965, THE NEWPORT FOLK FESTIVAL WAS THE place to be. As Bob Dylan said, the times they were a-changing, and folk music spoke to young people who wanted to be a part of that change.

American combat troops had just been sent to Vietnam that March, and thousands of young war protestors marched on Washington. At the same time, the Reverend Martin Luther King Jr.'s freedom marchers were attacked by police and state troopers in Alabama. It was a tumultuous time, and music—not just folk and rock, but R & B, jazz, everything—reflected that. And I was just one of the millions of kids who wanted a front-row seat for the revolution.

That April, I got a minimum-wage job at the World's Fair in Flushing, Queens, selling film and flashbulbs. I'd just moved into my first apartment in Manhattan, in the area below Houston Street that's called SoHo now but was part of Little Italy back then.

So, I was just one among the thousands who saw the list of performers who were going to be at Newport and really wanted to be there.

I was already into folk music. Or, at least, I had an acoustic guitar that I could strum, and I sang songs by Bob Dylan, Pete Seeger, Phil Ochs, and others. All of whom were going to be at the festival, alongside Joan Baez, Donovan, Mississippi John Hurt, Buffy Sainte-Marie, and Peter, Paul and Mary.

The music spanned the folk spectrum. While some of the performers sang traditional folk songs, others—Pete Seeger, Joan Baez, Buffy Sainte-Marie—performed their own compositions, new, topical songs that spoke to the changing times. And why? Because they sensed, as we the audience sensed, that music mattered. If you wanted to send a letter, you used the mail. If you wanted to deliver a message, you set it to music, and Newport was where everyone would hear that message at the same time.

I just had to be there, but I couldn't afford tickets, which I think were five dollars a night. I had no connections to the music press, no musician friends who could put me on the guest list, no reason at all to receive any kind of preferential treatment.

What I did have was a friend of my mom's who ran a public relations firm, who was willing to give me a letter saying I was there to represent them. It was a long shot, and it was not true. His company had nothing whatsoever to do with music. But with the optimism of youth, and that letter in hand, I quit my job at the World's Fair and, because I couldn't afford film any more than I could afford festival tickets, I stole a pack of twenty rolls of film on my way out.

Around one hundred thousand folk music fans descended on the quaint seaside town of Newport, Rhode Island, on the weekend of July 22–25. Thousands of them camped out on the beach, and that's where I pitched my tent, too. When darkness fell, cool winds swept in across the water, and I was chilled in my suede jacket, jeans, and cowboy boots. People built bonfires to crowd around, and we'd gather for hootenanny sing-alongs.

Becoming a part of the crowd was easy. Actually getting into the festival was a little more complicated. I made my way to Fort Adams State Park, where the festival was staged, and presented my letter at the press office.

Obviously, they had never heard of me, or the company I claimed to be representing. Their first reaction was to turn me away. But I remembered something my mom always said—"Never take no for an answer. Instead, it can be the beginning of an interesting conversation."

I was persistent and they were busy, with all the other journalists and photographers demanding their attention. They finally agreed to give me a photo pass. And that was it. I was in. Camera at the ready, and free to roam wherever I chose.

The audience was already in position, thousands of folk fans facing the stage in rows of folding chairs. Comparing that vision to the same scene a year or two later, it was a very staid event. The hippie scene was barely beginning. Guys were starting to grow their hair a little longer, but they were still wearing shirts with collars, like the Beat Generation. Khaki pants and tweed sports jackets. T-shirts wouldn't become ubiquitous for a few years yet.

The girls were wearing their hair long, too, but straight, down their shoulders and backs. They wore loose-fitting tops and jeans. None of them looked like proto-revolutionaries, but their hearts and their voices were already in the right place.

With my pass in hand, I was able to go backstage, where I saw Buffy Sainte-Marie playing an acoustic guitar, singing her anti-war song "Universal Soldier." I stopped dead, just watching her. I was a huge fan, knew all the lyrics, and when she saw me mouthing the words, she smiled and invited me to sing along with her!

But I couldn't—I was too stunned. To me, Buffy Sainte-Marie was the sexiest person at the entire festival. I just stood there, awestruck. I got good pictures of some of the performances, though—Pete Seeger, Ronnie Gilbert, Donovan, Joan Baez.

Then it was time for the star of the festival, Bob Dylan. His rock and roll (*not folk*) album *Bringing It All Back Home* had been out since

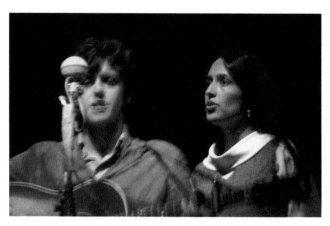
Donovan and Joan Baez, Newport Folk Festival,
Newport, Rhode Island, July 22, 1965

March and had long since sent shockwaves through the folk music scene. Rocking songs like "Maggie's Farm" and "Subterranean Homesick Blues" had very little to do with folk, but his lyrics were as sharp as ever . . . sharper, in fact.

I was completely enthralled. I was driving in my car the first time I heard "Subterranean Homesick Blues" on the radio, and I was so electrified by the words and images that flew through my head that I had to pull the car over and just listen, trying to absorb it. The last line—"The pump don't work 'cause the vandals stole the handle"—whirled around in my head for days.

Then, just a few days before the festival, Dylan's new single, "Like a Rolling Stone," came out. It hadn't been on the album—it would be on the next one, *Highway 61 Revisited*, but that was not the only surprise. The song felt endless; it was more than six minutes long, at a time when no single—certainly no hit single—had ever gone over three. Clearly, whatever Dylan had in store for Newport, it was not going to be traditional folk music.

The sun had just gone down as Dylan strolled onto the stage and the stage lights came up. He looked so cool. He looked like a rock star. He was often described as scruffy looking, but he came onstage in Spanish boots, tight black jeans, a black leather jacket, and under it, a really unusual orange shirt, with a tab collar that was fastened, but no tie!

You have to understand. That in itself was an act of rebellion. Nobody wore a tab collar without a tie. Nobody but Dylan. It looked so wrong—but on him it just looked right. In fact, that outfit might have been the thing that put off the folk fans in the audience, even before he started playing. That and his stance. He stood like a rock and roller.

As he and his band—a pickup group mostly comprised of members of the Paul Butterfield Blues Band—played the long, jangling "Like a Rolling Stone," about half the crowd started booing while the other half was cheering. Then they got to yelling at one another.

It was chaos! Nothing like this had ever happened at Newport. Butterfield and the Chambers Brothers had already played electric sets of traditional blues and everybody liked them. But for Dylan to do it, that was sacrilege.

Dylan, clearly upset, stopped playing and left the stage. I headed around to one side. Peeking through the fence that stood around the

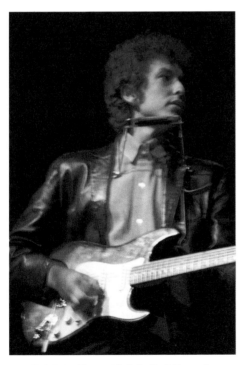

Bob Dylan, Newport Folk Festival, Newport, Rhode Island, July 25, 1965

backstage area, I watched as Peter Yarrow of Peter, Paul and Mary, pushed an acoustic guitar into Dylan's hands and begged him to go back out and play some of his old hits to mollify the crowd.

He did go back out, to sing "Maggie's Farm" and, fittingly, "It's All Over Now, Baby Blue," a familiar ballad that calmed the crowd down. But the damage had been done. The folk scene was never the same after that night. The times really were a-changing, and I think everybody there felt it. The message that Dylan once sang quietly with an acoustic guitar was now being shouted out above a loud, driving, rock-and-roll beat, and the mostly clean-cut crowd simply didn't know what to do with it.

To me, it was clear Dylan was announcing that the folk music of America was now rock and roll, and that the young generation wasn't going to be quiet and polite anymore.

The night Dylan started rocking out onstage—Sunday, July 25, 1965—was also the start of my life as a real rock photographer. Luck and timing would forever play big roles in my career, never bigger than being at that festival, on that night. Dylan changed a lot of people's worlds, but he changed my life. He showed me what was possible if you just went out and did it.

CHAPTER 2

GROWING UP

Mom and Dad · Great Neck Fire

AS A KID GROWING UP IN GREAT NECK, LONG ISLAND, I'd been into photography for as long as I could remember, and I have my mom to thank for that. Both of my parents were lawyers, but my dad went into real estate, building houses, and my mom specialized in immigration—she opened an employment agency that arranged for people to come from Europe to work in America. After a recession in the mid-1950s, my dad opened a travel agency to complement my mom's business.

She was also president, or honorary president, of a variety of different organizations, business and philanthropic. But her hobby was photography. She never took more than family photos, me and my brothers playing on the beach during vacations, visits to relatives, and so on, but she had a good eye and she bought herself great equipment.

My family—my parents, my three brothers, and I—lived in a suburban house, and, when I was five, my mom built a fully functional darkroom in the pantry off the kitchen. Some of my earliest memories

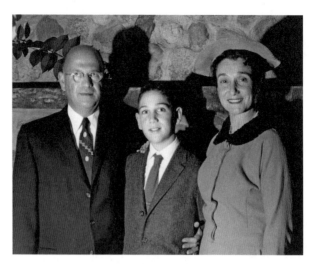

(Left to right) Rudolph Gruen, Bob Gruen, and Elizabeth Gruen,
Great Neck, New York, October 1958

are of the two of us there in the red-lit darkness, and the acidic smells of the chemical solutions of developer and fixer.

She taught me how to process film, and how to count off the seconds while the film was developing (because you can't see a clock in the pitch dark). I got to be very accurate at counting.

My mom gave me my first camera, a simple Kodak Brownie Hawkeye, for my eighth birthday in 1953. I soon discovered I was good at taking pictures—framing, timing. Even better, it was also something that was all mine, and not my older brother Richard's. In our family, he was the genius straight-A student.

Photography was where I could excel. I soon took over as the family photographer, snapping photos of visits with aunts, uncles, and cousins, Richard's bar mitzvah, and other family events and gatherings. I could not have known then that these early "assignments" would become so important for me later.

After all, taking family portraits is a lot like taking a band's picture. You have to get everybody together and in the right mood all at the same time. You have to make sure everyone is looking at the camera and is engaged with the moment. You have to make sure nobody's head gets cut off. Maybe it's not so surprising that the music world became my family.

I received my first "grown-up" camera for my own bar mitzvah. A friend of my parents, Harry Fink, owned the large camera store Haber & Fink in New York City; he gave me a 35-millimeter camera, a Kodak Pony II, and also discounts on supplies at his store. The new camera was still rather simple, but it was far more advanced than my Brownie Hawkeye: I could focus it and set exposures.

I carried that camera everywhere. I especially liked action shots— my high school's football games, dances, anything where something was happening. Whenever I heard sirens, I'd run to see what was going on. I had a drive to see exciting things and tell people about them—to show and tell.

One day in the summer of 1959—Friday, June 19, to be exact—as I was coming out of my mother's office in Great Neck, near the Long Island Railroad station, I was startled and excited to see fire engines pulling up outside a burning building nearby.

I got pictures of firemen climbing up a ladder to the second floor. But I only had a few shots remaining on the roll, so I ran home, which was about a half mile, grabbed more film, and sped back on my bike.

A local photographer, Mike Miyata, was now on the scene, taking pictures in front of the building. So, he had that covered. I wanted to get the scene from a different angle—something I would do throughout my career—so I went into the six-story apartment building behind the one on fire.

I ran up the stairs to the roof. From there, I got shots of the whole scene from above. I hurried back home, locked myself in the darkroom, developed the pictures, printed a few of them, and rushed them to the local weekly newspaper, the *Great Neck Record*. I'm still not sure what made me think that they'd want a picture from a thirteen-year-old kid; all I knew was that I had a great shot and my age shouldn't matter.

The editor liked one shot but wanted a better print. I went back home again, made a new print—dodging and burning, upping the contrast—and took it back to the editor.

I gave it to him, told him a little about myself, and left. It was only then that I realized that I felt hot. My breathing was normal, I was no longer sweating from all the biking, but it turned out that all the exertion

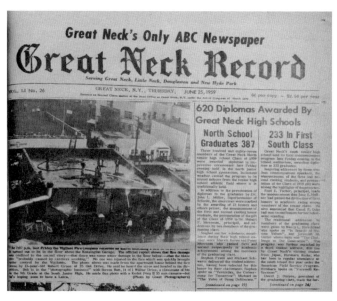

Great Neck Record, Great Neck, New York, June 1959

had brought on a full-blown fever, and I would spend the next two days sick in bed.

It was worth it. I woke up the next morning and saw my picture on the front page of the local paper. The caption: "The photo above was made from the apartment house behind the fire scene by 13-year-old Robert Gruen of 25 Oak Drive . . . Bob is in the 'photographic business' with Steven Rutt, 14 of 1 Wilbur Drive, a classmate of his in the 9th Grade at the South Junior High. He made this photo with a Kodak Pony II 35 mm camera—but he's hoping soon to have a Leica."

The "business" part was a stretch—perhaps that's why the copy department put it in quotes—but I was a bit of a budding entrepreneur. Steve and I had been friends since the third grade. He was the skinniest person I have ever known, his clothes hanging on him like on a scarecrow. He was already a genius inventor, always creating the most elaborate science projects while the rest of the class was still ooing and ahhing about the same old baking soda/vinegar volcanoes.

Steve and I once put together a pump, tubes, and a timer to build a rain forest where it actually rained every twenty minutes. We used to go shopping for parts on Cortlandt Street in downtown Manhattan. Before

they built the World Trade Center, a lot of little army and navy surplus stores were there, so that's where we'd get vacuum tubes, capacitors, and other electronics.

We became partners. I took and developed the pictures while he invented things like a strobe flash for my camera that is still the best I ever used. We called ourselves Coast Photographers, and that's how the *Record* credited the front-page photo.

Mike Miyata's picture, by the way, was on page twelve. As it turned out, he would be the first photographer I worked for as an assistant.

I continued to take pictures through high school, as well as at rallies for local political candidates. One year, when I was about fifteen, the images used on the campaign posters for both the local Democratic and Republican candidates were my photos.

High school itself didn't interest me too much. I was considered one of the nerds. The only place I shined was in the theater group, where I was the AV guy in charge of the sound and lighting; I was also the guy who would show the movies and the slide shows in your class, because I knew how the equipment worked.

Music was always a part of my life growing up, but never as much more than background. I sang along with the songs I liked, I had my favorite performers, I bought 45s like any other kid. My parents were not at all interested in music; the only record I ever remember my father liking was by the Talbot Brothers of Bermuda. And while Mom's uncle Joe was a jazz musician, I didn't meet him until much later.

I did enjoy Miles Davis. I've been a fan forever; I must have been seven or eight when I first heard him and I was immediately swept away by his music. One of the first records I ever bought was *Kind of Blue*. It was so beautifully smooth, soft and meditative, and when my school gave me the trumpet to play, I was happy. I remained a trumpeter for the next three years, until my orthodontist pointed out that the trumpet was pushing back my teeth, and I needed to wear braces.

I also enjoyed the Weavers and Pete Seeger; in fact, they were the ones who first showed me how music could become a force for something more than mere entertainment. Pete Seeger played at my elementary school when I was around thirteen. Pete sang about peace and love,

individuality and workers' rights. He had the audience singing along in three-part harmony and everyone went home smiling.

Just a few days after the show, there were letters to the editor of the local newspaper complaining that the school had allowed a communist to perform.

It seemed incredible to me that a simple folk singer could be accused of being a communist, of trying to subvert the system, simply for singing songs of freedom. For the first time, I found myself thinking about the incredible power of music—what it meant, what it was saying. I began to pay more attention.

THE EMERALD CITY

Hank Aberle and Al Lax · Justice League

ONE DAY IN 1963 WHEN I WAS SEVENTEEN, MY good friend from high school Mike Gayle came to my house with a record and said, "You've *got* to hear this."

When he played it, my knees went weak—I fell to the floor laughing. "This guy is not a singer! What is this?" I couldn't believe that Mike was so into this nasal caterwauling. "Who the hell is this guy?"

It was Bob Dylan.

Mike told me to listen to what Dylan was saying, rather than the sound of his voice, and when I did that, suddenly it made sense. Dylan's lyrics soon became my bible. He was saying things that I didn't know I felt about myself and the world until he said them. A couple of years later, in the same room, I played a Dylan song for my mother; "It's Alright, Ma (I'm Only Bleeding)" was filled with dark, surrealistic imagery like:

Disillusioned words like bullets bark
As human gods aim for their mark
Make everything from toy guns that spark
To flesh-colored Christs that glow in the dark
It's easy to see without looking too far
That not much is really sacred

I don't think Mom got it, but I did.

I was inspired, so I bought an acoustic guitar and taught myself the basic chords to play folk songs. It was also Mike who taught me how to straighten my curly hair. Mike was African American, and while he didn't straighten his own hair, his mom did hers, so he knew all about Perma-Straight, the hair relaxer.

I went over to his house and he put the goo on my hair. It smelled like formaldehyde and stung my scalp. When we washed it out, my hair was slightly rubbery but absolutely straight.

I was thrilled. Having grown up seeing Kookie Burns on *77 Sunset Strip*, and the guys in the Brylcreem commercials with their hair blowing in the wind, I loved having straight hair. Even better, as it grew longer, a lock of it curled down around my eye, which I thought looked very cool.

My dad, on the other hand, thought I looked like a girl.

I didn't care. Before going to bed each night, I'd comb my hair back and wear a stocking cap to keep it straight. I continued straightening my hair until 1969, when a hairdresser friend convinced me to stop, and he cut off all the straight parts. "From now on you'll never need a comb or a brush," he told me, and he was right. I've enjoyed naturally curly hair ever since.

As I was finishing high school, my parents, like all middle-class suburban parents, wanted me to go to college and get a degree in something I could use to make a living.

I had no interest in any of that. I wanted to take pictures, meet girls, and surround myself with interesting people and artists. I did try college several times—Southern Illinois University, C.W. Post on Long Island, and Baltimore Community College. But it didn't work. I was bored and restless every time.

In fact, the only things I learned were lessons that would serve me well in my desired career. In Illinois, for example, I took pictures for the college newspaper and learned how to hold my liquor. In Baltimore, I became a regular at a music club for the first time, but certainly not the last.

My first love, unsurprisingly, was a folk music club that I went to pretty regularly, even though I didn't have money to pay for the admission or buy drinks. I went just to be there and hang out and, after a while, I became friendly with the guy who ran the place, and he started to let me in for some of the shows.

I remember seeing Tom Paxton play there and getting to talk to him afterward. When I mentioned that I was driving back to New York City that weekend, he asked me if he could have a ride. So, I drove Tom Paxton from Baltimore back to Greenwich Village, the first of many musicians I would offer a ride to in my career.

The other thing I remember about Baltimore was having fierce arguments with a racist sociology professor who said he wouldn't allow "Zulus with spears" to take over the streets of his neighborhood. We were arguing one day when he suddenly told me, "Why don't you just go to Greenwich Village and smoke pot with the hippies?" He meant it as a put-down, but I thought, "Good idea!"

I dropped out of college in the early spring of 1965, came home to Long Island, and got that job at the World's Fair, selling film and flashbulbs. It wasn't the most glamorous occupation in the world, and it paid minimum wage, less than sixty dollars a week. But I was nineteen, and a dollar went a lot further in those days. You could drive around for two or three days on a dollar's worth of gas; hot dogs cost a quarter; a bottle of wine was a buck.

Alan Nevins, a guy I knew from Great Neck, had a Manhattan apartment, a one-bedroom with a living room and kitchenette on Sullivan Street between Spring and Prince Streets. Or, at least, he did until his father made him move back home. Mike Gayle and I moved into his apartment that June. Shortly after, Alan's father changed his mind and threw him out again, and Alan moved back in with us.

The rent was $125, split among the three of us—although we *didn't*

pay $125, because we could never come up with that much money. That would soon lead to problems, but for the time being, we were settled.

New York City at that time was, and still is, amazing. It *lives*; a vast organism with its own heartbeat, and always something new to discover. Kids still come to the city to be bowled over, and they are. Places may change, stores may disappear, but it's still New York City. A place where you can leave your past behind and invent a new future.

I used to wander Greenwich Village alone for days on end and never tire of the sights, sounds, and smells. There was music everywhere, coming from basements and windows and doorways. The omnipresent aroma of incense and pot and who knows what. Even now, no matter how many times I walk the narrow, cobbled streets around the Village, it never grows old. There is always something new to see.

I discovered so much music there that I might never have heard in Great Neck, like the Mothers of Invention. To this day, I remember "Help, I'm a Rock," a track from their very first album that sounds like nothing I've ever heard on another rock album. There, too, I was introduced to the music of the Holy Modal Rounders, who I regard as the first-ever punk band; and the Fugs, a band whose collision of rock, poetry, art, and protest was seminal in my life.

Hanging out in Washington Square Park one day, an established meeting place for countercultural types of all persuasions, I met two girls named Fritzy and Pixie. They were on their way to a club called the Scene, on Forty-Sixth Street off Eighth Avenue, up in the Times Square area.

I'd never heard of it, but I tagged along. I was impressed when the doorman, Teddy Slatus, allowed me in because I was with the girls and he knew them. They explained that the Scene had a policy of always letting the regulars in, and I soon discovered that a lot of the nightclubs operated this way, because that's how they developed the kind of crowd, and the kind of atmosphere, that they wanted—sexy rock- and-roll girls at one club, creative artists at another, great dancers at yet another.

As my first taste of true New York City rock-and-roll nightlife, the Scene was a great introduction. It was run by a guy named Steve Paul, and even though it had been open for less than a year, it was already a

very popular hangout for visiting musicians. You'd never have known it was there, unless you already knew about it. The door opened directly onto the street, and it really was just a doorway, nothing fancy, nothing to let you know what happened behind it.

First, you descended a staircase that opened into a kind of reception area or anteroom. There was a bar area, and in the middle of the bar, on the left, there was an opening into the larger room where the stage was.

There was seating toward the back, old worn-out banquet seats; and for some reason, my favorite became an especially worn banquette, with a hole in the seat, as though somebody had burned through it. Or burrowed!

I don't know why, but I loved sitting there. Sinking down into the hole, I could see the whole room, and I'd just stare at everybody and wonder what was going on. Because I was still new to New York City, I didn't really know anybody, and certainly nobody in the music scene.

I don't even remember talking to anybody there, except one time when I was with my friends Hank Aberle and Al Lax, who Mike met in the Village one day. I took some pictures of them there that night, in a room lit only by candles. And that was important, because it was the first time that I figured out how to take a picture in light as dim as candlelight.

Hank Aberle and Al Lax, the Scene, New York City, 1965

Having learned how things worked at Steve Paul's Scene, I started applying the same principle to other clubs, getting to know the doormen and doing what I could to be helpful to the venue, usually by taking pictures there and publicizing the club. Later, I'd even be publicizing the club owners by getting their photographs into the different magazines I was working for. They loved that!

Meanwhile, another type of connection with music developed for me. Hank and Al were musicians, and soon after we met, Mike and an old high school friend of ours named Tom Winer started their own folk rock band, the Justice League. Everyone clicked.

I had the use of my dad's station wagon for hauling the equipment, and I could also take pictures of the band—basically, I was a roadie with a camera. It also turned out that I was the only one of us

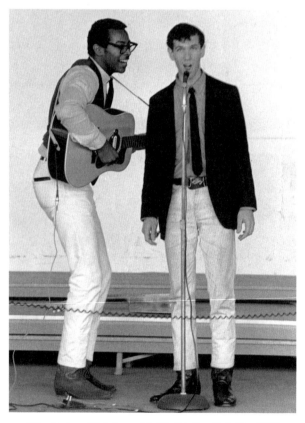

Mike Gayle and Bob Gruen, World's Fair, New York City, 1965

who could remember all the words to "Like a Rolling Stone," and once in a club, and once at the World's Fair, I got up onstage with them to sing it.

That was the extent of my singing career. I wasn't comfortable in front of an audience. Like a lot of photographers, I guess, I was happier behind the camera. It made me nervous to have everybody stare at me. Over the years, I'd get over that, come out from behind the camera and develop my public persona.

This was the summer I saw Dylan rock out at Newport. I got good pictures, but I had no contacts at any magazines or in the music industry where I could sell them. I wasn't even sure where the offices of the magazines or record companies were.

I did look in the phone book for the Manhattan office address of Dylan's manager, Albert Grossman. I took a couple of prints in, just to show them. I didn't get to meet Grossman or anybody famous. But the receptionist thanked me for the pictures and, in return, Grossman's secretary handed me a ticket to see Dylan at an upcoming show. She later told me that Dylan took the prints home, but I never heard anything more. It wasn't until the 1970s that I began licensing my Newport picture of Dylan, which has been published many times since.

Meanwhile, the Justice League was beginning to sound really good. They were rehearsing in our Sullivan Street apartment and becoming more and more proficient. Unfortunately, our Italian neighbors did not appreciate the music in the same way that we did. Adding their complaints to the fact that we never paid the rent, it's no surprise that, just three months into our tenure, in September, we were evicted.

We decided to throw one last big party, and deep into the night, music blasted from our apartment. Suddenly, around 3:00 A.M., the doorbell rang.

It was our landlady, standing in the doorway with a fireman.

"Your car burned up."

I had bought my mom's Singer Gazelle, a compact British car. You didn't see many little British cars on the streets in those days and it always turned heads. It was a black convertible with a blue stripe down each side and a red leather interior. A hot little car.

It wasn't always reliable. When the starter motor broke at one point, and I couldn't afford to fix it, I had to crank the engine to start it. It actually had a hole in the fender where you inserted the crank, like an old-time automobile. I did that for a couple of months, and there was one time in the heart of the Village, at the intersection of Third and MacDougal Streets, when the car stalled as I was making the turn. I'll never forget how embarrassed I was to get out and crank it up right there in the middle of the intersection; people were staring and scratching their heads. But it was a fun car to drive with the top down to places like Newport.

Now the neighbors had torched it. All that survived were my two John Lennon books, *In His Own Write* and the just-published *A Spaniard in the Works*, which one of the firemen solemnly handed to me. They'd been in the glove compartment and, oddly, they were all that was saved from the blaze. The Singer itself was a charred hulk.

The Justice League was having fun; they were just a bar band making twenty-five dollars a night, but audiences seemed to like them when they played.

They were now rehearsing at Tommy's house in Great Neck, and one day in November 1965, we were hanging out there when our friend Davy Simon arrived. He was accompanied by a guy he'd met walking down the street, who was looking cool and carrying a guitar case. Davy accosted him and asked, "Hey, you want to be in a band?" The guy said yes, so Davy brought him by.

His name was Larry Coryell, and he looked amazing. He walked into that basement, and we were immediately impressed. A very good-looking guy with perfect Hollywood hair. He was a couple of years older than me, and he explained that he had come to town to attend Mannes School of Music.

When he opened his guitar case, all the air went out of the room. He had a three-thousand-dollar Guild guitar in there. We were in awe.

He started playing, these pearly notes just hanging in the air. He was better than anybody in the room—he was better than anybody we had ever heard. He was just phenomenal.

Everything about Larry seemed impossibly exotic. One day when the band was rehearsing, we took a break to have a bite to eat, and Larry had a bottle of brown rice with some vegetables in it. When Larry told me about this diet, it was the first time I had heard the word "macrobiotic." He had a terrific sense of humor, and he knew so much about music, as I was about to discover.

Larry agreed to join the Justice League, and a few days later, they were at a rehearsal space on Bleecker Street. As they started to rehearse, I went up to Fourteenth Street, to Flag Brothers, to buy a pair of cheap Thom McAn Beatle boots—brown suede with a Cuban heel and a zipper up the back.

I saw a crowd of kids on the street outside the Academy of Music, gathered around a girl I knew, Freddie Taylor. I asked her what was going on.

"It's the Rolling Stones," she said. "Want some tickets?"

I said, "What's the Rolling Stones?"

"A band from England. They're fantastic."

I had never heard of the Rolling Stones. Musically, my world was bound up in the folk scene. I had never heard of a rock band playing in a theater, either. I thought rock bands only played in bars and at dances. The whole concept of a rock band giving a concert in a theater was new to me. And somehow exciting.

I had to make a decision. I had precisely ten dollars on me, which was the price of the boots. But Freddie had tickets for this show, which she was selling for five dollars apiece—double their face value. Boots or band? Band or boots?

I bought two tickets.

I ran back to the rehearsal loft and asked who wanted to go see these Rolling Stones with me. Nobody. "No, man, we're busy rehearsing."

All except Larry. He wasn't feeling at all busy sitting in with the Justice League, so he came with me. As it turned out, he'd actually heard of the Rolling Stones.

We sat in the mezzanine, just talking while we waited for the show to begin. Or, rather, Larry talked and I listened as he chattered on about guitars and amps and gear of all descriptions.

I had no idea what he was talking about. I felt more disoriented at that concert than I did taking LSD for the first time. There was so much noise and chaos. People were screaming. Paper plates flew through the air. Bands came and went and made some noise for a while. Until finally, the emcee announced, "The Rolling Stones!"

I heard no music, no singing for the rest of the concert. Just screaming. Mick Jagger jumped and jerked around like a marionette whose strings were controlled by a speed freak. Bill Wyman was absolutely stock-still. The only time he moved during the whole concert was when a paper plate sailed toward him and he shifted maybe four inches to his right.

Keith and Brian were probably doing a good job, but I still didn't hear any music. I just saw this mad Mick Jagger bouncing and jumping and leaping all over the stage, and the audience screaming throughout at the top of their lungs.

Larry, meanwhile, was sitting there calmly. I remember at one point he said something about the kind of amplifier the band was using. And I looked at him as though he was crazy. I didn't know how he could stay so calm.

At the very end, the Stones played "(I Can't Get No) Satisfaction" for what felt like fifteen minutes. Incredibly, I'd never heard it before. No matter that the song had been number one just a few months earlier. For me, it was brand-new, and when I got back to the loft and my friends asked what had happened, all I could say was, "Dum dum da da da . . . da da da." That riff stuck in my head for weeks.

Larry played with the Justice League for just three days, and then went on to a career in jazz, pioneering and innovating jazz fusion and working with everyone from Chick Corea to Miles Davis.

My exile from Manhattan did not last too long. I spent two months back on Long Island with my parents, but then I received a call from Alan, saying he had found us a new place on West Forty-Sixth Street. In fact, it was two separate two-bedroom apartments, one over the other. Hank, Al, and I were in the bottom one, and Alan and Mike were above. We still weren't certain how we would be able to pay the rent, but we thought we'd give it a try.

I was able to find jobs that had something to do with photography, including a spell at Stech and Stech, a photo studio that took pictures of lamps. It was down on Broadway, around Bleecker Street, and after I'd been there awhile, I was able to get my friend Al a job there as well. It was boring work. When I say we used to take pictures of lamps, I mean it. That's what we did. We took pictures of lamps and ashtrays for a host of different manufacturers to use in their sales catalogs and brochures.

My part in this enterprise was to go to what was known as "the lamp building," up on Twenty-Fourth Street and Fifth Avenue, a huge place where on almost every floor, all the offices were occupied by lamp wholesalers. There, you could find every kind of lamp you could possibly imagine. Every lamp you've ever seen in a motel or hotel, every lamp your neighbors have, or you have, whether it's the cheapest model available, or the most expensive, they were all for sale in that building.

Every visit, I would pick up twenty lamps, put them in the van, and bring them down to the studio; then, once they'd been photographed, I'd drive them back, and get some more lamps from some other company.

My other task was to print out the finished pictures, hundreds of them at a time, on a machine that automatically printed out contact sheets. Put the paper in, take the paper out. Put it in, take it out, put it in, take it out. Over and over again, with this automatic contact printing machine spitting out up to 150 copies of whichever kind of lamp it was that some company wanted to sell.

The Justice League continued their slow rise to recognition in the local folk scene. Hank had even dropped out of school—he'd been attending the High School of Music and Art up on 135th Street, but he quit to live with, and concentrate on, the band.

We even had our own following, as some of the girls he knew from school started to come over and hang out. We also started meeting girls at the band's gigs, and when I organized a party that New Year's Eve, I made sure to invite all the girls we knew. The apartment was packed, and cops came twice to warn us about the noise. They came back at eleven thirty and made everyone leave. I was alone in Times Square by midnight.

WHERE THERE'S SMOKE

John Lennon · Lisa Robinson

ONE EVENING IN THE LATE WINTER OF 1966, ALAN picked up the phone and it was Michelle, one of Hank's high school friends, who wanted to come over and bring her sister. Her sister's name was Nadya, and I thought she was really cool. In fact, she was beautiful, with brown eyes and light brown hair. She was sensitive and smart, an art major with a minor in education at Hunter College. We smoked a little pot and got to like each other, and soon we were dating.

Two weeks later, Nadya threw a party at her parents' apartment on Seventieth Street just off Central Park West. Her dad, Abe Lublin, was one of the biggest publishers of fine art lithographs in the world, and the apartment reflected that. There were three big original Toulouse-Lautrec posters on the wall, a Chagall, and a couple of Picassos. (Later, he would publish John Lennon's erotic lithograph portfolio, *Bag One.*)

Abe started out as a truck driver from the Bronx and in World War II had been the sergeant in charge of the Allied Powers' supply depot in Paris. If you needed anything, from a ballpoint pen to a jeep, you went to him. He met Nadya's mother, a young French actress, in Paris.

They were now away on a second honeymoon, which gave Nadya the perfect opportunity to throw a birthday party for her friend Roni Hoffman. That was the night I met Roni's boyfriend, Richard Meltzer, a rock critic at a time when there were only a few around. Roni went to Hunter College with Nadya, and Richard spent his days watching movies, "doing research," he said, for the Great American Novel that he was planning to write. Whenever Nadya's parents went away, Roni and Richard would move into their bedroom. They didn't have anywhere else to shack up.

Unfortunately, his Great American Novel is still up for grabs, but Richard did go on to write a few important books of rock criticism, including *Gulcher* and *The Aesthetics of Rock*, and his journalism is in a class of its own.

It was a fascinating party for me. Richard's music industry friends and contacts were everywhere. Steve Paul, who ran the Scene nightclub, showed up with the singer Tiny Tim, who was carrying his ukulele in a shopping bag. Rock writer and musician Lenny Kaye, who would later help Patti Smith start her band, came, and so did Lisa Robinson, who would become a very important rock writer.

They all knew Richard, and none of them knew me. But because I was helping organize the party, showing everyone where the hookah pipe full of pot was, essential services like that, everybody got the impression that this place was my apartment and that I was some rich, groovy guy with Picassos on the wall. In fact I didn't have three dollars in my pocket.

Later, when there were just a few of us left, Nadya suggested that we go up to Untermyer Park in Yonkers. I didn't know Untermyer Park, but I was happy to drive her father's Lincoln Continental there. So Nadya and me, Hank, Al, and some guy we had just met at the party drove off.

Untermyer turned out to be a wonderful place. It was the former estate of Samuel Untermyer, who was a wealthy corporate lawyer in the early twentieth century. Originally there was a ninety-nine-room

mansion on the site and, while that was torn down in the late 1940s, what remained was spectacular—150 acres overlooking the Hudson, with beautiful gardens, statues everywhere, and a man-made grotto. I've heard stories about some pretty swinging parties that went on there—Isadora Duncan dancing barefoot on the lawn, tales like that.

By 1966, the park had sadly fallen into neglect and ruin, like most everything else in and around New York City at the time. It was a beautiful night under a full moon, and really romantic in the way that moonlit ruins are, a magical place full of possibility.

As we were about to drive back to the city, a police car passed us. I didn't think anything of it. After all, we were in a Lincoln Continental. Plus, we had smoked the last of our pot, so all we had was the pipe and the little pill vial the pot had been in. Nothing to worry about.

But the cops pulled us over and arrested us for the residue in the pipe and the vial.

We spent a scary night in a Yonkers jail. They separated us, so Nadya was in one cell while the rest of us, including the poor guy who we didn't even know, were in another. The following morning Nadya's uncle and my father came to bail us out. As we rode the elevator together up to the courtroom, Nadya reached down and held my hand. That was the moment I knew for sure we were a couple.

Nadya's father engaged a lawyer and we were set to meet him in a week or so. Initially, Nadya's father intended to drive her up to Yonkers himself, leaving me to make my own way there. But Nadya told him, "I'm going with Bob." We took the train. The first time I met Nadya's father, my future father-in-law, was in the den of the high-priced lawyer he had hired for the occasion.

Nadya's father was furious. The lawyer drank bourbon through the whole meeting. He drank three glasses of it while railing at me about how the youth of today were completely worthless, taking drugs, listening to degenerate music, the whole nine yards.

It was a familiar litany, and he was good at delivering it. I chose not to comment on the hypocrisy as his words began to slur, and finally he got to the point of the meeting, which was to tell me that I should plead guilty.

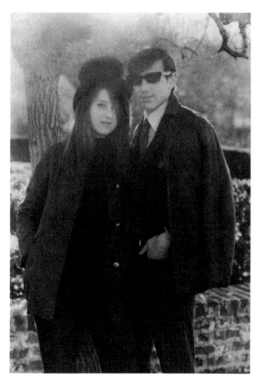
Nadya Beck and Bob Gruen, Great Neck, New York, 1966

"Do the right thing. Be a man and protect the girl."

"I'm not pleading guilty," I replied. "Nobody's pleading guilty. It was an empty vial. None of us are going to plead guilty because we're all going to get off. We weren't in possession of drugs. We weren't in possession of anything but a used pipe and an empty vial."

Ultimately the charges against us were dismissed, I think because the lawyer dragged the case out so long that the presiding judge actually died! So maybe he was worth all the money he charged.

Meanwhile, Nadya's father's troubles continued to multiply. The cops had impounded his Lincoln and were refusing to give it back to him. In the end, he had to pay five thousand dollars to the lawyer to get his car released.

Small wonder that he was not happy about our romance. Indeed, he tried desperately to keep Nadya and me apart. First, he refused to let Nadya see me, so we used to set up clandestine meetings in Central

Park, near the zoo. He found out about that and sent her to Spain for the summer, convinced that would bring her to her senses. But it didn't. In fact, while she was there, she met a Spanish prince who tried very hard, but unsuccessfully, to sweep her off her feet. When September rolled around and she returned to New York City, she came back to me.

Untermyer Park would also become a part of my life. There were so many great, inspiring locations on the grounds—wide lawns, formal English gardens, a beautiful mosaic of Medusa, the grotto, a long stairway down to the Hudson. I did several photo shoots there, including one of my first album cover jobs, with the Shirelles in the early 1970s.

We did a fantastic session all over the grounds. The art director, who apparently had a drug problem, picked a shot with the Shirelles looking really tiny in the distance, running toward me across one of the fields.

I had sent him better shots but, because of his drug-addled brain, that was the one he chose. I hated it, their manager hated it, and the Shirelles hated it. But the art director said he didn't have any others, because after he picked that one shot, he threw the rest away. He got fired, the band left the label, and the record never came out. I felt terrible because somehow, I felt it was my fault for even showing him that shot in the first place. I learned a lesson then, to only give people the photos that I would want them to choose.

The next time I returned to Untermyer Park was in 1975, for a beautiful session with John Lennon. That was one of my favorite afternoons with him. It was a chilly day and, on the way home, we stopped at a diner for tea and a roll. I've always loved the picture of John with his cup of tea, and the dollar bill lying on the check. He's got a nice jacket on, but he's also got an army coat over it. The image shows a "working class hero," which is indeed what John was to so many people.

So, there were definitely some positive outcomes of the otherwise disastrous night of our arrest: Nadya and I realized we were in love, and I met some friends of Richard Meltzer's. In a few years, we'd all be working together in various capacities.

When Lisa Robinson; her husband, Richard Robinson; and Lenny Kaye started the magazine *Rock Scene* in March 1973, they used my

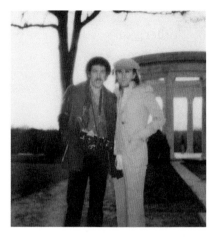

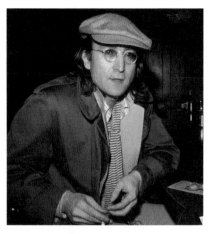

Bob Gruen and John Lennon, Untermyer
Park, Yonkers, New York, March 28, 1975
(photograph by Francis Schoenberger)

John Lennon, Yonkers, New York,
March 28, 1975

photos in the first issue, and they appeared in all the issues after that. Lisa got me many of my photo passes in the seventies. She got me my first Rolling Stones pass when they played Madison Square Garden in 1972, and it was through Lisa that I ended up photographing the now famous picture of Led Zeppelin standing in front of their airplane, an iconic image of the excess of the seventies.

Rock Scene didn't only publish photographs of the rich and famous, however. I had gotten to know all the people who actually made the New York clubs work—the owners, the bar staff, the doormen and security guys—and we put them all in the magazine, so they would be nice to us. And they were. We were the only magazine that would publish pictures of the people who worked behind the scenes in the clubs. They were thrilled to be in our magazine and let us in free all the time.

There were other kinds of fallout from our arrest that were less pleasurable. For a start, it meant that Hank, Al, and I had to give up our apartment in the Hell's Kitchen end of Forty-Sixth Street, real *West Side Story* territory. Our parents were furious with us and laid down the law: "That's it. You're coming home and getting jobs."

My dad even made me get a haircut and sign up at an employment agency that specialized in photography. They got me a job in the

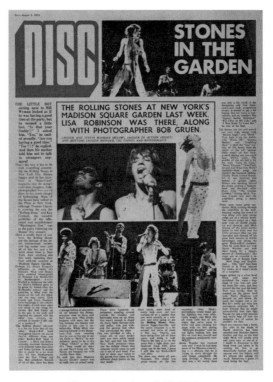

Disc magazine, August 20, 1972

mailroom at the Nabisco Corporation. I started work on May 1, 1966, commuting from my father's apartment in Great Neck.

Actually, there was a method to that particular piece of madness. Nabisco had their own photography department, which took the still-life photographs that graced their cracker boxes, cookies, and other products. The idea was that I'd work my way up from the mailroom—they'd see I was a good worker and promote me to the photo department, and that would be a solid, secure career. I probably could have made a lot of money doing that, posing Wheat Thins and Oreos in fun and innovative ways. In any event, I thought I'd give it a try.

At first, it worked out well. Soon after I started, an efficiency expert was brought in to run a survey, and I was noted as one of the most efficient workers in the place. I found it amusing that whenever the efficiency expert came to the mailroom, everybody else suddenly started bustling around looking very busy. Normally, the other mail boys moved

so slowly that it took all morning to sort the mail, whereas I'd be finished in fifteen minutes and could sit down to read *Billboard* and *Record World*. Somebody there had subscriptions, and that's how I started to understand how the music business actually worked.

I was doing well. In fact, I'd not been there long before I could afford to have a suit custom-made—a very conservative, dark gray pinstripe banker's suit. But I had the back of the vest and the lining made from a black fabric with big white polka dots. When I took off my jacket, everybody was stunned, and while it's hard to explain today how a simple thing like a polka dot vest could make such an impact, this was the mid-1960s corporate world, and it did!

The Nabisco building was on Fifty-Fifth Street and Park Avenue, and that was perfect for me because it was close by the Wollman skating rink in Central Park, home first to the Rheingold Music Festival, and then the Schaefer Music Festival.

My musical tastes had expanded; I was no longer listening exclusively to folk.

Festival tickets were one dollar and, over the years, I saw Fats Domino and the Who on their The Who Sell Out tour in 1968. I saw many other bands, but I missed a few as well—the Jimi Hendrix Experience and the Young Rascals, in 1967, and Otis Redding, in 1966, a gig I still regret not attending.

The Anderson Theatre, in the East Village, on Second Avenue between Third and Fourth Streets, was neither the best venue in the city nor the most comfortable. Its appeal was that it was free to enter. Not officially, but while exploring the venue one day, Al and I discovered that if you went up the fire escape and pushed the doors, they were so old and rusty they simply sprang open. So that became our chosen route when we went there.

Bill Graham opened the Fillmore East, on Second Avenue near East Sixth Street, on March 8, 1968, and we were very excited for the opening night, featuring Albert King and Big Brother and the Holding Company.

We went up the fire escape like we did at the Anderson, only to be confronted with a brand-new set of solid steel doors that looked like the entrance to a bank vault. You could not get a toothpick between them;

they were firmly locked. They didn't even rattle when we knocked on them, hoping that some like-minded hippie might be passing by who would let us in.

We listened to Albert King's set through the doors, and then we gave up. As we were walking away, we ran into a bunch of roadies as they reloaded Albert's equipment. We stopped to watch, and they immediately started yelling at us to get out of their way, then pushed us . . . straight through the open doors of the backstage area. At which point Bill Graham himself appeared, took one look at the two kids standing there, and *he* started yelling at us as well.

"What are you kids doing back here? This is completely out of bounds." He grabbed us and dragged us away, threw open a door, and pushed us through it—into the very auditorium we'd been trying to get into all evening. Even better, we were right at the front, pressed up against the stage as Graham turned around, and moments later appeared on the stage to introduce the next band.

We had never heard Big Brother and the Holding Company. The moment their singer opened her mouth, I knew we would be hearing a lot more of her in the future. She was absolutely phenomenal. I turned to the person next to me and said, "Who is that?"

It was Janis Joplin.

Soon I was going to the Fillmore every chance I got. Tickets weren't expensive, and Bill Graham was booking some of the best bands around—everybody wanted to play the Fillmore.

Of all the groups I saw there, though, the best had to have been the Who. The first time I saw them, I sat there in awe, astonished that just three guys could make so much sound behind the singer! I'd never really considered the actual makeup of a band before. Listening to the Who on record, it felt as though there were dozens of people playing. But there was just the three of them, and they were even louder than the albums.

They were the most dynamic rock band I had ever seen, and I went to every show they played around New York City. I was there on the night of the famous Fillmore fire, May 16, 1969, the last night of a weeklong engagement. I had been to every show and this last night I brought Nadya. Toward the end of the show, with *Tommy* over and done

with and the band now slamming through choice oldies, Nadya turned to me and asked, "Do you smell smoke?"

Not at first, but as the moments passed by, there was definitely an acrid scent in the air. I told her I did, and she asked if I thought we should leave. I looked over the balcony (that was always my favorite place to sit at the Fillmore) and I could see a few people at the front of the auditorium, standing up and looking around a little nervously. But I couldn't actually see anything wrong, so I sat back down and said, "The Who are still playing, I'm not going until they do." After all if the place really is on fire, they're not going to be sticking around.

Suddenly a guy in a denim shirt jumped up on the stage and grabbed the mic from Daltrey. He was about to say something into it when Pete Townshend literally flew across the stage and sent him flying off to the side of the stage, into the arms of some roadies who grabbed him and hustled him out. It was bizarre.

Then Bill Graham came on the stage, walked to Pete, and said something in his ear. You could see Pete nod in agreement, and Graham turned to leave, at which point Pete went straight into "Summertime Blues." Graham looked furious, but there wasn't much he could do about it. He waited until the song ended and then he walked up to the microphone to announce that there was a fire farther down the block, and the emergency services needed everybody to leave the building as a precaution.

We filed out, looked to the left, and it was hard to comprehend what we were seeing. The building next door to the Fillmore was completely ablaze, all three floors of it, and the flames were licking against the walls of the venue. The Fillmore itself wasn't alight, but it looked like it could be soon. And then all eyes turned away from the conflagration to watch the Who's limo as it disappeared up the street. Keith Moon was in the back, with his bare ass pressed against the window, mooning the city.

I quit Nabisco in the fall of 1966, when I heard that they were laying off people in the photography department. I also had a case of conjunctivitis that my doctor thought was brought on by working all day beneath fluorescent lighting.

I also moved back to the city, to an apartment on West Twenty-First Street where I split the rent with Alan Nevins, which made job hunting much easier. Soon, I had new employment, making filmstrips at the Manhattan Photo Lab. I also took two photography classes at the Fashion Institute of Technology (FIT) where I learned some basic technical skills. Something my professor said really stuck with me. He told us to take a picture that showed the presence of someone, without actually showing the person.

I said, "Like a cigarette burning in an ashtray next to a couch?"

"Yes, if the couch is still warm," he replied.

I said, "Like a car with the door open?"

"Only if the engine is running and the radio is on," he said.

I got what he meant, and it gave me new insights into what photographs can show; that they can reveal feelings not just facts. The professor also went on to recommend me for a job at Commercial Studios, a fashion catalogue house, and from there, I moved on to manage a studio on Forty-Sixth Street, which made slides for the Museum of Modern Art and various other museums.

That was extremely exacting work, which largely consisted of taking photographs of different paintings. But not any old photo. The goal was to capture a *precise* photographic image, every shade of color, every brushstroke, every last nuance of the original piece. I learned so much about perspective, lighting, and how the chemistry of film interprets colors in different ways.

THE RISE AND FALL OF GLITTERHOUSE

Spider-Man • Karen Allen • Glitterhouse • Lotti Golden

I WAS STILL TRYING TO FIND MY WAY INTO NADYA'S parents' hearts, even taking courses in French and art history at the New School, so I could hold up my end of the conversation when they had artists and collectors to dinner.

If I have to think of a turning point in that relationship, it was one lunchtime with her family and friends when we were talking about the war in Vietnam. I said we shouldn't be there, not just because I was against war, but because it had grave economic and geopolitical consequences.

Her dad just sat there, watching and listening. I think that was the night he realized that I had an intelligent opinion to offer. I wasn't just the kid who got his daughter arrested. We got on a lot better after that.

One day in the spring of 1968, Alan, who was always the resourceful one in our bunch, announced he had managed to rent two floors of loft space on Twenty-Ninth Street between Seventh and Eighth Avenues for just two hundred dollars a month, which was a total steal.

We needed the space. Steve Rutt, my genius friend since grade school, had invented an early computer circuit board that he was selling to businesses. Hank and Al worked for him silk-screening the circuits onto the boards, and then soldering in the transistors and resistors. They set themselves up on one half of the lower floor and I had the other half for my first photo studio. We intended to convert the upstairs floor into a rehearsal studio.

The one thing we were concerned about, however, was the need for soundproofing. We didn't want neighbors banging on the door and setting fire to our cars again.

We went down to what's now lower Tribeca, but back then was still the "dairy district." Manhattan still had a lot of light industry, and the different trades were each clustered in their own area—the meatpacking district, the flower district, the fashion district, remnants of which exist today. Lower Tribeca was the dairy district, and that's where we collected a lot of cardboard egg crates to staple to the walls and ceiling. We completely covered every surface and were rather proud of our accomplishment. It didn't really block out the noise; it just muffled it a little. But it looked interesting.

Over the course of the last year or so, the Justice League had abandoned folk music and morphed instead into the more psychedelically inclined Pop Art. They even released a single—"Rumpelstiltskin," on Epic—before changing their name again, to become Glitterhouse.

They had also been joined by a keyboardist, Mark "Moogy" Klingman, who would go on to a great career in music, working with a lot of talented people . . . despite being the most aggravating guy I've ever met. But, he really did seem to know everybody, and had made a lot of friends. He'd played with Jimi Hendrix when Jimi was still Jimmy James and, later in life, he played with Lou Reed, Jeff Beck, and many others. He was even Bette Midler's bandleader and cowrote her hit "You

Gotta Have Friends," which is a pretty ironic title, considering Moogy's remarkable talent for alienating people.

He's probably best known for the years he spent alongside Todd Rundgren, and I can take at least some of the credit for that.

Taking the train into the city one day, I got talking to another "longhair"—because these were the days when, if you saw someone who dressed like you, and wore their hair like you, you automatically bonded, even if only for a little while.

It turned out this particular longhair was Thom Mooney, the drummer with the Nazz, a Philadelphia band who had recently relocated to New York City, and even more recently been re-relocated to Great Neck by their manager, who didn't want his charges running riot across the city.

They lived together in a big house in Great Neck, where they could write and rehearse in the basement as late into the night as they wanted to without disturbing any neighbors, and to which they had to return every night at a decent hour, because the trains stopped running around one in the morning.

He introduced me to his bandmates, and that's how I met Todd Rundgren, and then I introduced them to Glitterhouse, Moogy among them. Soon enough, Todd was recording his first solo album at the Record Plant, and Moogy was playing electric piano. They would continue working together in Todd's band Utopia, right up until Moogy's death in 2011—in fact, he passed away on the eve of what would have been Todd and Utopia's first reunion tour.

Another person Moogy knew was Rick Derringer of the McCoys. It had been a few years since that band burst onto the scene with the hit "Hang On Sloopy." When we got the Twenty-Ninth Street studio finished, Moogy brought Rick along to see it.

The McCoys ended up renting the studio for two hundred dollars, which effectively meant they were paying the rent for all of us. Alan, Steve Rutt, and I continued our own enterprises on the floor below, and things went on very happily for a while. But then Alan was arrested for selling 3,500 tabs of LSD to an undercover agent posing as a New Jersey

junior high school teacher. They had an airtight case against him and he went to jail, which left me responsible for the lease on the two floors.

I went to the landlord and asked, "Why don't you make a lease with the McCoys for two hundred dollars? That way, you don't need to charge me for my floor."

"Well, I can't give you the floor for free," he replied.

I thought, why not? But we dickered and I agreed to pay seventy-five dollars a month for my floor. It was a great bargain, although the truth is, I couldn't have paid any more.

That was my first studio. It had previously been used as a massage parlor and, when the police raided it one time, they had torn down one sheetrock wall leaving the exposed brick. It was twenty by thirty-five feet, with a sink and a toilet, and a small closet with a lock where I could store equipment. I also made the closet lightproof, so I could load film for my 4 × 5 camera in there.

There were bars on the windows that I could unscrew so I could climb onto the roof and take pictures out there. In 1972, Buddah Records and Marvel Comics put out an album—or, as they put it, a Rockomic—called *The Amazing Spider-Man: From Beyond the Grave*, combining a few songs performed by Ron Dante and the Webweavers with stories interspersed between the musical selections.

The cover, the gatefold comic strips, and the poster that was given away with the record were all designed by Spider-Man artist John Romita. They also hired a muscleman to wear a Spider-Man outfit for promotions, and his manager asked me to take pictures of him. What a great commission! Spider-Man was my hero, an American teenager with a camera. The roof would come in handy.

The costume looked great—it was made from a heavy-duty stretch canvas. Really strong material, exactly like a superhero should have. It was not so easy to wear, however. The only opening in the entire outfit was a four-inch gap in the back of the neck, and it took two people to hold the outfit open while the guy squeezed himself in and pulled the cowl over his head.

He was completely enclosed, which became a major problem when we got to a mall in Long Island, where I was photographing a promo

appearance, and he needed to use the bathroom. The publicist and I ended up in the bathroom trying to drag him out of the suit.

I photographed him on my roof, sitting on a skylight like *The Thinker*, with his elbow on his knee and his chin on his fist, the way he is often drawn. When *Creem* magazine printed the photo, I asked them to credit it to Peter Parker, just like in the comic book.

I shot the New York Dolls in that studio, Alice Cooper with Wolfman Jack, and many others.

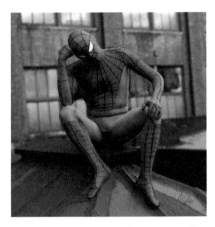

Spider-Man, West Twenty-Ninth Street studio roof, New York City, December 7, 1972

(Left to right) Bob Gruen, Wolfman Jack, and Alice Cooper, West Twenty-Ninth Street studio, New York City, November 27, 1973 (photograph by Jonathan Takami)

Because the studio was just around the corner from the Fashion Institute, I used to go downstairs to the street and look for FIT students to come model, so I could practice portraits. One young woman, a very pretty brunette named Karen, came up and we did a great session together.

The pictures sat for years in my file cabinet until one day, about thirty years later, my assistant Linda was going through some old shots and suddenly called out, "Hey, do you know who this is? It's Karen Allen. She's the actress in *Animal House, Indiana Jones* . . . ," all these great movies, and I thought, "Really?"

I didn't think about them until October 2019, when I was at the Woodstock Film Festival, sitting and talking with my friend Matt Dillon. He was working the room; he'd sit with us for a while, then go off for a

while, then come back to talk some more. One time, as he returned, he said, "Oh, there's a woman who wants to meet you"—and it was Karen! "You took some pictures of me in New York when I was about nineteen, and I just wanted to thank you, because you were so nice." I was amazed that she remembered me.

Karen Allen, West Twenty-Ninth Street studio, New York City, October 18, 1970

Soon modeling agencies were sending young women over for me to photograph. The doorbell would ring, and there they were, these stunning models ready for the camera. I kept that space into the mid-seventies, and I wish I had it now. But the building is long gone. There's a hotel there now.

Meanwhile, Glitterhouse had finally got their big break. Paul McGregor, the hair designer who created the shag style for Jane Fonda in the film *Klute*, and Bob Crewe, the legendary pop music songwriter and producer, threw a party.

It was to celebrate the opening of McGregor's new unisex salon—the first to offer hair styling for men as well as women, and the latest Bob Crewe Generation album, which was based on a beautiful new book called *Birds of Britain*, featuring John D. Green's photos of different British models.

The party was being held at the salon, on St. Marks Place, and Moogy's dad knew the organizers of the affair. He convinced them to offer Glitterhouse one hundred dollars to play, and Bob Crewe, who had cowritten a string of huge hits for the Four Seasons, Leslie Gore, and many others, liked what he heard.

Over the next few months, Crewe took them into the studio to record three songs for the *Barbarella* soundtrack, including the opening title song; he gave them a recording contract with his own Dynovoice label, and then produced their album, *Color Blind*. Rosko, a deejay at WNEW FM, wrote the liner notes; and when the label needed photographs for publicity I had them.

I was also beginning to work with Bob Crewe myself. In fact, the first album cover I ever had my name on was by an urban poet-singer he had recently started recording, Lotti Golden.

(Left to right) Moogy Klingman, Bob Crewe (in window), Mike Gayle (seated), Joel "the Bishop" O'Brien, Al Lax, and Hank Aberle, Glitterhouse, A&R Studio, New York City, 1968

The session took place at Lotti's apartment, and it did feel strange being there; this was her home and I was looking around, finding the best spot to place her for the shot, checking the light—doing all those things that photographers do while she sat watching me, a slight smile on her face. I think this was new for her as well; this was her first-ever LP and I'm not sure how many photographers she had worked with in the past.

It was important to me that the photo make an impression, not only on Bob Crewe but also on Bob Rolontz, who was the vice president for Atlantic's advertising and publicity department, to whom Bob had just introduced me.

One of the first things I noticed about Lotti was her eyes, they were so expressive. I saw the blinds that Lotti had hanging in the windows, and an idea occurred to me. If she were to stand behind the blinds, opening them enough that parts of her face could be seen . . . her forehead, her eyes, part of her nose . . . and if she were to look deep into the camera, I could get the sheer magic of her eyes, and that's what my photo achieved.

Lotti Golden, *Motor-cycle*, New York City, 1969

Bob Rolontz would be responsible for giving me a lot of work over the next few years, including a session with Tommy James and the

Shondells in 1970, at a rally for Hubert Humphrey in a rain-swept parking lot in Yonkers. The following year I shot a Bee Gees party celebrating their tenth anniversary (and ten years later, the Bee Gees' twentieth anniversary at the mayor's official residence in New York City).

By the end of the 1960s my career was definitely snowballing. One contact led to another, which led to another. For Glitterhouse, unfortunately, things didn't work out. Their album didn't sell, Crewe dropped them, and they broke up. But the Justice League/Glitterhouse crew kept in touch.

Steve Rutt and a partner invented the Rutt/Etra video synthesizer in 1972, which enabled the production of the first animation and special effects on television and revolutionized the industry. Steve died in 2011, the same year Moogy passed away. Alan Nevins has left us as well.

The rest of us, though, are still friends—in fact, Al is now my stockbroker. Hank taught classical music at Juilliard, then went into dubbing voice-overs for foreign films. Mike moved on to producing instructional videos. And years after the band broke up, in October 1981, I was walking on Columbus Avenue uptown and I saw a crowd of people in an art gallery at an opening.

I went in, figuring I'd get a free glass of wine, and to my surprise Tom Winer, the Justice League drummer, was running the gallery, Radius Graphics. He also had a frame shop in the back. I saw that he was selling photos, showed him some of mine, and ended up having my first-ever big gallery exhibition there.

Being married is not about finding the person you can live with; it's about finding the person you can't live with*out*. Nadya was that person. She was creative, she liked rock-and-roll and soul music, and we enjoyed going to the country to camp out and ride horses together. She also gave me a lot of freedom. We would have dinner and hang out, then she would watch the eleven o'clock news and go to sleep while I'd go out to clubs all night.

We decided that we'd get married when she graduated from Hunter College in June 1969. One day she said, "Come over tonight. My dad wants to talk to you."

"He wants to *what*?" Her dad spoke very little. Although relations had definitely thawed, he and I had very little contact in general. "Are you kidding? Talk about what?" I figured it couldn't be good.

I went up to their place. They had moved from the Upper West Side to an apartment in the Upper East Side, Seventy-Second Street and First Avenue, in a tall building with a view of the East River and Long Island. He was sitting at their glass dining table when I walked in and sat down.

He didn't beat around the bush. "So you're planning to get married?" he asked. "And how are you planning to support my daughter?"

I hadn't planned to support his daughter at all. I thought she'd get a job and I'd keep taking pictures, and somehow we'd get by. I certainly couldn't support her the way he had. I was getting work from the music business, but at this stage, having left the photo studio job to set up my own studio, I was barely supporting myself.

"I guess I'll get a job," I said. And I did.

My first job was taking baby pictures in public housing projects. Unfortunately, I wasn't very good at it, and soon got a much better job working nights at the Colony Music record store in Times Square.

Colony was the record and sheet music store to the industry. It was open all night, and it specialized in having every single record in existence, and all the sheet music.

Each week's new releases were in a big box on the counter, and because the store was right next door to the Brill Building, the center of the music business, all kinds of people were in there, every hour of the day and night. If anybody needed a record, they went to Colony. The store's shopping bags showed a cheerleader jumping in the air, with a record in hand, saying, "I found it at the Colony!"

It was a great job, and very instructive. I learned the record-filing system. I learned what records were coming out, which artists were hot, which were new, what labels they were signed to, and who I needed to contact at all of them. The store got *Billboard, Cashbox,* and *Record World* every week, so I read through those and educated myself some more about the business.

One night, Frank Sinatra called down to order a record player and a half-dozen records to be delivered to his room in a nearby hotel.

They sent me. A thuggish guy opened the door to Frank's room, took the delivery from me, and tipped me with a hundred-dollar bill. In 1969, if you were handed a hundred-dollar bill, you were a happy boy. That was more than I made in a week!

Muhammad Ali came into the store one night, just shopping for records. A huge crowd followed him around and he put on his usual show for them, spouting his "I am the greatest" poetry. It was rare for a shift to pass without seeing *someone* I recognized.

Because my salary was minimal and Nadya's father wanted her to have a nice place to live, he bought us a condo at Seventy-Ninth and Lexington. It was way uptown for my tastes, but it was a beautiful place, with a huge living room and three bedrooms. We moved in there in June 1969, as soon as we got married.

However, even though Nadya's father had bought the place, there were still maintenance fees to pay, and they were way out of our league: $650 a month, at a time when I had paid only $125 a month for my share in rent for my last apartment.

If I really stretched the budget, I could up that amount to $200, but definitely no more than that. So Nadya's father paid the other $450 a month, which was great but awkward as well. I simply didn't feel comfortable being supported by her father, particularly after he'd asked me how I was going to support his daughter a few months before.

We ended up living in the condo for the first six months of our married life, but on Christmas Eve, when I answered the phone, I received the greatest gift I could have imagined.

An unfamiliar voice: "Are you still interested in an apartment in Westbeth?"

Long before Nadya and I were wed, I had put myself on the waiting list at Westbeth Artists Housing, the first—and still, the only—federal-government-subsidized artists' housing in the country.

It was downtown in the West Village, a converted former Bell Laboratories complex between Bethune and Bank Streets on the Hudson River, and when I signed up, the waiting list had included maybe a thousand people for fewer than four hundred apartments. I'd figured it'd be a long wait. Now I was being told that there were four units left, and one

of them was ours. Eight hundred square feet for $125 a month. Yes, you could do better elsewhere; you could get a three-thousand-foot loft in SoHo for $250. But that was $250 we didn't have. Half of that, on the other hand, was perfect.

In January 1970, we moved in. In truth, it wasn't the best apartment in the building; we were on the first floor, right by the elevators and the mailboxes, and there was an all-night truck repair place right across the street. Everybody in the building went by our door every day; the alarm in the elevators sounded several times a day; passing dogs barked at all hours; and people were constantly knocking on the door to ask directions to other apartments in the building, because its maze of corridors could be very confusing.

Westbeth is a unique place, a large industrial-style complex filled with quirky and eccentric artists. There are 389 units, and inside each one is an artist's very particular vision of Utopia.

Moving to Westbeth was important to me for two reasons. For the first time in my life, I had my own apartment, with my name on the lease; and secondly, everyone who lives in Westbeth has been recognized as an artist by the U.S. government.

I was officially an artist now, and I felt it gave me carte blanche to work and live the way I wanted.

It was Nadya's sister, Michelle, who first introduced me to Max's Kansas City. Her husband worked for one of my favorite artists, Ad Reinhardt, and he told us that Max's Kansas City was a place where artists hung out. It was also a restaurant, open during the day and the evening. One night Nadya and I went there with Michelle and her husband for dinner.

The food was actually pretty good, but I didn't see very many artists. In fact, the only diners were people who worked in the neighborhood, having dinner after work. We enjoyed the evening, but while we were there, Nadya lost a small gold bracelet, an heirloom that she had gotten from her grandmother that was very special to her. The following day I went back to Max's to ask if anybody had perhaps turned it in. The owner, Mickey Ruskin, was standing at the door

He was brusque. Even before I opened my mouth, he said, "What do you want?"

I explained the situation. "I was here having dinner last night with my wife and she dropped her gold bracelet. Do you know if anybody saw it?"

He didn't say a word. He just turned around and walked away as though I weren't even there. I was astonished, but I got my answer. Nobody in Max's cared whether you lost a bracelet or not.

That experience soured me on the club, and it was a long time before I went back. I didn't know about the back room . . . the *legendary* back room, where all manner of behavior took place.

I was enlightened by a guy named Ari, a fellow Westbeth resident, who went to Max's pretty regularly.

He told me it was a great place and that I should join him there; "I'll come by and pick you up around midnight."

Midnight? Who goes to a restaurant at midnight?

A lot of people, apparently. "Max's doesn't really get going until one in the morning," Ari explained. I was just repeating his words back at him: "One o'clock in the morning!?" I knew the bars stayed open until four, but I didn't know that people went *out* at one o'clock in the morning.

THE IKE AND TINA EXPRESS

Tina Turner • Elton John • The Allman Brothers •
Iggy and the Stooges • Keith Moon • The Who

O NE DAY IN THE SUMMER OF 1970, NADYA AND I were asked if we wanted to go to see Ike and Tina Turner at the Felt Forum. Our good friend Judy Rosen, a graphic artist from Long Island, was a huge fan and she convinced us that we had to go. The Ike & Tina Turner Revue was opening for Sam and Dave, and it was one of the most enthralling shows I've ever seen.

Tina is unique. There is nobody else like her. The backup singers, the Ikettes, were amazing, but Tina stole the show in a sparkling mini dress that was so short you could hardly call it a dress, although it did have a fringe. She was so dynamic—dancing, jumping, spinning around in high heels, projecting a powerful, earthy sexuality.

As she danced off the stage in a blaze of flashing strobe lights, I was mesmerized. The whole place was chanting, "Tina! Tina! Tina," and

when Sam and Dave came on, I was *still* looking at the curtain through which Tina had disappeared, because I was totally taken by her.

The next day we went out to see them again at the Honka Monka Club in Queens. It was a nondescript room with a linoleum floor and a small stage only a foot high. Nadya and I sat on the floor right up against the stage. I wanted to be close because, unlike the evening before, I had brought my camera to take some pictures.

Besides Ike and Tina, there were the three Ikettes, four horns, a drummer, a piano player, and bass and rhythm guitarists, all squeezed together on that tiny stage. I shot off a lot of pictures, and by the end of the show, I had only a few frames left.

That was when Tina started to dance in the strobe light.

I couldn't take my eyes off her—she was like a whirling tornado. I raised my camera, but I didn't know where to focus. I didn't know what the exposure would be. I didn't know when the timing would be right. All I could see were flashes of her in the strobe.

Thinking fast, I decided to see what would happen if I opened the camera up to a one-second exposure and let the strobe flashes expose the film—and I got one of the best pictures I've ever taken.

There are five Tinas in the frame, trailing streamers of light. Technically it's not a perfect image, not crisp and clear the way they teach in a photography class, but more like Duchamp's famous painting *Nude Descending a Staircase*. That's what Tina seemed like onstage—in multiple places at the same time.

I made prints of that image, and a few others I thought had come out well. Two nights later when we went to see Ike and Tina's show in New Jersey, I brought the prints and the contact sheets to show to Judy.

Ike and Tina put on another great show. As we were leaving the theater, passing the trailers that were the dressing rooms for the performers, Judy saw Ike going from one trailer to another, and pushed me toward him.

"Show Ike the pictures."

Ike heard her and turned to us.

He had a very deep voice. "What pictures?" he rumbled.

Tina Turner, Honka Monka Club, New York City, July 8, 1970

I'd had no thoughts of showing the pictures to Ike Turner. He was a rock-and-roll legend. Who was I? A twenty-four-year-old fan. And now here I was, handing Ike Turner those contact sheets and prints.

He looked me right in the eye and it felt like he was seeing inside me, from the top of my head to the tips of my toes. Ike Turner could look inside your soul. "I took these at the Honka Monka a couple of nights ago," I said.

"Yeah, I was aware that somebody was taking pictures," he replied, leafing through the prints. "I had a feeling somebody was getting pictures at the right time." He looked up at me. "These are great. I gotta show these to Tina. Come with me."

I was stunned. Ike took me into Tina's trailer, and suddenly Tina Turner was looking at my pictures, and liking them a lot. Being that close to her, I had trouble breathing. She was beautiful, sexy, and glamorous, and yet there was not one iota of the diva about her. She put on no airs, and never has. She was very friendly, grounded, and real.

Ike said, "I want to buy these pictures from you. Come meet me in New York on Monday at the Plaza Hotel, and I'll take you to the record company."

The next day, Nadya and I and some friends piled into my black VW Beetle and drove up to the Newport Jazz Festival to see them play again. It was a beautiful, warm evening, just turning to dusk when we got there. It's still one of my favorite concerts I've ever attended.

First, the jazz guitarist Kenny Burrell played. We got some food and sat there on the lawn listening to his mellow sounds as the sun set. It was a perfect start to the night. Next up was Rahsaan Roland Kirk. They called him a jazz musician, but to me he was as close to rock and roll as jazz can get. He was blind and had several instruments gaffer-taped together, so that he could play three saxophones at the same time, or two saxes and a nose flute. He was tremendously exciting.

There was a quick thunderstorm, the kind that is a welcome relief on a hot humid summer night, and then the Ike & Tina Turner Revue came on. They were fantastic again. Three world-class acts on one bill.

I had no backstage access, and no plans to try and get it. We went to enjoy that phenomenal show. I probably didn't even know I was going two days in advance. We just jumped in the car and went. At the end of the night, we all climbed back into the car for the drive home. It was late, and my friends started nodding off. l was pretty tired, too, and looking at maybe a five-hour drive, I figured that I'd get myself a coffee at the first rest stop after we got on the highway.

I was just getting out of the car when two limousines pulled in right next to me, and Ike and Tina and their band stepped out.

Ike looked at me and said, "I remember you from last night. What are you doing here?" I told him that we'd just seen the show. "Well, come on in and have breakfast with us."

So I went into the restaurant with them, sat with the band, and chatted, and they bought me breakfast. They asked me where I was from, I asked them where they were going. But I was shy, and mostly just listened to them talk among themselves. As we headed back out, Ike said, "See you Monday in New York," and disappeared into his limo.

I got back into my Beetle full of sleeping friends and said, "Oh my god, you won't believe what just happened."

Somebody stirred and mumbled. "What?"

"I just had breakfast with the Ike and Tina Turner Revue."

"What? You didn't wake us up?"

They were pissed. I hadn't felt that it was appropriate to wake them up. Ike invited me to breakfast, not all of them. They got over it.

It turned out that Ike was too busy to take me over to his record company, United Artists, that Monday, but he called Marv Greifinger, who was the publicist there, and told him, "I'm sending this guy over to meet you. I want you to buy these pictures from him." And off I went.

I met Marv in his tiny, windowless Midtown office. He was a small, thin guy with short brown hair, a high voice, and really nice. We got along right away. He liked my pictures and apologized that he didn't have much of a photo budget. The label didn't work that way.

He paid seventy-five dollars for ten pictures, I think because Ike wanted him to, but they probably never used them. I was just happy to get the seventy-five dollars, but more importantly, Marv would end up connecting me with a lot of work. He lived around the corner from me on Bank Street, and we became friendly. He also introduced me to Jane Friedman, who booked a lot of English groups into the rock club Hurrah, and who later managed a poet named Patti Smith.

By the fall of 1970, I was becoming aware of what it takes to sell photos. You have to take, and then give away, a lot of pictures to spread the word and establish your credibility. I had an idea. Using the same principle that I was deploying at the clubs, whenever I was backstage with a star, I made sure to get shots of them with their publicist and manager. I'd give them the prints, and they'd inevitably hang them in their office. It kept me and my pictures in their minds. I also carried a

bottle of Boone's Farm Apple Wine everywhere I went and shared it freely, making friends along the way.

I had a large 20 × 30-inch print made of the multiple-exposure photo of Tina. I figured that I'd give it to her the next time I saw her. By then, I knew enough about their operation to know that I couldn't just send it to their recording studio and hope she'd get it. I had to deliver it myself.

The day I picked the print up from the lab, I came up the stairs from the Sheridan Square subway station, and just as I hit the top of the stairs, Jimi Hendrix walked by, down Christopher Street.

Jimi had always spent a lot of time in Greenwich Village—it's where Chas Chandler of the Animals saw him playing at the Cafe Wha? on MacDougal Street, back when he was still Jimmy James, and whisked him off to London to become Jimi. It's also where he built his recording studio, Electric Lady, on West Eighth Street.

I followed him for about a block and watched him turn into the Pink Teacup, which was a great twenty-four-hour soul food place on Bleecker Street. I stood outside, hesitating, watching him sit down with some friends. Finally, I plucked up the nerve to unwrap the picture of Tina and take it over to his table.

"I just want to show you this picture," I said.

He looked at it and said, "Man, that's a great shot."

That encouraged me to say, "I'd love to take your picture."

"Well," he said, "we'll meet again."

We didn't. He died that September.

That fall, Marv Greifinger took me to a party at fashion designer Lenny Baron's place. That was where I met the publicist Billy Smith, an excitable kind of guy whom I immediately hit it off with. He was always so upbeat, and really enthusiastic about my work. In fact, one November day he asked me to meet him at MCA Records, because he wanted to introduce me to their publicist.

He did more than that, because he also told them to hire me to photograph a new, up-and-coming piano player from England named Elton John. The publicist wasn't actually thinking about hiring a photographer,

but I remember Billy telling them, "Yeah, you should get a photographer. This guy's new. It might be something big. Hire Bob. He's really good." And that was that.

Elton was opening for Leon Russell at the Fillmore. Although I'd been to the venue a lot over the years, that night, November 21, 1970, was the first time I ever went there "on assignment," so it was a big deal for me. I met Billy, and we went backstage to meet Elton and his songwriting partner, lyricist Bernie Taupin.

That surprised me. Bernie was not a musician and had nothing to do with the live show beyond the fact that he wrote the lyrics that so exquisitely matched Elton's music. But the pair were inseparable at that time, and I have never seen that kind of relationship in music, where the songwriter was an integral part of the touring party, despite not being a part of the show.

Bernie Taupin and Elton John, Fillmore East, New York City, April 9, 1971

At that time Elton was not as outrageous and larger-than-life as he would become. I admit I was a little concerned about how to, forgive me, shoot the piano player. It's hard to get exciting pictures of a guy sitting at a piano. He just sits there. And the piano gets in the way.

When Elton started his show I realized he was different from any piano player I had ever seen. He was very active, and he faced the audience. He kept turning to the crowd and addressing them, and he made certain that he was singing to them, not to his piano. Elton was already

a fabulous showman, and this was long before all the giant glasses and feather boas. It was easy to get good photos of this piano player.

Immediately after Elton's set, I had to make my way to the airport with Billy and fly to San Francisco to photograph the James Gang— another one of his bands.

Elton's set ended at nine thirty; an hour later, I was at the airport for my flight to San Francisco. We landed around one in the morning and went straight to the recording studio to meet and photograph the James Gang.

Nadya had come with me, and after a few days in San Francisco, we flew to Los Angeles to deliver the big print of my Tina photo. I went to Ike's studio, which was on La Brea, and they told me he was at their house, so that's where I headed, a few minutes away in Baldwin Hills.

It was a modern ranch house, with a small circular driveway, a pool in back, and a Great Dane in the yard. In the living room, Ike had a large built-in console in the shape of a whale, with a television for an eye. There was also a formal oil painting of Ike and Tina. I was surprised to meet five kids, who between them had three mothers and two fathers. Only Ronnie was Ike and Tina's child. Ike Jr. and Michael were from Ike's former marriage; Craig was from Tina's; and Mia was Ike's daughter with the Ikette Ann Thomas.

Ike was sleeping when I arrived, and when Ike fell asleep, it would be a few days before he woke up. As I was just finding out, Ike had a cocaine habit of epic proportions. I heard that he'd be up on coke for many days—his record was supposedly eighteen days without any sleep.

I never did see Ike on that visit. But I delivered the print to Tina and went home to New York City.

Elton was back at the Fillmore again in April. That's how fast his career was taking off. Less than six months later he was back, this time for three nights at the top of the bill. A few months later, in June, he played two nights at Carnegie Hall; in September, he sold out a week at the Greek Theater in Los Angeles. And the next time he was in New York City, he was playing Nassau Coliseum. His hit records were everywhere and, luckily, he liked my pictures.

Elton John, Fillmore East, New York City, April 9, 1971

Every time I saw Elton, his show was more extravagant and brighter and louder, and the costumes were getting bigger and bigger. He was starting to wear headdresses and feathers.

For the Carnegie Hall performance, Elton's mother was flown in as a total surprise for Elton. He had no idea that she was coming, and he was overjoyed to see her there.

Elton John and his mother, Sheila Eileen Dwight, Carnegie Hall, New York City, June 10, 1971

Gigs were coming fast and furious for me, and I photographed all that I could: Dizzy Gillespie at the Gaslight and Iggy and the Stooges at the Electric Circus in May; Eric Andersen and BB King at the Fillmore in June; the Allman Brothers at the same theater the following week; and Edgar Winter a few days after that. I did sessions with Canned Heat, James Taylor, and Black Sabbath.

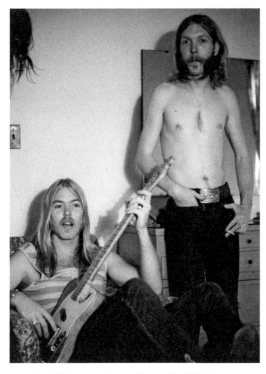

Gregg Allman and Duane Allman, One Fifth Avenue, New York City, June 27, 1971

In the summer of 1971, for the weekend of July 13, Ike and Tina came to New York City to play in Central Park, where they were opening for the Beach Boys.

They were staying at the Plaza Hotel, and I'd made arrangements to meet Ike there. I had recently bought a Sony Portapak videotape machine, and I thought the Ike and Tina show would be the perfect opportunity to use it.

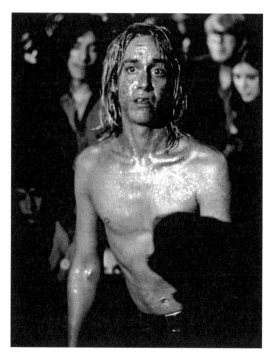

Iggy Pop, Electric Circus, New York City, May 14, 1971

Today, when anyone can shoot a movie with a cell phone and put it instantly on the Internet, it's hard for people to imagine what a revolution the Portapak was.

It was the first-ever portable, consumer-affordable, accessible video equipment. Before this, if you wanted to film a concert (or anything else, for that matter) and you didn't have a big budget (I had no budget), your best option was to shoot a 16- or 8-millimeter home movie. That meant buying a lot of film. Then you had to get it all developed, which could take a week or more, and it was expensive. You also had to have a projector and screen to show it.

The beauty of the Portapak was that you could shoot a half-hour of videotape, which cost around ten dollars, then go to the hotel with the band, plug it into the television, and watch it that night.

The technology was still primitive. The camera shot only in hazy black and white, it didn't work very well in the dark, and the sound was mono. Nevertheless, it was a miracle.

That night in Central Park, I made a fairly simple video, just standing in the first couple of rows with the audience, and then Nadya and I went back to the hotel with the band and played it back for them.

Tina loved it from the start, not only as a record of a great performance, but also as an instructional tool. She was able to show the Ikettes any mistakes they were making while the concert was still fresh in their minds.

"See, that's what I'm talking about. You're turning left when everybody is turning right." She didn't scold or lecture them, and they were excited to learn and improve the act.

After Ike and Tina saw that video, whenever they came to the area, they'd make me feel welcome. Ike told me early on I had carte blanche to photograph and video anything I wanted, and Nadya and I started becoming part of the entourage. They never called and arranged for us to be somewhere. We just knew they were coming, and showed up. They'd say, "Hi, glad you're here."

Even better, we were paid for the work we were doing, which isn't always the case when musicians start taking your presence, and services, for granted. If we spent a day with Ike and Tina, Ike would peel off a hundred-dollar bill as they were leaving, and give it to me. Two days, I'd probably get two hundred dollars; three days, three hundred dollars. There were no invoices. No discussion of what it was for or what the expenses were. He just believed in paying people for what they did.

I have heard so many people telling stories about how Ike gave them a car or an apartment or a house, gave them a job, gave them a life. Just gave them whatever they needed, no questions asked. Little Richard said that when he was down and needed money, Ike gave him five thousand dollars. It wasn't a loan. Just, "You need it, take it." A few years later, when Ike was down and had his drug problem, Richard gave it back.

My visit to the Plaza to see Ike paid other dividends, too. As I was walking down the hall toward his room, I saw a woman I didn't know, standing outside Ike's door, looking just a little nervous. I think she didn't want to go in alone.

She saw me and asked, "Are you here to see Ike?" I said yes and she asked, "Can I go in with you?" I said of course.

She introduced herself. Her name was Vicki Wickham and, back in the mid-sixties, she produced the groundbreaking British television music show, *Ready Steady Go!* That's how she knew Ike and Tina, from their appearance on the show. In fact, she knew everybody, because they were *all* on *Ready Steady Go!*, from the Beatles and the Stones, to Dusty Springfield (with whom she cowrote "You Don't Have to Say You Love Me") and the Supremes. She was the first person to put people like Marc Bolan, Jimi Hendrix, and Donovan on British television, and was instrumental in bringing Motown acts and other black American artists to England. She broke so much ground with that show, and she was one of the leading figures behind the scenes, making things happen.

Currently, she was managing Labelle—Patti LaBelle, Nona Hendryx, and Sarah Dash. "Patti's like Tina Turner, but different," Vicki explained. She was right about that. Tina and Patti were both very dynamic performers, yet each had her own unique style. Thanks to Vicki, I ended up photographing three album covers for Labelle. Vicki was also working with Track Records at the time, which meant she represented the Who in America.

Vicki and a small group of fellow British expats would meet after work at the Russian Tea Room or City Squire, drinking cognac and chatting. One of them was Nancy Lewis, who was the New York publicist for Buddah Records. I would go on to do 125 jobs for Nancy and for Dominic Sicilia, a consulting art director at Buddah, who also designed the concert posters for the promoter Ron Delsener.

Among those jobs was a Sha Na Na gig at Carnegie Hall in December 1971. Through Vicki, Nancy arranged for Keith Moon to emcee the show. When he came out to introduce them, he was dressed like a British lord in a top hat, looking very much like the Mad Hatter. Then he came out the second time wearing a form-fitting silver dress. It was not a pretty sight, but it was hilarious. My picture of him in the top hat became my first *Rolling Stone* cover in December 1972.

Vicki Wickham got me a pass to the Who concert at Forest Hills Stadium in Queens; it was the opening night of their Who's Next tour, and I was excited. For years now, I had been buying tickets to go see them whenever I could, but now I was official.

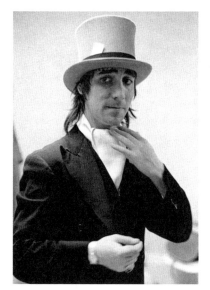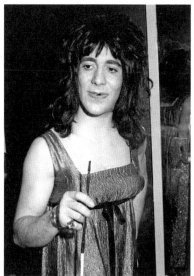

Keith Moon, Carnegie Hall, New York City, December 28, 1971

I was invited to the after-party, one of the first after-parties I attended. It was held back in the city, at a little basement club on the East Side, and for whatever reason, I'd not taken my car to the show. Instead we hitchhiked to the party, which was really difficult and took a long time on a rainy night.

We finally got to the place, went down the stairs, and the Who came stumbling down right behind us. By being late, we were right on time.

They weren't dressed like flashy rock stars. Roger Daltrey wore an open shirt and jeans with big patches on them. Pete Townshend, who was a devotee of the Indian guru Meher Baba, wore a large badge with Baba's picture and his mantra on it, "Don't Worry, Be Happy." I hung out with Keith Moon. He was indeed mad as a hatter, a wild, loud, extra-size personality with eyes darting in every direction at once, looking for excitement.

Later in the summer, as I was editing the photos I had taken of Ike and Tina, I became convinced that one of the pictures I'd taken, a beautiful picture of Tina in profile, would make a really good album cover.

Once again, I knew I couldn't just mail it to them, all the more so after witnessing the disorganized scene in Los Angeles. The only way

Pete Townshend and Keith Moon, Forest Hills,
New York, July 29, 1971

Tina Turner, International Youth Expo, Bronx, New York, July 5, 1971

RIGHT PLACE, RIGHT TIME

I could get Ike to consider the picture would be if I showed it to him myself. I found out they were playing in Baltimore and woke up one Saturday morning determined to show him the picture. Their office told me they were staying in a hotel near the airport in Washington. I took the inexpensive shuttle flight to go there.

Unfortunately, when I arrived at National Airport, I discovered that the hotel they were staying in was actually at Dulles Airport, which was about forty miles away. I only had eighty dollars or so with me, but I figured I'd be OK after I connected with Ike. I took a taxi to the hotel at Dulles, only to arrive at the hotel desk and discover that the band had changed plans and was now staying at a hotel near the venue in Baltimore.

I had almost no money left, but someone nearby overheard my story and said he was driving that way to a concert and offered me a ride. I found myself sitting just behind the gearshift between him and his girlfriend as we sped down the highway in his Corvette.

Suddenly, he screeched to a stop. He had forgotten his tickets and had to go back for them. That left me standing by the side of the highway hitchhiking, and the first vehicle that came by was a police car.

I told him my story, and he said he would give me a ride to the end of the highway. He also explained that I was lucky that he had picked me up, because the other policeman on that route was older, hated hippies, and would have given me a really hard time.

He dropped me off at the exit, and I put my thumb out again and almost immediately got a ride with a young man coming home from working at the airport. He drove me right to the theater in Baltimore. I offered to get him into the show but he declined.

I was almost in. The guard at the backstage door demanded proof when I told him I worked for Ike and Tina. I showed him some of the photos of Tina that I had with me and, in exchange for giving him one of them, he let me in. I found Ike and Tina's dressing room and said I was looking for Ike. Rhonda Graham, the manager, knocked on the door at one side of the room and called out that I was there.

The door opened and I heard Ike say "Come in." I went in and found myself in a tiny toilet stall with Ike on the seat! I've heard some

people were comfortable doing business like that, but I was somewhat surprised. I didn't let it phase me though, and I showed Ike my picture.

He agreed it was a great shot and asked me what I was doing the next day. I said I didn't have any plans, so he said, "Then come to Los Angeles with us, Rhonda will get you a ticket"—and then, he reached out and put his coke spoon under my nose.

I'd only tried cocaine once or twice before. Now I felt an instant rush of energy. It felt nothing like being stoned. Ike's coke was very pure, a little bit went a long way, and Ike tended to give out a lot.

I called Nadya and told her what was happening: "Ike is taking me to California." She was thrilled that I had made the connection and was working with him, although I really didn't know what I was in for. Between the Saturday morning when I woke up to go down to Baltimore, until the following Friday night, when I flew back to New York City, I did not get a moment's sleep.

The whole time in Los Angeles I was doing coke with Ike and the band. It's the longest I've ever stayed awake, but Ike was up when I got there, and he was still up when I left, with no sign of slowing down as he lay down tracks for several songs at the same time. The days came and went like somebody was turning a light on and off in another room.

Bob Gruen and Tina Turner, Los Angeles, August 1971

Tina Turner, Los Angeles, August 1971

(Left to right) Craig Turner, Michael Turner, Ike Turner Jr., Tina Turner,
and Ronnie Turner, Los Angeles, August 1971

One afternoon that week I spent just with Tina. I took pictures of her with the kids around the house, and while she was making lunch. After she dropped them at football practice, I went shopping with her and took pictures along the way. I followed her on her daily rounds, snapping candid pictures as we went, and she was very comfortable with me.

Sleep was not the only thing I went without. I didn't change my clothes either because I only had what I was wearing. At one point, Ike said to me, "Hey, if you want to change your shirt, go into my closet and take any one you like."

I stepped into his vast walk-in closet. Ike had unique taste in clothing, loud and funky . . . lots of hot pink, purple, and green. There was no way I'd feel comfortable wearing any of his clothes. Instead, I washed my T-shirt in a sink and dried it out back in the Los Angeles sunshine.

That Friday, I accompanied Ike on a visit to United Artists in Los Angeles. He played them some demos and I met Bob Cato, the art director. Ike told him I had some great new pictures, so Cato told me to meet him in New York City Monday morning at eight o'clock. I flew back on the red-eye that night. I drank a pint of cognac and finally fell asleep for the first time in a week.

Ike and Tina Turner, 'Nuff Said, Los Angeles, 1971

I got to New York City early Saturday morning, developed the film, and drove upstate to Mahopac to see Nadya, where she was housesitting for a friend of her parents. Sunday afternoon, I drove back to New York City and spent the night developing and printing pictures in a rush to get them done by morning. I met Bob and he went through the pictures. He picked out a profile of Tina that I took when she was paying at the cash register in the grocery store. It wasn't a great print; I'd made it at four in the morning and the contrast wasn't good. It was kind of gray. I asked if I could make him a better one, but he said no: "This is fine, I'll fix it. Don't worry about it."

Well, he *didn't* fix it, it *is* gray, and he forgot to include my name and photo credit when it appeared on the album, *'Nuff Said*. Tina looks great in the photo, and I had a sense of pride that I made a real album cover photo.

1971—IT'S ALL HAPPENING

La Diferente • Larry Coryell • Alice Cooper •
Holly Woodlawn • Jackie Curtis • David Cassidy •
Marc Bolan • Ike Turner • John and Yoko

IT WAS 1971, AND I WAS GETTING MORE AND MORE work, including assignments from Atlantic Records, Buddah Records, and Warner Bros.

I was still struggling to pay the rent and cover expenses, however. Record companies paid very little for photographs, and magazines even less. Magazines paid twenty-five dollars for a black-and-white photo and forty dollars (or less) for color.

Record companies were a little more generous; they might pay you $150 to cover a press reception, concert, and after-party, but for that, they also licensed the rights to use all of the images that you took, meaning you really couldn't send them to anybody else, because the label would supply them for free, as promotional material.

It helped that Nadya had gotten a full-time job. Concert promoter Ron Delsener had mentioned one day that he was looking for a personal assistant. I suggested Nadya, and he hired her. Every morning she'd go to his office on the Upper East Side. She enjoyed it a lot, and it helped me make more connections.

Someone I had recently met was Izzy Sanabria, the art director for Fania Records, and a wildly interesting guy who was also involved in Puerto Rican politics. He had an office in a loft in a big white building, 888 Eighth Avenue, and he hired me to shoot several different album covers and jobs for the label. One of the first, at the end of March 1971, was for La Diferente, a salsa band produced by Willie Colon.

Rafi Val Y La Diferente, *La Diferente*, New York City, 1972

The most interesting part, though, was simply visiting Izzy at the office. He always had other people visiting—that's where I met Felipe Luciano, a poet who became the chairman for the Young Lords, which was a Puerto Rican activist group. Felipe later had a career as a respected journalist, but I knew him when he was a young rebellious poet.

Izzy left the music industry and art direction and went on to start *Latin New York*, the single most influential magazine in the Latin

community. He was a great help for me in my early career, hiring me to shoot these album covers for Fania and broaden my experience.

I also met jazz producer Bob Thiele, who had his own record company, Flying Dutchman. The first session I did for him was the cover for Larry Coryell's album *Barefoot Boy*. (It was a very small world!)

Larry Coryell, *Barefoot Boy*, New York City, 1971

Another album cover I did for Bob, in December 1971, was *California Here I Come* by veteran pianist Willie "the Lion" Smith and Mike Lipskin.

I met Willie at his apartment in Harlem, and it was like stepping into another world. The building was old, so still, so calm. I remember watching the dust hanging in the sunlight as it blazed through the windows, the sheen of the furniture, and how comfortable the place felt. Willie himself was a really sweet, nice old man, laughing and joking the whole time.

I was out almost every night. One of the most theatrical shows that I ever shot was Alice Cooper, and I think that was another one of my friend Billy Smith's projects. The band had been around for a couple

of years; it had originally signed to Frank Zappa's label and released a couple of albums that really didn't do much. But when they released "I'm Eighteen," an intense anthem of teenage angst and rebellion, suddenly they were huge.

In June 1971, they arrived in town to play the Fillmore. It was not an exciting time visually—most bands basically wore their street clothes, then went out and played without much showmanship other than some flashy lighting and a few tried and trusted poses.

Alice Cooper was different. Alice himself acted out every song. He didn't just stand there with a microphone and sing lyrics. He had a whole theatrical stage show, including props. Some were gimmicks, of course. He had a little doll that he would stab with a sword and he'd hold that over the audience. In one routine, which was really great from a photographer's point of view, he took a pillow stuffed with feathers, stabbed it with a blade and, in that precise moment, hit it with a jet of compressed air. Instantly the entire room was filled with tiny feathers. But Alice wasn't finished. He picked up a spotlight, on the end of a long cord, and spun it around his head so it would flash in your eyes and then light up the rest of the room, illuminating all the little white feathers as they floated down.

It was an amazing effect, because suddenly there were all these little white dots in front of your eyes. Then you were blinded, then you saw these little dots all over the room, then you were blinded again. The whole act—pillow and spotlight included—probably cost five dollars, and yet it was so effective. I love visual effects like that, especially inexpensive ones. Alice was a master.

His other big routine was the mock execution at the end of the show. A lot of Alice's songs gave the impression that he was incredibly evil, but there was always a moral to them because, in the end, after all the carnage and killing, he would be punished for his crimes, either hanged or electrocuted. Eventually, he was even guillotined!

Then he would come out at the end for a big encore, and everything was OK. I really liked Alice for his visuals, because they guaranteed some spectacular photographs.

My work was nothing if not varied.

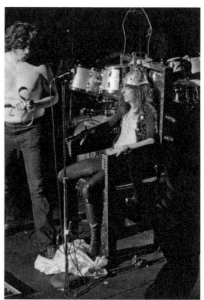

Alice Cooper, Fillmore East, New York City, June 12, 1971

* * *

Screw magazine called. They wanted me to take pictures of Holly Wood-lawn for the cover of their July 12, 1971, issue.

Holly was one of Andy Warhol's superstars, at a time when the New York art world was focused on his studio.

Holly was a terrific performer. I guess today you would say she was vogueing, firing off one great pose after another, and looking so

Holly Woodlawn, West Twenty-Ninth Street studio, New York City, May 1971

elegant. I worked my way through five rolls of film, and almost every shot was a good one, including a few of Holly in very provocative-looking poses.

Screw was delighted, and so was Holly. She was the roommate of two other Warhol superstars, Candy Darling and Jackie Curtis. In November, a few months after that session, Jackie called me up out of the blue and said she'd heard I was a great photographer, and would I take some pictures of her as well?

Jackie was rehearsing for her play called *Vain Victory* at the time. I went to the rehearsal space and we did some pictures. Candy Darling was there, too, and so was Ondine—another name in the Warhol circle. Jackie and I developed a friendship, and a short while later, I was invited to come and see the play.

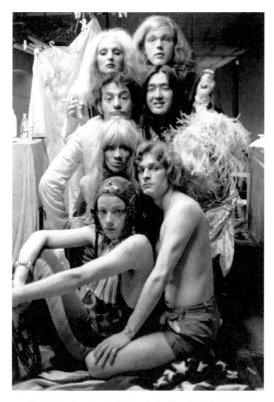

Clockwise from top left: Candy Darling, Paul Ambrose, Agosto Machado, Jay Johnson, Jackie Curtis, Prindiville Ohio, and Ondine, New York City, May 11, 1971

It was off-Broadway in every sense of the phrase . . . off-off-*off*-Broadway might be a better way to put it.

We sat until showtime arrived, but nothing happened. Five minutes went past . . . ten minutes . . . People were beginning to grow restless, when suddenly Jackie burst in through the main door, utterly frantic and looking around the room. Jackie saw me in the audience and came running over.

"Bob! Bob! Could you pay for my taxi?"

I was surprised, but I went out into the street to pay for the cab . . . and that was how the play opened! Apparently, it was very impromptu, with a slightly different opening every night, but when the show was over, Jackie actually thanked me for being in the first act.

While I was still getting to know Jackie, we once walked from Max's Kansas City across the Village, down Christopher Street, and then up the West Side to my apartment. As we were walking through the West Village, people out cruising waved at us and called out, "Hey Jackie! Oh, hi Jackie." It felt as though I was walking around with the biggest celebrity in the Village. I was impressed.

Finally we got to my apartment and we were sitting around talking, and Jackie started doing some odd things that people on speed often do, in her case dressing up in whatever was around, wrapping herself in aluminum foil, holding up all kinds of little odd props while sitting in

Jackie Curtis, Westbeth studio, New York City, December 27, 1972

the chair, and I took a whole series of pictures. I really enjoyed hanging out with Jackie.

One day she called me because she was going to the Limelight to get married! She wanted me to be her escort. This was one of several "marriage performances" she organized from time to time.

I put on a tuxedo and there I was, Jackie's escort for the night. She was a very funny person, and it was a very good friendship. Sadly, she is gone now.

Jackie Curtis and Bob Gruen, the Limelight, New York City, February 1984

I shot my first teen idol in September. David Cassidy was playing the Monticello racetrack, and it was astonishing how popular he was; the entire place was filled with screaming teenage girls—to the extent that, when we left the hotel where he was staying, David was scrunched down in the backseat between two bodyguards.

I shot Marc Bolan and T Rex at the Academy of Music. I didn't know too much about them. It was before I started getting the English music papers.

We met at the building that Warner Bros. Records had on East Fifty-Fourth Street, a nice townhouse. The top floor had been converted into a loft-like lounge where they could hold receptions or send their acts to do interviews. Marc Bolan was really nice, and we had a great

David Cassidy between bodyguards, Monticello, New York, September 5, 1971

conversation while I took pictures. The thing I remember best was, he was wearing Mary Jane ballet shoes that looked like little girls' shoes, and with his curly hair and cute face they didn't look at all odd.

I saw him one other time at the Playboy Club, after a Who show, and he was very drunk. But so was I, having spent most of the evening drinking with Keith Moon. When I left, I saw a photographer I knew from my building. He asked for a ride home and I told him, "You can

Marc Bolan, New York City, December 10, 1971

RIGHT PLACE, RIGHT TIME

have one if you drive." I was staggering. Because that's what happens when you hang out with Keith Moon.

In October, I went to a show at the Beacon Theatre. I mentioned Ike and Tina to someone, and a guy who overheard me got very excited and said I had to meet Jeannie Clark, the promoter who was booking the Beacon shows.

We went backstage and up a winding staircase, through one dressing room and a bathroom into another dressing room, where a large black woman was stretched out on a chaise longue.

I thought I was looking at a Bessie Smith album cover. Jeannie had just sprained her ankle, but she wasn't letting that stop her. She told me she wanted to book Ike and Tina at the Beacon for four nights over Thanksgiving 1971 and asked if I could get a message to them. I said I probably could. I checked the band's itinerary and I discovered that they would be upstate in Ithaca in a few days' time. Nadya and I flew there. I found Ike after the show and explained the offer.

"Tell her to come up here," he said. "I'll be happy to talk to her."

I called her, and Jeannie hired a small private plane and flew up to Ithaca. Ike agreed to do the shows and Thanksgiving that year for me was three days of Ike and Tina. It started with some magical moments after a late-night sound check, when Ike found the old but still operational

Ike Turner and Tina Turner, Beacon Theatre, New York City, November 26, 1971

keyboard that played the big pipe organ built into the theater when it was a new silent-movie palace. Ike found bird sounds and train horns, but after fooling around a bit he figured it out and started rocking. The whole theater vibrated with the organ sounds of rhythm and blues in the wee hours of the morning!

In complete contrast to people like Alice Cooper and Marc Bolan (although they were all on the same label, Warner Bros.) was Tracy Nelson and her country rock band, Mother Earth. I was a big fan of hers, and in December 1971, I was sent to Nashville to photograph her.

Tracy has one of the best voices in America, the kind that makes you cry, it's so beautiful. She'd had a big hit with her song "Down So Low," and had recorded her own records. She had sung with just about everyone. She was open and friendly. In addition to photographing I wanted to make a video of the trip from her farm to her upcoming show in New York City.

My first night in Nashville, I was supposed to meet up with Gail Buchalter, a publicist who'd been very nice to me when she was in New York City. Unfortunately, what should have been a very straightforward meeting instead turned into a comedy, largely thanks to the Black Beauty amphetamine pill that I took to help me after several days with little sleep. The car rental company had run out of compact cars and upgraded me to a huge Ford LTD. It was much bigger than the little VW Beetle I was used to driving.

Wired and weirded out by the sheer enormity of the car, cruising around what was then a sleepy Southern city, I made my way to where Gail and I were meant to meet. I was late and she'd moved on, leaving instructions for me to join her at a studio. I got there and she had just left. In a rush to catch up I jumped into the car. Forgetting the size of the car, I backed up and turned and wrapped the right front fender around a telephone pole (good thing I had checked the "all collision" insurance box).

She had invited me to stay at her place and I had her address, an old log cabin on the outskirts of town. She'd told me where she kept the spare key. I found it, made myself at home, lit a fire, lay back . . . and

finally she called to let me know she was staying at her boyfriend's for the night, so I should just stay put. I never did meet up with her.

The next night I spent at Tracy's small horse ranch, outside of Nashville, with her and her boyfriend/manager, Travis Rivers. He was from Texas, and before managing Tracy, he'd hooked up Janis Joplin with her band Big Brother and the Holding Company. Later, after he and Tracy broke up, he became one of the first Apple computer salesmen in New York City.

Tracy Nelson, Nashville, Tennessee, December 1971

I filmed Tracy and Travis at the farm, then flew back to New York City with them, where Mother Earth had a gig at the Beacon Theatre. In those days, bands played two shows, the first at seven o'clock, the second at eleven. It was a long wait, so between sets, I left the Portapak set up in the venue, jumped into my VW, and drove up to the Apollo Theater to see a benefit for the families of victims of the Attica prison uprising.

A few months earlier, the prisoners had rioted and taken hostages. Governor Rockefeller refused to intervene; instead, the New York state police stormed the place, igniting a bloody massacre that left thirty-nine people dead. Across the city, people felt unsettled and angry. The benefit concert was supposed to be part of the healing process.

I knew that Aretha Franklin was performing, and I thought I'd take some photos of her, then get back down to the Beacon to film Tracy's second set. That was normal for me in those days. There was always a lot happening. The guard at the back door of the theater knew me, since I had been working there recently with Gladys Knight and the Pips, and he let me in.

Just as I was walking up the aisle, however, I heard the emcee announce, "John Lennon and the Plastic Ono Band!"

Like the rest of New York City, I knew that John and Yoko had moved to the Village—right around the corner from me, in fact, in a basement apartment on Bank Street. There was a buzz on the street, everyone saying, "John Lennon moved in," or that they spotted John and Yoko casually riding their bikes down Bleecker Street.

A lot of people had an "I saw John Lennon" story, but no one bothered him. That was the way of New York City then, when Jackie Kennedy could hail a cab, entrusting her life to an unknown driver. New York City has always been thick with celebrities. The way I put it is: If you see a guy who looks like Robert Redford in Des Moines, it's probably a guy who looks like Robert Redford. But if you see a guy who looks like Robert Redford in New York City, it probably *is* Robert Redford. I may tell my friends that I just saw Robert Redford on the street, but I'm not going to let him take my cab. I've got places to go, things to do.

People like John Lennon lived in New York City because they could get that kind of privacy, even in public. A few years later, when John stood on the steps of the New York City courthouse after his immigration hearing, a reporter asked, "Why do you want to live in New York?" He answered simply, "Why do you?"

Still, I was surprised to see John and Yoko at the Apollo. I hadn't even gotten a good look at the stage yet, but I immediately ran up the aisle to the front to take some pictures. Access was that easy in 1971.

Yoko was wearing a black sweater. John's hair was shoulder-length under a beret, on which he wore a button that said "Indict Rockefeller for Murder." They played a few songs, including one they'd written about the uprising called "Attica State." Yoko sang "Sisters, O Sisters" and John sang "Imagine" to the accompaniment of just his acoustic guitar.

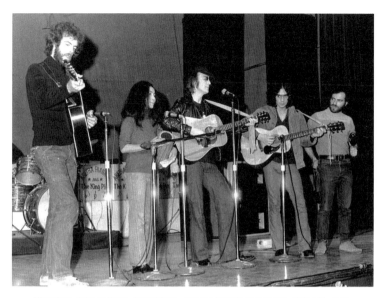

Yoko Ono, John Lennon, Jerry Rubin, and the Plastic Ono Band, Attica Benefit,
Apollo Theater, New York City, December 17, 1971

They stayed for Aretha's set, and when I went backstage, I saw them with a small crowd gathered around them while they waited in an alcove for their car. The people were fans, who would hand a simple camera to someone, stand next to John and Yoko and say, "Take a picture of us." I took a few pictures, and John joked, "People are always taking our picture—but what happens to all these pictures? We never see them."

"I live right around the corner from you," I replied. "I'll show you my pictures."

"You live around the corner? Well, slip them under the door then."

That was the first time I ever spoke to John Lennon, and I was astonished by what a neighborly, casual exchange it was. I never would have thought to show him my pictures if he hadn't said that—and said it so warmly.

A few days later, I walked over to John and Yoko's place and knocked on the door. They didn't have a twenty-four-hour staff, but they did have people over during the day to help them if they needed something. No security guards, just one efficient secretary and a personal assistant.

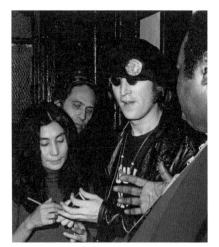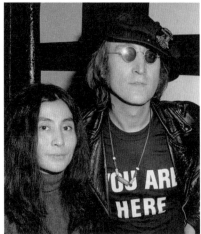

John Lennon and Yoko Ono, backstage at Attica Benefit, Apollo Theater,
New York City, December 17, 1971

The door opened and there stood Jerry Rubin, the anti-war activist and Yippie movement cofounder. It caught me a little off guard—I'd never seen him in person before, although I recognized him.

I told him I had photos for John and Yoko. He asked if they were expecting me, and I said no, so I left the photos with him. Later, when John, Yoko, and I were first becoming acquainted, Yoko remembered the gesture; the fact that I hadn't pushed too hard and hadn't asked for anything from them. I was just doing what John had suggested. They appreciated that respect, and it helped our relationship develop. I'm sure it helped that they liked the pictures, too.

CHAPTER 8

ELEPHANT'S MEMORY

Chuck Berry • Bo Diddley • John and Yoko •
Elephant's Memory

I MET ABBY HIRSCH IN MID-FEBRUARY 1972. SHE WAS putting together the first book of rock-and-roll photography, titled *The Photography of Rock*, and wanted to include me. She sent me to Henry Edwards, a journalist who was writing the biographies of the photographers in the book.

Looking back on that first interview, I could cringe. Henry was so professional . . . and I wasn't. It may have been the first time anybody ever sat me down, pointed a microphone at me, and asked questions about what I did. I didn't know what to say! I remember getting to the office and the first thing Henry said was, "Give me a couple of quotes about yourself."

I said, "Well, what do you want?" So he said, "Oh, OK, where were you born? Where did you go to school? What else do you do?" He needed to write up a little biography to accompany the pictures he'd be using in

the book—John and Yoko at the Apollo, Elton horizontal on his piano, Dylan at Newport, and Labelle at the pool, Ike and Tina, Keith Moon in drag, David Cassidy, the Beach Boys, Fleetwood Mac, Little Richard, Alice Cooper, Jackie Lomax, and Merry Clayton, the voice behind the Stones' "Gimme Shelter."

We kept talking after the interview was over. He was telling me how much he liked my work. Then suddenly he asked, "Would you like to come and photograph John and Yoko next week? I'm doing an interview with them."

How do you even respond to a question like that? I tried to keep my cool—"Yeah, I would love that."

Henry was writing a story for *After Dark* magazine about Elephant's Memory. They were a rough- and tough-looking band, leather clothes and cowboy boots, and very politically minded. They played at every leftist political rally around the city, and they were very well known for that. If there was a flatbed truck, they were on the back of it playing rousing R & B rock-and-roll music. That was what caught John Lennon's ear. Now they were recording his new album with him.

Henry also gave me passes to the Elephants' shows that weekend with Chuck Berry and Bo Diddley. They were appearing for three nights at the Anderson Theatre, with Elephant's Memory playing their own set first, and then backing both Chuck and Bo for their performances.

The Elephants went onstage, and while they were playing, I saw a couple of members of the Hells Angels Motorcycle Club come in and stand on one side of the audience, near the back. Then a couple more came in and stood a little farther down the aisle along the side. And then a couple more, positioned a little farther down the aisle.

I stood to one side, watching the Angels come in until it seemed like the audience was surrounded. A couple more came into the backstage area. When Elephant's Memory came offstage after their first set, there were Angels milling around everywhere, and nobody knew what they were doing there.

Apparently, the theater was on a block that was very close to their headquarters, and they liked to be involved in anything that happened in

their neighborhood. The band went to the dressing room, and suddenly one of the musicians discovered that his leather jacket was missing.

"Well, who's guarding your dressing room?" asked one of the Angels. Someone pointed to one of their roadies, a skinny kid, and the Angel turned around, grabbed him, and literally threw him down a flight of stairs.

"Well, he's no good," the guy said. "He can't guard anything. We'll take care of you from now on." From that moment on, we became friends with the Hells Angels.

One of the guys promptly took out his buck knife, clicked it open, and produced a small mayonnaise jar that was completely full of methamphetamine. Now, methamphetamine is one of those drugs where all you need is a match head's worth to keep you up for a couple of days. This guy had enough to keep you up for a month.

He stuck his knife in the jar, and in a friendly gesture held it up under my nose with the blade facing toward me, and said, "Have a snort."

A Hells Angel holding a knife under your nose is not someone you say no to, so I took a snort. Then he went around the room, to the band members and Angels alike, and I swear that we were all awake for the next several days, the kind of situation where, at nine in the morning, you find yourself telling your new good friend, some burly bruiser Hells Angel, about the things that your third-grade teacher taught you. You get kind of silly on speed and you don't shut up.

Chuck Berry pretty much kept to himself during those concerts. Bo Diddley was more friendly, and he too fell in with the Angels; in fact, he ended up playing some benefits for them over the next few years.

Back when my Tina Turner picture was chosen for her album cover, I was talking with somebody at the record company. We were negotiating my fee, and had just settled on five hundred dollars, which I later discovered was about one-tenth of the usual going rate, and he asked me what kind of camera I was using. I was still using the Minolta I had borrowed from my dad, so I told him that, and he said, "Well, why don't you get yourself a good Nikon when you get the check?" So that's what I did. I went and bought my first Nikon F, a good, fully professional camera.

That same night, I was going to photograph what they called the Rock and Roll Revival, which was Chuck Berry, Bo Diddley, Little Richard, the Shirelles, and a few other classic rock acts at Madison Square Garden. I was taking pictures of them that night, having a pretty good time, and at one point toward the end of Chuck Berry's set, with most of the audience standing up around me, I climbed onto a seat to try to get above the crowd.

I was on my toes, straining to get a clear shot of Chuck Berry, and I just couldn't do it. I couldn't get that last inch or two above the hands waving in front of me. Suddenly, a security guard started yelling at me, telling me to get off the seat. When I didn't, he lifted me up into the air, and before he dropped me in the aisle, I got a perfect shot. He yelled, "If you take another picture I'm going to smash your camera." Once I was free, I ran up the aisle away from the guard. But I had the picture, one of my favorite pictures ever, of Chuck Berry looking like he's kissing his

Chuck Berry, Rock and Roll Revival, Madison Square Garden, New York City, October 1971

guitar. Soon after I took that picture, it was on the cover of *Crawdaddy*'s April 1972 issue.

One weekend around this time, Nadya and I were up in the country to relax and ride our horses. While we were there, I had a dream that Bob Dylan called me, and I wasn't home to get the call. It was just a dream. Then the strangest thing happened. We came home from riding, and a writer friend called me. He told me he had been interviewing Chuck Berry that weekend for the cover story and he showed him the picture that I'd taken. Chuck liked the photo and had called me, but I wasn't home to answer the call!

Most nights Chuck didn't wait in the backstage area. Usually he would show up, come out of his car when it was time to play, go right onstage for the show, then come offstage and go right back into his car. He didn't socialize much at all. But one night, for some reason, he was standing by the side of the stage being more friendly than usual.

I raced out, jumped into my car, drove home, grabbed a print of the photo, and then raced back to the theater and approached Chuck. I said, "Excuse me, Mr. Berry, I wanted to show you this picture I took. Somebody told me that you liked it."

He said, "Oh, that's your picture? Come here." He took me to the back of the stage behind some amplifiers where no one could see us, and he said, "Can I buy that picture from you?" I had been planning to give it to him, so I said, "Yeah, sure."

He opened his wallet that was about two inches thick with hundred-dollar bills. I don't think I've ever seen so many hundred-dollar bills in one place. He took one of the hundreds out and gave it to me.

And then he said, "I want you to autograph it for me."

I couldn't believe it; I was being asked for my autograph by Chuck Berry. Of course, I did it. I turned the picture over, and, on the back, I wrote, "To the King of Rock and Roll Chuck Berry," and signed it "Bob Gruen." It was the first one of my prints that I signed.

Showtime was approaching. Suddenly, there they were, John and Yoko walking across the back of the stage. For a moment, I wondered if I should try to take a photo, but I decided not to. I didn't want to intrude. Besides, I'd be seeing them up close in a few days' time.

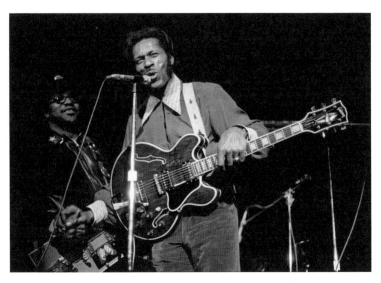

Bo Diddley and Chuck Berry, Anderson Theatre, New York City, February 19, 1972

The day arrived. Henry Edwards had explained that John and Yoko had taken a suite at the St. Moritz Hotel on Central Park South, as they didn't want to have reporters coming to their apartment.

I arrived there just as Henry emerged from the elevator. He told me John and Yoko had just woken up, and were a little cranky. They didn't want to be photographed, but if I waited a little while, they'd be feeling better soon. He said, "I'm sure they'll like your pictures. They'll like you, as well." He even predicted that we'd become friends and I'd take lots of pictures for them, probably even album covers. "Because that's the way they are."

I told Henry to let me know when they were ready; "I'll be in the bar." Twenty minutes passed, and finally Henry came to tell me it was OK to go up to their room. I was feeling nervous now, and walking down the hall to their door, I realized I was trembling. I knew I wouldn't be able to take good pictures shaking like that.

I stood still, took a few deep breaths, and decided to just be myself and hope for the best.

Henry introduced me to John and Yoko as I walked in, but we hardly spoke during the interview. I just moved around, trying not to be distracting. Whenever I saw a good moment, I captured it. John and

Yoko were on the bed, and in the far corner there was a carton of deluxe grapefruits; I noticed that because I knew Yoko had published a book with the title *Grapefruit*, and I was amused to see that they ordered actual grapefruits by the case.

John wore a T-shirt from the Home restaurant and bar on Ninety-First Street and First Avenue that he frequented after recording sessions. It's a place I would come to know well during my friendship with him, as a whole group of us would often go there after late sessions. Without fail, Richie the owner would open the kitchen for us, and we'd eat steaks and drink cognac until dawn.

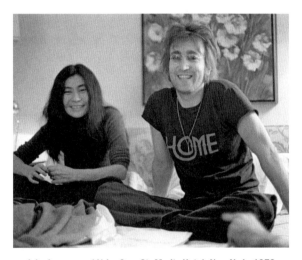

John Lennon and Yoko Ono, St. Moritz Hotel, New York, 1972

I like to sum things up in one picture when I can. During that first shoot with John and Yoko, I realized it would make sense to photograph them together with Elephant's Memory. I knew they'd all be at the recording studio together after the interview. Since the story was really about the band, I decided to ask if I could come along.

I had noticed that it was Yoko who was the one talking to their assistant, May Pang, and working out all the plans for the evening. Toward the end of the interview, I approached her.

"Since this story is about the Elephants, can I take pictures of you and John with them?"

She said yes, that would be fine, but she warned me that I'd have to wait around until they were done recording before I could take any posed photos. If I didn't mind waiting, I could come.

"And you'd better watch out for Phil Spector," she added. "He'll be there, and he hates photographers." I gulped and nodded. Phil's temper was legendary. He was said to be highly emotional and erratic, and I'd heard rumors that he could be violent.

I didn't know what I was getting into, but I was not about to back out. Since I had Yoko's permission, I started to feel comfortable about being with them. We were driving to the studio in the Lennons' big American station wagon; me in the back, May up front with Tommy, their driver, John and Yoko in the middle seat. As we drove down Ninth Avenue, John casually made jokes about what we saw passing outside—an advertisement, an odd-looking person on the street, whatever caught his eye.

By the time we arrived at the Record Plant studio on West Forty-Fourth Street, the engineers were ready for John to record a vocal. We walked down a hallway, and suddenly John motioned for me to follow him as he went into the recording booth. I had no idea why I was being invited into such an intimate space with him; later I suspected he just wanted someone there to sing to. I'm a good observer—I tend to take things as they come without asking questions, and maybe John sensed that. We stood in this close space, and the engineers said, "Okay, John. We're ready."

John turned to me and put a finger to his lips for silence, so I couldn't take photos. He started singing "Woman Is the Nigger of the World," one of his most controversial songs.

I was very open to his message. I'd had many conversations with Nadya and various friends about the growing women's liberation movement, and while I was shaken by the intensity of the statement, I thought John's song was a brilliant way to express his feelings on the subject. Years later when Don Letts was making a documentary about me, he asked Yoko why John would have taken me into the booth with him. She said maybe he just wanted to get a stranger's reaction to what he knew was a controversial song.

When the song was released in June 1972, no radio station would play it. However, the song and the message behind it were too important to John to leave it at that, and he decided to set up a special phone line for people to call if they wanted to hear it.

The setup was extremely simple by today's standards—a room in Apple Records headquarters with phones hooked up to two hundred answering machines, all playing just that one song. If one line was busy, the caller was rotated to the next. That was the only way to hear "Woman Is the Nigger of the World," unless you bought the record.

I spent the rest of the night quietly watching and taking photos in and around the studio and lounge area. I found I had free reign as long as I wasn't intruding. I also tried very hard to avoid Phil Spector. He didn't look all that intimidating or strange; he was small and thin, casually dressed, and his hair was relatively short and curly. Still, he was intense and jumpy, and he did have a reputation for anger.

I knew if he yelled at me, I'd be thrown out, so I didn't want him even to see me. For the most part I was successful, until at one point in the night I was standing near John at the piano, and Phil came in and stood on the other side of him. I froze. There was a mic stand there, and I was trying to *be* that mic stand.

Earlier in the evening, though, I had noticed Phil was carrying a bottle of Rémy Martin. Since meeting Vicki Wickham and her friends, I'd started drinking the high-priced cognac myself, and I noticed that Phil's bottle had an interesting top made of cork, instead of the usual screw cap. I thought the cork was much classier. It's the sort of detail only someone who's drinking too much would focus on.

In a moment of daring, I asked him, "So, where did you get that bottle of Remy with the cork?"

He looked at me, surprised, and told me where he got the bottle, and that was that. He didn't seem so bad. But later, I saw him screaming at someone on a pay phone and he ended up smashing the phone booth's glass.

When Phil left and the work was winding down, I reminded Yoko that she'd said I could take some photos with her and the band. They started off posing in the studio with a giant Hershey bar Yoko had found.

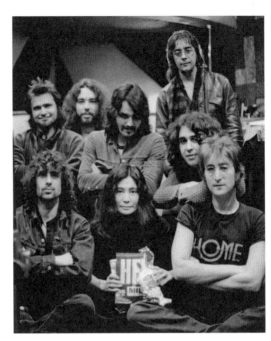

(Top row, left to right) Stan Bronstein, Gary Van Scyoc, Wayne "Tex" Gabriel, Jim Keltner, and Adam Ippolito. (Bottom row, left to right) Rick Frank, Yoko Ono, and John Lennon. The Record Plant, New York City, 1972

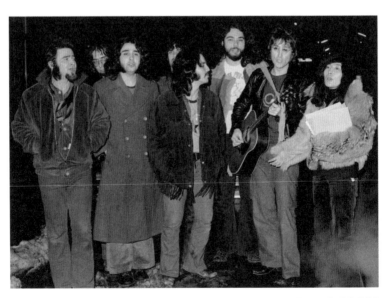

(Left to right) Stan Bronstein, Jim Keltner, Adam Ippolito, Rick Frank, Wayne "Tex" Gabriel, Gary Van Scyoc, John Lennon, and Yoko Ono, New York City, 1972

It struck me how Yoko sat there, a woman surrounded by all these big, burly men, and the only two letters visible on the candy wrapper were HE.

Then John started playing old rock songs on his guitar, and everybody joined in, singing along as I took pictures of them in the lobby and then out in the street in front of the studio. I kept photographing and everyone kept singing, prolonging the spirit of the session in the open air. And then we said good-bye.

The Lennons drove off in their station wagon, the members of Elephant's Memory dispersed, and I found myself alone on the street at 4:00 A.M. I caught a cab down to the Village, my head in the clouds, unable to believe I'd just spent a night working closely with John and Yoko, and everything had gone smoothly.

I felt sure I had taken some good pictures, but you never really knew until you developed the film. I had to find out.

Nadya was asleep when I got home. Despite the late hour, I went straight to the bathroom to develop my film, holding my breath. In those days, if the speed or f-stop were set wrong, nothing would come out. Only when I saw that the negatives were properly exposed did I begin to breathe normally again.

The next day I sent my photos to *After Dark* magazine. Henry loved them.

CHAPTER 9

COAST TO COAST

Tina Turner

I KE AND TINA WERE PLAYING IN SYRACUSE, AND WE decided to go to videotape the show and connect with them again. As we were walking across the yard in front of the venue, a guy called out to me. He was the guy who gave me a ride to Baltimore months earlier! I got him into the show this time to repay his favor. We actually didn't get to see Ike that night; his coke supply was low and he went to sleep after the show. So we joined the band and drove with them to Burlington the next day.

That night, after taping another show, Ike said he wanted to take Nadya and me with him and the band so I could continue filming. We said yes, and soon we were on our way to Chicago, where we ran the entire length of O'Hare, a very big airport, to catch a flight to Fargo, North Dakota, a freezing cold place. When Ike asked if we wanted to come back to Los Angeles with them, we were happy to do that, as well.

We filmed backstage and as they were driving between gigs. We were starting to get more intimate moments. The band always enjoyed watching concert footage right after a show. There was never any firm commitment, like "We're hiring you to film this." It was just happening.

Business arrangements were often loose in the seventies. One thing always seemed to lead to another. There were no set plans, and it was easy to go with the flow.

Los Angeles was crazy. We ended up spending a few weeks out there with Ike and Tina, with almost no sleep. We stayed in Ike's studio on La Brea, in what was basically a concrete bunker with a curved roof, steel doors at each end, and no windows.

There was a reception area in the front and a room with a pool table. Down the hall, Studio A was on the left and Studio B on the right. Up above were small rooms where you could sleep, but Ike kept us so hyped-up on coke that we didn't do much of that. In fact, I quickly discovered that he had cocaine stashed everywhere.

There were a lot of little objects all over his studio that opened up to reveal coke—snuffboxes, an ashtray, a small figurine. I once picked up a small statue of an old-fashioned record player and turned it over, trying to figure out how it opened. Then I looked on the front—it was the Grammy Award statuette for "River Deep, Mountain High." That one didn't open up.

Once in a while, Nadya and I would go upstairs, fall onto a bed, flip a switch, then lie on our backs and vibrate. The whole building was wired with video security cameras, and there were monitors everywhere, where anyone could see what was going on at the front and back doors and in the studios. Ike even had a special key that unlocked a box that contained buttons he could push to see what was happening in the bedrooms upstairs. That was another reason Nadya and I didn't spend too much time in bed.

Ike's equipment was all very high-tech. He kept up on the latest gear. Whenever he'd meet an engineer on the road, the guy would say something like, "I can build this box that does a special kind of reverb," and Ike would reply, "What are you doing tomorrow?" And he'd bring him to Los Angeles, and keep shoving the coke spoon under the guy's nose

to keep him awake until he finished building whatever it was he could build. Then he could go home. There were times that Ike had so many techies working away beneath the control boards that you had to step over them just to cross the room. We filmed Ike in the studio, and then went up to the house to get casual footage of Tina cooking for the kids. Little by little, it was turning into a feature-length documentary, Ike and Tina Turner onstage, on the road, and at home. It's the only footage that shows them as they were, not just as they were onstage, exhilarating as that is. And it was all shot on our simple Portapak.

We'd been there around two weeks when I got the strongest feeling that I needed to go back to New York City. For one thing, I had to file my taxes. I really wanted to keep them straight—it was taxes that brought down Al Capone, after all. So I sought out their manager, Rhonda, and told her that I had to go.

"You can't," she said. "You're still filming. Ike wants you here."

"I'll just be a couple of days, and I'll come right back," I said.

"No," she said.

Rhonda was a tough one. There were a few times when I stood up to her, and this luckily was one of them. In the end, we agreed Nadya would stay to keep working—and to make sure I came back. I flew to New York City, and when I got there, it turned out to be another example of incredible timing, although the trip did not get off to a good start.

I flew into New York on a red-eye, arriving at seven in the morning, and the first things I saw when I entered our apartment were—roaches! We had been away for two weeks, and clearly the bugs had decided to move in. My first hour home was spent poisoning the insects, and then vacuuming up the corpses as they dropped from every surface. Only then could I even begin to tackle my taxes.

The phone rang. Ron Delsener wanted to know if I was interested in photographing an award ceremony where the boxer Rocky Graziano was scheduled to be speaking. I said yes; I couldn't afford to turn down any assignment.

That night after the job, as I headed home, I stopped off at a local bar to get a drink. And who was sitting there, almost as though he was waiting for me? Rick Frank, Elephant's Memory's drummer.

"Man, we've been trying to find you," he said. "We want to use your picture in the album package." He asked if I would go over to John and Yoko's with him the next day, to show them the pictures I'd taken.

All I could think of that night was how amazing this was. If I hadn't insisted on coming home for those two days, I never would have heard from them—the deadline would have passed. But I did come home, and I did hear from them and, the following day, I crossed the threshold into John and Yoko's Bank Street home for the first time.

It was a relaxed visit. Since we'd already been introduced and spent an evening in the studio together, we just sat around, talking, watching television, and smoking.

The front room was dark wood like a farmhouse, long and low, with an office desk near the front door, a kitchen, and a seating area. Their bedroom, in contrast, was completely open, with a high ceiling, and painted entirely in white. It had a massive bed, which was actually an oversized mattress between two wooden church pews. They often held court with friends and assistants as they lounged on the huge bed.

Their bedroom was also home to the largest television screen I'd ever seen in my life. John loved television. To my great annoyance over the course of our friendship, the television was always on, even when we were having a conversation. I found it very distracting and complained to him about it once, asking why he always had to have it on.

"If you have the window open," John replied, "you can still have a conversation. And the TV is like my window, except it shows the whole world."

John was fascinated by how the media worked, how advertisers used words and images to send out a message, and how people reacted. He was, above all, a communicator, with a way of distilling ideas to their simplest essence, like "All we are saying is give peace a chance." He saw television doing a similar thing.

It was clear that they liked my photographs. They went through the shots I'd taken at the studio and selected one for the inside of their album cover. Then, because I always carried a box of all my good pictures with me, I pulled that out and showed them others that I'd taken—Ike and Tina, Elton, Patti LaBelle, and so on.

When I was leaving, Yoko said, very directly, "We want you to keep coming back, to hang out and take any pictures you want. We're not hiring you or paying you, because you'll sell pictures to magazines and make money for your photos. But we'll give you access as long as you show us the photos you take and let us choose which ones you use."

Yoko told me she liked my work, and she liked me. She also said they always had people working for them whose job it was to keep people away, but I shouldn't be put off. "If they don't let you in," she said, "try again in a few hours or a few days." She asked me always to stay in touch, and I have ever since.

I was still excited when I flew back that night to the West Coast to reconnect with Nadya and Ike and Tina. Ike was waiting impatiently for me to get back. While I was gone, he had reviewed some of the Portapak footage with Nadya. He liked the concept, but not the quality. High-tech Ike wanted us to use only the best color film equipment with the finest sound possible.

I got back to Los Angeles on a Thursday night. The following morning, which happened to be Good Friday, Ike threw me the keys to Tina's Jaguar and sent me to the best professional movie equipment rental place in Hollywood. A lot of shops were closed for the start of the Easter weekend, and this place was closing early, but thankfully they were still open.

All I knew about making movies was that Jean-Luc Godard, D.A. Pennebaker, and other new filmmakers used Eclair cameras and the Nagra tape recorder. The Eclair is a French 16-millimeter film camera that, if you know how to use it, is fantastic. The Nagra is a very high-quality portable stereo tape recorder with 5-inch reels.

I rented those, a microphone, some earphones, some cans of film, and whatever else I thought we needed. And I bought something I still have, a little brown book called *The Cinematographer's Field Guidebook*. I put that in the back pocket of my jeans. Everything I found out about filmmaking, I found out by osmosis. I was filming by the seat of my pants.

In all, I had picked out forty or fifty thousand dollars' worth of equipment, and the store was dubious. They wanted a letter of credit from the bank before I could take it away, so I called Rhonda. She knew of

a bank that was open until noon that day. I raced to the bank. I collected the letter of credit and rushed back to the rental place. Then I hauled all the boxes of equipment to the car.

I got back to the studio just as everyone was getting ready to leave for two nights of gigs in San Francisco. Ike took one look at all the boxes and said, "That'll never fit." They were flying on a little private plane. "Take the Jag."

Ike gave me a giant rock of coke.

"Try to make it by the second show." Nadya, sensibly, chose to fly with everybody else.

Being a New Yorker, I had no idea how long a drive from Los Angeles to San Francisco should take. On the map, it looked like New York City to Philadelphia, an hour and a half. I said, "Okay, sure." I didn't know it was 450 miles!

Now, this teenager who was an old blues player's son, or maybe his grandson, had been hanging out in Ike's studio for a couple of days. He hadn't gotten any sleep either, was whacked out of his head, and Ike said I should bring him along with me.

That seemed like a good idea. It meant that we could split the driving, so I asked the kid if he could start the drive, and I could take a nap. "No problem," he replied. He just neglected to tell me that he had no idea how to drive.

We got onto a freeway, and he was all over the road. It was terrifying. He was so high, he didn't even notice he was going to get us killed.

I pointed to an exit and shouted, "Pull off, pull off, get off the highway, pull over there, I'll drive!"

He aimed in the direction of the exit, almost hit a steel lamppost, flew off the exit ramp and down toward a gas station, and he was not stopping.

"Put your foot on the brake!" I yelled.

We sped around the gas station and almost back onto the highway before he finally figured out how to stop the car. I jumped out, shaking all over.

"Thanks for showing me what you know about driving. Now get away from the wheel."

I drove the rest of the way, nonstop, and the kid jabbered, equally nonstop. Finally, I turned on the heat and pointed all the heat vents toward him, and that put him to sleep. I kept driving though the darkness, relishing the silence.

At some point in the night, the dashboard lights started piercing my exhausted eyes. I reached into the camera bag behind me and found a roll of gaffer's tape and covered over all those blinding indicator lights. I was doing eighty. I was afraid to go any faster with that huge rock of cocaine in the car, but I knew that if I didn't make it to San Francisco before Ike and company left the theater, I would have no way of knowing where they were. I didn't know where they were staying, I didn't have any phone numbers.

Somehow, we made it, about three-quarters of the way into the second show, and then I drove to the motel and passed out.

The next day, I started opening all the boxes of equipment, and reading up on basics like how to load the film into the camera. The Ikettes were at Fisherman's Wharf and I thought we could test out the equipment there. I put the earphones on Nadya and said, "You're the soundman."

I knew how to work the tape recorder. "That's the volume knob. If you can't hear, turn it up." But then I realized I didn't know how to turn the camera on. No clue, and there was nothing in *The Cinematographer's Field Guidebook*. As I'm trying to figure out the camera, some young people came over and asked what I was doing.

"We're film students. Are you making a film? Can we help you?"

"Yeah, that would be great," I said. "Do you know how to turn this kind of camera on?"

They looked at me funny. "Really?"

"Really."

When they showed me, I said, "You like rock and roll? Want to come and see Ike and Tina Turner tonight and help me out?" They did. Between the *Guidebook* and those kids, we got some wonderful footage.

But they forgot to show me about using the clapboard. You have to use a clapboard, or clap your hands in front of the camera, so that later you can synch the film and the sound. I didn't know that, so we ended

up with some reels of silent footage and some rolls of audiotape and, for years, I had no idea how to sync them together. (Eventually, forty years later, it was all edited together into a documentary on DVD titled, *Ike & Tina on the Road 1971–72.*)

It was time to return to Los Angeles. Since I had the Jaguar, I figured Nadya and I should have a leisurely, romantic drive down the Pacific Coast Highway, the most beautiful road in America, in this beautiful car. Unfortunately, just as we started out, a thick fog set in, so we couldn't see the Pacific. We couldn't see the beautiful rocky coastline, and we couldn't even see the outer edge of the road, which had no barriers to keep us from plunging off the beautiful cliff straight down into that beautiful Pacific.

I inched the Jaguar down the coast through the fog. It was taking us a while, and at one point a phone suddenly rang. In the car! I jumped. Cars didn't have phones in those days, but Ike had installed a radiophone

Tina Turner, Los Angeles, September 1974

down between the seats, yet another one of his high-tech gadgets. I picked it up and Rhonda growled, "Where the hell are you?"

"I have no idea," I said. "We're in the fog."

"Well, Tina wants her car back."

Oops.

Finally, we got back to Los Angeles, and I thought it would be a nice gesture to run the Jag through a car wash before handing it back. What I didn't know was, you're supposed to take the radiophone's antenna off the top when you do that. So I had bent the antenna and, as the Jag rolled out, I saw that it was also scratched on one side. Also, for some reason there were two gas tanks, with a switch on the dashboard to go from the left to the right tank, and one of them had stopped working.

So that's how I returned the Jag to Tina. She never mentioned it.

A couple of days later, we were back on the road with Ike and Tina, going to Mississippi and then up to Carbondale, Illinois, this time, filming everything with the Eclair and the Nagra.

CHAPTER 10

SOME TIME IN NEW YORK CITY

John Lennon and Andy Warhol • Geraldo Rivera and
Rudolf Nureyev • Tex Gabriel and John • John and Yoko
with Mick Jagger • Smith Connection

OUR TIME IN LOS ANGELES AT AN END, NADYA AND
I finally got back to New York City, and I made my way to the
Record Plant to find out how things were going with John
and Yoko.

It was a highly charged environment. *Some Time in New York
City* was to prove a pretty controversial album when it was released
in June 1972; the political content of the songs ranged from "Attica
State," about the Attica prison riot, to "Sunday Bloody Sunday," which
addressed the British Army shooting civilians in Northern Ireland
just months before.

There were songs about John Sinclair, the Detroit revolutionary
jailed, as the song says, "for breathing air," and political activist Angela
Davis; Northern Ireland was addressed again in "The Luck of the Irish."

The mood around the album—revolution!—was further fueled by the presence of people like Jerry Rubin, Abbie Hoffman, and Tom Hayden at the Bank Street apartment, and my understanding was that they were trying to convince John and Yoko to come out against the still-ongoing Vietnam War and the presidency of Richard Nixon.

It was a fascinating conflict. Although John was extremely political, his views differed significantly from theirs. John and Yoko were peaceful; they always made a point of saying they weren't against anything, but rather were in *favor* of things.

They weren't against war; they were in favor of peace. They weren't against the upcoming Republican Convention, but in favor of supporting a candidate who made sense—and clearly, that candidate was not Richard Nixon. No matter how many radicals were drawn to John, and how convincing their arguments may have been, he remained adamant. In interviews and in everyday conversations, he stuck to his view that the only way to change the system was to do so nonviolently.

In addition to opposing destruction of any kind, John was also an Englishman, and unlike many of his countrymen, then and now, he didn't feel it was his role, or even his right, to endorse any American political candidates, or to tell anybody how the United States should be run. He not only had British citizenship, he also sometimes exercised a very British restraint.

In the midst of all the activity inside the studio, John was producing an album for the Elephants. Famous faces appeared frequently, as did various girlfriends, friends, and, on one occasion, a random group of filmmakers from Canada. One night, Andy Warhol stopped by for a visit. Andy usually had very little to say, but he seemed to enjoy talking with John.

Another night, Rudolf Nureyev walked in with Geraldo Rivera, much to everyone's surprise. The next day, you might find Jane Fonda sitting at the mixing desk with Tom Hayden. It was an ongoing party of who's who in the New York artist celebrity scene, where the unexpected was the norm.

John Lennon and Andy Warhol, the Record Plant, New York, April 13, 1972

(Left to right) John Lennon, Yoko Ono, unknown, unknown, Rudolf Nureyev, unknown, Geraldo Rivera, and Al Steckler, the Record Plant, New York City, May 7, 1972

(Left to right) John Lennon, Wayne "Tex" Gabriel, and Mick Jagger, the Record Plant, New York City, October 1972

One morning I came home from the studio around three in the morning and had just crawled into bed when Claude Haynes, the road manager for Elephant's Memory, called.

"Bob, I think you should come back to the studio. Mick Jagger's on his way over."

I got dressed and was back at the studio around four. Mick walked in a few minutes behind me, and John greeted him like they were old schoolmates. They had the kind of rapport you'd have with a good friend you haven't seen in a while. John asked Elephant's Memory guitar player Wayne "Tex" Gabriel to show Mick some chords he was working on, and they all sat and played together for a while.

As they played, Yoko sat off to the side and spontaneously wrote a song. Later, Yoko, Mick, and John sat at the piano and tried it out. Whenever I read or hear about any rivalry John might have had with Mick, or the competitive spirit between them, I just think about the picture I took of Mick, John, and Yoko at the piano, laughing and having a great time, singing and playing together.

In May, John and Yoko appeared on *The Dick Cavett Show*. Yoko sang "Sisters, Oh Sisters," and the shots I captured were used often for publicity—they show Yoko in such a strong role. She is the singer, with

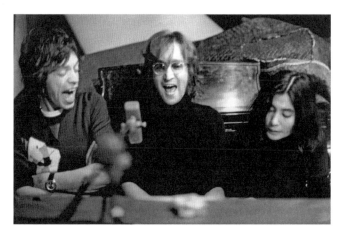

(Left to right) Mick Jagger, John Lennon, and Yoko Ono, the Record Plant,
New York City, October 1972

John in a supporting role on guitar. John put Yoko out there, front and center, to get people to realize what she was doing with her music. A lot of people felt Yoko forced John into that supporting role, but that's not true. He admired her.

A lot of people got very upset about Yoko during this period. There was the ongoing insistence that she had somehow been responsible for breaking up the Beatles, or that it was her influence that shifted John's

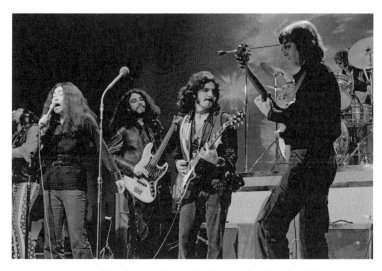

John Lennon, Yoko Ono, and Elephant's Memory, *The Dick Cavett Show*,
New York City, May 11, 1972

writing talents away from Beatles-esque pop songs and into the realms of protest rock and avant-garde jamming. Yoko's art conjures a lot of feelings, and not all of them pleasant. While some art makes you think, Yoko's art makes you feel. Some of her pieces are really intense. But instead of realizing that Yoko was evoking powerful emotions and that her ability to do that was in itself impressive, many people resented her for making them feel uncomfortable. Through it all—or maybe *because* of it all—Yoko was always very strong.

The music industry was a tough environment for a woman in the early 1970s. When Yoko was working in the studio, she was constantly undermined, even though she was trained as a classical musician and is very knowledgeable about music. It wasn't unusual for her to tell the sound engineer at a recording that she needed more bass, only to have him respond with, "What's that? What do you think we need, John?"

Invariably, John would say, "I think Yoko said we need more bass." The tech guys would have to hear it from John; they wouldn't follow Yoko's instructions. I guess it was hard for them to have a woman telling them what to do.

Yoko was constantly surrounded by all these men, and yet she never allowed her voice to be silenced and she was never intimidated. Neither did she care about the critics, whether they were professional writers or passing fans.

All my life, I've run into people who tell me that they don't like Yoko (mainly those who have never met her); they just like John. Well, John liked Yoko. It's true that she comes off in photographs as very aloof, a strong kind of character, and she doesn't look like she has a sense of humor.

That is deceiving. John was a comedian, and you couldn't hang out with John Lennon and be a humorless person. When people ask me, as they often do, "What kind of a woman is Yoko?" my first answer is, "She's the kind of woman that John Lennon would marry."

Soon they were planning a concert at Madison Square Garden called "One to One." It was a benefit for the Willowbrook State School, a facility on Staten Island for mentally and physically challenged kids. John and Yoko had seen a Geraldo Rivera report on the terrible

conditions there and decided to raise money to help them. John, Yoko, and Elephant's Memory were headliners, along with Stevie Wonder, Roberta Flack, and Sha Na Na.

Into the summer of 1972, the rehearsals came more frequently as everybody—John, Yoko, and Elephant's Memory—got ready for the Madison Square Garden concert, which they hoped would lead to a *Some Time in New York City* world tour.

John and Yoko had rented a space on West Tenth Street, four blocks from their house, and christened it Butterfly Studio. John planned to start his own recording studio there, so he could just walk down the block and record whenever he wanted. He'd even brought over the control panel from his studio in Ascot, without ever considering the fact that the panel worked on a 220-volt system with English plugs and couldn't be used in New York City without significant and costly rewiring.

The project was never finished. But they had soundproofed the back room, so it made a great rehearsal space.

It was a lot of fun to watch rehearsals at Butterfly. One thing John and the Elephants bonded over was their love of fifties rock. At Butterfly, they'd warm up by playing some old rock and roll and the *Some Time in New York City* songs.

Then John would play something like "Come Together" or "Imagine," and I realized, "Wow! That's a Beatle!" I had gotten so used to thinking of him as just a New York City guy, part of a team with Yoko. But when he started singing Beatles' songs in his incredibly distinctive voice, I remembered the John that was synonymous with Paul, George, and Ringo.

I attended as many rehearsals as I could, but I was in no position to turn down paying jobs as well. Shortly after the sessions moved to the Fillmore, where they pretty much went on all night, I came out of a session at six in the morning and flew straight to St. Louis, to photograph a soul band called the Smith Connection.

They met me at the airport; we went somewhere for lunch, and then we took some pictures in a park. Because the album's name was *Under My Wings*, they wanted to have some pictures that were actually taken under a plane's wings. We spent about an hour down at the end

of the runway, with them standing there posing for pictures, and me waiting for a jet to take off. Every time one did, I would get four or five shots of it rising up behind them. Then we'd have to wait for the next plane, and another bunch of pictures, then the next plane, and so on. They also had a small plane at their disposal, so we made our way onto the tarmac and the band members stood around beneath the plane's wing for the picture they used on the front cover.

The Smith Connection, *Under My Wings*, St. Louis, Missouri, 1972

I flew back to New York City and went straight to the Fillmore for that evening's rehearsal. Walking in, the first thing I heard was the band going into John's "New York City" song. It felt so good to be home.

The concert was on August 30, 1972. There was such a demand for tickets that they added a second show in the afternoon. In many ways, the show was a success; I think they raised some money, the crowd had some fun, and so did the performers.

The most poignant moment, though, was when John sat at the piano next to Yoko and sang "Imagine." Standing on the side of the stage, photographing them from so nearby, is still the highlight of my years as a photographer.

As loudly as they cheered for John, they booed Yoko. She was using a vocal technique that enabled her to make a modulating sound. People simply didn't understand what she was doing; they thought she was just screaming and making noise. Indeed, it took me a while before

I understood that she was using her voice the way her friend Ornette Coleman used the saxophone—she was voicing emotions, not words. Many people still don't grasp her method, and they certainly didn't at that concert.

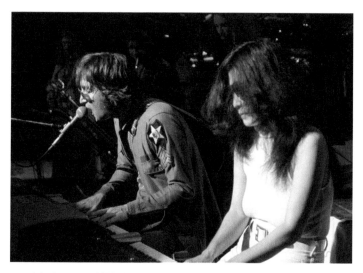

John Lennon and Yoko Ono, One to One concert, Madison Square Garden, New York City, August 30, 1972

Nadya came with me to the concert, and backstage she met Yoko's assistant, Sara Seagull. Sara is an artist who knew Yoko from the New York arts scene, back before she met John. She was impressed with Nadya and hired her; then, when Sara left the job a few weeks later, Nadya replaced her. Making the five-minute commute from our apartment in Westbeth to Yoko and John's on Bank Street was easy.

A *Daily News* reporter who came to interview John and Yoko once described Nadya as "curt and brusque," which we took as a compliment. That was how she was supposed to be as gatekeeper and personal assistant to John and Yoko. To this day, when I want to give her a hard time, I say, "Don't be so curt and brusque." Because she can be. She's a powerful, no-nonsense person.

Reviews of the concert were harsh. Critics blasted John's "sloppy" performance, and what they felt was sloganeering in his lyrics. There was some truth to that, and the crowd didn't respond to the politics of

the album, or to the fact that John had given Yoko such a big part in it, when they had expected Beatles music.

Nobody was surprised when plans for a world tour were abruptly canceled.

John was more affected by bad reviews than Yoko, who seemed utterly impervious to them. From her point of view, the concert was a success. Most artists try to please. Yoko wasn't interested in trying to please anyone; she wanted people to react seriously to serious things. She once told me that she came from a school of art where, if half the audience didn't walk out, you hadn't done your job properly.

When Yoko and John had first become involved with each other, she'd showed him books of her reviews. John's reaction was, "But these are all bad reviews. Why do you keep them, let alone put them in books?" Yoko's response was, "No, they're not all bad. They're all expressing strong feelings about the art."

That's something a lot of people don't realize about Yoko, how funny she can be, what a sense of humor and mischief she has. They simply hear what they want to hear—or because they react negatively to the feelings that her work induces, they turn away from her, and refuse to allow themselves to truly experience what she is saying. If you do that; if you approach her work with an open mind, it makes a world of difference.

Despite the demoralizing reviews from the Madison Square Garden concert, they all went back to the studio to finish the Elephant's Memory album and record a new solo album of Yoko. But John was depressed. The thwarted tour was an embarrassment, and everyone started drinking even more.

When I began hanging out at the studio, maybe John and one of the guys in the band would bring a bottle of booze. Later in the night, someone might go to the store if we ran out. By the fall, John was coming in with two bottles, I brought a couple, everyone brought bottles. We later called these "The Tequila Sessions," because there must have been a dozen or more bottles of tequila for just ten people.

Yoko wasn't a drinker, but she didn't put limits on John. No one could have controlled his drinking anyhow. As she wrote, "If there was

one thing about John, it was that he was a very strong-willed person and did what he liked most of the time." When he drank, he'd get really into it and drink a lot. And when he drank a lot, he would drink more.

Unfortunately, when this happened, John could get pretty aggressive and self-centered, not caring about whom he hurt. There would be some very wounded feelings in the studio.

I'm not saying this to excuse his behavior, but John was under a lot of pressure. In addition to the bad reviews for both the album and concert, he and Yoko were also under a deportation order. The U.S. government was trying to throw them out of the country, describing them as "undesirables" because of what was perceived as their political stance and influence, and they suspected they were being followed. They weren't sure, but they thought they heard clicks on the telephone and saw people in the neighborhood watching them closely.

As November and Election Day drew nearer, it became clear that President Nixon was the popular favorite, and the Lennons' fears were only exacerbated. There was no doubt that their removal from the country was one of the Nixon administration's goals, and given another four years in which to scheme, it was very possible that, eventually, they would prevail.

Paranoia was rampant. But is it paranoia when you know it's true? Even I was followed a couple of times. Once, I left the Record Plant at about three thirty in the morning and noticed a car driving a block behind me. The car tailed me through the city all the way to Greenwich Village, which, at that time, was usually pretty deserted.

I parked outside my apartment and jumped out so I could try to get a look at my pursuers. Two men wearing suits and those old-fashioned fedoras that G-men wear in the movies glanced at me, then sped away down the block.

My neighbors told me they often spotted guys out on Bank Street, wearing trench coats and those trademark fedoras, asking passersby if they'd ever noticed anything suspicious about John and Yoko.

A couple of days after the Madison Square Garden concert, John, Yoko, and the Elephants performed at a Jerry Lewis telethon benefiting

muscular dystrophy research. I went while Nadya recorded it at home with our black-and-white mono video recorder.

We had a viewing party in our apartment after the show. The apartment was only about eight hundred square feet, including the loft platform we had built for the bed, and the dressing area underneath. In the small living room, there was a couch, one large chair, and another hanging from a ceiling pipe. I'd built a darkroom off to the left of the entrance, and the kitchen alcove was just past that.

For John and Yoko, seeing their performance directly after a show was a rare experience because almost nobody had a videotape machine. It was also probably the first time they'd ever seen themselves playing with the Elephants.

IN JULY, *CREEM* MAGAZINE SENT ME DOWN TO MACON, Georgia, for two days to do a story on the hometown of Little Richard, Otis Redding, and the Allman Brothers. The publicist showed the writer and me around the local sites—the grave of Elizabeth Reed, inspiration for the Allman Brothers' song, the bus station where Little Richard hung out. One thing I saw that really stood out was a band's van with the words "Miss Shake-A-Plenty Her Orchstry and Her Revue" on the back, and I have always wanted to know what that show was like! We didn't get to see Otis Redding's farm, but we did interview Bobby Womack, and then we flew to Florida to see the Allman Brothers play.

We arrived as they were going onstage, and they were phenomenal. The power of their music combined with the power and energy of quaaludes, alcohol, and young people was intoxicating. After the show,

Miss Shake-A-Plenty truck, Macon, Georgia, July 1972

the scene at the motel was right out of a rock-and-roll fantasy movie. Musicians and groupies were in and out of the rooms all night.

At one point, three girls were in my room and asked if they could take their clothes off. I said yes, and they did. Then they ran out of my room, down to the pool, jumped in and out of the water, then came back to dry off, put their clothes back on, and left.

I didn't get the chance to meet the band until the next day. When everybody started getting on the bus, I joined them. Although their road manager knew I was meant to be there, the band didn't, so as we pulled away, they turned around and asked me who I was.

I always carried my 8 × 10-inch box of recent photographs with me. I opened my camera bag to get it. On top were other pieces of my equipment—not just cameras and flashes and film, but also a bottle of Cuervo tequila.

We passed the tequila around while I showed pictures and told stories as we cruised along the Florida highway. We finished the tequila, and I took out a bottle of Rémy Martin. There were beers as well, so inevitably we had to pull over to relieve ourselves on the side of the road. As everybody was coming back, I took a couple of pictures.

RIGHT PLACE, RIGHT TIME

Then I said, "Hey guys, just stand by the bus here for a minute." The Allman Brothers notoriously did not pose for group photographs, but everybody was in such a good mood that they stood there. That's when I got the group shot of all the Allman Brothers.

(Left to right) Butch Trucks, Gregg Allman, Dickey Betts, Berry Oakley, and Jai Johanny Johanson, Florida, July 1972

Creem planned a series of centerfolds called "Creem Dream" featuring rock stars. I was asked to shoot the first one, and my friend Todd Rundgren posed as the Venus de Milo.

I wanted to make sure we got the pose right. I went to an art store to find a postcard, so we could copy the pose. Unfortunately, I couldn't find a small one. I did come across a picture in a fine art book, so I took a Polaroid of that.

Todd showed up with his new girlfriend, Bebe Buell. Apparently, they had been dating only about a week. He had recently colored his hair blue and red. A *Creem* artist airbrushed a print to remove Todd's right arm, like in the statue, and added color to his pubes to match his hair.

**Todd Rundgren, West Twenty-Ninth Street studio,
New York City, June 1972**

I also took some photos of Todd and Bebe together; he's wearing a gold lamé suit that he got from the legendary tailor Nudie, identical to the one Elvis Presley wore. Bebe is the beautiful model who is hugging his leg.

My apartment saw a lot of cozy gatherings of rock and rollers, usually there to watch tapes, usually of themselves. Labelle or Sha Na Na might turn up at a viewing party, or members of Ike and Tina's band. This neighborly way of being not only defined our friendship, but defined the Village music scene, too. With its narrow, tree-lined, cobblestone streets, the Village always seemed a different world from the rest of the rigidly ordered city. Because so many artists and musicians lived there, people were often up late, and it was not unusual to see them out and about at all hours.

John and Yoko were among the many visitors, particularly around this time. They had bought a video recorder after seeing ours, only to

Todd Rundgren and Bebe Buell, West Twenty-Ninth
Street studio, New York City, June 1972

(Left to right) Nona Hendryx, Nadya Beck, Vicki Wickham,
Sarah Dash, Patti LaBelle, and Armstead Edwards,
Westbeth Studio, New York City, 1973

then donate it to a group fighting for Native American rights in the Midwest. Sometimes that group would send tapes to John and Yoko, and they'd come around the corner to our place and watch them on our machine.

The election campaigns were in full swing now, Nixon and Democratic Senator George McGovern battling it out for what we believed was the nation's soul. John was as downcast as the rest of us as the Elephants worked in the studio on election evening. Nixon had won long before the final result was called, and what we had all hoped would be a celebration party at Jerry Rubin's SoHo apartment later that night was already beginning to feel tragic.

John Lennon, the Record Plant,
New York City, November 1972

John's drinking was particularly heavy that night. We set out for Jerry's place, squeezed into my Volkswagen, and John was cursing at everyone in the car. You'd have to be a Liverpool sailor to understand half the language he used. The rest of us were upset about the election, too, but only John was yelling about it.

By the time we got to Jerry's, just a few stragglers were left. More people started drifting away as John got further and further out of

control. He went over to a woman and then took her to an adjoining room while the rest of us sat around awkwardly with Yoko. It was embarrassing. Yoko was obviously really upset and uncomfortable, and I think that incident was what led to John and Yoko's eventual temporary separation. We could hear John and the woman moaning through the wall, and so, to drown out the noise, I put on a record.

I meant to play something lively, but I put on the wrong side of *Blonde on Blonde* and the song that played was the mournful "Sad-Eyed Lady of the Lowlands." Okay, I thought, time for me to leave, and I went home.

Yoko's album sessions resumed a couple of days later and, although the environment was business as usual, it was hard not to notice when John showed up later than the rest of us, still unshaven and looking hungover.

John, Yoko, and the Elephants recorded all night, and at dawn we went to the Pink Teacup. It was open twenty-four hours a day. You could get a good breakfast at five in the morning. There was also a jukebox that pounded out James Brown and other soulful greats.

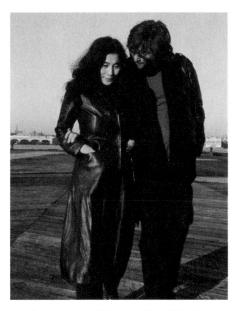

John Lennon and Yoko Ono, West Side Pier,
New York City, November 1972

John, Yoko, and I lived near the Teacup, so after breakfast we walked down Bleecker Street toward home. The sun was just coming up so we walked out on a dock along the Hudson River. It was quiet and calm and I took some pictures. John was apologetic and very attentive to Yoko.

A week or so later, I was off to California. The Elephants were playing some shows out there, to coincide with the release of their new album, including a major KROQ show at Los Angeles Memorial Coliseum.

I picked up a souvenir at the hotel, this time courtesy of the parking attendant out front. The gentleman's name was Yossarian—it was right there on his name tag—just like the main character in Joseph Heller's *Catch-22*, one of my all-time favorites.

It's a story about paranoia and hustling, and at the end of the book, Yossarian is walking around naked, except for his service handgun, and he's walking backward to ensure nobody can sneak up on him. I was so flipped out that this guy had a name tag that said "Yossarian" that I bought it off him. When I got home, the first thing I did was put it on my army jacket. It's been there ever since.

Following the completion of John and Yoko's album, John produced a self-titled album for Elephant's Memory.

The Elephants had asked me to take the pictures for their cover; they had seen a Peter Beard photograph of an elephant graveyard in Africa, decaying elephants beneath a cliff, and they wanted me to make a picture that they could superimpose onto it, showing the band on top of the cliff.

I took them to Central Park, to the rock faces there, and took the picture. Then, for the gatefold, they wanted portraits of each band member, at a time when a few people were making fun of me for my soft-focus style. So, I had the band come to my studio and took out the Hasselblad, which was perfect for taking really sharp pictures.

I got great shots, but while I was making the prints, one of the pictures of Rick came out a little too light. I left it in the developer while I made a better one, and it ended up being left in there for twenty minutes,

half an hour, a really long time, and when I looked at it again, it had taken on a strange ethereal quality. It looked kind of arty, both overdeveloped and underexposed, so I kept it aside as a gift for Rick.

He loved it, but so did the others. Suddenly, they wanted me to make the other four portraits exactly the same. I said I would try, but it was really hard to reproduce—in fact, looking at the pictures now, the original Rick is the best one, and that's because you can never reproduce the perfect accident.

As I was bringing the pictures to their management office, Leber-Krebs, I ran into Tony Machine, who had been a drummer with the Rich Boys but was now working with Steve Leber. While we were talking, he said I should check out this other band they managed called the New York Dolls, who were playing at the Mercer Arts Center.

The first time I went to the Mercer, I was not impressed. I didn't know there were so many rooms, because the bar in the middle had a little bandstand at the end and I was expecting a band would come on and play there. But nobody did.

The clientele was also unusual. I was having a beer when I saw some guy walk by me wearing eyeliner. I had been hanging out with the Hells Angels; in fact, I went to the Mercer directly from the Angels' clubhouse. The last thing I expected to see were regular guys walking around with eyeliner. My immediate response was that this was not my kind of place to hang out. Later, when I saw Tony again, I mentioned this, and he said, "No, you should go back. It's really cool."

I did, and that's where I saw the New York Dolls.

The Dolls were rockers who wore makeup and dressed like dolls . . . because girls like to play with dolls. Their shows were loud, fast, creative, chaotic fun. I like a band that puts on a show and has a look and a sense of style that matches and completes their sound, and they certainly did. I've been told by bands as diverse as KISS and the Clash that seeing the Dolls made them think, "I can do that."

I was at the Mercer, watching the still-empty stage, when I suddenly saw people going in and out of a door on the other side of the foyer area. At first I thought it must be the men's room, and I'd just been

wondering where it was, so I walked over and, instead, I found what was called the Oscar Wilde room. When I opened the door, it was like opening the door to *Fellini Satyricon.*

On the left side was what looked like a very steep set of bleachers, or maybe just a vertical wall of people, all odd, all excited, yelling and laughing. On the right side there was a crowd of people dancing and moving around, and smack in the middle was a band that was playing at a deafening volume.

The whole thing hit me all at once. "Where am I? What is going on in here?"

It was a wild, chaotic scene with loud music. I stepped over to one side to watch and that was it. I was hooked. It was the first time I ever saw the New York Dolls, and it was mayhem—but great mayhem. It was loud, it was bright and fun. The people were interesting. Just the way they looked and acted. It all seemed so free, and the fact that it was hidden away in a room that you didn't even see when you walked into the venue made it feel like some kind of great secret. I went home and told Nadya that I had just seen the most amazing band, and that she had to come with me the next time they played.

As it happened, I encountered the band again before their next show. Toby Mamis, the publicist for Elephant's Memory, who worked in a similar capacity for the Dolls, set up a photo session. I returned to the Mercer a few afternoons later, where I met the band's bassist, Arthur Kane, and drummer Jerry Nolan. Guitarist Johnny Thunders and singer David Johansen weren't there yet, and I think the other guitar player, Sylvain Sylvain, had gone out to get a sandwich. We sat around for a while, but after half an hour, I left.

A couple of days before Christmas, I went out to see them at a theater on Avenue A, the Village East. They were on a bill with Teenage Lust and Eric Emerson's Magic Tramps. This time I did get to meet them all backstage, and I took a photo as well.

The following week, the Dolls were at the Mercer once more, this time for the big 1972 New Year's Eve party. Nadya and I were spending the evening with Rick and Stan from the Elephants and their girlfriends, Daria and Maria—three couples enjoying their New Year's Eve together,

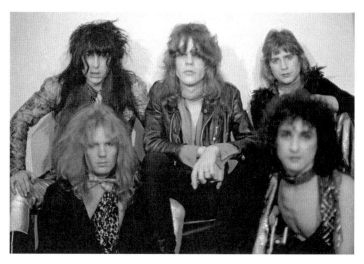

(Clockwise from top left) Johnny Thunders, David Johansen, Jerry Nolan, Syl Sylvain, and Arthur Kane—the New York Dolls, Village East, New York City, December 23, 1972

going out for a nice dinner, sitting around talking, just relaxing. Then I suggested we go down to the Mercer Arts Center.

We stood at the top of the stairs looking around at the mad, colorful melee. Arthur Kane, the Dolls' bassist, walked by, resplendent in bright yellow hair, a yellow women's sequin bathing suit, yellow glitter stockings, and engineer boots that he had painted bright yellow. He had a little pink chiffon scarf on his wrist. He was a vision. He also had a rather high voice, and I remember him doing a little limp wrist thing with the pink chiffon and saying, "Hi boys" as he passed us.

As the only member of the group with whom I'd exchanged more than a word or two, I greeted him back, and as he walked away, Stan just looked at him before asking, slowly, "What . . . was . . . that?"

"Oh, that's Arthur, he's the bass player. You're gonna love this band." Stan just looked at me, completely unconvinced, which makes me laugh because, two years later, Stan played the saxophone on the second Dolls album.

The show was mayhem. There was no set stage; just the room with the bleachers, and the audience crowding around the band. People were even walking *through* the band, or dancing *through* the band, until it was difficult to determine where the musicians ended and the audience

New York Dolls, Mercer Arts Center, New York City, December 31, 1972

began. Sax player Buddy Bowzer would appear for a song, and then he'd disappear. Was *he* a part of the band? Or just someone who had dropped by with a saxophone? There was no way of knowing. The New York Dolls were fantastic, and I wanted to see more of them.

It was early in the new year, 1973, when I received a very perplexing phone call from Toby Mamis. It was late in the afternoon, five thirty or six, and he was calling to apologize for the band not showing up to our photo shoot that afternoon.

What photo shoot? I had no memory of making an appointment with them. I didn't tell him that. I just told him that everything was fine, and we'd catch up some other time. I was thinking, "Oh, we're on the same time schedule." Which is to say, no schedule at all.

I videotaped the Dolls for the first time a couple of weeks later, at Kenny's Castaways bar, uptown on East Eighty-Fourth Street. It was the first time I'd been there. It was one of the Dolls' favorite hangouts and soon became one of mine. I was back there again when they played in April. I took a group photo on the stairway that stood between the stage and the closet that was called a dressing room—which was, in fact, in the building next door.

I still didn't really know the group at this point. I didn't make a big deal about wanting to take a lot of shots. I just asked for a photograph

New York Dolls, Kenny's Castaways, New York City, June 23, 1973

and they said yes. I really began to connect with them when I ran into David by the bar at Max's Kansas City one night, and we started talking.

We ended up spending a couple of hours deep in conversation; I invited David and his girlfriend, Cyrinda Foxe, to visit Nadya and me to watch the video from the Kenny's Castaways show, and afterward, I handed him my business card. It was a picture of myself upstate in Roscoe, New York, sitting on a fence in the countryside, which I took by the light of a full moon.

Bob Gruen Studio 232 West 29th Street NYC 212·656·5286

Self-portrait business card, Roscoe, New York, 1971

You could see through me, as though I were a spirit. He looked at it for a moment and then said, "This photo is to photography what my voice is to singing."

David and Cyrinda came over a few days later. I cooked a roast chicken dinner. That was how Nadya and I had always arranged things; she was a "morning person," so she made breakfast; I functioned better later in the day, so I made dinner. We ate and then we all watched the tape together. I began seeing the band more often, both onstage and socially.

The Dolls all had unique personalities, a great sense of humor, and amazing style. They really opened up my own fashion sense. When I met them, I would wear a green T-shirt or a blue T-shirt with a denim jacket and jeans and cowboy boots. And that was pretty standard.

Little by little, I became brighter and brighter and, over the next couple of years, I wore some very bright clothes. I did not become a New York Doll. I didn't dress like them, but I fit in a little better.

One of my favorites was a cut-off T-shirt that somebody gave to David, which he passed on to me. It had a picture of Marilyn Monroe on the front, a black-and-white picture, and whoever gave it to David had colored it in with full makeup, with crystal studs for earrings. It

David Johansen, Los Angeles, September 1973

RIGHT PLACE, RIGHT TIME

was a beautiful piece of work, and I wore it constantly, particularly at Dolls shows.

I became a regular at Kenny's Castaways and got to know the owner, Patrick Kenny, and the manager Don Hill. They let me videotape the musicians who performed there, including Willie Dixon, Larry Coryell, Yoko Ono, Tracy Nelson, and the Dolls.

Around this time, cable television was beginning to make itself known in New York City. It was a new development, and it was expensive—twenty-five dollars a month. Very few homes were wired for it. Part of the licensing deal was that the cable company, Manhattan Cable, would have two channels available for public use, and I decided to put on a show, *Bob Gruen's Rock and Roll*.

Every month, I'd book two half-hour blocks and two one-hour blocks, all at odd times during the week when I thought rock-and-roll people might be watching television. There was no host, just some crude handwritten titles that I would shoot for the beginning and end of each "episode." I never got much of a reaction from it. I was just doing it hoping that somebody would be watching, although I wasn't—they were only wiring up the wealthy neighborhoods!

And it turned out, I did have an audience. One day I called the cable company to ask if Westbeth was on their schedule to be wired up, and the guy told me no. I explained why I was interested, and it turned out he loved the show. He also said he'd put us on the list to be wired up, and he did. Finally, I was able to watch my own show. *Bob Gruen's Rock and Roll* ran until 1976.

SURREAL DAYS

Nutopia • John and Yoko • Alice Cooper and Salvador Dalí

I HAD AN ASSIGNMENT TO TAKE A PHOTO OF JOHN AND
Yoko for *Words and Music* magazine. They had been putting it off
for a while, but one day Nadya called and said, "If you can be here
in five minutes, you can take the picture."

I grabbed my camera, ran around the corner, and took a photo of
them standing against the brick wall by their Bank Street house and,
simple as that, I had the cover photo! An art director at the magazine
added fake graffiti for a more "New York" look.

In January 1973 John called to tell me that he and Yoko had decided
to move away from Bank Street.

The government surveillance had not ended; the guys in the fedo-
ras were still hanging around. They had other visitors, too, who quickly
proved to be just as unwelcome. Anyone could just walk up the sidewalk
and knock on their door . . . and they often did.

One time we were in the bedroom talking when their assistant
came in and said, "There's someone here to see you. He says his name
is Jesus. And he's from Toronto. Jesus from Toronto."

John Lennon and Yoko Ono, *Words and Music*
magazine, New York City, November 1972

John laughed and said, "Nope, don't know that one." That sort of thing lost its humor after a while.

Initially, John and Yoko were thinking of leaving the city altogether, and Greenwich, Connecticut, was discussed—Nadya's parents lived there then, so Nadya and her mother arranged for a real estate agent to show them some houses in the area.

I drove Nadya, John, and Yoko there in their station wagon. We stopped first at Nadya's parents' house, so John and Yoko could take a walk through the garden to acclimate themselves to country living. They even took a ride in a rowboat on the pond, despite the thin layer of ice on the water, John smiling broadly as he pulled away from the bank while Yoko gazed nervously back at the receding shore.

On April Fool's Day, 1973, John and Yoko had called a press conference. Nobody knew what they were planning, not even their attorney, Leon Wildes. The assumption was, it was something to do with the U.S. government's continued attempts to deport them.

In fact, they were announcing the conceptual existence of Nutopia, a country with "no land, no boundaries, no passports, only people." As ambassadors for this new country, they were requesting diplomatic

John Lennon and Yoko Ono, Greenwich, Connecticut, January 5, 1973

immunity. They even waved Nutopia's national flag—a white handkerchief. Later, they would attach a brass plaque to their back door, reading "Nutopian Embassy." John's next album, *Mind Games*, would include the "Nutopian National Anthem." It was three seconds of silence.

Nobody in the room knew what to make of it. John and Yoko were very serious about their declaration. They may have been residents of the United States, but they were citizens of the world, as are we all.

John Lennon and Yoko Ono, American Bar Association,
New York City, April 1, 1973

RIGHT PLACE, RIGHT TIME

"Imagine there's no countries. . . ."

The next day, John asked if I wanted to ride uptown with them, to take some pictures of them in Central Park. The session wasn't long, but it was spontaneous and fun, on a beautiful, fresh spring day. We walked around the area that is now known as Strawberry Fields, and the images we took that day ended up being some of their favorites.

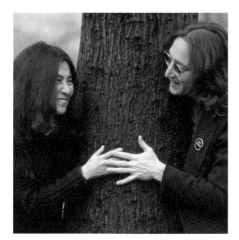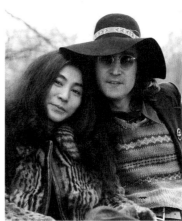

Yoko Ono and John Lennon, Central Park, New York City, April 2, 1973

I went downtown while John and Yoko went to the Dakota building to view an apartment that they were interested in. Coincidentally, I'd been to the Dakota before, when Jackie Curtis took me to a party being thrown by the actor Robert Ryan. All I really remembered was the tiny decorative balcony, about a foot wide, where Jackie and I went to smoke a joint. It had a beautiful view over Central Park.

John and Yoko moved into the Dakota shortly after, and one day when I was visiting, I stepped out onto the balcony, looked out at the view, and realized this was the same apartment that Jackie and I had visited months before.

Meanwhile, I was spending more time with the New York Dolls, and also working with various other acts, including Alice Cooper.

Since that Fillmore gig, I'd made sure to keep in touch with Alice . . . or, rather, with his manager, Shep Gordon, at his office, a brownstone on Thirteenth Street, just off Sixth Avenue.

I enjoyed photographing Alice, and not only because I was guaranteed some great pictures at every encounter. Alice was signed to Warner Bros., and I was already doing a lot of work for them. But when it came to photographing him, I worked through Shep, which was good for me because he would pay me a lot quicker.

Warner Bros., being corporate, usually cut checks after ninety days. With Shep, I would walk into the office and give him an invoice; he'd tell me to take it downstairs to Joe, his partner, and Joe would write me a check and I'd walk out with it.

As Alice got bigger and bigger, Shep was often literally snowed under with work, so more and more of my dealings were with Mandi Newall, who Shep had brought over from Warner Bros. in London to work on their upcoming Billion Dollar Babies tour. I still remember the first time I saw her, sitting there on the couch. Long black hair, black lipstick, black fingernails, black jeans, dark eye makeup. She looked really exotic and together. She looked like the ultimate no-nonsense rock-and-roll businessperson. I was impressed, and from then on, most of my sessions with Alice were set up by Mandi. She is still one of my closest friends today.

One night, when Alice was on his tour, just before his show in Philadelphia started, a girl I knew backstage handed me a beer and said, "Oh, I just opened this, but I don't really want it. Why don't you take it." I drank it without really paying attention because I was getting ready to photograph the show.

Afterward, though, I started feeling wobbly. I was becoming more and more dizzy, and the longer the show went on, the worse I was feeling. By the time the gig was over and we were making our way out to the limos, it felt as though I was moving in slow motion. I even got into the wrong limo!

I was in the front seat, and looked behind me. Alice and his girlfriend Cindy were there, Todd Rundgren and Bebe Buell, too. I was growing more and more nauseous by the second. I didn't know what to do.

It was even worse once we started to move, and I realized that I was going to be sick. I couldn't open the window, because there were fans

all over the ramp, reaching for the car. I looked at the driver and he was busy trying to get the car through the crowd without running anybody over. Alice, Todd, and the girls were chatting, having a good time in the back seat. Nobody was paying attention to me. So, as subtly as I could muster, I leaned over between the door and the seat and threw up.

I felt horrible about doing it, but I had no choice. I was still throwing up when we got to the after-party, which happened to be on a boat—and that only made me feel worse.

Alice's agent, Jonny Podell, helped me from the limo to a bathroom downstairs in the middle of the boat. I remember kneeling down with my head in the toilet while the engines hummed, the high-pitched metallic whine that reminded me of a dentist's drill, the boat rocking back and forth. I missed the entire party, and I really wasn't feeling better the following day.

I was meeting up with Lisa Robinson. There was a young singer from Philadelphia that she wanted me to take pictures of, and the whole journey there, she was asking if I was OK, if I'd taken anything, and I was telling her "No, no, all I had was beer." I felt sicker than I had ever been; nothing I had ever drunk had flattened me in that way. I couldn't figure it out.

It was three or four years before I found out what had actually happened.

I was at a Jerry Lewis telethon, standing on scaffolding watching whoever was performing, when Jonny's wife, Monica, turned to me, and said, "You know, I'm really sorry that I gave you that beer with the quaalude in it at the Alice Cooper concert."

It took me by surprise.

"What? What?" And then, as my mind went back to that night, I asked, "You mean I really was dosed?" And she went on to remind me how Shep and Jonny loved playing pranks on people, and that night, I was the chosen victim.

To be honest, I still don't really see the humor in it, hiring somebody to take photos and then messing them up so badly that they can barely stand. Where's the fun in that? But that's what happened, and I would never want to go through it again.

Another key figure in my relationship with Alice was Ashley Pandel. He was a fellow Dolls fan—in fact, one day when I was looking back at my pictures from the Mercer, I recognized him leaning against a pillar in one of the photos. He worked as Alice's publicist for a time, and he later ran a restaurant-bar, Ashley's, on Fifth Avenue at Thirteenth Street.

Now, *that* was a rock-and-roll hangout! They had decent food, and two floors of fun. Ashley was friends with a lot of people, and whenever Alice was in town, he would be there. I would often stop by on my way home from photography jobs or when I was going to other clubs, or David Johansen and I would drop by after one of our evenings out. I could always count on Ashley to treat me well.

I'd visit around three in the morning for a night cap and to see what was up. One night in February 1973, I stopped by and Ashley said, "Are you coming tomorrow?"

I said, "Coming where tomorrow?"

"Well," he replied, "Alice is filming a hologram with Salvador Dalí, and you should be there." He gave me the address, and that is typically how I would find out about my jobs. People would forget to call the photographer for events, even when it was something like Alice Cooper and Salvador Dalí making a hologram. They had a filmmaker to make the hologram, but they had not remembered to call a photographer to document the event. It worked out, because twelve hours later, I was meeting everybody at the loft in Midtown.

That was a really entertaining shoot. Dalí was wearing a gown and looked quite spectacular and very eccentric. He had ordered two and a half million dollars' worth of diamonds (around fifteen million dollars in today's money) from Harry Winston, the jeweler. The elevator door opened and in came a little man in a bowler hat, who was carrying an attaché case.

He had a beautiful woman by his side and a large thug who made it very obvious that he was carrying a machine gun, and who stayed by the elevator, so that nobody went out with the diamonds before the man in the bowler hat retrieved them.

The bowler hat guy went to a little table, opened his attaché case, took out a velvet pillow, unwrapped a diamond necklace and tiara, and

laid them on the pillow. He handed the pillow to the pretty girl, who walked across the room and presented them to Dalí, who arranged them on Alice just the way he wanted them. Dalí explained that he was using real diamonds because he wanted them to sparkle in the hologram. Alice looked really good!

Another prop that Dalí had made looked like a human brain. He announced that it was the brain of the pop star. Dalí had placed a chocolate éclair into the middle and little ants running across the brain trying to get to the chocolate. He set that up behind Alice and gave Alice some disjointed spinal bones to use as a microphone stand.

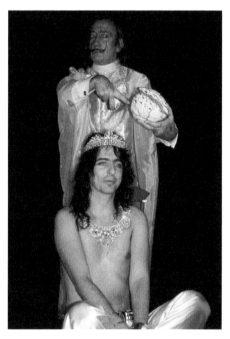

Alice Cooper and Salvador Dalí, New York City,
February 25, 1973

The whole day was surreal. In fact, Dalí said that he picked Alice as his model because Alice was also a surrealist, in that he acted out his songs in such bizarre ways.

At one point, Dalí spoke to the press. There were only a few people present; aside from myself, there was somebody from the *New York Times* and either *Time* magazine or *Newsweek*. Dalí took the time to

talk to us, explaining that he called his art "Confusionism," because everybody in life is confused. Nothing is ever really clear; nobody ever really understands or knows anything. Life is a continual state of confusion.

I thought that was brilliant, and I think he realized that I understood him and was *not* confused, because suddenly he started screaming at me in different foreign languages! Just going off, and I had no idea whatsoever what he was saying, so *yes*, after that I was confused.

A couple of months later, there was a press conference at the opening of the exhibition featuring the holograms, in a gallery on the East Side. You walked in and they had some of Dalí's works on a wall and then there was a crudely cut hole at the back of the gallery, where you stepped out onto a temporary wooden staircase into a side room in the building next to the gallery. That was where they had the holograms set up.

There was the hologram of Alice, and there was also one of a room of men playing cards. The card players were moving their hands and picking up and putting down the cards, and Alice was actually singing. Moving three-dimensional holograms were still a relatively new invention at the time. Everybody was floored.

NEW YORK TO LA AND BACK AGAIN

The New York Dolls • Sable Starr • KROQ

I WAS GETTING TO KNOW EACH OF THE DOLLS WELL. David first, and then Sylvain, who I always thought of as a kind of Charlie Chaplin–esque guy. He had curly hair and he wore oversized things. For example, he would have a pair of sunglasses that were a foot wide, and he'd wear them with a bow tie that was a foot and a half wide, and then maybe no shirt but pants with suspenders, and the pants were always some kind of bright color. He'd wear women's panties on top of that. Anything to be shocking and different.

They each had their own unique style. Johnny's was certainly the least overtly feminine, although he always had the greatest taste in everything, regardless of who it was made for. Jerry was new to the group and catching on fast.

And then there was Arthur. He was the biggest band member, and he made certain that he was also the brightest. He was so very slow-moving that he put me in mind of some kind of Frankenstein's monster, although I mean that with the greatest of affection. He habitually wore those same huge yellow engineer boots that I'd seen on New Year's Eve, and they were Frankensteinian, too. But because they were yellow, much like everything else he wore, it wasn't at all threatening. It was a cartoon.

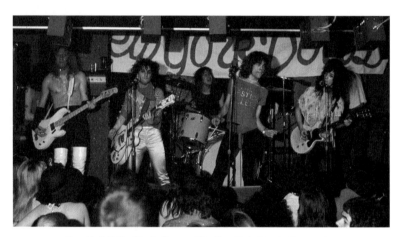

New York Dolls, Max's Kansas City, New York City, April 14, 1974

I was inspired by the band, so much so that I started videotaping every one of their shows that I could. I wasn't being paid to do it; the cost of the film and everything else came out of my pocket. It was just something that I wanted to do. Naturally, the Dolls loved it. There was nothing they liked better than seeing themselves in a mirror or a photograph, and now they could really enjoy themselves on television.

As soon as they came offstage, they would want to watch the tape. We would often take over someone's apartment, or a hotel room, and the band and their friends would pile in and have a video party.

Their first album was about to be released. I went to some of the sessions—not a lot of them, because I had other things to do. I needed to work with lots of other bands in order to pay the rent. I couldn't just hang out with the Dolls. But I did, as often as I could.

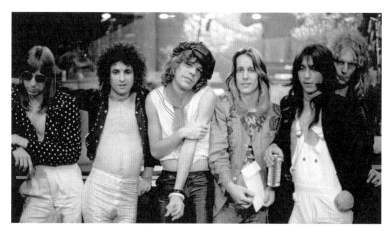

(Left to right) Jerry Nolan, Syl Sylvain, David Johansen, Todd Rundgren, Johnny Thunders, and Arthur Kane, the Record Plant, New York City, June 29, 1973

Todd Rundgren produced the album, and the engineer, Roy Cicala, had been the engineer on the Glitterhouse album for Bob Crewe years earlier. Now he owned the Record Plant.

The album sessions over, the Dolls planned a week of performances at Max's in August, immediately followed by a week in LA, at the Whisky a Go Go. I wanted to be there for it all. At Max's there were generally two shows a night, at eight and eleven o'clock, while weekends often saw a *third* set at one in the morning.

By this time, I loved Max's Kansas City. They had so many great bands over the years, and I saw so many of them. It was a wild scene, pulling in a lot of young people. The drinking age in those days was eighteen, but all that meant was, if you looked eighteen, you could get in. They didn't spend a lot of time checking IDs at Max's, and a lot of people today talk about going to Max's when they were fourteen or fifteen years old.

The Dolls' week was packed every night. In the dressing room, it was funny to watch the Dolls react to the girls that were constantly coming on to them. They—the girls—were all stoned and/or drunk, but they were loving the guys, hanging on to them, climbing onto their laps, and the Dolls would just push them off! "Don't sit on my leg! Get away from me! Leave me alone, don't touch me, get off of me! Who the fuck do you think you are?"

I was so surprised, because in my recent experiences at shows bands would spend the evening trying to pull girls in. The Dolls' whole "Don't bother me, honey" attitude was so different, and it seemed to work better. The Dolls certainly had many more girls coming on to them; more, in fact, than just about anybody. The girls seemed to really enjoy their company.

The Dolls were scheduled to fly out to California for their West Coast debut immediately after the shows at Max's, and Nadya and I agreed to accompany them to document the visit.

The management wasn't paying, but I was having fun recording the Dolls. I felt it was important to create a record of the visit. We rented the necessary equipment, including a camera that would shoot in very low light. It had a brand-new, advanced tube developed by the U.S. government to work in the dark. It worked more on infrared light, so I rented that one and I used it for a long time. Eventually, I bought one of my own. I also borrowed one of the band's spare Anvil equipment cases, and packed it with the tape deck, batteries, extra batteries, chargers, extra tape, extra camera, tripod, and film for the still camera.

This being the Dolls, even the most carefully prepared trip could not pass off without some kind of drama—on this occasion, Arthur waking up to find his girlfriend Connie (or Connie the Cutter, as she was forever known after) trying to cut his thumb off! She was so in love with Arthur that she didn't want him to go to California without her. But she couldn't go, because the band had instituted a "no girlfriends" rule on the road. It was too distracting. Connie couldn't accept that. She decided that if she couldn't go, then neither could Arthur. It was true love!

Arthur woke up just as she started cutting his thumb, and luckily, he escaped before she got too deep. He still ended up with a very bad injury, and a large cast that meant he wouldn't be able to play bass. Peter Jordan, who was one of the band's roadies, stepped in to replace him onstage.

Connie's plan didn't work. Arthur came along anyway, and he appears in several of the videos with a large cast around his thumb.

Arthur did appear onstage, miming his bass part while Peter was actually playing, tucked away out of sight behind the amplifier. He

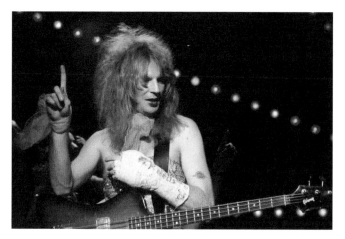

Arthur Kane, *The Real Don Steele TV Show*, Los Angeles, September 1973

wanted to be on the stage and look like part of the band, even if he couldn't play anything.

I filmed a lot on that tour, beginning the moment we arrived in Hollywood and a record company guy picked us up in a limo. I have footage of the guy telling the Dolls about Los Angeles, and everybody's excited reaction as we drove past Tower Records, which was a brand-new

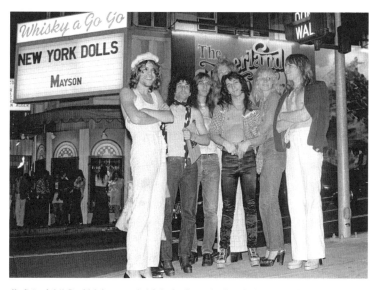

(Left to right) David Johansen, Syl Sylvain, Peter Jordan, Arthur Kane, Johnny Thunders, Sable Starr, and Jerry Nolan, Los Angeles, September 1973

idea, this gigantic record store. Before Tower Records, record stores had been small neighborhood outlets with only a few copies of each record that came out. If there was a hit record, they might even have five or eight or ten copies, but not a lot. You went into Tower Records, on the other hand, and they had stacked cases of records, piles of them.

The Dolls were playing at the Whiskey a Go Go, two shows a night, all sold out for the entire week, with lines around the block every afternoon. And when we walked into the Continental Hyatt House, there were more groupies in the lobby than I'd ever seen for any band, most of them brought along by DJ Rodney Bingenheimer, later known as "the Mayor of Sunset Strip," who was a huge supporter of the Dolls.

I had stayed there before, and in my experience, when a band arrived, there might be one or two girls hanging around waiting for them. When the Dolls arrived, Rodney organized twenty, maybe thirty groupies, all in miniskirts and low-cut tops.

The lobby was full of them. Sable Starr, who was the queen of the groupies back then, made a beeline for Johnny; their eyes met, and you could see them connect in that moment. They immediately became a couple and were inseparable for a while after that.

Rodney seemed to know all the young, pretty girls in Hollywood who wanted to meet the bands, and among them was Lori Lightning.

Johnny Thunders and Sable Starr, Los Angeles, September 1973

When she wasn't chasing rock stars, she worked at a unisex hair salon run by Paul McGregor, the hair designer who was responsible for landing Glitterhouse their big break, back in 1968! Paul and I had kept in touch, so while we were in Hollywood, I went to visit his apartment, a tiny place with incense, pot, candles, fabric hanging from the walls. It looked like a paisley hippie version of a Bedouin tent. He was the hairstylist to the stars, and he knew everybody. The movie *Shampoo*, starring Warren Beatty, was probably based on Paul.

A couple of the Dolls got haircuts at Paul's salon, and Sable took them to Hollywood makeup stores.

**Johnny Thunders and David Johansen,
Los Angeles, September 1973**

On the corner across from the famous lingerie store Frederick's of Hollywood there was a long, shiny black car. It had the look of a pimp-mobile, and David was inspired.

David Johansen, Los Angeles, September 1973

Quick as a flash—I didn't even see him do it—he pushed one side of his hair up and around the back, and then took one thread, pulling it down like it was a long sideburn; he must have used a storefront window for a mirror, but he did it all with one hand. Then he was sitting on the fender of the car, the archetypal Hollywood pimp with his big, flashy motor.

I took some pictures, and they looked great. A couple of years later I was making prints, trying to bring out some additional detail through the shadows, and I saw the car's license plate for the first time: IM EAZY. It was perfect!

Los Angeles was wonderful for the Dolls. They were treated like the second coming. Journalists, deejays, everybody wanted a piece of them, and there were so many parties to attend.

Rodney invited us to KROQ's anniversary party one afternoon. It was a beautiful day—it was Los Angeles in September—and David spent the entire afternoon lounging around the pool in his bathing suit. He was still wearing it when we went into the party, and he was *still* wearing it onstage that night, a tiny Speedo.

(Left to right) Sable Starr, Johnny Thunders, Syl Sylvain, Shadoe Stevens, David Johansen, Peter Jordan, Rodney Bingenheimer, Arthur Kane, Jerry Nolan, and Bob Crewe, Bel Air Sands Hotel, Los Angeles, September 1973

The party was fabulous, because I got to reconnect with Bob Crewe, who I also knew from the Glitterhouse days. He had moved to LA, and it was good to see him, and to show him that I had moved on, that my career had advanced, and he had helped out at the start.

On our last night in Los Angeles, Nadya and I went to the Rainbow, and I ran into the record producer Jack Douglas, who had been an engineer on *Some Time in New York City*. Jack told me he was there because, in a couple of days, Yoko would be playing a concert in San Diego. I knew nothing about it, so I went straight to the phone and called Yoko. She picked up and I told her we were in Los Angeles, and asked was there anything she wanted us to do before the show?

There was. Although Nadya no longer worked for her regularly, Yoko asked if we could both remain in LA, so Nadya could be her personal assistant, and I would take pictures of the show. This put me in a bit of a predicament because I had the rented camera equipment from New York. If I didn't have it back to the store on time, there would be some hefty penalties to pay.

I explained it to Yoko, and the solution was simple. Fly home, drop off the gear, and then she'd fly me back out to California. I returned to New York City with the equipment, Nadya moved into the Beverly Hills Hotel, where Yoko would be staying, and forty-eight hours later, I was back in Los Angeles.

I got in around midnight, very hungry, and started looking around for the room-service menu. Unable to find it I called room service and asked them to send one up. The guy asked what I wanted, and I told him again, a menu. He repeated, "What would you like, sir?"

"You mean I can order anything?" He said yes, so flippantly, I asked for oysters, caviar, and champagne.

"We'll be right up." One of the nice things about working for Yoko!

The show itself was strange. Yoko and the latest version of the Plastic Ono Band were playing the San Diego Stadium. It was dramatic driving in there, watching the stadium rise up ahead of us while the radio played the theme from *2001*. Inside, however, we realized that the venue really wasn't laid out for concerts. The playing field itself was untouched; Yoko and the band were set up on one end, behind the outfield, the audience was in the seats on the opposite side, with a vast expanse of grass in between them.

There was no way they could connect. She was so far from the audience that it was impossible to even gauge the crowd's response. I did enjoy seeing the band, though, especially Gordon Edwards, the bass player, because he was so fun to hang around with. That was also the night I met Elliot Mintz, a journalist with a television show in LA. He'd interviewed the Dolls, and on the way to San Diego, we got to know each other. He went on to be spokesman for Yoko, and later for Don Johnson, Bob Dylan, Diana Ross, and, eventually, Paris Hilton.

Later that year, back in New York, I did an album cover for B.J. Thomas, and that was kind of an awkward day because it was also the day of Lillian Roxon's funeral.

Lillian was one of the first serious rock journalists around, and certainly one of the first serious woman rock journalists—by which I mean, one of the first that the industry actually took seriously. When

she wrote a review, her word was gospel, and she was a tremendous influence on me, and a big help as well, in my early days.

She was Australian, the New York representative for the *Sydney Morning Herald* newspaper, good friends with people like Lisa Robinson, Lenny Kaye, and Danny Fields. She told me one day that I really needed to publicize myself and get my name around.

Instead, Lillian included me in *Esquire* magazine's "Heavy 100," and that did me a lot of good. Lillian was full of ideas, and I really enjoyed being around her. Her death came as a complete shock. She had a severe asthma attack and was gone.

I couldn't attend her funeral because I already had the assignment to do an album cover for B.J. Thomas. I had to do it—with all the travel I was doing, I needed all the money I could get. But it meant I couldn't go to Lillian's funeral, and it also meant I couldn't accept an invitation from John Lennon to meet a friend of theirs, who owned one of the only Japanese restaurants in New York City at the time, Taste of Tokyo on Thirteenth Street. He was coming over to teach him how to slice sushi. John knew that I liked cooking, and that I loved Japanese food. I had to turn him down as well.

I met up with B.J., and he turned out to be a good-looking country singer. I remember him saying that when he got a hit record, he was going to buy a Corvette.

"What color?" I asked, and he looked at me as though I was the dumbest thing in the world and said, in a heavy Southern drawl, "Red. Like, what other color would you get a Corvette? Red!" I hope he got it.

AIRBORNE!

*Led Zeppelin • Enterprise Starship 1 • Robert Plant •
Elton John and Stevie Wonder • Linda and Paul McCartney •
Alice Cooper and "Santa"*

ELTON JOHN'S PUBLICIST CALLED. COULD I COME photograph Elton on the *Starship*?

The *Enterprise Starship 1*, to use its full name, is one of *the* legends of rock star excess, a beautifully equipped private plane that sundry rockers would hire to get them from show to show. When a band rented it they'd paint the band name across the plane so it would look like they owned it.

I'd been aboard once, two months before. I got a call one morning from Lisa Robinson, asking me to go with her to Pittsburgh with Led Zeppelin. I asked how we were going to get there, and she said they had their own plane.

We met at the Midtown hotel where the band was staying, and I took pictures of the band in the lobby. After that, I was out on the side-walk when Peter Grant and his fixer, Richard Cole, came walking out of the hotel, where five or six kids were waiting with autograph books.

Grant and Cole just kept going. They walked straight through them, knocking them over. It was as if those kids hadn't even been there and I was shocked that anyone would treat someone like that, especially the manager of a group doing that to his band's fans.

The band didn't talk to me. They were really stoned, and I wasn't a girl, so there was no reason for them to bother. It wasn't until the 1990s that I actually had a conversation with either Robert Plant or Jimmy Page.

We got into limos and went out to the airport. When we got there Lisa said, "Bob, let's get a picture of the band with their airplane." I called them over and they stood by the engine, where I could see the band's name painted on the side. It captures the sheer excess of these arrogant young kids with their shirts open, who've got their own airplane.

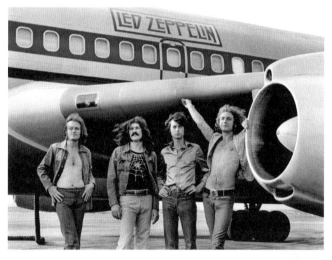

Led Zeppelin, New York City, July 24, 1973

The *Starship* itself was luxurious, six rows of first-class seats in front, a large area in the middle with a brass bar, with electric keyboards built in and banquette seating on the other side. In the back there were two bedrooms, one with an electric fireplace built in.

I took a lot of pictures around the plane. There wasn't much partying going on that day, as there were a lot of lawyers and record-company people on the trip.

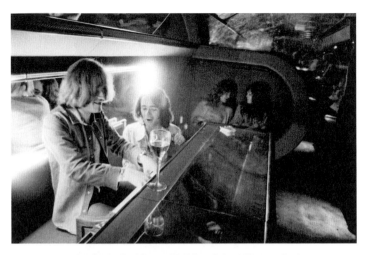

(Left to right) John Paul Jones, BP Fallon, Robert Plant, and unknown, *Enterprise Starship 1* en route to Pittsburgh, July 24, 1973

After we got off the plane, there was a police escort to get us through the lines of traffic making their way to the stadium. It was the first time I saw Led Zeppelin actually play—in fact, I really wasn't that aware of them at that time, beyond a gray zeppelin-shaped balloon hanging in someone's office at their record company. When I did hear them . . . I wasn't a fan. They were difficult to photograph, too, because they played in dark light, with a lot of soft yellow and blue.

The Elton John job was just a short flight up to Boston, and Stevie Wonder was onboard. He was hiding in one of the bedrooms when we took off as a special surprise for Elton.

Elton knew nothing about this, and he wasn't in a great mood. He may have been hung over. By the time he boarded the *Starship*, all he wanted to do was sleep. He fell into one of the seats when the publicist started bothering him, saying that the airline company had hired a piano player to play for him in the cocktail lounge.

Elton didn't care. "I'm tired and hung over, I've got a show to do and just leave me alone. I've got to rest for twenty minutes."

The publicist wouldn't give up. "I can't leave you alone until you come back and see this piano player."

Elton was getting annoyed. "I don't care about the piano player. I rented the plane, I don't have to see a piano player."

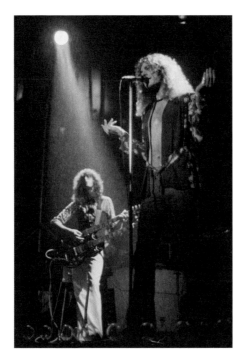

**Jimmy Page and Robert Plant—Led Zeppelin,
Madison Square Garden, February 1975**

The publicist was relentless. "Yes, you do. It's part of the deal. You have to come back and see the piano player and I'm not gonna leave you alone until you do."

Finally, begrudgingly and very angrily, Elton followed her back to the cocktail lounge—and there was Stevie, sitting at the piano, playing "Crocodile Rock."

Elton's expression changed immediately. His face burst into the brightest, happiest smile. I got a picture of Stevie Wonder and Elton shaking hands, with everybody around them just beaming.

They went off to talk and I went to the bar, because my job was done. I didn't have to take any pictures of the concert, or anything else. I could just kick back and relax. The bartender had just the thing to help me out, a mix of champagne and cognac.

We landed, got in the limos, and went to the show. As I wasn't required to take any pictures of the show, they didn't even give me a photo pass. We walked into the dressing room, and on the table, I

**Elton John and Stevie Wonder, *Enterprise Starship 1*
en route to Boston, September 24, 1973**

saw another bottle of cognac. By the time the show started . . . well, let's say that by the time I got to the photo pit, I was beginning to feel the effects.

Which must be why one of the security guards noticed that I didn't have a pass. He took it upon himself to grab me. Suddenly, he was literally holding me by my neck against the wall, with my feet off the ground, and just then, John Eastman, who was Linda McCartney's brother, came walking by. He was a lawyer, and right then, I needed one.

I'd only met him on the plane, but he sized up the situation immediately; informed the guard that, yes, indeed I was with the band, and he should unhand me immediately. He put me down, and that's something I never forgot. The day that John Eastman saved me.

There's a funny postscript to that story. Two, in fact. A year later, I was photographing George Harrison at Madison Square Garden and, as I was looking around the auditorium, I spotted John Eastman. It was strange. He was smartly dressed as always, but he was sitting with what looked like a couple of hippies. Looking closer, I realized that they were actually John's sister Linda and her husband, Paul McCartney, minus the wigs and Paul's fake mustache.

I couldn't believe it. Paul and Linda McCartney, disguised as hippies, sitting in the middle of the crowd at Madison Square Garden, at a George Harrison concert. I fired off some pictures. I was the only photographer in the place who recognized them. It was all thanks to meeting John Eastman on the *Starship*. That's how things happened. One thing led to another.

I had to wait another forty-five years before I discovered the postscript to that part of the story. In 2019, I bumped into John Eastman again at a benefit for Tibet. I mentioned that picture, and he was astonished: "You took that one? We love it!"

(Left to right) John Eastman, Paul McCartney, and Linda Eastman McCartney,
Madison Square Garden, New York City, December 1974

Meanwhile, my *Starship* adventures weren't over just yet. By the time we returned to the plane, I was very drunk indeed. I struck up a conversation with a girl who said she was the sister of songwriter Al Kooper. I never knew if that was true or not, and she was as drunk as I was.

It was a short flight, and just half an hour after we took off, we were landing again. I'd been showing someone some color slides on the flight, and as we came in to land, I remembered that I'd simply tucked them into the overhead compartment. I got up on a seat to get them, reaching into the compartment, and suddenly I heard Elton

yelling, "Bob Gruen, what are you doing standing up? You're going to fall on somebody!"

He was right. Embarrassed, I made my way back to my seat. I sat like a good boy until the plane had landed, and somehow made it to the limo that was taking me home. My last memory of that night was getting out of the limousine, looking back, and seeing the girl, Al Kooper's maybe-sister, stretched out on the back seat, her long legs extending out from under her miniskirt, her high heels kicked off, and a bottle of cognac rolling around on the floor.

There were different projects all year, but I rounded out 1973 back with Alice.

The band was playing a short Christmas tour, portraying sailors on leave, rampaging across the country. I was already part of the entourage, taking pictures, but there was a writer named Bob Greene, who wanted to come along as well. He was hoping to write a book about the tour.

Shep wasn't sure. "The only people on tour are people who work on the tour," he told Bob. "If we can find something for you to do, then you can come along." Shep came up with the idea that, at the end of the show, they could have a Santa Claus walk on waving to everybody, wishing everybody a Merry Christmas, and that Bob could do that. He could play Santa Claus.

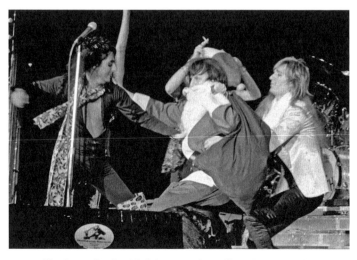

Alice Cooper Band and Bob Greene as Santa Claus, December 1973

Bob went for it, not knowing that every night, while he was waving to the crowd, calling out his season's greetings and ho-ho-ho-ing, the entire band would gather round and beat him up! They were knocking him down and punching him onstage.

We arrived in Toledo on December 13. I went for a walk before the show. I was going to see a movie about the Kennedy assassination, of all things, but the streets and stores were decorated for the holidays, and I was just enjoying being there, thinking what a lovely city it was. I had my backstage passes around my neck (on tour, you never took them off), and I was walking by a woman who was handing out religious pamphlets on the sidewalk.

Suddenly she started screaming, "The devil! The devil!" She had seen my pass and she was absolutely horrified: "Alice Cooper is the devil!" That night in Toledo, the entire crowd seemed to be on edge for some reason. I don't think anything had actually happened, but different audiences often give off different vibes—some are happy, good-natured, there for a great time. Others are harder to pin down, and this was one of them.

As soon as Alice came out and started the show, he was hit in the chest by a flashcube, a small, one-inch square piece of hard plastic that you'd use in a point-and-shoot camera to make a flash. Alice ignored it.

A minute or so later, somebody threw an M-80, which is a very powerful firecracker. It blew up on the side of the stage, and that was it. Alice was already pissed because somebody had hit him with the flashcube, but the M-80 was too much. Alice walked off the stage, they cut the lights, and the whole place was in darkness. Backstage, road manager Dave Libert was pleading with Alice to get back out there, saying, "Come on Alice, go back on. If anything else happens, then we can cancel."

To which Alice responded, "What do you mean if anything *else* happens? The first thing they threw hit me right in the chest. The second thing they threw exploded. I'm not waiting for a third thing."

Dave didn't know what to do. He called Shep to ask for guidance, and Shep had just three words for him: "Get the money." That's Shep's order of business: number one is get the money; number two is *remember* to get the money; and number three is *never forget* to *always remember*

to get the money. Dave went off to talk to the promoter while Alice got into a limo back to the hotel.

Meanwhile, the audience was still milling around the darkened auditorium, wondering whether or not the show was going to continue—the low lights were a calculated move, designed to calm people down. Sensibly, somebody realized that, if they'd announced the show was canceled on the spot, there might easily have been a riot.

The crowd needed time to come down from whatever pills or booze they had consumed, and while it took an hour or so, finally the room quietened enough for everyone to be sent home. The police were on hand to ensure things were sorted out.

Somebody got onstage and announced that the firecracker had blown up a spotlight and that a little piece of glass had gone into guitarist Glen Buxton's eye, and the show would have to be canceled. The lights came up, the crowd moved out, and a crisis was averted.

Alice Cooper and policemen, Toledo Sports Arena, Toledo, Ohio, December 13, 1973

NEW YORK CLUBS

The New York Dolls • The Bottom Line • Mick Jagger •
Bob Dylan • Queen • Debbie Harry • Television •
Alice Cooper

CLUB 82 HAD BEEN AROUND A LONG TIME BEFORE they started booking bands. It was at 82 East Fourth Street, hence the name, and its history stretched back to the early years of the twentieth century, when it was a nightclub. During Prohibition it became a speakeasy, and then it turned into a drag venue, at a time when such performances were illegal. It was always below the radar, a secret little venue tucked away behind the most nondescript doors.

It was presided over by a tough little lady named Tommy, with a short DA hairstyle, who was stationed at the bottom of the stairs that led down from the front door, collecting the admission money and sizing everyone up, to see whether she wanted them to come in.

The Dolls played there in April 1974, a night that went down in history as the only time the band ever actually appeared in drag onstage.

It was a tribute to the history of Club 82; David was wearing one of Cyrinda's sequined dresses while Sylvain, Arthur, and Jerry all got into the spirit as well. Johnny resisted; he ended up donning a black girdle that looked like modern bike shorts. That was as far as he would go.

The New York Dolls, Club 82, New York City, April 17, 1974

I had many great nights at Club 82. I saw the Stilettos back before anybody knew who Debbie Harry was. There was another night John Lennon came with me. We had been drinking earlier, and by the time we got to Club 82, he was definitely a little unsteady. He completely lost his balance at the edge of the first flight of stairs, stumbled over the landing, and rolled down the second flight.

He landed on his back on the floor, almost at Tommy's feet; I followed him down and saw her standing there, just looking at him. "Hi, Tommy," I said. "I'd like you to meet my friend John Lennon." At which point, John got up and Tommy motioned us inside.

Another great venue was Hurrah's. It had been around for a while—it was up on the West Side, around Seventieth Street. Jane Friedman was the booker there. I first met Jane through Marv Greifinger, back in my earliest days, and she and I got along from the day we met. I remember her giving me a plant to take home from her back porch.

I hung out a lot at Hurrah's, partly because Jane always booked great bands. A lot of British groups like the Kinks and the Hollies played there. I did my bit, photographing the bands, keeping the venue in the public eye.

Allan Pepper and Stanley Snadowsky opened the Bottom Line, on West Fourth Street, in February 1974. I'd known them for a few years by then, because they were booking shows at the Village Gate, and I went to at least one or two of them, probably on assignment from a record company. They were also operating the Mercer Arts Center up until that sad day when the building collapsed.

That was the end of the Mercer, but Allan and Stan simply moved farther up the block, to the corner of Fourth Street and Mercer Street, and renovated a bar. They built a big, proper stage, and dressing rooms and a kitchen. When it opened, the Bottom Line was more like a cabaret or a supper club.

They were very fussy about the venue being the best possible place for a performer to present themselves. They brought in a high-quality sound system, and geared the club toward being the kind of place where record companies would showcase new talent. Labels would hire the club for the night, and have their act perform a showcase for the press and the company executives. There were a lot of nights like that.

The Bottom Line was also a great place to hang out. You knew that they would always book interesting bands, and everything from blues to jazz to rock to funk was welcome. I saw Labelle there, Miles Davis, Bruce Springsteen, the Ramones, Lou Reed, the list is endless.

The opening night I was working, taking pictures of Mick Jagger and Dr. John in the dressing room. Later, as Mick was leaving, I ran out ahead of him, turned around, and got a picture of him underneath the awning that said Bottom Line. And right behind him was Allan Pepper, the owner of the club.

We put that picture in *Rock Scene*, and probably *Creem* and some other magazines, and Allan was very happy. Mick Jagger—probably the biggest rock star in the world at that point—came to their club opening.

Allan Pepper and Mick Jagger, the Bottom Line, New York City, February 12, 1974

I don't think Bob Dylan was ever on the stage, but I did take a picture of him when he came to see Little Feat. I was standing by the bar, when I saw him get up out of his seat and come walking toward me. I set the camera to take a picture at four or five feet away, and as Dylan came toward me and he looked up, I just snapped the camera right in his face.

Which is not a nice thing to do to a person, but I couldn't resist.

He looked at me; I could tell he was startled, and he came nearer, gave me the finger, and then he leaned forward and he put the finger right on my face. Touched my cheek. It was gentle, just a brush, but his meaning was an unmistakable "Fuck you."

I was absolutely stunned, just standing there as he walked out, thinking "Bob Dylan just *touched* me!" At the same time as he effectively told me to fuck off.

Bob Dylan, the Bottom Line, New York City,
September 18, 1974

I felt horrified, because I don't like upsetting people. But it's such a great picture.

The New York Dolls played at the Bottom Line, which was a surprise because the club's choice in bands was generally more sedate. Out-and-out rock-and-roll groups, with raucous reputations and crowds of unruly kids, were not Bottom Line material at that time. Later, it changed, but at the start, not so much. They didn't want to host "kid's music." They wanted to host music for people who could afford to come in, eat and buy drinks, and who would sit down and watch a show. That's why they had seats.

Nobody sat down at a New York Dolls show!

I was in Memphis the day before the show, photographing a brand-new band from England called Queen. They were so unknown that, even with all the kids around in the afternoon, I was able to take them out to the parking lot to get a picture. I found some hedges and photographed them as though they were standing in the countryside.

After their show, I stayed to watch the headliner, Mott the Hoople, and was supposed to be traveling back to the hotel with Queen. But they left early, so I went out to the parking lot to see if I could find someone to give me a ride, and I saw a group of kids with unusual makeup. One

(Left to right) John Deacon, Freddie Mercury, Brian May, and Roger Taylor—
Queen, Memphis, Tennessee, April 20, 1974

was painted entirely green and wearing green clothes, and the others were clearly enjoying a wild night out in makeup, too.

They asked me if I knew where the band's hotel was, so I told them I'd let them know if they'd give me a ride there. I got into the car and told them where we were going. It was one of those nights when some of the band members were playing in the hotel bar. There we were, these kids and I, getting a free show. I had a late-night flight booked back to New York City, because I had a photo session scheduled with Suzi Quatro the next afternoon, and the Dolls at the Bottom Line that night.

I'd shot Suzi before, when she supported Alice on tour, but this was the first time she came to my studio and I wasn't going to be late. We did a photo session out on the dock, and then went to the show.

Although Suzi was an American, she was completely unknown in America. She had top-ten hits in the United Kingdom while America knew nothing about her. Suzi was a wonderful, sexy rock and roller in a leather jumpsuit. Everyone was blown away by her performance. Suzi finished her set and we were standing around waiting for the Dolls when we were told to evacuate the premises because somebody had called in

 RIGHT PLACE, RIGHT TIME

The Bottom Line, New York City, April 21, 1974

a bomb threat. We all poured out onto the street. The audience for the second show was already lining up out there, so it was quite chaotic.

The place was searched, and it turned out the call had been a hoax, so the first audience was allowed back in, and the Dolls show went on. Meanwhile, when everybody else was out on the street, waiting for the all-clear, Arthur was still inside, walking around and downing all the drinks that had been left behind on the tables. When David came out to open the set, he actually had to apologize, "If your drink was missing when you came back after the bomb scare, you can blame Arthur."

The Bottom Line was a fantastic club, and one of my favorites. It was open for a long time. It closed down in 2003.

Hilly Kristal had been one of the promoters, with Ron Delsener, of the Schaefer Music Festivals that I used to attend in the sixties. Now he was opening his own bar, Hilly's on the Bowery, a run-down place that was next to a homeless shelter.

It really wasn't an area where you'd want to hang out, but Hilly had the idea of bringing bands in to play. Jayne County and Eric Emerson

became the first artists to play his place in the fall of 1973, and that was the beginning of rock and roll on the Bowery.

While he was in the process of setting up the bar, he was visited by representatives of ASCAP and BMI, the organizations that are responsible for collecting and paying what are called mechanical royalties to songwriters from live performances of any published songs. Any venue that staged live music was expected to pay a royalty on any published music that was played there. The owner of the venue would be responsible for writing the check. Hilly's wife, Karen, encouraged him to hire bands that were just starting out, because they would not have published any songs so there would be no fees.

Hilly's on the Bowery became CBGB/OMFUG—which stood for Country, Bluegrass, and Blues and Other Music for Uplifting Gormandizers—in April 1974. Television was the first band to play there.

Word spread quickly; Patti Smith, who had just formed her band, started gigging at CBGB, Jayne County was a regular, and suddenly other bands started playing. The Ramones, Suicide, the Miamis.

(Left to right) Elda Gentile, Fred Smith, Rosie Ross, Billy O'Connor, Debbie Harry, and Chris Stein—the Stilettos, CBGB, New York City, June 24, 1974

RIGHT PLACE, RIGHT TIME

(Left to right) Richard Hell, Billy Ficca, Richard Lloyd, and Tom Verlaine—Television, CBGB, New York City, June 24, 1974

The Stilettos, the band Debbie Harry was in before Blondie, played there, and I went to see them with Chris Charlesworth, New York City correspondent for the British weekly music magazine *Melody Maker*.

Television was also on the bill that night, which means Chris was one of the first major British journalists to catch the new scene that was happening in New York City. I was working a lot with Chris Charlesworth around this time—for one assignment I was meant to fly with Chris and Shep to see Alice Cooper in Madison, Wisconsin, except I missed the flight! Thankfully, in those days, that was not a big deal. I just took the next flight.

The point of the trip was a press reception with the mayor of Madison, who was going to be presenting Alice with the keys to the city. I was in a cab on my way to the venue, and it was unusual at the time that there was a woman driving the taxi, a college student. I was looking up the road toward a large domed building. It was just a gorgeous view of a state capitol in America.

Everything about it was unique. And the driver asked me, "Do you find that in your job, traveling and taking all these pictures, does it get to

be just the same all the time?" And I remember looking up at this building shining in the sunlight and saying, "Yeah, it's all the same." But actually, what I was thinking was that nothing's ever the same. It's always different. What's the same is that every day in my life is so different.

The press conference went off smoothly, and the presentation, too. The keys had been placed within an aluminum foil package meant to represent a kilo of marijuana. The joke being, the key to Madison was two pounds of pot. The whole room burst out laughing.

(Left to right) Mayor Paul Soglin, Alice Cooper, Dennis Dunaway, Glen Buxton,
Neal Smith—the Alice Cooper Band, Madison, Wisconsin, December 1973

CENTRAL PARK TO BYBLOS

John Lennon and Harry Nilsson and Elton John •
Al Kooper • Yoko Ono • Eikichi Yazawa •
Hiroshima Peace Park • Roc-pic

JOHN AND YOKO HAD PARTED WAYS. I COULDN'T believe it. I was driving John home from a session at the Record Plant when he suddenly mentioned that he was no longer living at the Dakota, and would I drop him instead at May Pang's apartment. Shortly after that, he left New York City and went to Los Angeles for what became known as his Lost Weekend. I didn't see him during that time, but in April 1974 I was out driving, listening to the radio, when I heard that John Lennon was going to be in Central Park, at a March of Dimes benefit with Harry Nilsson and the deejay "Cousin" Bruce Morrow.

It struck me like lightning; I didn't even know John was back in town. In fact, there were times when I wondered if I would ever see him again. It turned out that he'd been back a few months, keeping a low profile, staying in a penthouse on the East Side. He was finishing the

Rock 'n' Roll album that he began in LA with Phil Spector and working on Nilsson's new album, *Pussycats.*

I went straight to Central Park, and my timing was perfect. As I walked toward Sheep Meadow, where the event was being held, a limo slowly came to a halt alongside me, and John and Harry stepped out. They didn't see me at that moment, but I fell in right behind Harry and followed them onto the stage.

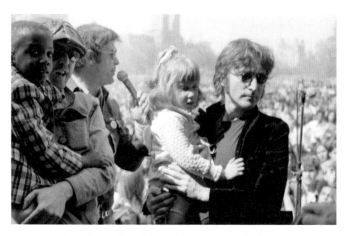

Harry Nilsson, "Cousin" Bruce Morrow, and John Lennon,
Central Park, New York City, April 28, 1974

I started taking pictures of John talking to the audience, with the crowd in front of him. He turned and, without missing a beat, said, "Oh, hi Bob."

John asked me to come to the Record Plant. He was still separated from Yoko, but they were talking regularly. John was definitely trying to clean up his act. He was making a point of approaching work in a much more serious way. He had come back from some chaotic sessions in Los Angeles with a core group of real professionals to work with.

I was there the night Johnny Winter came to the studio. I was friends with his manager, Steve Paul (he had owned the Scene nightclub), and some time before all this, Steve had called and asked if I could put him in touch with John, because they wanted him to write a song for Johnny; John's answer at the time was, "I wish I could write one for myself."

They also asked Bob Dylan and Mick Jagger; Dylan didn't answer, but Jagger sent him a song. When John heard that Johnny was in the studio recording, he gave him his song "Move Over Mrs L." This is a perfect example of what my mom had always told me: It's lazy not to ask for something, because if you don't ask, you are the one saying no.

One early summer evening, I stopped by the studio. I only went by occasionally—when you're not involved in the actual recording, there's only so much time you can spend in a recording studio without getting bored. As soon as I arrived, John said, "Where have you been? We've been recording with Elton John for hours, and you should be taking pictures!"

"You could have called me," I said.

They were recording "Whatever Gets You Through the Night," and I was capturing what was happening, the camaraderie that existed between John and Elton. It was a familial atmosphere; John and Elton were old friends from London, and the following year, Elton would become godfather to John's son Sean.

I had just started using a kind of film that had been developed for army surveillance. It was super sensitive and was intended to work on an infrared spectrum, which means it worked in the dark.

It had some drawbacks. It was more grainy than regular film and lower contrast, but the fact that you could take pictures in dark situations made that worth the sacrifice. And when I say "dark," I mean it. Think candlelight, because that was the level of light that most musicians recorded in. For whatever reason, whenever they were in a recording studio, they turned the lights down to nightclub level, which made it very difficult to take any kind of pictures without an intrusive (and generally forbidden) flash. It was the first day I was using the high-speed recording film, and it worked out great.

During John's absence, I had remained close to Yoko, and in August 1974, she asked me to accompany her on an upcoming twelve-day Japanese tour. She called on a Saturday morning; we would be leaving on Tuesday.

I couldn't answer her immediately. Nadya was eight months pregnant at the time; she was due to give birth on September 1. I was lying

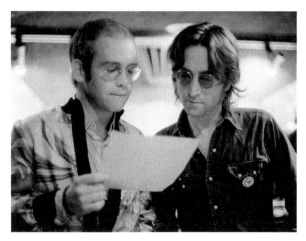

Elton John and John Lennon, the Record Plant, New York City, 1974

in bed, looking over at her pregnant belly beside me, trying to calculate whether I could go.

The timing was tight. We were leaving August 6 and would be home by August 15. What if the baby decided to come early? Nadya and I had been through the entire pregnancy together. I was attending Lamaze classes with her, and I was also making a video of the entire process, the climax of which would be the birth. How could I drop everything and go to Japan?

I knew that Nadya was the most punctual person in the world. She had never been early, or late, for anything in her life. Not once. I discussed the trip with her, and she agreed. She was due on September 1. She told me I should go.

I had a lot to get ready. I wanted to gather together a wide selection of my work to show to any industry people I might meet when I was there. I needed to get started in the darkroom, making prints. I also had a commitment that weekend to make a video of Al Kooper's show at Max's; his idea for his next album cover was a picture of him watching himself on television in a Greenwich Village apartment. The show was that Saturday night, and I was leaving in three days.

Nadya and I were now living on West Twelfth Street and Eighth Avenue, five floors up. We still had the Westbeth apartment, but we had taken this nearby place temporarily, so she could be away from

all the photographic chemicals during her pregnancy. It had a window that overlooked Greenwich Village and Abingdon Square. We had a little television and I had the videotape machine. I could film the show and then play it back, and Al could watch himself in my Greenwich Village apartment.

I recorded his show Saturday night and, on Monday morning, Al came over, and I got the picture he had asked for. This was so many years before Photoshop came along, so it wasn't easy—I had to balance the light to get the television picture to come out clearly, and for the background view of the Village not to be too bright or dark. So it did get complicated. Unfortunately, the record never came out.

Al Kooper, West Twelfth Street studio, New York City, August 1, 1974

From the time Yoko called me until we left for Tokyo, I'd barely slept. The first thing I did when we boarded the plane was find myself somewhere to sleep. We were traveling in first class, but I made my way back into coach, which was almost empty, threw a bunch of pillows across a long, vacant row of seats, and passed out.

The flight was in two legs; a seven-hour haul to Anchorage, Alaska, where we would refuel, and then another seven hours to Tokyo. We learned that President Nixon had resigned as we sat in the lounge at

Anchorage airport, watching the coverage on one of those little lap-sized televisions that you pop a quarter into to watch. All the way to Tokyo, I was thinking how embarrassing it was to be American at that moment in time, when our president was revealed as a criminal.

We arrived in Japan, and even if somebody did mention what had just transpired, they saw it as a cause for celebration, not despair. It proved that the system worked. The president was exposed, and he was replaced in an orderly fashion; Vice President Gerald Ford took over, and the country got on with its business. I'd barely been there a couple of hours, and already I loved Japan. It is a romance that has only grown deeper over the years. I have been back on many occasions; I even lived there for a while.

I learned so much on my first visit and discovered so much more. I had always enjoyed Japanese cuisine, but it was really limited in New York City in those days; there were only two or three Japanese restaurants in the city.

My education began before we even landed. The flight attendant brought me a Japanese meal on the plane. I was hungry and started eating, and halfway through the meal I realized, for the first time in my life, that I was easily using the chopsticks. Not once in the past had

Yoko Ono, Tokyo, Japan, August 1974

I ever mastered them. This time, I didn't even think about it, and I've been comfortable with them ever since.

When we arrived there was a huge crowd of photographers waiting for Yoko. It was my first inkling of how respected she was in Japan.

After checking in at the hotel, I accompanied Yoko to a television interview. On the way, we stopped at a restaurant and Yoko ordered for me. The chef reached out and placed a tray in front of me. On first glance, it appeared to be a conch shell that had just washed up on the beach, with flames under it. It's called *sazae*: I ate it, it was delicious, and that was when I realized that, on top of all her other talents, Yoko knew food.

As Yoko's personal photographer, I would be accompanying her everywhere on the tour, beginning with a meeting with Mr. Udo, who was the most important promoter in the country. He introduced us to Yuya Uchida, who organized the biggest show on the tour, which was the One Step Festival in Koriyama.

The festival was modeled on Woodstock. It was a three-day event with a large campground for the audience, the first event of that type ever to be held in Japan. It was also just one step toward achieving Yuya's greatest ambition, to bring together musicians from all over the world to play together.

Yoko was the headliner on the last night, another example of just how popular she was in her homeland. It wasn't until I saw her performing in Japan that I realized what an amazing artist she is. How intense and emotional her music is. I didn't understand that until I saw the Japanese crowds reacting to her performance.

The festival site was packed, and I spent my afternoon wandering the hillside that rolled down to the stage area. There were thousands of people there, and I had free rein, walking out in the crowd, looking at people who were looking at me, this American covered with cameras.

I made my way back to the stage to see a band called Carol. They were incredibly popular—I'd been told they were Japan's answer to the Beatles, and judging by the audience response, I could believe it. They played a very dynamic set, looked and sounded very 1950s, very rock-and-roll in their leather pants, white T-shirts, and greased DA haircuts.

There were fifty thousand people at that festival, all of them glued to Carol's show. The band was playing the last song; they were into its final moments, the music was building up to a climax, and—bang!

The singer's chest exploded.

My first thought was that somebody had thrown a firework at him. The singer, Eikichi Yazawa, dropped like a stone, falling back onto the stage, smoke curling from his chest. The band stopped playing; they looked as shocked as the audience. Nurses appeared, rushing out to scoop Yazawa's still body onto a stretcher, and now the screaming had begun, fifty thousand people in shock.

I didn't know what had happened. I started running, following the nurses as they made their way backstage, across to the dressing rooms . . . and there sat Yazawa, having a cigarette and laughing.

Eikichi Yazawa, One Step Festival,
Koriyama, Japan, August 1974

Yazawa explained that this was the last-ever Carol show, and that was his way of ending the band. By exploding.

I don't know how they calmed the audience down after that. Yoko came on and the crowd loved her. At the end of the show, she was

throwing ladies' panties out to the audience and people were scrambling all over trying to get them.

That was the first time I ever saw a crowd enjoy a Yoko Ono performance; the first time I'd ever seen her without everybody booing. I watched the audience almost as much as I watched Yoko, seeing how they reacted to the music, how it affected them, and that's how I learned what her music was really all about. It's not words or stories, it is about emotions. The more I saw her perform on that tour, the more I appreciated it.

We traveled to Hiroshima. I went with Yoko to do a photo session at Hiroshima Peace Memorial Park, built around one of the very few buildings that remained standing after the atomic explosion there.

I had two cameras with me, one for black and white, one for color, and while I was changing the film in the color camera, I placed the other one on the ground. Later, when I developed the film, I discovered

(Left to right) Rick Marotta, Michael Brecker, Steve Kahn, Yoko Ono, Andy Muson, Steve Gadd, Don Grolnick, and Randy Brecker, Peace Memorial Park, Hiroshima, Japan, August 1974

that the entire roll was fogged from the radiation that was still in the ground. That was a very sobering realization. Hiroshima is a disturbing place.

The Peace Museum has models of people with the skin hanging off their hands, horrible to look at. There were pictures of the city before and after the bomb, startling photos of the entire city flattened, but here and there, a couple of people were walking, and I couldn't help wonder who they were and where they were going.

While traveling around Japan for eight shows in ten days, I got to spend a lot of time with the record company publicist, Kei Ishizaka, and Yuya. He was a musician in his own right; in the sixties, his band opened for the Beatles at the Budokan, and he had a big hit with the song "Welcome Beatles."

Yuya and Kei also had a band together when they were young. Yuya was still performing, and, on a night off, Yoko's assistant, Sarah, and I went along. Yuya was wildly enthusiastic, very energetic. He loved Chuck Berry and the Beatles, and he did Japanese versions.

Every day on the train, you'd have found us tucked away listening to my cassette tapes of the Dolls, Suzi Quatro, and other new bands.

I met editors of magazines, including *Music Life*, for whom I would end up doing a lot of work. Another editor, at *New Music Magazine*, asked if he could hold on to a few of my photos, to illustrate a feature he wanted to write about me.

I said yes, and didn't think much more about it until after I returned to New York City. He wrote and said they'd been having problems deciding which pictures to use in the magazine. If I could send them more, they would put out a special edition devoted completely to me!

I selected another twenty or thirty shots and a few months later, I received copies of *Roc-pic*, an 8½ × 11-inch magazine made up entirely of my photos and essays about me. I used a picture of the cover of that issue as my business card for the next five or six years.

The tour wound down back in Tokyo. I usually spent evenings with the Japanese contingent of our entourage. The band preferred to retreat to the penthouse bar, where they could order martinis and complain about the food, and how they couldn't wait to get home.

Roc-pic business card, 1974

I started going to the downstairs bar, where the Japanese crew members were. I'd hang out with them and they'd take me out for the evening and introduce me to another aspect of Japanese culinary culture that I hadn't known.

In the West, when we go out for dinner, we choose a single restaurant and eat there. In Japan, you tour different restaurants—one place for an appetizer, another for some yakitori, then somewhere else for a drink, then a sushi place, and so on. You'd spend the night eating and drinking at six or seven different spots.

Preparing for the tour, I called Ike Turner, the only person I knew who had been to Japan, when he and Tina toured there. He said, "Go to Byblos." It was a nightclub right next door to the theater where he and Tina had played, and Ike was right to recommend it. The place was wild.

Byblos was modern and bizarre. The main room was about three stories high, with different levels and stairways in between, all built around a clear plastic elevator shaft, which is where the deejay was. He would spend the evening just going up and down the shaft, playing music.

It was also known as the place where Japanese girls would meet visiting American rock-and-roll stars. What a place it was: beautiful girls, interesting people, and great music.

WHATEVER GETS YOU THROUGH THE NIGHT

John Lennon and New York City T-shirt photos • Elton John Madison Square Garden • The New York Dolls • KISS

JOHN CALLED JUST AFTER I GOT BACK FROM JAPAN to ask whether I would come over to shoot the cover for his *Walls and Bridges* album. The art director had an interesting, but somewhat unconventional concept, a series of pictures, all of John's face, all the same size, but each with a different expression. They would then cut the pictures into a series of foldable flaps, so people could rearrange them into different faces and expressions, like a toy.

They wanted him to go to a studio to get the photos taken, but he didn't want to deal with the whole formal process, which would entail makeup and styling and various assistants fussing; it could take a day

or two out of his schedule. Instead, he asked me to do the whole series myself in a quick and simple way.

I loved the sound of it, and we arranged a time for me to go over to the penthouse in a couple of days. And, in the interim, John saw a flying saucer.

He was in his living room the evening of August 23, 1974, when he saw colored lights reflecting on the penthouse window. He looked up at the sky and there it was. May Pang was with him, and she'd taken some photos. John called me, asking if I would develop the pictures immediately.

I was already planning to develop some of my own films that evening. I picked up their film and got to work. Weird thing, though. My film came out perfectly, but May's was entirely blank. She had used a good, ultra-high-speed film that I'd recommended, and it should have worked well in low light. But there was not a single picture on the entire roll.

I brought the film back to show them and asked if he'd called anybody. He said, "I can't call the newspapers, say I'm John Lennon, and I just saw a flying saucer."

I said, "Well, I can." I called the *Daily News*, asked if anyone had reported a UFO last night. They said yes. "On the East Side, one or two people." The police said they had no reports, and the *New York Times* simply hung up on me.

The photo session with John, on August 29, went perfectly. I took dozens of photos of John wearing different eyeglasses, and at one point he ended up putting all the glasses on at once. I also took a shot of him pointing up to the sky, where he saw the flying saucer (he mentions it on the album sleeve). Then he suggested that we take more pictures, so we would have the publicity kit ready when the album was released.

We were on the roof, John in his black jacket with the entire Manhattan skyline visible behind him. I had an idea to play on the New York City theme, and suggested he put on the New York City T-shirt that I'd given him about a year before. I used to buy them from the guys who sold them on the street in Times Square and had a half dozen of them myself. One night, on the way to see John at the studio, I'd bought one for him and cut the sleeves off with my Buck knife, to complete the

John Lennon, New York City, August 29, 1974

New York look. I was surprised he still had it after his Lost Weekend. He disappeared for a minute and returned wearing the shirt.

We had a good time that day. John enjoyed having his picture taken. He had been posing for pictures for years, ever since he was first in a band. He knew how to do it and posing came naturally to him. John saw it as part of show business, which it very much is.

Like a good model, John would change positions and his expressions while I took photos. I don't give a lot of direction; I'm not one of those photographers who shouts, "Give me more, baby!" I'm actually pretty quiet when I take pictures and I let my subjects find their poses naturally. Some photographers love to give direction, but I feel that if I tell people what to do, they're more likely to focus on pleasing me, rather than just being themselves. My style worked well with John. He and I would usually chat and make jokes while we worked. I would keep up a conversation and the pictures would inevitably become part of it.

I think people are drawn to the New York City picture because John is so relaxed, open, and available. I once heard a graduate class in communications studies critique the photo. One student described it

as "self-revelatory"—the shirt says New York City, the background says New York City. The crossed arms and cut-off shirt say New York City attitude. New York City is represented as a strong, independent idea, and John is as well.

One of the reasons I like this picture so much is I felt John wasn't posing as a New Yorker—he was a New Yorker.

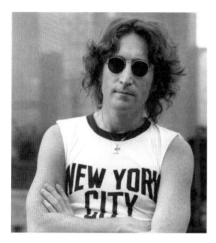

John Lennon, New York City,
August 29, 1974

Bob Gruen and John Lennon, New York City,
August 29, 1974

A few days later, my son, Kris, was born, on Monday, September 2. As planned, I was in the delivery room, videotaping the birth, taking Polaroids—everything I could think of to document this miraculous moment.

I was not home for long. The New York Dolls were making another trip out West. I went with them. This was the Dolls' third trip to California that year; the first, back in March, was memorable because we opened their Santa Monica show with a screening of *Lipstick Killers*, the movie I'd put together to open their New York City St. Valentine's Day Massacre show, portraying the Dolls as Chicago gangsters.

We were out there again in July for some gigs and the Don Kirshner show, and again in the fall for the filming of the Dolls' part in Ralph Bakshi's movie *Hey Good Lookin'* and for the band's appearance at the Hollywood Street Revival and Dance with Iggy Pop, the GTOs, and Flo & Eddie on October 11, 1974.

The New York Dolls during the filming of *Lipstick Killers*, New York City, January 27, 1974

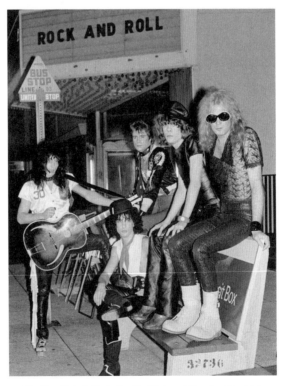

The New York Dolls during the filming of *Hey Good Lookin'*,
Los Angeles, October 1974

RIGHT PLACE, RIGHT TIME

I would be missing the show itself. Nadya and I had arranged to take a vacation to Vermont. I would have to leave Los Angeles on the day of the show. I hung out with the band for a few days, and then flew home. It would be a much-needed break for both of us . . . well, for all three of us, now.

By chance, as I was leaving the hotel, Yuya was arriving. It was a complete surprise to both of us. Knowing how much he liked the Dolls, I took him upstairs to Sylvain's room, introduced them, and asked Sylvain to take care of him. It was that spontaneous meeting that eventually led to the Dolls' trip to Japan the following summer.

I've always been drawn to symbolism in photography, where, with just one look, you get the message. I had the idea to take a picture of John at the Statue of Liberty. It would certainly help dramatize his case; the symbol of America's most time-honored welcome, at a time when the government was trying to throw out one of the world's greatest artists.

John loved the idea.

"Get up early," he said, as I dropped him off the night before, "and bring your eyes."

The next morning, we went down to Battery Park to catch the ferry to Liberty Island. As we walked around, waiting for the ferry, John looked up at the buildings around us and said, "I bet I'm paying rent on every one of these buildings. There's a lawyer working on something for me in every one of them." He told me how every lawyer he had ever visited seemed to move to a bigger office as soon as he hired them. "And it always has my picture on the wall."

We were waiting for the ferry and a crowd gathered, a bunch of schoolgirls who saw John and immediately started screaming. John told them that if they'd quiet down, he'd sign autographs. After that, nobody bothered us.

We went to the statue, walked around to the front, and took pictures for a little while. The hard part was trying to get the proportions right, a person 5 feet 10 inches tall standing in front of a statue 305 feet tall. That took a little adjusting, but eventually I got it.

We didn't know exactly what impact these photos would have, but we both had a feeling that they would present an inspiring image. In fact, it didn't work out like that. Although a few magazines picked up on the pictures—*Rock Scene* here and the *New Musical Express* in England—I had expected more interest. It was only later, after John won his case, that the Statue of Liberty picture really became an iconic image representing peace and personal freedom.

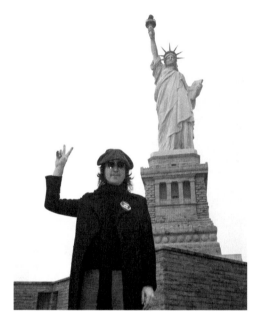

John Lennon, Statue of Liberty, New York City, October 30, 1974

The night that John and Elton recorded "Whatever Gets You Through the Night," and they were listening to the playback, Elton asked John if he would sing with him at his Madison Square Garden show. The gig wasn't until Thanksgiving, and John replied jokingly, "If this song gets to be number one, I'll sing it with you."

It did reach number one, on November 16, 1974. True to his word, John made the appearance.

I was at my in-laws' in Greenwich, Connecticut, on Thanksgiving Day, when I got a message from May Pang. She told me John was playing with Elton at Madison Square Garden and she'd left a ticket for me

at the box office. Just a ticket, not a backstage pass, not a photo pass. I worked my way down to the front, and just as I got there, a security guard came over.

Sitting at the front of the audience was a guy named Joe Pope, who had organized the very first Beatles convention; I'd met him before, and as the guard came to tell me to get out of the aisle, I squeezed onto Joe's seat and said, "Let me stay here." Joe was accommodating, if slightly puzzled: "Where's your big-time photo pass?"

When Elton announced John's surprise appearance, the crowd erupted in cheers.

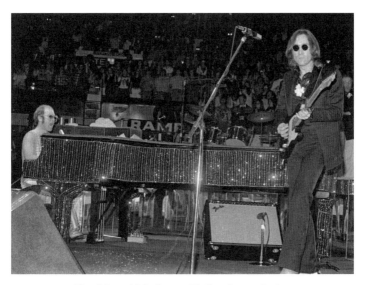

Elton John and John Lennon, Madison Square Garden, New York City, November 28, 1974

Soon after, John and Yoko reconciled and, by December, he was back living in the Dakota. The following year, on John's thirty-fifth birthday, he won the right to stay in the United States, and their son, Sean, was born. John called me to take the first pictures of Sean when he was only two months old.

I had first photographed KISS at the Academy of Music on Fourteenth Street on New Year's Eve, 1973, when they were largely unknown. They were opening for the Stooges and Blue Oyster Cult. Appearing

as larger-than-life superheroes in Kabuki-style makeup, towering in eight-inch platform boots, they played straight-up rock and roll with flames on candelabras behind them. Gene Simmons tossed balls of fire out over the audience. It was so exciting the audience was going crazy. Even when something went wrong and one of the fireballs burned a kid's face, there were no recriminations. The kid loved KISS so much that he didn't care! Gene's hair caught fire, too.

That was a spectacle I'd never before witnessed. Backstage after the show, things became even more unusual. My customary way of working was to take pictures of a band before, during, and after the show. When I went backstage after KISS's performance, I was told not to take any pictures. KISS could not be photographed unless they were in full makeup. That made it an early night for me.

I was working regularly for *Creem* magazine by then. In the fall of 1974, they came up with the idea to do a two-page photo novella with KISS as Clark Kent types in regular business suits in full makeup, leaping out of a phone booth in KISS regalia, to save the world with rock and roll.

The band put their makeup on at my Westbeth studio and borrowed a couple of my suits and ties. Nadya loaned Gene her clogs.

The session went well. I remember one particular moment, as they were changing from the street clothes into their costumes. I was

KISS, West Twenty-Third Street and Eighth Avenue subway station, New York City, October 26, 1974

KISS, West Fourteenth Street and Eighth Avenue subway station, New York City, October 26, 1974

RIGHT PLACE, RIGHT TIME

(Left to right) Gene Simmons, Paul Stanley, and Peter Criss, New York City, October 1974

arranging my cameras when I suddenly felt . . . I can only call it an eerie presence . . . behind me. I turned, and there was Gene towering over me in full costume.

It was a startling transformation. The guy I'd been talking to all day was now a superhero, a totally different persona.

KISS and I worked a lot together over the next few years. My photo from the *Creem* story became the cover photo for their *Dressed to Kill* album.

KISS, *Dressed to Kill*, New York City, 1974

Every day, I was either working or traveling, because even when I went to a show "for fun," my camera was always with me, and I was always ready to take pictures for *Rock Scene*. It was good for my career, but my marriage was suffering.

I was spending more and more time away from home, and that meant time away from Nadya and Kris.

For as long as she and I had been together, she never really got into the rock-and-roll life in the same way that I did. She came with me on different trips occasionally, but she had her day job and she slept at night, whereas I was out working most of the night, and I slept when I could.

When Nadya told me that she was pregnant in early 1974 I was excited, but I was also worried that I didn't have the time to be a proper father. I certainly wasn't around for much of her pregnancy, and while I was present at the birth, and I did everything I could to help once Kris was born, my lifestyle barely changed to accommodate the new arrival. I continued to be out working every night while Nadya stayed home caring for Kris. We'd see each other for a few hours in the late afternoon; it was obvious our lives were going in different directions. It couldn't last and it didn't.

RIGHT PLACE, RIGHT TIME

*Malcolm McLaren • John and Yoko • John and Yoko
and David Bowie • The Rolling Stones*

I MET MALCOLM MCLAREN IN JANUARY 1975. HE
owned a boutique on London's Kings Road, and was in New York
City looking to sell clothing to various wholesalers. He and Syl were
friends from way back, and when Malcolm heard that the Dolls had lost
their management, he saw the ideal opportunity to both help them out,
and sell the clothing that he would dress them in.

His partner back home was Vivienne Westwood. She would be
designing and making the clothes that the Dolls would wear, and Mal-
colm asked what they wanted. They wound up with an entire wardrobe
of red.

That had not been the original intention. It started with somebody
asking for red shoes. And then one of the other guys wanted red pants,
and then somebody said, well, "Give me a red jacket." Each of them ended
up getting a jacket, pants, and shoes. David got a three-piece suit, and

there were a couple of vests involved, as well. They got as much as they could. And they were all different fabrics: David's suit was gabardine, Johnny's was leather, but they were all in the same bright red color.

Unfortunately, by that time, Johnny and Jerry were deep into heroin habits. Arthur was drinking way too much, and David and Sylvain were partying pretty heavily. Their management had abandoned them, and their record label had dropped them. Although Malcolm had never managed a band before, he was brimming with ideas. The Dolls offered him a blank slate. He also arranged for Johnny, Jerry, and Arthur to go into rehab.

Malcolm's idea was to send them out as some kind of communist statement with the idea of riling up so many people that the media would start paying attention to them again. They got a big piece of red cloth and Cyrinda sewed a hammer and sickle on it.

Malcolm did make a go of it, but the Dolls weren't in any shape to carry it out. David tried. He started walking around carrying Chairman Mao's *Little Red Book*—which, in truth, was in bad taste, but at the time they thought it was funny. Instead of a press release, Malcolm issued a manifesto declaring that the "puppet management of Leber-Krebs" was no longer working with the New York Dolls and they were going to have a "red party" to celebrate at the Hippodrome club.

Malcolm McLaren, Hippodrome, New York City, February 28, 1975

I understood what Malcolm was trying to do, and he would do it a lot better once he returned to the UK and launched the Sex Pistols' career. He didn't understand that the music press in the United States didn't hold the same command over the public imagination as it did in Britain. Being able to outrage a few hundred people at a show did not translate into outraging several million across the country.

Malcolm's whole communist ploy was destined to fizzle. It didn't work at all. But the Dolls were still popular in New York City. The red shows were sold out, and the band was actually held over for a third weekend.

Malcolm used a number of my pictures to promote the Hippodrome shows, running off color Xeroxes of some of my slides, which impressed me because that was the very first time I'd ever seen a color Xerox. In 1975, the idea that you could put a transparency in a machine that would just crank out multiple copies for three dollars apiece was unbelievable.

I wasn't able to attend all the shows, because one of them took place on the same night as the Grammy Awards, March 1. That was when John Lennon made his first public appearance since reconciling with Yoko. David Bowie was there to hand out one of the awards; Simon and Garfunkel were there to celebrate their first reunion, and Malcolm was there in spirit, because I borrowed his white raw silk

(Left to right) Bob Gruen, Yoko Ono, and John Lennon, Uris Theatre, New York City, March 1, 1975 (photograph by Chuck Pulin)

dinner jacket for the evening. It was such a cool jacket, I really wish I could have kept it.

When the award ceremony was over, I went back to the Hippodrome to catch the end of the Dolls' set and take David and Cyrinda to the Grammys' after-party, at Le Jardin on the top floor of the Hotel Diplomat. It was still pretty crowded when we got there.

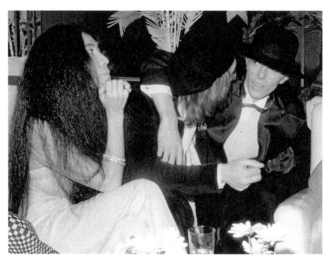

(Left to right) Yoko Ono, John Lennon, and David Bowie, Le Jardin, New York City, March 1, 1975

At some point, Tony King, who had worked for the Beatles for years, came up to me and said, "Have you seen John? Yoko's looking for him."

I hadn't, but I said I'd keep an eye open for him. A little later, I was walking down a hallway when somebody went into the ladies' room, and I happened to glance in and saw three pairs of cowboy boots under one of the stall doors. One of the pairs looked very much like John's. I went to find Tony King, and I told him what I'd seen—"I think he's in the ladies' room." "Ah, it's ladies' room, is it?" replied Tony, as though it was perfectly normal.

The Dolls went off for a tour that Malcolm had planned for the South, but they didn't get very far. The next I heard was a call from David saying he was back in New York City and the band had broken up. Soon

after Johnny and Jerry hooked up with Richard Hell, who had just left Television, and that was the beginning of the Heartbreakers. A few days later, I was photographing them.

That May, in 1975, Elton released a new single that became, much to everyone's surprise, a huge disco hit. It was called "Philadelphia Freedom," and it became the first record by a white artist ever to be played on WBLS, the black radio station in New York City.

Now they wanted Elton to come into the studio, up in Harlem, to do an interview with the deejay Frankie Crocker, and I was hired to capture the moment. There was just one thing on my mind. For days, there had been rumors that the Rolling Stones were about to make a big announcement, and the very day before the interview, those rumors crystallized around a press conference, somewhere in New York City.

Like every other journalist in town, I was looking forward to it with anticipation. Where would it be? Who would be invited? What was it about? And that night at the Bottom Line, I happened to run into Paul Wasserman, the Stones' press officer.

I said to him, "Oh, I heard the Rolling Stones are doing a press conference tomorrow." I don't know for sure, but I think he must have figured that I knew more than I was letting on, because he immediately replied, "Yeah, we tried to get Times Square but they wouldn't let us use it, so we're going to go on lower Fifth Avenue."

I couldn't help myself. Jokingly, I shot back with, "What, are they going to get on a flatbed truck and go down the street?" And Paul just looked at me and said, "Shh shh, be quiet. Don't say it so loud."

I couldn't quite believe it, but early the following morning, I received a telegram telling me to be at Flowers restaurant on Fifth Avenue and Eighth Street for a Rolling Stones press conference. They didn't give much time, but I made sure I was there early, around eleven that morning. In the back room, they had set up a whole lot of seats for the press to sit and a table with microphones.

There was something wrong with this scenario. Apparently, the emcee for the occasion would be Professor Irwin Corey, a comedian who was very popular in nightclubs and on television. He was well known for being able to speak absolute academic nonsense, talking in circles

and basically confusing everybody, being extremely funny while making no sense whatsoever.

I thought about it, and there was no way the Stones planned to have Professor Irwin Corey conduct their press conference, so I started to think that maybe it really was true that the Rolling Stones were going to come down the street on a flatbed truck. The more I thought about it, the more likely it seemed. I remembered Paul's shocked expression when I suggested it, his insistence that I lower my voice . . . I looked again at the setup and went outside.

I walked two blocks up the street to Tenth Street, and I saw a flatbed truck and, getting out of the limos that were clustered around it, the Rolling Stones!

They climbed aboard the truck and down the street they came, blasting "Brown Sugar," and I was running alongside them, taking as many pictures as I could. I'd run, pause to fire off a shot or two, then start running again, through the crowds that suddenly congregated on the sidewalk and spilled out into the street. People were hanging out of the windows. I'm surprised nobody fell.

Then they were outside Flowers playing in front of all the journalists.

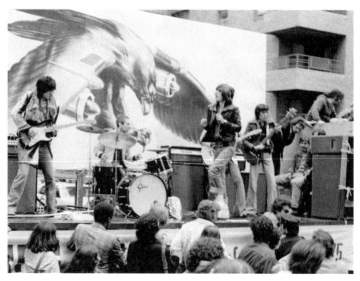

The Rolling Stones, Fifth Avenue, New York City, May 1, 1975

The truck stood still for a moment, and then started up again, round the corner, and that was it. The Rolling Stones' latest tour had just begun.

It was the most astonishing sight I had seen in months. Just one song, yet it put so much energy into my life that I jumped on my bicycle, rode home as fast as I could, ran into the darkroom and developed the film, hung it up in the bathroom, dried it with a hairdryer, made some contacts, made a couple of prints, dried them, and then rode uptown.

I was supposed to be meeting Elton somewhere near Fifty-Seventh Street, which is where Paul Wasserman's office was. Paul wasn't even back from lunch yet, but I dropped the photos on his desk, so he'd see them as soon as he got back.

I was still high on the sheer excitement of the morning when I reached Elton, but I knew I couldn't say anything. This was Elton's big moment, and I could not spoil it by raving about another band. I kept quiet, and shot photos of Elton and Frankie Crocker.

We were heading downtown when the driver said, "Did you hear about the Rolling Stones this morning?" I said, "Yeah, the Rolling Stones did the most amazing press conference!" And that was it. Once I started, I couldn't stop. I went on and on about the Stones. I realized I was way too excited to be there. I didn't want to bring Elton down. So, I said, "I've got to go." The car wasn't moving because of a red light, so I just opened the door, leaped out, and ran. The last thing I heard was Elton John telling me to be careful as I dodged through the traffic.

MONEY HONEY

Bob Dylan • The Bay City Rollers

AT THE END OF JUNE 1975, NADYA AND I MOVED from our first-floor apartment at Westbeth to an upstairs apartment on the other side of the building. As part of the photo novella with KISS, I had gathered up some fans at a show and staged an orgy. (Not a real one, of course!) Afterward, I kept in touch with one of the women, Cindy Difford, and she was helping me move when we had our first visitor. It was a Sunday afternoon and we were still moving in when John Lennon called and asked if he could stop by.

"Sure," I said. "But I'm in a new apartment. I moved upstairs and it's a little hard to find. When you get here, have the doorman buzz me and I'll come down and get you." Westbeth is a big complex of several buildings, with different stairs and elevators and long, long hallways and getting around can be confusing.

About half an hour went by and he hadn't arrived yet. I was just going to buzz the doorman and ask him if he'd seen an English guy when John strolled into my apartment. "Boy, you have some crazy neighbors,"

he said. "I was ringing doorbells asking where Bob Gruen's apartment was, and people were going nuts."

Everybody in Westbeth is an artist. It was Sunday afternoon and they answered the door, and there's John Lennon standing there. What did he expect to happen? One says, "Oh! John Lennon! I'm a painter! Let me show you my paintings." And the next says, "Oh, come in! Let me read you my new poetry." And the next says, "Let me show you my latest dance." Everybody wanted to show off for John Lennon. And John was having fun ringing doorbells and meeting them. It made me legendary in the building.

Aside from the Stones, the other big tour that year was Bob Dylan's Rolling Thunder Revue, which crisscrossed New England in the fall. With the exception of a handful of shows in bigger cities like Boston and New York, the band would simply appear someplace, and one of the entourage would go outside and start handing out flyers to passersby, letting them know that Bob Dylan was in town. Every show was sold out.

Larry Sloman—Ratso, as the band and crew referred to him— was covering the tour for *Rolling Stone* magazine. He would literally follow the tour bus around, then he would call me up and let me know where they were playing. I saw seven of the shows on that tour, which is probably more than anyone outside of the tour party itself, and it's all thanks to Larry. The moment he called, I would jump into my car and race to the show.

Dylan was adamant that no photographs were to be taken, unless Ken Regan, the tour's official photographer, was taking them. Cameras were strictly forbidden. I was a journalist, and I felt it was my job to document what was happening, and I was not going to allow any regulation to stop me.

I slipped my long lens into the hood of my big army coat. My two cameras were in my cowboy boots, one in each. I took Chris Charlesworth with me to one of the shows. He was amused to see me taping roll after roll of film to my arm. I wouldn't make my move until the encore, when everybody was out of their seats and jumping around. I would stand on my seat and quickly take as many photographs as I could.

When the Rolling Thunder Revue reached Madison Square Garden, Dylan had an after-party at the Felt Forum. He was sitting in the seats talking to people. Larry said, "I'll introduce you to Bob Dylan." We walked over and Larry told Dylan, "Bob, I want you to meet somebody," and Dylan just turned and pushed him away, saying, "I'm tired of meeting people. I'm not meeting anybody else tonight."

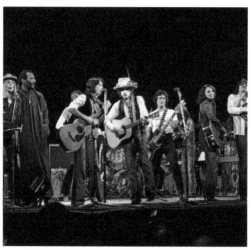
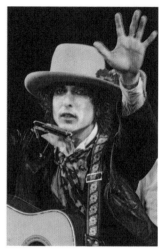

Bob Dylan's Rolling Thunder Revue, Springfield, Massachusetts, November 6, 1975

Bob Dylan, New Haven, Connecticut, November 13, 1975

I met the Bay City Rollers in the fall of 1975, courtesy of their publicist, Carol Strauss Klenfner. People don't remember just how huge the Rollers were. After eighteen months of positively dominating the British and European charts, the Rollers had set their sights on America.

They'd already had a hit or two in the United States, and they were very popular. This was their first American tour, and teenagers were talking about it as though it were the second coming of the Beatles, at least in terms of fan hysteria. The girls would be screaming so much that they would hyperventilate, and the medics would come in and carry these kids over to the side and have them breathe into a paper bag to help them get back to normal.

The Rollers had a very distinct image, playing on their Scottish origins by ensuring that everything they wore was trimmed in plaid. Because they didn't merchandise any of these plaid items, the fans got

RIGHT PLACE, RIGHT TIME

their own plaid fabrics and made outfits themselves. Every show was the same: the doors wouldn't be open until seven, but the kids would be there by three or four in the afternoon, lining up, comparing their colorful outfits and accessories and bringing their scrapbooks to show to one another.

Since I always try to fit in with whatever band I'm working with, I tried to find something to wear to match their style. I came up with a couple of items, and one just came to me at the perfect time.

(Left to right) Alan Longmuir, Derek Longmuir, Eric Faulkner, Stuart "Woody" Wood, and Les McKeown—the Bay City Rollers—and Bob Gruen, New York City, January 1976

Jim and Jean were designers I knew who had made one of my all-time favorite T-shirts, which had dabs of paint and the word "Artist" right in the middle of it. For some reason, they had come up with a T-shirt design that wasn't made for me but was perfect. It was blue, and in the center was an image of several frames of film, with sprocket holes, and the middle frame was a square of plaid!

It was the ideal shirt to wear as the photographer for the Bay City Rollers shows, so I wore it most of the time when I was with them, unless I was wearing this other shirt that my friend Cindy made for me that said "Money Honey," the title of one of their hit songs.

I thought it was great to wear the "Money Honey" shirt when I was with them, because I was making more money from Bay City Rollers photos than any other band I worked with. They were so popular that, instead of just publishing articles about them, with a couple of pictures, magazines would do entire issues dedicated to them. Rather than license one or two pictures from me, they'd license up to forty-five or fifty pictures, and I was lucky that Carol kept hiring me to work with them. In fact, I had exclusive access.

One time they did a couple of in-store promo events. We went out to Long Island, and they hired a helicopter to take us down to New Jersey. They also did an event at Rockefeller Center where I took some pictures of them down in front of the ice skating rink, with all the press there. Then we went up on top of the RCA building, and I took pictures of them with the Manhattan skyline in the background.

That was the first time I went to the observation deck and saw the view. I went back there with the Clash in 1981; and then, twenty-eight years after that, I came back again with Green Day.

The Bay City Rollers, Top of the Rock, New York City, September 30, 1975

I learned things from everyone I worked with, and one of the things the Rollers showed me when I was traveling with them was a simple way to get better sound from a small cassette player. I had a little flat tape recorder that I would carry to play my music on. Everybody had cassettes then, and most of those tape players had very small one-inch or two-inch speakers, so the music was very tinny and didn't have much bass sound.

The Rollers showed me how you could place an empty cup upside-down over the speaker, and this would add bass and produce a much fuller, richer sound from your simple tape recorder. I showed that to many other bands and musicians after that, and it always amused me that a band that really didn't get much respect as musicians taught me a trick that all musicians love.

The other thing I learned was never to undersell myself. It might sound as though I was living the high life now, hanging out with rock royalty, and certainly anybody who subscribed to *Creem* or *Rock Scene* would have imagined I was literally raking the money in. It didn't work like that. I was still living from paycheck to paycheck. Magazines rarely paid more than twenty-five or thirty dollars per shot that they used; record labels seldom went above a hundred dollars or so for a session. In a good month, I could cover the rent, gas, food, and a few incidentals. But good months were by no means the rule, particularly when you considered how many hours went into getting that twenty-five-dollar shot—travel, attending the show, hanging out afterward, buying chemicals and film, developing and printing the film, and so on.

But you get used to getting by, so when the Topps company came to me asking what I would charge for no less than eighty of my photographs, to be used in a set of trading cards, I didn't want to appear greedy, and blow my chance of what, by my standards, was a major payday. Eighty photos at twenty-five dollars each was two thousand dollars, so that's what I asked for.

They paid, and a while later they came back to me for rights to reprint the series. I don't think I even registered the disbelieving pause in the card company guy's voice when he asked what I'd been paid for the first run, so I was thrilled when they offered me thirty dollars a shot.

It was only later, years later, that I discovered the average going price for a job like that was in the region of two hundred fifty dollars apiece. Not twenty-five.

The Rollers had some major hits that really did become anthems of the day, songs like "Saturday Night," which was a top hit on the radio everywhere. They played a very lively, fun kind of music, and I enjoyed it. It was good rock and roll. It was fun to sing along to. And when they played a concert, the audience went absolutely berserk, the kids mobbing the stage and climbing on top of one another, screaming until they couldn't scream anymore. Then they would pass out.

It was also a lot easier than working with other bands at other concerts. At a Who concert, for example, the fans would get excited and run down to the front, most of them large, drunk, and possibly stoned men, and they could be dangerous. With the Rollers it would be twelve- to fourteen-year-olds—just wild children, and I could easily navigate my way around them.

TROUBLE IN JAPAN

Rino Katase • The Dollettes • Sable Starr

I N APRIL 1975, MY FRIEND YUYA UCHIDA CAME INTO town, and one unseasonably wet, snowy night, he, David Johansen, and I went to see the Miamis. We were on the sidewalk when suddenly Yuya started to ask David why he wasn't bringing the Dolls to Japan.

A little taken aback, David explained that the Dolls had broken up—to which Yuya replied, "Then why don't you put them back together? A new band! And bring them to Japan."

David was not going to say no, and neither was Syl or anyone else they invited to join. A new band, nicknamed the Dollettes, came together, and Yuya invited them to appear at his World Rock Festival tour in Japan that summer.

Nadya handled the business side of things—she was the only one of us who would be awake early enough to take calls from Tokyo, and she

would be on the tour to make certain that the deals were adhered to. I set to work organizing publicity with my media connections.

The band played a warm-up show in Vermont; Nadya and I had a place up there, a little log cabin that we visited from time to time. We returned to New York City about a week before we left for the Japanese tour, and Nadya and I decided to separate at the same time. It was all very calm; we simply sat down and discussed our situation. We were very logical and reasonable about it. Afterward, I went outside and I cried like I'd never cried before.

I knew Nadya was right, that we shouldn't raise a child in the chaotic life that I was living. We also knew that I wasn't cut out to hold a nine-to-five job, and live in the suburbs. She moved out, and we shared raising Kris. We didn't even get divorced until four years later, when she wanted to remarry. She lives in Vermont now and we've remained good friends. Not only that, but when Nadya married her third husband, I was the wedding photographer; and in 1995 when I married Elizabeth Gregory, whom I am with today, it was Nadya who officiated at the wedding, pronouncing us man and wife!

But even though we were separating, Nadya and I did the Japan trip together and it was fantastic. We were treated like superstars; everybody seemed to know who David and Syl were, and they reveled in the attention. It was also a very high-profile outing. The World Rock Festival tour was conceived as the follow-up to the One Step Festival that Yoko headlined the previous year, only now it had expanded considerably. Jeff Beck was the headliner, with Felix Pappalardi of Mountain, the Dolls, and a number of Japanese bands.

There was one night at an outdoor venue when Jeff Beck fell ill before his performance, so Yuya asked if the Dolls would step in for him. That was the night when Nadya truly came into her own as the tour's business manager. The band had been paid to play a show, and they had played it. If they were asked to play a second show, Nadya demanded a second payment, and they got it.

My interest in Japan continued to grow. I loved the politeness of the society; how you could walk down the most crowded sidewalk and, instead of everybody jostling as they hurried about their business,

people remained completely aware of their surroundings, and the people around them.

I met Rino Katase at the first gig. She spoke fluent English and we asked her to be a translator and guide for the band. She even came along with me to a meeting I had arranged at the Olympus camera offices, where I was hoping to strike some kind of sponsorship deal. "Bob Gruen uses Olympus cameras," that sort of thing. They gave me a set of cameras, though they never did run the ad campaign. To this day, I believe that 50 percent of the reason I got my deal with them was because they wanted to see more of Rino.

Rino Katase, Japan, April 1977

Riko Kitamura was another young woman I met on the tour, and she also became a great friend over the remainder of the trip, and on my subsequent visits.

At the beginning of the tour, waiting at Tokyo airport for the flight to the first gig, some of the musicians from one of the other groups started telling us about a young Japanese girl they had picked up in a nightclub the previous evening. There's no need to go into what they said transpired over the course of the night, but it was pretty kinky, and they were still laughing about it as we waited around the airport.

Cut to the last night of the tour in Tokyo, where I was hosting a screening of the videotapes that I had shot at the Grand Finale show at

(Left to right) David Johansen, Nadya Beck, and Syl Sylvain, World Rock Festival, Japan, August 1975

Tokyo's Korakuen Stadium. We were all gathered together at the hotel when suddenly the doors burst open and a bunch of tough Japanese guys came in.

They started passing around a photograph, a high-school graduation class of a hundred tiny faces, and demanding to know whether any of us had seen one particular girl in the picture. I didn't know what this was all about, so I told them bluntly to get out. "We're having a screening. What are you doing?" At which point they retreated to the bar and sat quietly until the screening was over. Then they came back and they were focused on Sylvain. Apparently, the last time this girl had been seen, she was with an American with curly hair. He fit the description. (I had a mustache, so I didn't.)

An awful truth began to dawn on me. This was the same girl that the musicians had been messing around with on the first night of the tour; and, just to compound the problem, she had been with Syl the previous

evening. Quietly I asked him what had happened and he swore all they did was talk; that she was still upset over her earlier experience. He took her in, and they just talked and he convinced her to go home. When she returned home, her father found out what happened. He was at the forefront of the gang that had burst in on us. He was with Yakuza, the most feared gangster organization in Japan.

The Yakuza descended upon Syl, yelling at him, demanding to know what he had done with the girl.

Syl was trying to explain but getting nowhere. I picked up the phone at the front desk to call the police, only to discover it had been cut off. I grabbed the desk clerk by the shirt and pulled him over the counter, shouting in his face, "Turn on the phone." My friend was in danger and this guy was keeping me from getting help.

There was an American student with us who spoke Japanese fluently, and he told me that the guy had taken a key out so that the phone wouldn't work. I yelled at the desk clerk, "You put that key back and call the police or whatever happens to him," meaning Syl, "is gonna happen to you. Don't just be afraid of the Yakuza. You're going to be afraid of me."

I had never threatened anybody in that way in my life, but I was scared—for Syl, for myself, for all of us. The desk clerk finally switched the phone back on, called the police, and handed me the phone. I passed it to the student, and told him, "Tell them the name of the hotel first and then tell them we're in trouble. But first say the name of where we are." I'm glad I took that precaution because one of the Yakuza guys realized what was going on and snatched the phone away.

I pulled it back; he grabbed it again, and we were going back and forth. I'm not a fighter, but I wasn't going to simply surrender. This guy might want to kill me. I was going to make sure I hurt him first.

Suddenly I saw Luli, the road manager's girlfriend, burst in the door, pulling a policeman by the arm. She was older than us, maybe close to fifty, a small white-haired woman from Vermont, and she had remembered that we were a block away from the British embassy. Police officers were stationed outside. She had run up the block and grabbed the first cop she saw. She started dragging him down the street, repeating over and over, "Trouble, trouble, help!"

She hauled him into the hotel where I was still wrestling the Yakuza for the phone. I let go of him and pushed the cop across the room, until he was in between Syl and the guy who was threatening him. Time froze. It was as if a switch had been pulled. The entire room came to a standstill, and suddenly an army of cops came pouring into the room.

The Yakuza could not have been more friendly to the cops. Everybody was talking in Japanese. We were growing even more nervous. As an American citizen in a foreign country, I thought, I could call the American Embassy for help. I found a phone number and called. It rang for a while. Someone finally picked up and I told then, "We're in trouble! We're Americans, we're having a problem here!"

"Well," he replied. "I'm a guard. I'm in the kitchen to get a beer, and I heard the phone ring."

"Look, we need some help. We need somebody from the embassy to come down and represent us." He said he'd see what he could do. The police wanted everyone to go to the station, but I said, "No one is going anywhere till someone from the U.S. embassy gets here." To my complete surprise, all the police and gangsters sat quietly and waited. About forty-five minutes later, a guy from the embassy who looked like Sidney Poitier showed up in a sharp suit with an attaché case and introduced himself.

I took him over to Syl and explained what was happening, and they all went off to the police station. I stayed behind to tell everybody to pack, because we needed to be ready to leave at a moment's notice to just get the hell out of there. Luli came running back into the hotel to tell us there were six cars full of Yakuza parked in front of the police station. I was about to start panicking again, when the phone rang. I snatched it up and it was Nadya.

"Everything's okay," she said. "The Yakuza's apologizing. They're signing a written apology right now."

"Well, what about the six carloads of guys out in front of the place?" I asked. And she simply said, "It's okay. Those are our guys." Apparently, one of the Japanese promoter's staff had also run out of the room when the gangsters first appeared, to get reinforcements. We had an entire army out there, a different branch of the Yakuza. When our assailants

realized exactly who they were messing with, they were writing apologies and begging forgiveness.

It didn't end there. On my next trip to Japan, I learned that the leader of the Yakuza that had attacked us had something for me. He had cut off his pinky and wanted to give it to me as a form of apology. I was horrified. I didn't want his finger. I didn't want anybody's finger. I explained that while I understood his customs, I couldn't accept it because I would have to deal with U.S. customs officers.

David, Syl, and I decided to stop in Hawaii on the way back to New York City, and rest for a few days. Although Nadya and I had worked happily together on the tour, the fact remained that our breakup was still underway. I wanted to give her time and space back in the city to sort herself out.

From there, David went back to New York for his sister's wedding and Syl said he wanted to go to LA to hang out. I didn't know what I wanted to do, so I stayed in Maui for another day, to sit on the beach.

I called up my friend Dominic, an art director I knew from Buddah Records, just to see what was going on in LA. It was Dominic who invented the glow-in-the-dark necklaces that are so popular. Those things flooded the world, every concert, every event. His dream was to make a million dollars by making something that cost one dollar and selling a million of them.

My timing was perfect. Dominic was about to leave for New York City, and he told me that if I could get there before he left, he would loan me his apartment, which was just down the street from the Sunset Marquis, and his car—a beautiful Cutlass convertible.

I took him up on it. I said, "Yeah, I'll be there tomorrow," and I booked a flight immediately. Dominic actually met me at the airport, because his flight was that same day; he gave me the keys to the apartment and the keys to the car, and he told me where it was parked. When I returned to New York City, we timed it so that we met at the airport again.

The first person I called in LA was Sable Starr. I had remained in touch with her, particularly after she came out to New York City to be with Johnny. After one too many drugged-out fights, she ended up living

with Richard Hell, until she tried to commit suicide in his bathroom. After that, she returned home to Los Angeles and somehow cleaned up and survived.

I would see her on and off whenever I was in LA; I would call her because she always knew what was going on out there. I drove around with Sable, found Sylvain, went to Tijuana for two days, and, after two weeks, finally headed home.

Sable Starr, Chateau Marmont, Los Angeles, 1976

THE CLUB SCENE

Jayne County • The Tubes • David Bowie • Grasshopper • Virginia Lohle • David Johansen • Sylvain Sylvain

ONE LATE JUNE NIGHT AFTER I PHOTOGRAPHED THE Stones at Madison Square Garden, I went downtown to the Bitter End in the Village. As I walked in, Patti Smith and her band were singing "Time Is on My Side." And I thought, "Yes, it certainly is."

The downtown new-band scene, of which Patti was such an integral part, was becoming the epicenter of New York rock. Seeing a band in a bar downtown was so much more intimate and close than in an arena or stadium, and now there were so many to choose from: Patti, Blondie, Television, the Shirts, the Mumps, the Miamis (I always think of the Miamis as the band that wrote seventy-eight number-one singles that were never released!), Johnny Thunders's Heartbreakers . . . at first, they were playing only for one another, and it was very do-it-yourself.

Richard Hell ripped his T-shirt and safety-pinned it together while the Ramones used to take the subway in from Queens with their guitars in shopping bags, because they couldn't afford cases. Although I later learned that there was another reason why they traveled so cheaply. Johnny, who organized the band's activities, kept expenses to a bare minimum.

Even later, when they were making money, the Ramones were very self-contained, traveling around in a small van that basically held Monty (their road manager/driver) and the four guys. Most of the time, not even their girlfriends or wives were allowed in the van.

Johnny ran things with military precision, as I discovered when the Ramones were opening for David Johansen in Boston. They were there for two nights, Friday and Saturday, and after the first show, David asked Joey if he wanted to hang out for a while.

Joey said no. "We're going to go drive home tonight."

David was surprised. "Well, aren't you playing with us tomorrow night?"

Joey nodded. "Yeah, we'll be back tomorrow to play the show."

"Why," David asked, "are you going to drive five hours back to New York City and five hours back to Boston? Why don't you get a hotel room and stay over?" and Joey explained, "Oh, Johnny doesn't want to pay money for a hotel room."

In most scenes, bands develop at least partially in isolation, locked away in their parents' garage or wherever. In New York City in 1974–75, it was as if places like CBGB and Max's were the garage, and the bands could grow and develop side by side. In the earliest days, the bands were one another's audience, and it was that familiarity that encouraged everybody to come up with something new to impress their friends. That was a big incentive to keep getting better.

The list of bands kept growing. Talking Heads, who came down from Rhode Island to be a part of the scene; the Dead Boys, who came from Cleveland; the Dictators, the Fast, Suicide . . . now that was a band!

It's interesting how tastes and fashions change. Suicide today has gained a lot of acclaim and followers, and you rarely hear a bad word spoken about them. They were one of the very first electronic

bands, a duo of Marty Rev playing synthesizer and Alan Vega singing very intensely.

It was an acquired taste. Some people liked them, because they were minimal and because of how powerful and driving their music was, but most people were absolutely horrified, and would run away when they heard the fierce sound.

I was at Max's one night when they had Suicide opening for the New York Dolls. The venue was under new management now; Tommy Dean took over the lease, and it was a whole different incarnation from Mickey Ruskin's version.

Both of them ran a daytime restaurant business. That's what paid for the club to be there, the lunch crowd and the after-work drinking crowd. Late night in Mickey's day, it was all artists. In Tommy Dean's day, it was musicians.

Jayne County, Club 82, New York City, June 12, 1974

Tommy's idea when he first got the place was to have a disco. Drawing on the traditions of people who had been coming to Max's, he had Jayne County as the deejay. Jayne was more in touch with rock-and-roll people—she was signed to David Bowie's Mainman management company, she worshipped sixties rock and the British Invasion bands, and she had her own band, Queen Elizabeth.

The people who started to come were more of the rock-and-roll crowd, which prompted Tommy to start booking live bands. Some nights, though, all he wanted to do was get through the show, and then pack up and go home, and this particular night was one of them.

There were two shows, and the Dolls came on late and played late, until it was three in the morning. The place was still packed, but Tommy just wanted people to leave.

He had Suicide go back onstage and, within five minutes, the only people left in the club were Tommy, David, and I. David turned to me and said, "Well, that's one way to clean out a club. Put Suicide on."

Another memorable show was when the proto-punk glam rockers the Tubes came to the Bottom Line in 1975, with their full "White Punks

The Tubes, the Bottom Line, New York City, November 6, 1975

on Dope" show—Fee Waybill, who called himself Quay Lewd, in platform boots and a choir of heavenly angels as the backing vocals.

I continued videotaping a lot of shows. Nobody objected. A lot of people didn't even know what videotapes were! They were kind of funky in quality, but I'm glad I did it. I have a reel that I put together of Jayne County, Patti Smith, Blondie, Robert Gordon, the Heartbreakers, and the Dolls. They were all regular bands at Max's.

Another artist who fueled rock's drive for extravagance was David Bowie. I first saw him at Radio City Music Hall, and his staging was minimal. When he played New York City in 1974, on his Diamond Dogs tour, the staging was impressive, with vast sets, choreographed dancing, and even a cherry picker that would raise him up and out across the audience when he sang his hit "Space Oddity."

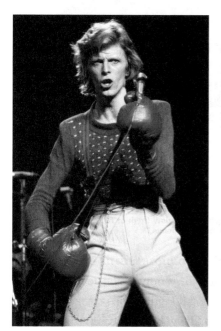 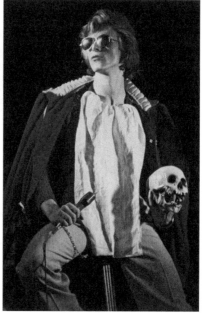

David Bowie, Madison Square Garden, New York City, July 19, 1974

He was back in town in March 1976, and I photographed him again. What is bizarre, however, is that I remember what happened afterward a lot better than I recall the show itself. There was an after-party, and

when that wrapped up, a bunch of us, Bowie included, moved on to what you could call an after-after-party being hosted by Norman Fisher. Norman was a photography collector who lived in a penthouse apartment overlooking Abingdon Square. He had pictures by William Henry Fox Talbot, one of the inventors of photography, he had daguerreotypes, and works by Diane Arbus. This was a serious collection of photographs, and he liked me as a photographer, because I helped support his collection by trading my pictures to him for pot.

What I found interesting was that he had little interest in my rock-and-roll pictures. He liked my unusual pictures. For instance, on a trip down South one time, I saw a black grasshopper, which is something I didn't even know existed. I photographed it and I traded it to Norman.

Grasshopper, Macon, Georgia, July 1972

Norman regularly hosted these late-night salons with fascinating guests. He knew a lot of artists. One night, you might meet someone who was just back from two years of sculpting in Sri Lanka, and the next you'd meet a painter, and at another there would be a musician or writer.

At Norman's, May Pang introduced me to Ronnie Spector, the voice of the Ronettes and somebody I absolutely adored. I couldn't believe I was meeting her, that she was chatting away with me. Ike and Tina Turner were in town for a show at the Waldorf Astoria the following day, so I invited Ronnie to the show.

She accepted! I had a date with Ronnie Spector! I didn't get home until about five in the morning, but I was awake again before ten,

bubbling over with excitement. I even went out to a nearby record store and bought a Ronettes record, and returned home and danced around the apartment listening to it.

Ronnie had given me her number and I was waiting and wondering what time would be appropriate to call. I managed to hold out until around two that afternoon. The phone rang, a woman picked it up. It was Ronnie's mom; after her marriage to Phil Spector broke up, Ronnie had moved back in with her mother. I asked for Ronnie—and she wasn't there. She'd just left for Jamaica with David Bowie.

I wound up taking my dad to the Ike and Tina show, but I did get to know Ronnie in later years. She became friendly with Joey Ramone and I met her again at a benefit party she hosted with him. I also met her husband Jonathan and we all became friends—so friendly that one night, perhaps after a few drinks too many, I confided in Jonathan about my lifelong crush on Ronnie, and how she once stood me up for David Bowie. He laughed—and immediately went over and told Ronnie. I console myself with the knowledge that it was her loss. Ike and Tina Turner broke up shortly after that show, and Ronnie never did get to see them perform.

The Dollettes had a short tour lined up, a handful of dates across the Midwest that they would be undertaking in a Winnebago mobile home. I was asked along to document the occasion. I was also appointed road manager, although mercifully my duties consisted mainly of showing the driver a map of where we were headed and explaining how to get there; collecting payment after the gig; and putting together the contract rider for every show. Since I wrote it, there were always a couple of bottles of Rémy Martin listed among the band's requirements.

Ellwood, the driver, was a real character, a wild, loopy guy with the Dolls logo tattooed on one arm. We picked him up at the Chelsea Hotel, where he lived. The only luggage he brought along for the trip was a box of third-rate porno magazines with titles like *Big Boobs* and *Big Butts*, *Girl Next Door*, and *Trailer Park Queen*.

We ended up wallpapering the Winnebago with pictures torn from the magazines—none of us could stand the idea of being stuck inside

this sterile Formica and plastic vehicle for the tour, so we took it upon ourselves to brighten it up.

It was an interesting tour. Akron, Ohio, was where we met the Dead Boys for the first time—they would be relocating to New York City soon enough, but for now they were just a local band who came out to see us at a place called Tomorrow Land.

As road manager, it was my solemn duty to ensure that all of the items we asked for in the rider had been supplied. I looked around and it was clear that they hadn't been.

I found the manager. "Where's the cognac?" He looked at me blankly. "What's that?" I said, "Well, it's on our rider. We get two bottles of cognac." And he asks, "What's cognac?" So, I told him, "It's kind of like brandy. Do you have any brandy?"

"No, no, we don't have brandy. This is what we have." He pointed to the bar, which had your typical rye, whiskey, vodka. But I saw 151 rum, so I said, "Well, it's kind of like that 151, why don't we take two bottles of that?" Bacardi 151 is the rum with the highest available alcohol content. By the time the show was over, and we were ready to return to the Winnebago, everybody was staggering.

The next show was in Detroit, at the Cobo Hall. We'd all sobered up by then. I was in front taking pictures, when suddenly one of the security guards loomed up in front of me, grabbed me by the collar, and started to drag me through the audience toward the lobby. He opened the door, and on the other side I saw three more security guards—all as huge as the first one. They were waiting to beat the living crap out of me.

I jerked away and ran back toward the audience. The guard chased me, but suddenly someone jumped out and tackled him. I don't know who it was or why he did it or what happened to him. But he saved me from serious injury. I kept running until I got to the Winnebago and locked myself in.

There was a show in Boston, at a Catholic girls' school, of all places—the Dollettes couldn't afford to be choosy about bookings. It was an early gig, so when it was over, we made our way to a neighborhood known as the Combat Zone—it's where a lot of nightclubs and strip clubs are. I was driving, so I dropped most of the band off outside one of the

clubs. Tony Machine stayed behind with me, and we drove around the corner looking for a parking space.

I started backing up to make a U turn, and all of a sudden there was a car behind me. Looking back, I think it was a setup; I think the guy positioned himself there deliberately so he could pull an insurance scam of some kind. The car itself was an absolute junker, the trunk tied down with string, a broken window, all manner of bumps and dents.

I punched a hole in his door with the big metal fender of the Winnebago, and as I was trying to pull away, three big guys came running out of the car. Meanwhile, Tony got out to try and sort things, at which point one of these guys hit him with a tire iron that he was carrying.

I was still looking for our insurance papers, but Tony didn't care about that. "Bob, Bob get the gun!" We didn't actually have a gun; he was just trying to scare the guys off. But I played along, at which point the rest of the band reappeared. Apparently, the club I'd dropped them at had refused them admission.

They saw what was going on, and suddenly I saw Ellwood running toward us, waving his attaché case over his head. This was no ordinary attaché case. It was made by Anvil, the same company that manufactures flight cases for bands, and as strong as one as well, with steel corners that could really do damage. He was swinging this thing over his head, bearing down on the three guys. They backed down at that point, and we escaped.

Another memorable night with the Dollettes was the Bicentennial, July 4, 1976. Two hundred years of the United States of America, and for me, and a few hundred other kids, that came down to a night at Max's Kansas City.

I went to the show with my friend Ginny—Virginia Lohle. I'd known her about a year at that point, and she would often come and help when I was shooting videos. Actually, she did a lot for me. She was only nineteen, but she would stay by the camera, so I could leave it with her in between the sets and go to the bar, or up to the dressing room to take pictures.

She also used to babysit Kris for me, although I knew that when I got home, the floor would be covered in my Beatles records. She was a

massive fan—the Beatles and Eric Clapton were her absolute idols—and she'd just spread the albums out over the floor while deciding what to play next. She was working as an elevator attendant at the World Trade Center when I first met her, and she would often come over still wearing her uniform. One of my favorite photographs of her was taken that July night at Max's.

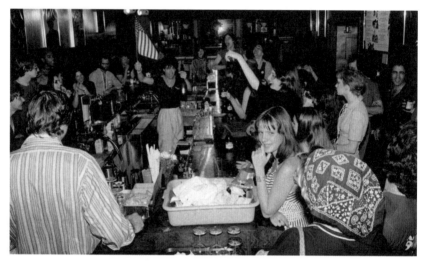

Syl Sylvain and Ginny Lohle, Max's Kansas City, New York City, July 4, 1976

The place was completely packed. The Dollettes were playing three sets that night, with the last one starting around three in the morning. Joe Perry was there, Robert Gordon, David had his trumpet, and the show was still going on after the club was supposed to be closed.

So, what did Tommy do? He went downstairs, pulled down the gate, and turned off the lights, to make it look as if the club was closed. Out on the street, it was silent. But upstairs in the back, three hundred people were rocking, the music was blasting, and the trumpet was going.

I should mention that David only decided to "learn" how to play the trumpet because somebody gave him one. Cyrinda threw him out of the house because he was making so much noise. After that, he started coming to my house to rehearse, walking back and forth in my loft, blasting his trumpet. Finally, I couldn't take it any longer. "You can't do that. You're driving me crazy! Go out on the dock. There's nobody out there."

He went across the street, out onto the dock on the Hudson River, and I could still hear him honking away. Eventually, he learned how to play a few notes. And that night, July Fourth, we all got to hear how much progress he'd made. It was just a night of fantastic music and fun.

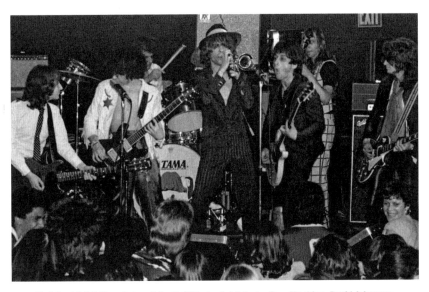

(Left to right) Jeffrey Salen of the Tuff Darts, Syl Sylvain, Tony Machine, David Johansen, Johnny Thunders, Peter Jordan of the New York Dolls, and Joe Perry of Aerosmith, Max's Kansas City, New York City, May 1976

A very important friend from around this time was Sheila Rock. I met her through Stephanie Bennett, a publisher who was putting together a book called *Growing Up with the Beatles*. (She went on to produce Chuck Berry's *Hail! Hail! Rock 'n' Roll* movie.)

The book was actually about a guy who grew up in the sixties, during the *time* of the Beatles. It was *his* story, not the band's. But just putting the Beatles' name in the title would sell books. Stephanie let me know that her researcher, a woman from England named Sheila Rock, was going to come to look at some pictures of John for the book's back cover.

I'm not sure what I was expecting. "Sheila Rock" sounded like a stage name, particularly in my line of work, but meeting her took me completely by surprise. My first impression of Sheila was that she was beautiful, elegant, very sophisticated and aware. I remember offering her some coffee, and she said OK. "Or tea?" I asked, remembering that

she came from England, and she said OK to that, too. I made the tea and we started talking as I showed her the pictures of John.

It turned out that although she lived in England, she was actually American, born in Chicago to Japanese parents. She'd married an English photographer, Mick Rock, and had lived in London for a few years. She was in New York City for a short while, so I offered to take her to a concert at the Beacon Theatre. Then she invited me to an art opening.

She took me down to SoHo, which was still an up-and-coming neighborhood in those days, and the opening was for a tattoo artist named Spider Webb. It was one of the strangest openings I ever went to. They had pictures of some of his elaborate tattoos on the walls of the gallery, and there were people walking around who had more of his work decorating their bodies. Their clothes made certain the tattoo was on full display—for instance, if the tat was on their shoulder, then their shirt had no shoulder.

I realized people weren't really looking at the artwork on the walls, they were looking at different parts of one another. Somebody would be leaning over and looking at the back of somebody's leg, and somebody else would be leaning over examining somebody's stomach. It was very peculiar, but then it got stranger still.

There was a back room where the artist had jewelry, necklaces and bracelets and things, that were made out of human bones. I remember thinking, "Who is this Sheila Rock, and why does she know about such peculiar people?"

When Mick moved to New York City, Sheila stayed in London, and later, when I was in London, Sheila would let me stay in her guest room.

LONDON CALLING

*The Runaways • Malcolm McLaren • The Clash •
Soo Catwoman • The Sex Pistols • Don Letts • Patti Smith •
Kris Gruen • Aerosmith • Led Zeppelin Movie Opening •
Pati Giordano*

THE RUNAWAYS WERE FORMED BY MY FRIEND KIM Fowley. I first met the group when I visited him during a trip to LA, and he introduced me to sixteen-year-old Joan Jett and Cherie Currie in his basement.

Kim's idea was that the Runaways would be promoted as the first-ever all-girl rock group. They weren't; there had been many before that, including Goldie and the Gingerbreads, Fanny, and many others.

Kim didn't care. The five girls, all teenagers, were marketed as something completely new. Kim promoted them as underage jailbait, which Joan Jett hated, but it did attract fans. There was a lot of excitement when they came to New York City that summer. They were playing CBGB, and I knew the place would be packed. So instead I went out to

see them at My Father's Place on Long Island the day before. It was only thirty minutes away, but there would be far fewer people around.

We also did a photo shoot at my studio. Joan was a massive Suzi Quatro fan. The first thing she did when she came in was go over to my file cabinets to look at my Suzi pictures.

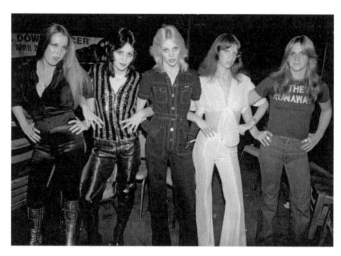

(Left to right) Lita Ford, Joan Jett, Cherie Currie, Jackie Fox, and Sandy West—
the Runaways, My Father's Place, Roslyn, New York, August 1, 1976

A few weeks later, I visited Europe for the first time, to see my son, Kris, who was in Paris with Nadya's parents. I flew first to Munich to visit the photo editor at *Bravo* magazine, the most popular music magazine in Europe. He arranged for me to stay on a writer's couch and sent me off to the famous Oktoberfest. I drank large steins of beer and ate pickled herring. That was the mistake. The herring was still causing me problems three or four days later.

The next morning, I stopped in Hamburg where I managed to persuade the photo editor at *Musikexpress* to give me a cash advance. My next stop was London. When the New York Dolls broke up in 1975, Malcolm McLaren had the idea of building a new Dolls-style band in London with Sylvain. That fell through, but the band he eventually created, the Sex Pistols, became the nucleus of the British punk scene.

When David Johansen first told me about them. I said, "Sex Pistols? You can't call a band that. Nobody will play their records on the radio."

How wrong I was.

The only people I knew in London were Ray Coleman, the editor of *Melody Maker*, and Malcolm McLaren, so that's who I called. Malcolm found a cheap room for me to stay in. All I wanted to do when I got there was sleep—I was *still* suffering from the aftereffects of that herring. Malcolm gave me a few hours, and then it was time to go out, to a gay club called Club Louise.

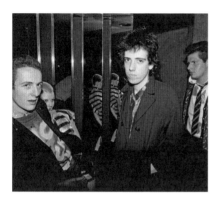

(Left to right) Joe Strummer, Soo Catwoman, Mick Jones, and Marco Pirroni, Club Louise, London, England, October 1976

(Left to right) Johnny Rotten, Helen "Helen of Troy" Wellington-Lloyd, Steve Jones, and Jo Faul, Club Louise, London, England, October 1976

Club Louise was my introduction to London's punk rock scene. Malcolm introduced me to the Sex Pistols, and I caught a glimpse of the Clash—Joe and Mick milling around the crowd. Malcolm encouraged me to photograph the people at Louise's, which included Siouxsie Sioux (who would soon be leading Siouxsie and the Banshees) and Soo Catwoman. The scene was a sharp contrast to New York City. The hairstyles were short and spiky, and the girls' makeup was severe.

I photographed the Sex Pistols in their rehearsal space; and I went with them when they signed with EMI—the first of three British record labels they would have over the next nine months. I discovered the singer, Johnny, really was Rotten—one of the most caustic, sarcastic people I ever met. He enjoyed insulting people, but when I didn't react, we got on well. As a band, the Pistols had a great camaraderie and sense of humor that reminded me of the Marx Brothers.

The Sex Pistols, Denmark Street studio,
London, England, October 1976

The Sex Pistols, London, England,
October 1976

Sheila Rock introduced me to Don Letts, who she knew was one of the biggest Beatles fans around. He worked at a boutique that sold all manner of rock-and-roll accessories—T-shirts, belts, boots—and I was surprised that he would be into the Beatles, because he was a full-on Rastafarian, with dreadlocks down to his shoulders, and reggae booming in the store around us.

Don Letts, Acme Attractions, London, England, October 1976

He was a fascinating guy, and we got into a great conversation. He had 4 × 5-inch negatives from a photo session with the Beatles, and he gave me one negative of each Beatle. Don used to go down to Abbey Road, where the Beatles recorded, and get to know the security people, so they would let him go through the trash. He got two-inch master tapes, all kinds of photos, and Beatles things that they were throwing out. Don ended up with this huge collection of Beatles stuff. He was also a deejay and I found out later that it was Don who introduced reggae to the punk scene. In fact, he gave me a tape to give to Lenny Kaye who I would see soon. I listened to it, and when I saw Lenny, I told him I'd give it to him after I got back to New York and had made a copy. Don's mixtapes became legendary.

The Runaways were in England, and I saw them at the Roundhouse on October 1. The following day, Caroline Coon, who was one of the top journalists at the time, and Malcolm's partner, Vivienne Westwood, took me to see the Clash, at the ICA Benefit Party.

Vivian drove, piling us into her little Mini, a tiny car about the size of a phone booth that you could barely fit in. We got to the venue, and I was sitting up on the side watching the band. Between the English

The Clash, the Institute of Contemporary Arts, London, England, October 1976

accent and the fast pace of the music, I didn't understand a single word Joe Strummer sang. It didn't matter. The Clash was a powerful band and what they were saying seemed urgent. Experiencing the feeling of the crowd, and the force of the music, blew me away.

Patti Smith, Paradiso, Amsterdam, Netherlands, October 1976

A few days later, I was in Amsterdam to catch Patti Smith at the Paradiso. From there I made my way to Paris for a few wonderful days with Kris, taking him around the city, and then it was back to London for Aerosmith at the Hammersmith Odeon.

I flew back to New York City on October 18 and made my way directly to the party being thrown for the opening of Led Zeppelin's concert movie, *The Song Remains the Same.* I was among the crowds of people waiting outside as the band arrived, and I had to think quickly if I was to get any decent photographs. There was a car parked next to me. I jumped onto it and was getting some great shots when suddenly I heard a cop yelling at me to get down. It turns out I was standing on a police car!

RIGHT PLACE, RIGHT TIME

Kris Gruen and Bob Gruen, self-portrait,
Paris, France, October 1976

Steven Tyler, Hammersmith Odeon, London, England, October 17, 1976

The Song Remains the Same film premiere, New York City, October 19, 1976

A few weeks later, I got a call from *Music Life*, Japan's largest music magazine. I had met them when I went to Japan with Yoko, and I had been given several assignments since. The Bay City Rollers were coming to Japan in December. *Music Life* said they would advance me money for the plane ticket and hotel if I could guarantee that I would have full access to the band. So, I checked with the band's manager, Tam Paton, and he said, "Yes! We'd love to have you."

I went, and it was a lot of fun. We were staying at the Hilton Tokyo hotel. The place was surrounded by thousands of kids, up to eight thousand young fans. At night, the crowd would dwindle down to about three thousand, but during the day we would be surrounded by kids, all singing Rollers songs, fantasizing about the Rollers, and checking out each other's outfits. The Japanese kids were very creative and had the best Rollers outfits.

I don't recall where we were headed, but one afternoon we were traveling by bus, and I was showing the band some of my videotapes from Max's Kansas City. I showed them a rough edit that we made of the New York Dolls videos; then I showed them Blondie, Jayne County,

RIGHT PLACE, RIGHT TIME

Patti Smith, and all those bands that I had been recording at Max's. I just remember thinking how funny it was that the Bay City Rollers, who many people consider to be one of the squarest bands in the world, were sitting in a bus in Japan, happily watching some of the hippest bands in the world, straight from Max's Kansas City.

I also met one of the most extraordinary people in my life on this tour. I was in my hotel around eight thirty one night when I got a call from someone who said, "I am Mr. Gan. I'm a friend of Yuya." Yuya was out of town at the time, but had asked Gan Murakami, a Tokyo club owner, to meet me and take me to dinner. I went down to the lobby and I met a very impressive guy, short but as solid as Muhammad Ali. We took a taxi to the restaurant and, on the way, Gan-san asked me what I thought of Japan. I told him I was fascinated and I wanted to come back and stay there. I was hoping someday I could stay in a monastery and learn about Zen thinking.

He said, "You can learn about Zen in the back of a taxicab." It hit me like an epiphany. Zen is basically being aware of the present. And that's a truth you can discover no matter where you are.

I returned to New York City in time for Christmas, and on December 31, New Year's Eve, I met Pati Giordano.

I hesitate to call her my girlfriend, although ultimately we were together on and off for the next twenty years. It would be more accurate to simply describe her as a part of my life at that time, for better and for worse. Pati was very punk—a pretty girl from New Jersey who cursed like a sailor and got even with anybody who pissed her off. We went to see Evel Knievel, the motorcycle daredevil, once; he was doing a signing, and one of his stories was how he had broken sixty-three bones in his body in the course of his career.

Pati wasn't impressed. She walked up to the table where he was sitting, all five foot two inches of her, and told him, "I've broken sixty-five." And it was true. She had. Pati was twenty when we met, I was thirty-two, and our relationship was crazy. We would fight for five days and then make love for five hours. She lived next door to a police station, and the cops would regularly come over to break up our fights. She took off her high-heel shoe once and hit me on the head with it. I ended up

with four stitches. We'd be pogoing and choking each other punk-style, but we weren't kidding. We were actually choking each other.

I tried so many times to break up with her—at one point, I simply stopped answering the telephone when she called, or hung up the moment I heard her voice. That ended three months later, when she told me, "If you want to hate me, that's fine, but you're in my life and you can't get out."

She said something similar about ten years later. Dee Dee Ramone was living with her at that point, but she insisted there was nothing going on between them. "He's a junkie. We're not having sex." I wasn't so sure; there was only one bed in the apartment, so one day I asked Dee Dee himself. "Well, I'm living with her," he said. I asked Pati, "Am I your boyfriend or not?" She put on the sweetest, dreamiest voice and said, "You're not my boyfriend. You're my man." I laugh now, but there were a lot of times I wished she would leave me alone.

At one point she moved to London to be with the singer from the band Killing Joke—they were even engaged to be married. At last, I thought, I was free. Shortly after she moved there, I was visiting London

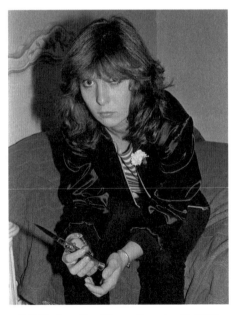

Pati Giordano, New Orleans, November 11, 1977

RIGHT PLACE, RIGHT TIME

myself and hoped that I would not run into her. I assured myself that, in a city of eight million people, that was highly unlikely. I was walking up Tottenham Court Road . . . and there she was! Making her way home from the hospital where she'd just had bandages removed from a broken nose. She had said something to one of her fiancé's bandmates, and he had punched her in the face. She broke off the engagement soon after.

Pati is another one who is no longer with us. In 1986, she contracted AIDS, and nine years later, I took her to the hospital where she died at the age of thirty-nine.

EVERYTHING WILL BE ALRIGHT

John and Yoko and Allen Klein • '54 Buick • Blondie •
John and Yoko, Merce Cunningham, James Taylor, and
Carly Simon • Led Zeppelin • Mick Jagger and Andy Warhol •
Riko Kitamura • KISS • Debbie Harry

ONE MORNING IN EARLY JANUARY 1977, JOHN
called me. And when I say "one morning," I mean it. I looked
at the clock—it was barely 3:00 A.M.

"Are you busy?"

"No," I told him. "It's three in the morning."

He wanted me to meet him at the Plaza Hotel. The Beatles were in
their final negotiations with Allen Klein, the shrewd accountant who
had been looking after their interests since the death of their manager,
Brian Epstein.

John was the only Beatle there; Paul, George, and Ringo had all sent lawyers. John told me that the original agreement between Klein and the Beatles had been three paragraphs on a single piece of paper. Now it was going to take an eighty-seven-page legal document to dissolve.

Allen Klein (center, with pen), John Lennon, Yoko Ono, and lawyers, Plaza Hotel, New York City, January 8, 1977

The negotiations went on through the night; at one point, Allen Klein went to Zabar's to get breakfast for everyone—bagels, lox, the works. Finally, the deal was done and, at dawn, they signed the papers. Klein then produced a large loaf of bread and placed the contract on top

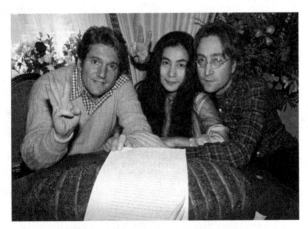

(Left to right) Allen Klein, Yoko Ono, and John Lennon, Plaza Hotel, New York City, January 8, 1977

of it. I'd been taking pictures all night, including one of Allen signing, and John behind him with a huge grin. But this one was the most telling, Klein "splitting the bread" with John and Yoko. It was later used in the press release announcing their settlement.

It was early morning before we got out of there, and I offered to drive John and Yoko home. "You're going to love my car."

I had only bought it a few months earlier. I was looking for something inexpensive, and my brother David told me that he would keep an eye out for me. One day he called to say he'd found the perfect car. He was going to college on Long Island, and one of the girls in class mentioned that her father was looking to sell an old car he'd bought for her mother, which she had never driven.

Apparently she suffered a stroke. The car had only been driven to church, just to keep the battery charged, and this had been going on for twenty-two years. He wanted three hundred dollars for it.

"And what kind of car is it?" I asked, expecting the worst.

"A '54 Buick."

"What color is it?"

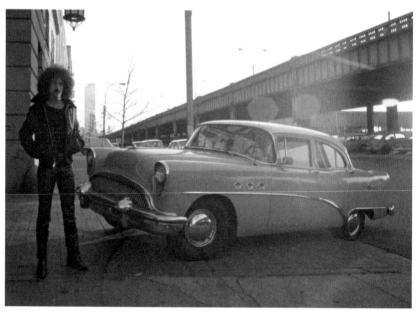

Bob Gruen, Westbeth building, New York City, December 1976 (photograph by Karen Lesser)

RIGHT PLACE, RIGHT TIME

"Blue, with a white top."

"I'll take it."

Only then did I ask him how it ran. It was a blue '54 Buick. And it was mine for three hundred dollars.

Those monthly trips to the church had put a few miles on it, twenty thousand to be precise, but when you think that's less than a thousand miles a year . . . how fantastic was that?

John looked at my fifties dream machine. "Should we all jump in the front, like in a teenage movie?"

Of course!

He asked what I'd been doing recently, and I told him about the Bay City Rollers, who I knew wanted to meet him. I asked him if they could. I was going to see them that night at the Palladium. John said, "Tell them that if they're still around in five years, I'll meet them." I asked if he had any advice he could share with the Rollers. Reflecting, I think, on the events of the previous night, he said, "Tell them they should get as much money as they can in their own name now."

One of my first big jobs in 1977 was producing a three-song video of Blondie for use on *Don Kirshner's Rock Concert*. Normally the show was taped live in Los Angeles. Blondie's schedule was full when the offer came in, with their second album, *Plastic Letters*, about to be released, so the band proposed a different solution. We would tape a performance in New York City, and send that along.

Kirshner's people agreed, and on January 26, Richard Robinson and I met the band at the MPCS (Motion Picture Camera Supplies) studio and filmed them performing three songs in front of a huge blowup of Debbie's face, made from a Polaroid taken by her neighbor, fashion designer Stephen Sprouse.

In order to be shown on network television, we had to deliver a high-quality two-inch master tape. There was no way we could afford that. Instead, we used less expensive three-quarter-inch tape. Then we went to the CBS studios, where, due to recent technical advances, we were able to convert to a two-inch master. It was one of the first times three-quarter-inch tape had been used on a broadcast television show.

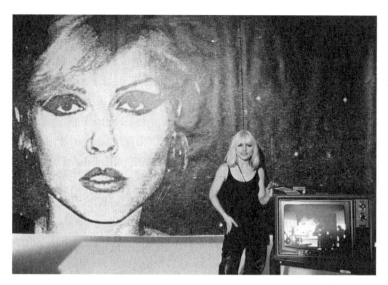

Debbie Harry, MPCS studio, New York City, January 26, 1977

My nights around this time were nothing if not varied. Yoko called me up one day to ask if I had a suit, and would I like to join them at the opening of Merce Cunningham's new production at the Minskoff Theater. I knew nothing about modern dance, but I thoroughly enjoyed the evening.

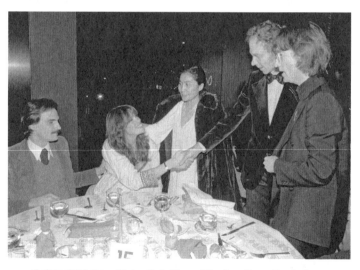

(Left to right) James Taylor, Carly Simon, Yoko Ono, Merce Cunningham, and John Lennon, New York City, January 1977

For all the time I was spending at places like CBGB and Max's, I was still doing a lot of work with major headliners. There was more with the Rollers—gigs in Philadelphia, Florida, and California (I got home from that trip just in time to catch six nights of Zeppelin at Madison Square Garden). I photographed Queen, Boston, the Kinks, and the Electric Light Orchestra. I shot Lou Reed and Bryan Ferry at the Bottom Line, and the Rolling Stones press conference with Andy Warhol at Trax.

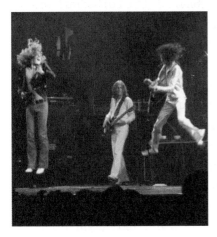

Led Zeppelin, Madison Square Garden,
New York City, June 1977

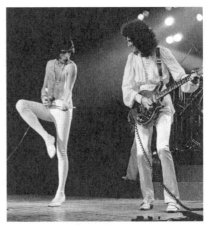

Queen, Madison Square Garden,
New York City, February 5, 1977

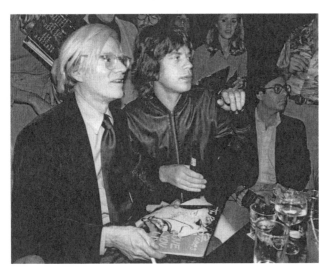

Andy Warhol and Mick Jagger, Trax, New York City, September 1977

I went on the 1977 KISS tour of Japan. It helped that I was feeling more at home in the country; I knew my way around, and I had friends who I contacted as soon as we touched down. Riko joined the tour as my assistant, and even had her hair permed so that we had the same hairstyle. I reconnected with friends like Yuya and Gan-san; and Rino, the translator from the Dollettes tour.

Riko Kitamura and Bob Gruen, Japan, spring of 1977

The tour opened with two nights in Osaka, March 24 and 25. It was going to be a hectic tour for me. There were ten journalists accompanying us on the tour, all writing for different magazines in different countries. I was hired as the photographer for all of them, meaning I had to supply different, exclusive pictures to each magazine, which I would also have developed and printed in Japan.

I had my network of friends to thank for making that job a lot easier than it might have been—the lab that I was introduced to on that trip would remain my go-to place for many trips after. KISS was unlike any other band on earth—since they only existed as a band when in makeup. Shortly before each show, when they were finished with their makeup, the band and I created moments to make it look like they were KISS all the time.

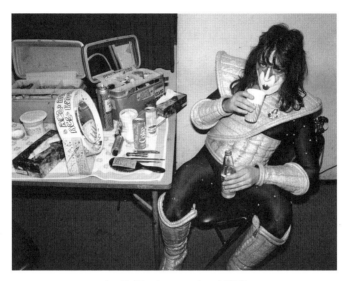

Ace Frehley, Japan, spring of 1978

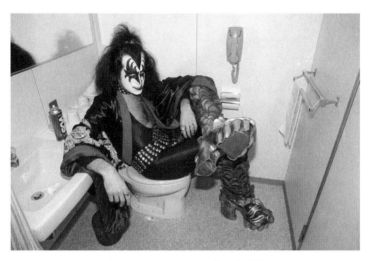

Gene Simmons, Japan, spring of 1977

Gan-san threw a party for KISS at his club in Fukuoka. He and a friend of his, Rikiya Yasuoka, were going to put on a demonstration of Iaido, a martial art sword meditation technique.

Gan-san asked Paul Stanley if the band might like to jam while they were there—the stage was set up. "We don't jam," Paul told him. "We play our music. We don't play anything else."

Osaka was where I first saw Japanese kids dressing up as KISS—but not in replicas of the band's outfits. They were coming up with their own versions. Some of the fans took me around town, showing me the sights. I had my palm read by an old woman that night, under a bridge in the pouring rain. She told me to keep doing what I am doing, and everything will be all right.

KISS fans, Japan, spring of 1977

From Osaka, we moved on to Kyoto, which was the ancient capital of Japan. The magazine *Music Life* had arranged to produce a special issue featuring KISS in Japan. We had to show that we were in Japan and not just in dressing rooms.

I hired a cab and spent the day being driven around Kyoto, scouting locations. I took Polaroids that I showed to the band that night. The following day, with the same cab driver leading the way, KISS and the journalists piled onto the bus and we made our way to the first stop, a massive Buddha statue.

The band got out and I started taking photographs. Everything was going really well. A busload of school kids arrived, and Gene beckoned them over to stand with the band. It was at that point we were told that this was a very sacred shrine for the dead and we were disrupting the peace.

KISS and Japanese children, Kyoto, Japan, spring of 1977

We apologized profusely and left.

Our next stop was the Golden Pagoda, a Zen Buddhist temple. By now we had attracted a lot of attention. People passing by could not believe that KISS was actually on the street, in the middle of the day, and they wanted to tag along and find out what was happening. As the bus left for the next destination, I watched a lot of cars form an orderly line behind us. There must have been fifty vehicles and, when we reached the shrine, there were even more.

KISS, Kyoto, Japan, spring of 1977

Gene Simmons and fans, Kyoto, Japan, spring of 1977

Marching around with so many people trailing after me, I felt as though I'd been promoted to general of the KISS army. The photos came out great; the band loved them and so did the magazine. In fact, when KISS flew home on April 5, they paid me to stay in Japan and work with *Music Life*. I remained in Japan for close to another two weeks. I got to see Cyrinda when she came to town to promote Warhol's *Bad* movie, which she was in, including an appearance on the shows where Rino was the break girl.

The "break girl" is one of the institutions of Japanese television; whenever a show went to commercial, instead of simply fading out as they do in the United States, they show a short sequence of a beautiful girl posing for the camera.

Rino found herself at the center of a media storm when it was reported that she'd spent the night with Gene Simmons after I had introduced them. She had never experienced anything like it. People were both outraged and fascinated by the latest gossip. Rino didn't know how to react on her live TV moment. She called me to see if I had advice. I told her not to look embarrassed, to look right at the camera to show them it was none of their business.

Back in the United States, I flew with KISS and Marvel Comics publisher Stan Lee to Buffalo. Marvel was producing a KISS comic book,

and I was on hand to capture the most dramatic part of the printing process. KISS added vials of their own blood to the red ink being used to print the comic!

In August, I went to Coney Island with a crowd of downtown musicians for *Punk* magazine's *Monster Beach Party* novella. Roberta Bayley was shooting a story featuring Joey Ramone saving Debbie Harry from aliens. I just went along because all of my friends were there. They asked me to be in a scene as a biker fighting off the aliens. Life was chaotic, fast-paced, and full of surprises.

**Debbie Harry, Coney Island,
New York, August 7, 1977**

ANARCHY IN THE UK

*The Heartbreakers • The Sex Pistols • In Blue Plastic •
The Clash*

I RETURNED TO LONDON IN OCTOBER 1977 TO EXPLORE the punk scene. In the year since my last visit, it had exploded. Back then, you could count the number of punk bands on one hand. Now, there were dozens, and more forming all the time.

I was staying with Sheila Rock. As soon as I got there, she told me, "You're just in time. We're going to see Robert Stigwood about Don Letts's movie." Sheila and Don explained on the way there. Someone had given him a movie camera and he sold off his Beatles collection and used some of the proceeds to pay for film and processing. He had documented the London scene as a fan shooting film for fun. Sheila convinced him to splice together the raw footage and see if someone would pay to make a film.

The footage was rough, but it was eventually edited and became a great film, filled with gripping footage of the Pistols, the Clash, the Slits,

Jayne County, the Heartbreakers, the Banshees, and more. This was the start of Don's filmmaking career that led to a stream of films and documentaries, including the Clash's Grammy Award–winning *Westway to the World* and, in 2011, *Rock 'N' Roll Exposed: The Photography of Bob Gruen*!

I visited Vivienne and Malcolm's boutique, now renamed Seditionaries, where I bought the oddest pair of shoes I have ever owned (green canvas and brown leather), then walked the few blocks up Kings Road to Oakley Street, where the Heartbreakers had a house. I wanted to show off my new shoes!

I got to the house to find Don Letts was also visiting, dropping off some pot. Chrissie Hynde was with him.

(Left to right) Walter Lure, Billy Rath, and Johnny Thunders, London, England, November 1977

We were sitting around talking when Johnny suddenly asked, "Why don't you guys come with us for the weekend? Just get on the bus. It won't cost you anything. I'll get you a hotel room overnight, and you can come to the gigs." And we figured, what the hell, why not?

I was sitting with Don, watching the Heartbreakers divide up the pot. They had got an ounce from him, and immediately they split it into quarters, and each went back to their own seat on the bus to roll a joint and smoke it by themselves. Don explained that most bands that he knew would have communal pot—they would roll up a bunch of joints

and share them. These guys were all off by themselves. I said, "Well, that's what the heroin will do to you."

We got to the first venue, some damp English club, and we were sitting in the dressing room watching Jerry trying to fix up a shot for himself. His needle wasn't working well, and it struck me how sad this was. Jerry looked around the room and asked, "Does anybody else have any works? Anybody got a needle that works?"

One of the support bands was there with us, a bunch of kids who couldn't have been more than sixteen, seventeen years old. They weren't into dope, but one of them had a syringe attached to his jacket like a pin. It didn't even have a needle, but he took it off and handed it to Jerry. "Is this okay?"

Jerry was looking at it, squinting. "Nah, this ain't no good." He handed it back to him, and Chrissie and I were so disgusted by this entire scene that we went out into the back alley. I took out the flask of cognac that I always used to carry and offered her a sip. This was the first time we actually talked to each other. I asked, "Who are you and what are you doing here?" That's when she told me her story; that she was from Ohio, living in England and writing for the *New Musical Express*. Chrissie was also thinking of starting a band, and talking with her, it was clear that she knew exactly what she wanted to do.

She was grousing about how the Heartbreakers were a bunch of junkie wimps. She said, "I could do this better than them," and I replied, "Well, why don't you?"

Like the Heartbreakers, the Pistols were also gearing up for their album launch, and one day Malcolm asked if I wanted to join them on a visit to Radio Luxembourg, for an interview. I met up with the Pistols at Heathrow at eight in the morning. Johnny was late, so there was a debate over whether or not we'd actually make our flight. He got there in the end and I started taking pictures as soon as we were aboard the plane for the short flight over.

We landed in Brussels around noon. The radio people were there to meet us, and the first thing they did was take us all to a bar to get to know the deejay, before we went to the radio station. The Sex Pistols were the kind of band that knew how to pose together. Noticing them

(Left to right) Johnny Rotten, Sid Vicious, and unknown little girl,
plane from London to Brussels, November 1977

sitting side by side, I got up to take a photo. Johnny caught the movement, and promptly pulled the drinking straw out of his glass and stuck it in Sid's ear. The rest of the guys immediately got the joke and joined in.

Finally, it was time to head for the radio studio, a large, dark, and very imposing building that they told us had been used as the local headquarters of the SS during World War II, which certainly gave it a rather eerie vibe. They took us down to the basement to show us the old cells.

Sex Pistols, Luxembourg,
November 1977

Sex Pistols and Bob Gruen, Luxembourg,
November 1977

Back in the lobby, waiting for the elevator, I grabbed the opportunity to take some more photos. I did that whenever I saw the band all together in one place, because they really weren't the kind of band that would pose for group shots if you asked them. Steve saw me taking pictures and unbuckled his belt and dropped his pants, revealing a large dark stain on the front of his underwear. One of the receptionists called security. Before we even got into the elevator to go upstairs, we were almost thrown out of the building.

There was a big argument between security and Malcolm's assistant, Sophie Richmond, over whether or not we would be allowed upstairs for an interview that was due to start in just a couple of minutes. Sophie prevailed, the band did the interview, and we headed back to the airport. We got through security and customs without a problem, into the departure lounge. All the alcohol that had been consumed through the day, beginning on the plane, then in the bar in Brussels, and during the journey back to the airport really started to show. Everybody was staggering drunk. The staff at the gate took one look at us all and said no. We wouldn't be allowed on the plane.

They wouldn't allow us back through security either. The airline was saying we can't board the plane, the airport was saying we can't stay, back and forth. We were just drunk guys in the middle, wondering,

The Sex Pistols, London, England, November 1977

"Where are we going to spend the night?" After a while, they let us on the plane. We flew back to England and had a car pick us up at the airport, a Daimler stretch limo. I was struck by the contrast—a group of raunchy punks being driven around in an ultra-luxury Daimler.

I really wanted to see the Clash play again. I called their record company, CBS, who told me that the band was very difficult to work with, because they wouldn't communicate with them. The label couldn't even supply me with any passes for the show. I told them I would buy a ticket on the sidewalk if I had to, and they told me the Clash would be performing at the Glasgow Apollo Theatre, and which hotel they were staying at. I took the train to Glasgow and, as I was checking in at the hotel, Mick Jones and Paul Simonon were there at the reception desk, asking for something. Later, Joe told me that they saw me getting out of the taxi, and not only did they not recognize me, they were all stunned at what they saw!

"What the hell is that?" Mick and Paul promptly decided to go down to the lobby to find out.

I don't blame them. I had big hair, and I was wearing a bright blue plastic parka that I'd gotten in Japan. I also had the blue plastic pants from Paris, because they kind of matched the parka, and giant blue plastic moon boots that I bought in New York City. They were so light and warm. I looked like a science fiction spaceman.

I walked in, and that's when Mick recognized me from Club Louise a year earlier. "You're the guy from New York, right?" I said I was, and I'd come to see them play. He took me to their road manager, and he got me the photo passes that I needed to get into the show that night. Afterward, I went back to my hotel. I still didn't know the band, and I didn't connect with them after the show. I decided I would go on to their next gig, which was in Edinburgh. I found out later, after the Glasgow show, the police had been pushing some of their fans around at the back of the theater. Joe and Paul intervened, and were arrested for interference.

When I got to Edinburgh, the first thing I did was visit the castle. I discovered that just down the street there is a camera obscura, a building with a room on top that has a periscope-like mirror, which reflects the outside world onto a table in the room inside. It's a remarkable thing.

Bob Gruen, Crocodile, Tokyo, Japan, December 1979

(Left to right) Mick Jones, Joe Strummer, Topper Headon, and Paul Simonon—
the Clash, Clouds, Edinburgh, Scotland, October 26, 1977

You're looking at what you think is a picture, but the smoke coming out of the chimneys is moving and the little cars on the road are driving. It looks like a still picture, but it's alive. Camera obscuras date to the Middle Ages, and there are very few of them left in the world.

And then I saw the Clash again.

By that point, I knew the road manager well enough that I was able to get a ride with him down to Leeds the next day where Lester Bangs showed up.

Lester was, and remains, one of the legends of American rock journalism. He wrote for *Creem* magazine, and he had been sent over on a press ticket to see the Clash. We were on the balcony and feeling really excited because this was the exact same place where the Who recorded *Live at Leeds* in 1970, which is one of the all-time greatest live albums. And, even better, we were there to see the Clash.

The audience was a seething mass of drunken humanity, and completely into the Clash. At one point in the show, Joe Strummer started saying, "No more Queen Elizabeth!" and they all cheered. Then he said, "No more Beatles!" and they all cheered. "No more Led Zeppelin and Rolling Stones!" Cheer! And then he said, "but John Lennon rules, okay!" and they all cheered again.

Those words gave me chills. I turned to Lester and said, "Lester, John Lennon's okay? Everything else is bad, but they like John Lennon?"

I knew that the punks disavowed most of the music that had come before; that few artists escaped their disdain. John was the original punk? I felt so proud for my friend. The punks hate everything, but they love John! It was a good moment, in very strange surroundings. The Who's *Live at Leeds* was an icon, a classic above all classic albums. When you've been listening to it for seven years straight, you build a picture in your mind of the venue, which was the University of Leeds; of how that, too, must be glorious.

Then you get there, and it's got a linoleum floor like a school cafeteria, old-fashioned chandeliers hanging from the ceiling, and it's not even all that big. It wasn't even an auditorium, it was just a hall, a big open room. I imagine it's the same feeling that Japanese bands got when they arrived at CBGB in a limo and found out it was really a dump.

Being at Leeds was not exciting. Seeing the Clash play live at Leeds was very exciting.

I think the big difference between the Clash and the other bands was not only how they played and what they played, but also how they treated their fans, which was with total openness. A lot of bands get onstage and say, "We love our fans, and our fans are why we're here," but they don't really want to meet them. The Clash invited the fans to come back and talk to them.

Most bands want privacy after the show, and most bands don't let just anybody come backstage. They'll let people from the record company come back because they've got to make a living. They'll let the deejays come and say hello to them. If they see a pretty girl, they might let her come back. But generally they don't just open the door to random fans.

The Clash made a point of letting anybody in, and they took the time to wait for those kids and stayed up at night listening to them. They did that at every show I ever went to. They even did it at Shea Stadium, where they had sixty thousand fans and there were a hundred kids lined up to come back to the dressing room. I remember Kosmo Vinyl, the road manager, actually arguing with the Shea Stadium security, explaining to them that no, they were not going to keep the fans out. Yes, they wanted the fans to come back. And when the fans came back, the band was open to them.

When I was researching my Clash book, Paul Simonon mentioned that, in the early days when the fans would come backstage, everybody wanted to talk to Mick, and they weren't really talking to Paul or Joe. One day Paul and Joe went over and asked Mick, "What's up? Why do you think the fans are talking to you and they're not talking to us?" And Mick said, "Well, you're always looking like you're upset, and you're always scowling, and you look mean, and it puts the people off. If you smile a little more, maybe the people will talk to you."

After that, Joe started smiling and being more open, so the fans started talking to him, whereas Paul did the opposite. Sometimes he didn't really want to talk to anybody, so he'd start scowling even more and he said it worked. It kept everybody away from him. I was one of

those fans that they let backstage and that's how I got to meet the band, and I started to get to know them.

I returned to New York City in November. Before I left, I made arrangements with Malcolm to meet up with him and the Sex Pistols when they arrived in New York City for the beginning of their long-awaited U.S. tour. Their first engagement was to be an appearance on *Saturday Night Live.*

ANARCHY IN THE USA

Sid Vicious • Johnny Rotten • Ray Davies • Kim Fowley

THE SEX PISTOLS U.S. TRIP WAS DELAYED BY VISA
problems, and the *Saturday Night Live* appearance was
canceled—which was great for Elvis Costello and the Attractions,
because Malcolm suggested the show book them instead. That was their
introduction to the American audience and, if you ever watch footage of
their appearance, the drummer is wearing a T-shirt that says, "Thanks
Malc."

Ultimately, the Pistols tour would start in Atlanta. I flew down
there on the day of the gig with just my camera bag, planning to get
a late-night flight home, and made my way to the show. The venue
he found for the band to start the tour was a converted Chinese
restaurant in a strip mall that usually hosted local bands or country
music acts.

But that's what Malcolm wanted. He wanted them to play in places
where the locals had never seen anything like them; where they hadn't

seen the Ramones and hadn't heard of the New York Dolls. A completely new audience.

I was surprised by the press response. Yes, my picture of Johnny had made the cover of *Rolling Stone* back in October—it was one I'd taken in their rehearsal room on Denmark Street the previous year, but I was not expecting so many journalists to have made the trip to Atlanta.

I wasn't the only New Yorker in town for the show; there were people there from the *SoHo News*, the *Village Voice*, and *Rolling Stone*, and the music critics for both the *New York Times* and the *LA Times* were there. I watched the show, took some great photos and, after it was over, went out to the parking lot to say goodbye to Malcolm as everyone was getting on the bus. "So long, I hope you have a great time. I'm sure you're going to have fun. Too bad I can't come."

Malcolm said, "There's only room for twelve people on the bus. There's the band and the roadies and Sophie and me . . . that's only eleven, Bob. So why don't you get on the bus?"

What?

Picking up on my uncertainty, photographer Joe Stevens, who was photographing for the *New Musical Express*, said he'd get on. Malcolm said, "Sorry, Joe, but Bob's already asked first." I didn't remember actually asking. But I figured what the hell.

Malcolm told me he would get the record label to cover my hotel rooms and a per diem. It looked like I was in for the whole trip, although it very nearly ended less than two days later. We were in Baton Rouge, and we'd all gone out to a strip club after the show. I remember seeing one of the most beautiful strippers I've ever seen in my life . . . being picked up at the end of her shift by one of the biggest, baddest-looking bikers I've ever seen in my life! The following morning, I woke up late, very hung over, only to discover that the bus had left without me.

I stepped out of my room to see Sid Vicious and John Tiberi, known as "Boogie," the Pistols' English road manager, walking across the parking lot. Apparently, Sid had gone off with some girls after the show, and his bodyguard had gone with him.

Now, these bodyguards were big guys. Biker types, rough and tough with long hair, big boots, and hunting knives on their belts. Sid was

impressed with them and their knives. Sid was playing with this guy's knife, stroking it down his arm to see if he could cut the hairs with it, and instead he cut himself, a wound about about three inches wide, and an inch deep.

He wound up at the hospital, and for whatever reason, the hospital refused to treat him. He came to the hotel with a gaping wound in his arm.

Sid Vicious, January 1978

I flew with them to the next gig in Memphis. By the next night, Sid's wound was looking bad. I was afraid it would become infected, and I was sick of looking at it. Nobody else seemed to care, so I told him, "Let me fix that." From my boy scout training, I was always good at first aid, and I like to fix things.

I washed out the wound and I cut some adhesive tape into little butterfly stitches, covered everything in antiseptic, and then I pulled

the two sides of the wound together, stitched it up with the tape, and put a big bandage over it to keep it covered.

Baton Rouge was where Malcolm made an unfortunate business decision. He knew I had video equipment at home; he wanted to know whether I could have my assistant fly out with it, so we could start to record some of the tour. I told him we could, but it would be even quicker, and probably cheaper, if we just bought a Super 8 movie camera and some rolls of film, and for less than a thousand dollars, we could have had a record of the entire tour, onstage and off, on the bus, at the hotels, wherever.

Malcolm thought about it for a moment, thought about the cost, and then said, "Nah, this isn't so important. We'll do it on the next tour."

Time on the bus was pretty mellow, most of us were drinking beer, peppermint schnapps for Sid. The band played Don Letts's reggae mixtapes and Sid especially liked Dr. Alimantado's song "Born for a Purpose (Reason for Living)" and played it repeatedly. Between Austin and Oklahoma City we ran into a hailstorm, four or five inches of hailstones on the ground, and none of the band had ever seen anything like it.

We stopped at a truck stop and I found starter pistols for sale—these were basically a regular .22 caliber pistol with a screw through the barrel, so you couldn't actually shoot a real bullet in it. It could make a very loud bang. That's how Boogie and I occupied some of our drive time, by playing cowboys, sheltering behind the bus seats, and taking shots at each other.

Not only drive time, either. The band was doing a sound check in Oklahoma, and Boogie was at the mixing desk checking the levels. He was completely engrossed in the matter at hand, so I dropped to my knees and started crawling down the aisle, ready to jump up in front of the board and surprise him.

My gun was in my hand, and I was just about to leap out when I saw this pair of very shiny shoes just a few feet in front of me. Above that, there were a pair of absolutely straight, perfectly pressed pants and a giant gun hanging on a holster. I was looking at an Oklahoma state trooper. I froze and showed him that it was a toy.

Oklahoma state trooper, Bob Gruen, and Sid Vicious, Tulsa, Oklahoma,
January 12, 1978 (photograph by Lynn Goldsmith)

I was wearing a pair of steel-toe engineer boots I'd bought from the army and navy store on Christopher Street. Johnny Thunders had asked me to get him a pair, and I'd decided to get a similar pair for myself. Sid wanted them, because he'd seen Johnny wearing them. I was taking a nap on the bus, with my boots on the floor beside me. When I woke up, Sid was wearing my boots, and his boots, a pair of English paratrooper boots, were sitting on the floor where mine had been. What I found out later was, while I was sleeping, Sid had pulled his knife out and held it to my throat, then turned to Johnny Rotten and said, "If I kill him, I can keep his boots." And Johnny didn't say anything! He watched just to see what would happen. When I woke up Sid was wearing my boots.

He said, "Do you mind if I try your boots for a while?" I told him to go ahead. In fact, it was a relief to not be wearing them. I'd been at a show, trying to get a little height to take pictures over the crowd, and I'd put all my weight on one of the toe caps. It bent just enough that, when I stepped in a certain way, it would cut into the top of my foot. Sid's boots were the same size as mine, nicely broken in, and they didn't carve my foot up. I wore Sid's boots for the remainder of the tour.

To my surprise, all three of the other Sex Pistols individually came up and told me, "Don't let Sid push you around. We want you on the bus. If you want your boots back, just tell Sid to give them back. You don't have to let him keep your boots to stay on the tour."

When we got to San Francisco at the end of the tour, we found a store that was selling the exact same engineer boots as mine. I pointed them out to Sid; "Look, why don't you get a new pair for yourself? You can break them in for your feet and they'll be perfect for you." And he said, "No, I want to keep your boots, but I'll get you a new pair." So he bought me a brand-new pair and I came home from the tour with my boots *and* Sid's boots. Somehow, my original boots ended up in a museum of criminality in England, in a vitrine labeled "Sid Vicious's boots."

Somewhere in Texas, two girls from California showed up. Oddly enough, I had met these same girls once before, when they came to New York City. Very punked out, one of them even had a T-shirt modeled after Richard Hell's famous "Please kill me" shirt, with a target on it. And they were so rude and nasty that I remembered them very well.

It was back in July, the fifteenth to be precise, at CBGB. David and I had been to see Frank Sinatra at Forest Hills, and we were still wearing the forty-dollar leisure suits that we'd picked up for the occasion. The girls came in, and they were already putting everyone else down for not looking "hip" enough, or "punk" enough, and then they saw me and started to make fun of my suit. They were so obnoxious to so many people that nobody would take them home.

In the end, I let them sleep on my living room floor, so as soon as they saw me with the Pistols, we were old friends. But Noel Monk, the U.S. tour manager, wouldn't let them into the hotel, and when we got up the following morning, we'd found they'd painted graffiti all over the bus. They had spray-painted phrases like "Anarchy in the USA" and "We're so pretty."

The Pistols did not have a show booked in Los Angeles, but they wanted to stop there. First we stopped at a motel in the Valley. Very early on, Noel had realized that the media would have the names of every place the record company had booked us into, so he always made sure we stayed someplace else. We had reservations in decent hotels,

but Noel would stop at whichever motel was near the venue, hide the bus behind the back, and book us into the cheapest available rooms. The first thing we had to do, believe it or not, was wash Sid.

I have never met anybody with such low regard for personal hygiene. Incredibly, he hadn't taken a shower all tour long. The roadies decided that he had to wash before we went into town, although Sid was so drunk that he couldn't do it himself. They laid him on the bed, took his clothes off, lifted him up, placed him into a tub. I took the bandage off so it wouldn't get soaked, and cleaned out the wound again, although thankfully it seemed to be healing nicely.

We went to the Whisky, and inevitably we ran into Rodney Bingenheimer and Kim Fowley, who cruised the strip every night, just to see who they could see. And for some reason, Ray Davies happened to be there as well.

Sid Vicious and Ray Davies, Whisky a Go Go, Los Angeles, January 1978

The following day, we made our way to San Francisco, with Noel planning to check into a no-name motel on the other side of the Bay, in Berkeley. But the label had us booked into the Japanese Miyako Hotel, which was one of my favorite hotels, and that's where I went. It was the end of the tour. If there was a room with my name on it at the Miyako,

(Left to right) Kim Fowley, Johnny Rotten, and Sid Vicious,
Whisky a Go Go, Los Angeles, January 1978

that's where I was going to enjoy the deep hot tub that came with every room and the great Japanese food. The next thing I knew, everybody else was mutinying as well, and we all ended up at the Miyako.

Nobody guessed that this would be the last Sex Pistols gig of all, and Johnny's final words of the night, "Ever get the feeling you've been cheated?" were to become their obituary.

I ended the Sex Pistols tour sitting in a large Japanese bathtub, thinking, "I've got to go home." And the following morning, I picked up the phone and made one of my favorite phone calls. I called the concierge and asked, "What time is the next plane to New York City?"

I couldn't relax once I got home. I had somewhere in the region of seventy rolls of film that needed to be developed; that took an entire day, followed by another night and day of printing pictures. The city was at a standstill because of a blizzard, so that's what I did, that's all I did. And in the midst of this, the phone rang, and it was Sid.

From San Francisco, the Pistols were meant to go to Rio, to record a single with Ronnie Biggs—one of Britain's Great Train Robbers from back in the 1960s, who had escaped jail and holed up in Brazil. It was a ridiculous idea, but Malcolm knew the publicity that it would create, so that was his plan. Except Johnny didn't go, and it turned out that Sid

Johnny Rotten and Bob Gruen, January 1978

didn't go, either. He stayed on in San Francisco for a day or two, and then took a flight back to England.

He didn't make it. The drugs he'd been taking caught up with him and he passed out mid-flight. The plane had to land in New York City to transfer him to the hospital, and that's where he was calling from, because he knew I had a car and he wanted me to pick him up. But there was more than two feet of snow on the streets, and there was no way I could drive anywhere. Shortly after that, they put Sid on a plane back to England.

At last it stopped snowing, and I could leave the house. I walked to CBGB and found Johnny Rotten sitting at the bar. He'd made his way to New York City, where he was staying with Joe Stevens. He asked if I'd heard the news.

I replied, "What news?" so he undid his jacket and showed me his T-shirt. At the end of the tour, we'd all been given shirts by Warner Bros., emblazoned with the words "I survived the Sex Pistols tour." And underneath, on his shirt, Johnny had written "but the band didn't."

I asked him what that meant?

"We broke up, mate."

I was shocked. I realized, all those photographs that I'd taken, and all the hours I'd spent developing and printing them, would be for nothing. I'd been envisioning the Pistols going on and on . . . more records, more tours, more controversies, and selling my pictures for every single one of them. Instead, they would be given a postage stamp–size obituary and that was it.

I went home, I took all the pictures I printed and all the slides I developed, and I put them in a bottom drawer in my filing cabinet, and that's where they stayed for the next eight years. It wasn't until English

Sid Vicious, San Antonio, Texas, January 1978

film director Alex Cox made the film *Sid and Nancy* that people started to be interested again. Gary Oldman starred and made Sid a very charismatic and symphathetic character. Since then, there have been books, magazine articles, all manner of reasons for me to be glad I did that tour and took all those pictures. But for a long time, nobody cared, which is why the following story makes me smile.

Early one morning in 1999 I got a call from the National Portrait Gallery in London. They wanted to buy one of my pictures for their permanent collection, and to show in an exhibition called *Faces of the Century.*

David Bowie, one of several celebrity cultural figures who had been asked to curate this exhibit, had chosen one of my images. I was sure they were going to ask for one of my John Lennon photos, but it was the photograph I took of Sid Vicious eating a hot dog with mustard and ketchup smeared all over his face that they wanted. Sid Vicious qualifying for the National Portrait Gallery? I was stunned but thrilled at being included in the exhibit.

I went to London for the show. Walking through the formal galleries I turned into a hallway, and through an arch at the end of the hall, I saw the first image of the exhibition. It was not Sir Winston Churchill or Margaret Thatcher, not the Queen Mum or even the Beatles. It was my Sid Vicious.

ALL-ACCESS PASS

KISS and Godzilla • Patti Smith • David Johansen and Richard Hell • The Clash • Mick Jagger • Bo Diddley • Debbie Harry

I RETURNED TO JAPAN IN APRIL 1978 WITH KISS. IT was another whirlwind tour, but that was fine. By this time going to Japan was becoming routine to me; Riko came along again as my assistant. *Music Life* announced that they again wanted to produce a special issue about KISS, and again they wanted KISS to be seen out and about in Japan. But last year had caused so much chaos and disruption that KISS didn't want to step out in public again.

The solution was to do it indoors with Godzilla.

It was a brilliant idea. Godzilla is the quintessential Japanese monster, just as KISS was on its way to becoming the quintessential American rock band.

They arranged for an actor to come with the original suit from the movie. I gathered up some toy trucks and airplanes to litter on the floor,

KISS, Tokyo, Japan, spring of 1978

to make it look as though the monster had been destroying them. But they were too small to really make the point.

I was growing more and more interested in Japan, not just as a place for work, but for the culture. It was so fascinating. I had friends and contacts, and I was wondering if there was a way I could spend time there without being tied to a tour. I wanted to know what it was like to live in Japan.

I would have to wait to find out. I returned to New York City just in time for the Johnny Blitz benefit at CBGB. The Dead Boys drummer had been seriously injured in a fight and needed help raising funds for his medical treatment. It was a four-night event with almost every band in town and underground celebrities turning out to play.

It was a terrific weekend, another reminder of the sheer sense of community that bound the downtown scene, even as success started to splinter it. Patti Smith was there and also Stiv Bators; David Johansen was the emcee for the evening.

Patti Smith Group, Johnny Blitz benefit, CBGB, New York City, May 4, 1977

At another show at CBGB Robert Fripp played guitar with Blondie, and it was during that show that it hit me: Blondie was on their way to becoming very big indeed. They might even have been playing "Heart of Glass" at the time, the song that would become their breakout hit the following year. I was looking around, seeing how packed the place

David Johansen and Richard Hell, Johnny Blitz benefit, CBGB, New York City, May 4, 1977

was, and how strong the relationship between the band and their audience was, and it was inescapable. They weren't a funky little CBGB band anymore.

I was there when David Bowie came to town in May, and Bob Marley in June; and as 1978 rolled by, I photographed countless musicians: stars like Bruce Springsteen, Funkadelic, and the Electric Light Orchestra; rising talents like Ian Dury, Peter Gabriel, the Cars, and Elvis Costello; old friends like Elephant's Memory and the Heartbreakers; and veterans like Etta James, Dion, Muddy Waters, and Bo Diddley.

I joined the Clash in England in July. Suicide was opening for them, and I learned something new about British audiences. They could be brutal. English punks had developed a new fad of spitting on the bands (they called it gobbing). If they liked you, this disgusting act was somehow meant as a sign of affection, kissing from a distance. If they didn't like you (and they didn't like Suicide), it was simply disgusting. It sometimes looked like it was raining on the band.

England was not my first stop. First I was going to Hamburg to visit *Musikexpress* magazine. A week before my trip, the Rolling Stones played the old Academy of Music, which was now the Palladium—it was a far smaller venue than they normally played, one of a handful of "secret" shows during their latest tour. The first anybody knew about the shows was when a local radio station started giving away tickets in a competition, and it so happened that my friend Ginny called in and won one. She told me where she picked it up from, and then I went down and bought a ticket from one of the other winners.

I went to the show, and while I was there, I ran into Paul Wasserman, the Stones' publicist. I mentioned my upcoming European trip and he said he'd be there as well, with Bob Dylan, and if I met him before the show, he'd make sure I had a pass.

I would have to change my flights and head out a couple of days earlier than I'd intended, but I wasn't going to miss Bob Dylan in Berlin. Paul gave me the name of the hotel where they were staying. Of course, once I got there I discovered that they'd changed their bookings at the last minute. I didn't have a clue where they were. I decided to take a cab to the venue and try and meet up with Paul there. Out of the window, I

spotted Paddy Callahan, who was a professional bodyguard that I knew from the Bay City Rollers' Japanese tour.

He was with a couple of scruffy hippie guys, one with a walking cane, and it took me a moment to realize that it was actually Bob Dylan. Excitedly, I got the driver to stop, leaped out of the cab, and went rushing over to say hello. But I had no idea what to say to Dylan—"Hey man, I'm a big fan and you're brilliant" really isn't my style. So, I effectively ignored him, and talked to Paddy instead.

Which clearly didn't interest Dylan, so he started walking away.

Paddy asked if I was going to the show that evening. I said yes and he went off with Dylan. A couple of paces later, they stopped, and Bob swung around, his cane in the air. I don't know what happened; maybe he asked Paddy who I was, just out of curiosity, and Paddy told him. Suddenly Dylan was standing right in front of me, saying, "I know who you are, I've seen your little name next to the pictures all these years. You're always peeking in through the keyhole."

He was angry that I'd published so many photos from the Rolling Thunder Revue tour. I said, "Well, I tried to get a photo pass, but you weren't giving any out. I always tried to take good pictures." And he said, "What about that picture? You know, with Patti Smith?"

I knew which picture he was talking about. There's a picture where he's got a striped shirt on and he and Patti were both drunk.

"I didn't take that picture, Chuck Pulin took that picture."

Dylan paused. "Yeah." He kind of mumbled and grumbled a little, then he said, "Well, you took all those other pictures." And then he told me, "I always said when I met you, I was going to beat you up," and he was waving his cane over my head. I looked at Paddy, as if to say, "I know you're working for him, but you're my friend. Right? Don't let him hit me." I was the one who needed a bodyguard at that point.

Paddy stepped over and, while Dylan continued to grumble, eventually they walked away, leaving me standing, still jet-lagged, in a street in Berlin thinking, "What the fuck just happened?" I felt as though I had finally met God, only to discover that he wanted to kill me.

I got another cab, went to the gig, and found Paul, and he took me into the catering area—they usually have a pretty nice meal on the

upscale tours. I was having dinner when Paul came back about twenty minutes later, and he asked, "Did you run into Bob Dylan on the sidewalk today?"

"Well, yeah, I did. A little while ago."

Paul replied, "Why don't you go up to the back of the balcony and kind of make yourself scarce, and don't be seen for the rest of the night." I don't know what went down or what Dylan said to him, but I was definitely persona non grata. I've never met Bob Dylan again, and in a way it has helped me to remain a fan. (And I've seen him perform many times since.)

After Berlin, I met the Clash in England, and even though there were more and more kids at every gig, the open-door policy after shows remained in force; very often, the band would persuade the hotel to keep their bar open later than normal, so that musicians and fans alike could just kick back together, talk and drink until the small hours. And it was not a case of the band sitting back and regaling a captive audience with tales of their own brilliance, as I've seen so many musicians do over the years. Joe, in particular, made a point of listening to people, asking them what they were thinking about, wanting to find out who they were and what their dreams were, because he cared.

He knew the band was in a privileged position; that they no longer had to contend with the problems that consumed their fans—work (if you could get it); rent (if you had a place to live), and so forth. And he knew that the band gave those kids something to believe in. It was important that he believed in them in return, and he wanted to hear about their stories, their struggles, their triumphs, and their hopes.

It was not at all unusual for Joe to be sitting there at three or four in the morning, discussing current British politics with a handful of earnest young punks.

I was becoming an accepted part of the entourage now; in fact, the previous evening, I was the one that the road crew called upon to sort out a situation that had suddenly arisen. We were in Bristol and, following the show, we all made our way back to the band's hotel, which was one of those quaint old-fashioned places, more like a very large house as opposed to some modern box. It was more ornate, with a grand lobby and doors that overlooked a formal garden.

We went up to the desk, and the desk clerk took one look and told us that we couldn't stay there. The promoter begged and pleaded with him; the band was exhausted after the show, all they wanted to do was sleep. There'd be no trouble, no damage, so *please* let them stay. Joe and Mick even went over to one of the couches in the lobby, and I think Joe was playing on an acoustic guitar, soft, gentle melodies, doing his best to act like they were very nice boys, and they weren't going to upset anybody. And finally the clerk said they could stay.

The Clash, Bristol, England, July 1978

I was just drifting off to sleep when there was suddenly a furious banging on my door. I got up to find one of the roadies telling me that the promoter had gone berserk! Apparently, a girl he had brought back to the hotel was now refusing to sleep with him. Something needed to be done. The guy had already trashed the lobby, and now he was up in his room, crying like a baby. I remember sitting on the bed with his head in my lap, stroking his head saying, "There, there. It's going to be all right. It's going to be all right" and wondering how on earth I got this job.

In fact, everything would be all right. The following morning, he was back to normal and on we went to the next date in Torquay. The Clash had just played the local town hall and now we were back at our

hotel. Mick had just come up with the recipe for what he said was the Clash's "official drink," the Jellybean: vodka, Bacardi rum, and Pernod, a dash of black currant, and lemonade. It was delicious, so much so that we drank too many of them. Then, with the bar closing, Joe and I went back to his room to continue our conversation while he played and replayed a Bruce Springsteen cassette he had with him, *Darkness on the Edge of Town*.

He was fixated on one song in particular, "Racing in the Street"; it would play through, and Joe would play it again and again, a long ballad about growing up in New Jersey, about a bunch of guys in the 7-Eleven parking lot, lining up their cars and racing through the night. It was my last night in England and we stayed up all night, before I flew home. Back in New York City, I called Johansen to see what was up. He was playing a show that night in New Jersey. I told him I'd see him there, but because I was jet-lagged, David said he'd arrange for a friend to pick me up and she could drive.

Off we went and, at some point, we stopped at a 7-Eleven store to ask for directions to the gig. And I realized that there I was, in a 7-Eleven parking lot in New Jersey, and poor Joe Strummer was still in Torquay, *wishing* he could be in a 7-Eleven parking lot in New Jersey.

In many ways, that summed up our relationship, that I had access to things he dreamed of. Growing up in England, the Clash were utterly fascinated with the fantasy of New York City. They loved the movie *Taxi Driver*, because it had so many scenes of driving around New York City.

When they came to New York City two months later to mix their new album (*Give 'Em Enough Rope*) at the Record Plant, with Sandy Pearlman producing, all they wanted to do was have me drive them around the city in my '54 Buick and relive *Taxi Driver*. They wanted me to see if we could take some pictures in those steaming New York streets, those big billowing clouds of steam that just seem to erupt from the sidewalk and which, the moment you see them, let you know you're in New York City.

The problem was, while steam is easy to find in the winter, when it's cold and lots of buildings have their steam heat on, it's not so common in mid-September. But I was sure we would find steam somewhere, so

I told them I'd pick them up once they were finished in the studio and we'd go steam-hunting.

I was at my apartment with Kris—he was four years old now, and was staying with me for a few days. I'd arranged for Ginny to babysit, but she was running late and I really needed to get going. Finally, I decided to bring Kris with me and have Ginny meet us at the studio. But as we drove over, I was explaining to him that we were going into a recording studio, and he had to be on his best behavior; that the guys would be working, and we couldn't interrupt them or cause a distraction. Don't be noisy, keep to yourself, don't ask any questions, and don't touch anything!

Kris was a smart kid. He understood, so we got there and walked into the room, and what happened? The Clash see this little kid and they immediately start making little paper balls and throwing them at him, a bunch of kids themselves. And poor Kris didn't know what to do, because he had been told to be on good behavior and all of a sudden, there's four grown men throwing paper balls at him. After all my warnings to Kris, I ended up having to tell the Clash to behave.

The Clash, New York City, September 1978

Ginny arrived to pick up Kris and take him back to my place. And then I was driving around with the Clash, looking for steam and not finding it anywhere. Up and down, round and round we drove and it took forever to finally find enough steam for them to stand in. It was still a little skimpy, but we managed to get some pictures.

From there, we made our way down to the Feast of San Gennaro festival in Little Italy, hoping to get something to eat. It was a rainy night, one in the morning, and there were no food stands left open. I suggested we all come back to my place, and I'd cook something. We stopped at a deli for a box of spaghetti and some sauce, and then sat around watching my videos of the downtown scene—Blondie, New York Dolls and Heartbreakers, Robert Gordon, Jayne County, and so on. This was a history that they couldn't see anywhere else.

The Clash, New York City, September 1978

That summer I picked up a Super 8 camera and was soon filming wherever I could—Dylan in Paris; Bruce Springsteen at the Nassau Coliseum; Blondie in Boston; the Stones in Philadelphia—and also in Anaheim. Yuya was in the United States with a group of Japanese journalists, and he flew me to California to photograph their interview with Mick Jagger.

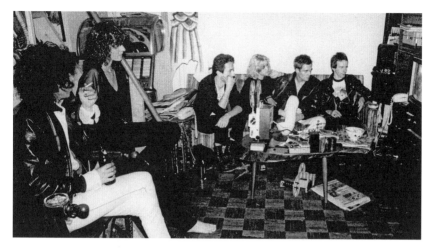

(Left to right) Mick Jones, Ginny Lohle, Joe Strummer, Debbie Chronic, Paul Simonon, and Topper Headon, Westbeth studio, New York City, September 1978

Even better, I had an all-access pass waiting, so I could roam around the stage and even go onstage while the band was playing. The band was in mid-performance when someone threw a shoe onto the stage. Mick ignored it, but when another shoe arrived a few minutes later, he told the audience, "If you're going to throw shoes, just get it over with." Which was the cue for about one hundred shoes to come flying onto the stage.

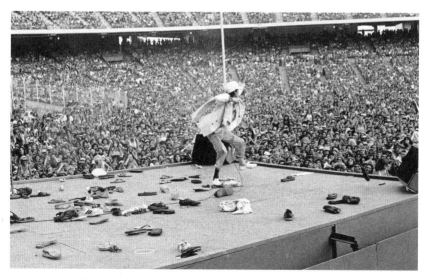

Mick Jagger, Anaheim Stadium, Anaheim, California, August 1978

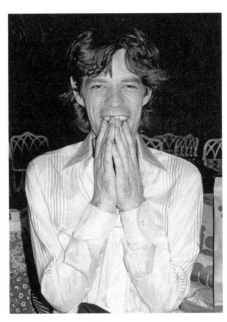

Mick Jagger, Los Angeles, August 1978

David Johansen had launched his own David Johansen Group, again with Syl, and they had signed with Steve Paul's new label, Blue Sky. I had connected with many of Steve's different projects, from my introduction to his nightclub, the Scene, to the party where he brought Tiny Tim, a gig in Central Park where I introduced him to Muddy Waters, and onto the night when Johnny Winter came to collect a song that John Lennon had written for him. So when David was looking for new management, I drove him to meet Steve.

I went with David's band when they toured Europe in November. They were doing a lot of television along the tour. There was one night in Paris where I, for at least a few moments, became both a television cameraman and a strikebreaker.

The band had just started playing when the French cameramen went on strike and just walked away. The band didn't know what had happened, so they just continued playing. But nobody was operating the cameras.

I went to the main camera at the front, focused it on the band, and locked it into place. I then went to another camera on the side and

started following David around the stage, and it was only when my red light came on that I realized the control room was actually taping what I was doing. So, I carried on until one of the striking cameramen realized what was going on, and came over and pulled out the plugs.

David wanted to know whether I had any way of getting in touch with Mick Jones. I called Chrissie Hynde. Before I knew it, me, Syl, David, and his photographer girlfriend, Kate Simon, went for a night out with Chrissie, her friend Bruno Blum, and Don Letts, at a reggae club in Dalston, the Four Aces.

The club was very dark. The only light in the room was in the corner, the little bulb in the deejay booth. The room was wall-to-wall Rastafarians, with their long dreads flying around them as they danced; I'd never seen anything like it. Or heard anything like it, either. The deejay was playing some really heavy dub music, my first time listening to that. The air was thick with pot smoke.

But we couldn't get any. Everybody Syl and I approached, everybody we asked, either ignored us or turned away. Nobody would even make eye contact, let alone answer my question. Finally, we had to ask Don if he could sort something out for us, and two minutes later, he was standing there grinning, with a handful of pot.

We finally met up with Mick Jones, and he joined us when we went to Manchester. David had asked Chrissie's band, the Pretenders, to open the show. It was their first gig. I remember thinking she was right, she could do this as well as any of the guys. She was a powerful, magnetic performer. Later in the evening, Mick got up and jammed with David's band.

The Clash returned to New York City in February 1979, this time to tour. Their manager, now Caroline Coon (who I knew from my previous trips to London) flew in first to make the arrangements, and I suggested I join the entourage as official tour photographer. Caroline agreed, and with the record company willing to pay my expenses, I was on the tour.

The band flew first to Canada for rehearsals and the opening gig; that's where I met up with them. We drove across the U.S. border the next day.

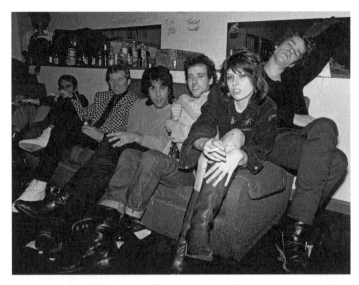

(Left to right) Martin Chambers, Frankie LaRocka, Mick Jones, Chrissie Hynde, and David Johansen, Russell Club, Manchester, England, November 25, 1978

We stayed the night in Seattle—and in the morning we awoke to learn that Sid Vicious was dead. We all knew him, and we were devastated. He was only twenty-one years old. There was a long journey ahead of us, all the way down to San Francisco, and everybody sat in stunned silence, staring out of the windows, lost in our own thoughts.

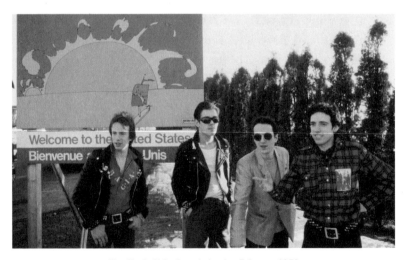

The Clash, U.S.–Canada border, February 1979

RIGHT PLACE, RIGHT TIME

San Francisco raised our spirits considerably. We were staying in a hotel down by the waterfront, a beautiful place that was completely circular. It was disorientating in a way; there was a round balcony inside the hotel, overlooking a courtyard, and when you stepped out of your room, all you saw were the doors to all the other rooms.

I took the band up to Mount Tamalpais. It was early afternoon on the day of the first gig, and they wanted to get out and explore. I'd rented a car because I was going up there anyway, but first I followed the band's van to a giant flea market in Sausalito, and then I told them where I intended to go.

The place I especially like, and revisit often, is a path halfway up the mountain. You walk out and suddenly the whole world seems to tilt. The path looks like it will just go straight out to the end of a hillside, but as you start walking, you realize you're on the side of a very steep hill. You can literally put your arm out and touch one side while to the left, you're looking down to what seems like hundreds of feet below. The view is of the Pacific Ocean on one side and San Francisco on the other.

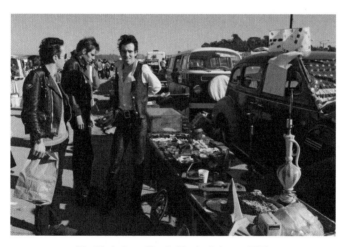

The Clash, Sausalito, California, February 1979

The roadies weren't happy; sound check was only a few hours away, and the last thing they wanted was for the band to go off on their own. I think they were also a little pissed that they couldn't come along as well in my little compact car. We drove off, just me and the band.

I took them to my favorite spot on the mountain, took out my flask, and passed it around. We smoked a joint and just relaxed. It was a welcome break from their schedule, just lying there . . . It felt as though we were on top of the world.

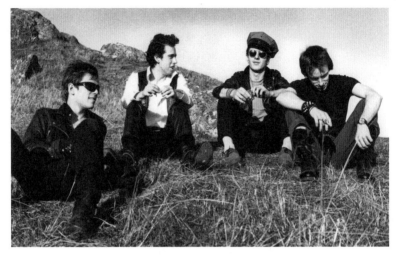

The Clash, Mount Tamalpais, California, February 1979

Soon it was time to drive back. Mick Jones was a very nervous passenger, particularly on high, winding, mountainside roads. So, I was going very slowly, with my foot on the brake most of the way, and we were about halfway down when I realized I'd overdone it. The brakes had overheated, and I had no way of stopping, or even slowing the car. We were picking up speed!

Thinking quickly, I downshifted, pulled the emergency brake and managed to stop the car. I pulled over and said, "Sorry guys, I've got to take a piss," to give the brakes time to cool off. I took my time, the brakes cooled, and we resumed our journey.

One of the highlights of that entire tour was having Bo Diddley on the bus. The Clash had hired him as their support act, and the funny thing is, I later discovered that Bo was actually getting paid more than the Clash! According to Caroline, they wanted so much to have him on the road with them that they agreed to take less money, simply to get Bo.

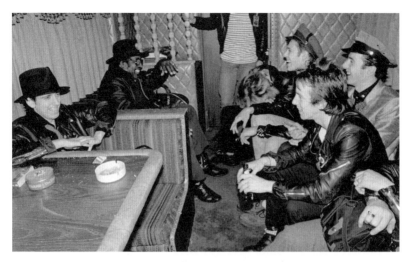

The Clash and Bo Diddley, February 1979

He was Bo Diddley, one of the originators of rock and roll, and he deserved it. They wanted to expose their audience to the music that inspired them, and as long as Bo Diddley was still around, was still working and still needed work, they wanted to help him like he helped them.

They would do the same for Screamin' Jay Hawkins and Lee Dorsey on later tours, and I was astonished that they would do that. So many

(Left to right) Topper Headon, Joe Strummer, Al Fields, David Johansen, and Debbie Harry, Palladium, New York City, February 17, 1979

bands look for a weaker support band because they know it'll make them sound good. But the Clash didn't care about that. They wanted to help their heroes and they did.

Bo didn't sleep on the bus; what he would do was put his guitar on the bunk, to make sure it was safe, and then he'd sit in the front with the band, telling stories and bawdy jokes. They loved hanging out with him. At sound checks, Joe would be asking him questions about playing.

Another highlight was the bus itself—it belonged to Dolly Parton! The Clash hired Dolly Parton's bus, which was painted red, white, and blue, with puffy blue vinyl inside.

The tour rolled on: Cleveland, Boston, and finally New York City, and that was a big deal. The gig was sold out weeks in advance. It was exciting backstage, too, because New York rock royalty was out in force— Andy Warhol, David Johansen, Debbie Harry, everybody was there.

CHAPTER 27

FULL MOON
RISING

Best *magazine* • *Kenney Jones and the Who*

IN MAY 1979, I WENT TO CANNES, FRANCE, FOR THE premiere of the Who's *Quadrophenia* movie and *The Kids Are Alright* documentary. This was memorable, in part, because it was also the first time that I, or anybody else, saw the Who perform with Kenney Jones, the drummer who succeeded Keith Moon.

My intention had been to fly first to Paris, where I would pick up money that *Best* magazine owed me—and that, in itself, is quite a story. Back in 1972, photographing the Stones at Madison Square Garden, I met a couple of French kids who introduced themselves as journalists, and asked if I could supply them with pictures. I said yes and went to meet them at their hotel room. They took the photos and sent me a copy of the magazine in which they appeared. One of my shots was on the cover.

The check never came, and I eventually wrote it off as a bad debt and forgot about it. But a few years later, when I was in England in 1977,

my old friend Jane Friedman asked me if I'd go to Paris to take some photos of John Cale, who she was now managing. At the show, I met Christian Lebrun, the editor of *Best* magazine, who invited me to meet at his office.

Best magazine, Paris, France, September 1972

The next day, I was showing him pictures when suddenly he looked at me and said, "I can't believe you're being so nice to me, after we didn't pay you for your Stones pictures." I was startled to find myself in the office of the magazine and suggested he pay me now. Instead, Christian explained that they now had a rep in New York City and he would pay me. That sounded fair enough, so when I returned to New York City I called up the rep, only to discover that they hadn't paid him, either.

I got back onto the phone with Christian, and this time, he told me that they were having trouble sending money out of France, due to various banking regulations. The only way I could get the money they owed was if I came back to Paris and they handed it to me in person.

So that was what I did and they paid me. Ultimately, we did other work together again, and *Best* financed a lot of my trips over the years. If I was in the United Kingdom or Germany or wherever, I'd always make

sure to stop in Paris and drop by the *Best* office. I knew there would be money waiting.

But not this trip to Cannes. I was just leaving my home for the airport when I realized that my passport had expired. I got a new one the following day and flew out, but that meant I would no longer have time to visit Paris, if I was to attend the movie premiere.

In Cannes, I wandered into the famous Carlton hotel, through the bar and into a large, open area filled with people drinking, talking, and generally carrying on . . . half-dressed actresses chatting up half-drunk producers, that kind of thing, and suddenly I heard a woman's voice call out, "Hey! Hi Bob!" And there she was, dancing on one of the tables, Mellany, a girl I used to date in New York City. I also ran into Annie Golden from the CBGB band the Shirts, who was in the just-released movie version of *Hair*.

The Who's publicist gave me a pass for the movies, and invited me to the reception afterward, which is where they introduced Kenney Jones as their new drummer. There were also two nights of concerts in a Roman amphitheater in Fréjus, Jones's first live appearances with the band.

(Left to right) John Entwistle, Pete Townshend,
Roger Daltrey, and Kenney Jones—the Who,
Cannes, France, May 1979

The Who had finished their set and the entire audience was on its feet demanding an encore. I looked up, and there was the moon just beginning to peek over one of the amphitheater walls. As the Who returned, the moon continued to rise. The Who debuted elaborate lasers, but for me the best part of the show was the full moon shining on the Who's first gig without Keith.

It was during one of my visits to Paris around this time that I ran into Malcolm McLaren again. I hadn't seen him since the Sex Pistols tour. He left England, because there was talk of having him charged with sedition—the aftermath of his role in the Sex Pistols' "God Save the Queen" campaign.

He and Vivienne had changed the name of their shop from Sex to Seditionaries. It made people wonder. Malcolm also remarked, in that inimitable way of his, "You know sedition is a capital crime? They still have the death penalty for that." He didn't think his case would come to that, but he wasn't taking any chances and was hiding out in Paris.

I asked him how he was getting by, and his reply was pure Malcolm. He was giving singing lessons to the daughter of some Middle Eastern ruler . . . a princess, in other words. He was also researching out-of-copyright music for use in soundtracks for porno films.

In July 1979, I went down to Kissimmee, Florida, to photograph the opening of the latest KISS tour. And it was while I was down there, alone in my hotel room, that I realized that the drugs were catching up with me. I had to stop. They weren't affecting my work, as far as I could tell. But they were affecting my judgment, and they were seriously affecting my health. Basically, I was sick and tired of being sick and tired.

I needed to go someplace where I could live a healthier lifestyle. I wanted to go to Japan. I had the means right in front of me, six boxes of color slides of KISS in their new outfits, which I could license for at least three thousand dollars in Japan alone. I decided to send the pictures to my agent and have her license them, and I would make my way to Japan, where I could collect the payment in person, find an apartment, and see how long I could stay there.

I was hoping that the respect the Japanese people seemed to have for me would lead to regular work. In the end it didn't, because they already had a lot of photographers in Japan, but still, when people asked me why I was in Tokyo when I could have been working in New York City, London, or Paris, I would reply, "Because the food is excellent, the culture respects artists, and it's safe to walk around at night."

The first thing I did was go to Crocodile, Gan-san's club, where I met up with Riko, who took me to her house in the beach town of Hayama. I remained there for several weeks recovering my health while my Japanese agent, Toshio Goto, and his wife, Fumi, looked for an apartment for me.

Fumi became one of my closest friends. One day, realizing I was feeling a little homesick, she invited me to their home to cook my favorite American meal. I decided on pan-fried Southern-style smothered pork chops; her kitchen had never seen so much grease.

The Crocodile was the center of rock music in Tokyo. Gan-san had a fascination with American ways, and the club was designed with a California style. By that time, he and I were such good friends that he told me the Crocodile would be my kitchen, and I would never have to pay for a meal there. Although the way he put it was a little more picturesque. "If you pay, you must die."

It was Gan-san, too, who found the apartment that became my home. I later learned that he had evicted the Crocodile club's manager and moved him into the club office, so that I would have somewhere to live. But it couldn't have been too bad—the Japanese *Popeye* magazine had done a feature on me, photographing me at home in New York, and the loft bed that Gan-san built at the Crocodile office was modeled on those pictures.

The apartment was in an excellent location in Harajuku, on a twisting little street halfway between the Crocodile and Kiddyland, a four-story toy store that was a landmark in Tokyo. When I came home from the first KISS tour, I had thirteen boxes of luggage, most of which were toys for Kris that I bought at Kiddyland—so many, and so many duplicates, that the customs guy at the airport asked if they were sales

samplers. I had to explain that my friends would probably want some as well.

I started going to clubs—the Crocodile, Yanayara, and Shinjuku Loft, which was the CBGB of Tokyo, where all the punk bands played. Years later, when we were there filming *Tokyo Pop*, I saw a ten-inch rat walking across a pipe there.

I was meeting bands—Sheena and the Rokkets, Sandii and the Sunsetz, the Sadistic Mika Band, the Plastics—and that was when *Best* magazine in France sent reporter Gilles Riberolles to work with me on a piece about the rising Japanese rock scene. That, in turn, gave me a reason to start contacting more of the local bands, and some of them, too, became friends.

(Left to right) Toshio Nakanishi and Chica Sato—the Plastics; Bob Gruen; and Sheena and Makoto Ayukawa—Sheena and the Rokkets, Bob's apartment, Harajuku, Tokyo, May 1980

Every Sunday, literally thousands of kids would gather on the Omotesando, the street in the center of Harajuku, dressed like 1950s American rock-and-roll movie characters, and they would do line dances, choreographing themselves according to the films they'd seen. Different bands would set up on the sidewalk to play.

Gilles and I did a great story together, but I remember how awkward it was trying to introduce him to people who didn't pronounce their Rs

and Ls. It was Gilles, too, who brought home to me just how easily I had acclimatized to Japanese life. I had only been in the country for a couple of months, but when he walked into my apartment and didn't take his shoes off at the door, I was annoyed. Leaving your shoes just inside the door is so ingrained into the rules of Japanese life that I had just slipped into the role. The expression on his face when I asked him to remove his shoes was one of total confusion.

I was getting around on an old basic moped that a writer I knew had loaned me. It was a simple little machine, just a couple of pipes welded together with wheels and brakes, but I took it to a store and had it tuned up, and I was set. Seeing a foreigner driving a moped around Tokyo was so unusual that I was often stopped by the police. I went and got a Japanese driver's license to prove that I lived there. It's one of my favorite souvenirs.

I celebrated my thirty-fourth birthday in Tokyo, at the Crocodile. That's where I met my next assistant, Gin Satoh—he came up to me and said, "I am Gin, I want to be your assistant," and that was just about all the English he could speak. But I hired him, and he's still one of my best friends today.

I remained in Tokyo for as long as I could. As the end of the year grew closer, I knew I couldn't stay much longer. For one thing, I was running out of money—I had thought my agent was going to be able to get me a lot of work in Japan, but it wasn't turning out that way. My agent had connections to license pictures, but no connections to get commissions from bands. She suggested I go back to New York City and take some more pictures that they could license to the magazines to make some money.

THE RECORD PLANT

The Damned • Debbie Harry and Bagpipers • Bo Diddley •
Yellow Magic Orchestra • The Rolling Stones •
John and Sean Lennon

AS IT HAPPENED, I WOULDN'T STAY PUT FOR LONG. Three days after returning to New York, the phone rang. It was Sheila Rock, calling to ask whether I'd be interested in house-sitting for her in London while she went to Greece for three weeks. All I had to do was get there and I had a free townhouse—a beautiful place to stay in London. I immediately accepted; in fact, I flew out the next day, connected again with the Clash, and I started finding out what else was going on around town.

The Pretenders had really broken through since my last visit; two hit singles, "Stop Your Sobbing" and "Kid," and then a number one, "Brass in Pocket." In six months, they'd gone from playing small clubs to theaters, and they were only going to get bigger.

I got in touch with Chrissie, and that night she took me to see the Damned at the Electric Ballroom. I couldn't believe the scenes at that show. It was the first time I saw something resembling a mosh pit, where kids were climbing up on the stage and then diving off onto the top of the crowd. That was new for me. I had never seen people literally diving onto one another.

It was insanity, and it kept getting more and more intense as the show continued. The security guys didn't seem to know how to handle it, so instead of waiting for a kid to jump, they'd push him first. But it was the same effect, they'd still land on top of the crowd, and then it became crazier still, when one of the musicians pushed one of the guards off the stage. He then climbed back up, and threw the *musician* into the audience!

And I was standing there in total shock, wondering what was going on. I've seen bands like the Who, who you could say became famous for smashing the occasional guitar at the end of the show. At the Damned show, somebody smashed a guitar and somebody else smashed the drum kit, and then the piano player smashed the electric piano!

That took a while, because there's a lot of dense material in a piano, but he kept battering it until there were keys flying out, and then they were flying into the audience, alongside random piano parts, and all the while, everything else was swirling around him, people jumping on top of one another, and just as I thought things couldn't get any more outrageous or surreal, guitarist Captain Sensible walked up to the edge of the stage, opened his pants and pissed on the audience.

At which point, I felt very happy that I was way up on the side, and not being pissed on. Although I did take a picture of it, which we even published in *Rock Scene*. The caption would have been suitably vague: "Captain Sensible reacts to the overwhelming excitement of the crowd," something typically *Rock Scene*. But really, he was pissing on the fans, and I was thinking, "This is ridiculous."

The Clash also had some shows coming up, including a benefit gig at Hammersmith Odeon, raising funds for refugees in Kampuchea. It

The Damned, Electric Ballroom, London, England, December 1979

was sponsored by the United Nations; the three-day bill also included the Who, Paul McCartney, the Pretenders, the Specials, and many more.

The day after Christmas, I was with Paul Simonon waiting for a lift to that night's show, a warmup for Hammersmith, when I noticed a bugle on his coffee table. I picked it up and started playing it, much to his surprise—and the next thing I knew, he was suggesting I play it to announce the band onstage at Acklam Hall that very evening.

I didn't really take him seriously until we were backstage, waiting for the band to go on, when Mick suddenly turned to me and said, "Let's go over your part."

What? My part? I realized Paul hadn't been kidding; that I really had been deputized into the Clash. I played the first thing that came into my head that seemed appropriate, the "Call to Arms" and "Charge" that is familiar from every old western movie. He liked that and then I was on, walking onto the stage, up to a mic, and I let it fly. Moments later Joe came on and as he passed me, he whispered, "That wasn't much of a blow, mate." I thought for a moment that he hated it, but no, afterward, he told me it just wasn't loud enough—or long enough.

I had the opportunity to do better at the Odeon. I went out with more confidence, doubled everything so it would be longer, and as I

ended, somebody at the back shouted "Charge!" It was the perfect intro-
duction to the band as they launched into "Clash City Rockers."

I spent New Year's Eve in Glasgow, where Blondie was playing at
the Apollo. I got myself a room and got dressed. Then I went across the
street to a pub for dinner and had the perfect meal, lamb chops with
mint sauce, exquisitely cooked in a Scottish pub on New Year's Eve.

The Apollo was a terrific venue; the stage was so high that, from
the back, it looked like an old-fashioned television, this great big piece
of furniture with a stage set in it.

Debbie Harry and Scottish bagpipers, Apollo,
Glasgow, Scotland, December 31, 1979

After the show we went back to the band's hotel. As the clock
chimed midnight, I got an unexpected kiss from Debbie. It made my day,
and what a great start to the New Year . . . a new decade.

I came back to New York City a few days later, spent a month or so
in the city and, in February, I was back out on the road with the Clash.
One night everybody was sleeping when we pulled into a gas station.
The bus driver got out to fill the tank, and I decided to take advantage
of the opportunity to use a stationary bathroom. I told him I'd be right
back, used the bathroom, and was looking around the store when I saw
a pair of gloves I wanted.

I was just about to pay when I heard the bus start up. I ran out,
forgetting my wallet, which I'd laid on the counter, and sprinted out of

there, but I was too late, the bus was moving. I raced after them dressed only in the jogging outfit that I had on, and a pair of moccasins. Oh, and there was about three or four inches of snow on the ground.

I was screaming at the top of my lungs, "Stop, stop, stop!" and then I heard the bus shift into second gear and start accelerating onto the entrance ramp. But somehow, Johnny Greene, the road manager, heard me through the window and told the driver to stop.

I caught up with them and banged on the door, and then I remembered I'd left my wallet back at the store. "Don't leave me here. Just wait. I have to go back and get my wallet." I had run a good quarter of a mile, so, still in moccasins and snow, I trudged back to the store, retrieved my wallet, and then back again to the bus (with the gloves).

I wanted to get back to Japan. I missed the country, I missed my little apartment, I missed the way of life. But most of all, I missed my friends. Again, though, the question was, how was I going to afford to get back to Japan? The solution simply presented itself one day in early spring. I got a call from Lisa Robinson. Her assistant, Deane, had an assignment to go to Japan to do a piece with the Yellow Magic Orchestra, and she somehow managed to swing it so that I would supply the photos. The record company would buy me a ticket to Japan.

There was just one problem. When I called my agent to tell her I was on my way back, she reminded me that I had accepted money from a Japanese magazine to do a feature on Bo Diddley at home. I couldn't return to Japan without it.

My schedule was already tight. The Yellow Magic Orchestra show was on Friday in Osaka; I'd arrive in Tokyo on Thursday and take the bullet train to the gig. Meanwhile, it was Tuesday, and I was up in Greenwich, Connecticut, visiting Nadya and Kris, and suffering from a horrible head cold.

I called Bo and asked if it was possible to squeeze me into his schedule. He told me that if I could be there the next day, Wednesday, we could do the feature. The next morning, I flew to Florida. The rental car office had no cars available. I had reservations, but they had run out. I was stuck. Bo lived about forty miles outside of town, and I had just

sixty dollars in my pocket. I was still trying to work something out with the rental people when a young kid standing nearby walked over and told me he was a taxi driver. He could get me there for forty dollars each way. He was willing to wait for me to do the session as well.

That was great, but I couldn't afford the return fare. "How about if I introduce you to Bo Diddley instead?" I asked. He agreed. We got there, and Bo pulled up on a tractor and showed us around his property, the man-made lake, the kennels where his daughter kept the big dogs that she bred, and the log cabin he was building.

Bo Diddley, Archer, Florida, March 1980

As well as taking pictures, I was also supposed to interview him. I took out my mini tape recorder and put it in my pocket. He told me about being the black sheep of his family, how they all said he was going to be a failure, would never amount to anything. He pointed proudly to all the different houses he'd built—one for himself, one for his mother, one for his sister, and so on.

With the cold still raging in my head, I could barely talk, but the interview was going great. As I was standing there, I realized that the taxi driver was asking Bo more questions than I was. He and Bo had a lively conversation, but that caused problems when I delivered the tape to the Japanese magazine. They tried transcribing it, but nobody in the

building could understand what the kid was asking in his thick Southern accent, and not much of what Bo said in reply.

In Japan they loved the photographs, especially the one that Bo let me take of the *back* of his guitar, where he kept a secret. It was layered with circuit boards that he'd had some Australian technicians install for him. Other guitarists had to carry all their effects around with them and lay them out on the stage. All Bo needed to do was press one of many buttons on his guitar, and he could get the sound he wanted. For all his simple country ways, Bo was a very sophisticated musician.

Bo Diddley, Archer, Florida, March 1980

The interview over, the kid drove me back to the airport. I caught my flight home, and the very next day I was back at the airport and flying to Japan. My agent was waiting for me, hustling me onto the bullet train, straight to Osaka. Our timing was perfect. Just as I started walking down the aisle, the Yellow Magic Orchestra was coming onstage.

Back at my place in Tokyo, standing at the sink, looking in the mirror, I suddenly had a powerful flash of realization. I was home again, in the place where I felt the most secure, the most creative, and the happiest. I got back into my routine of going to shows, visiting friends,

and hanging out. So much laughter, so much excitement. One night, Gan-san and I went to see the Eagles at the Budokan. I thought I knew their manager, and should say hello, so we walked up to the entrance. The kid on the door glanced at us and asked if we had a pass.

Gan-san looked at him. "My face is my pass." After that, we seemed to cruise through every door without a problem, until finally we were in the dressing room with the band and their manager. It turned out I had a different manager in mind. I didn't know this one. He didn't seem to be interested in meeting me, either. Instead, he turned to a nearby roadie and said, "Throw them out." The guy looked at my powerful friend and declined. We happily left on our own, inviting the band to come to Gan-san's Tokyo club, Crocodile, after the show.

(Left to right) Gan Murakami, Bob Gruen, and Gin Satoh,
Tokyo, Japan, October 2000

Gan-san went on to open several other clubs, one of them inspired by a gift I gave him. One day on my last visit, I was out with Gan-san, riding on his motorcycle. It was a cold day, and I felt he needed warmer clothes. When I got back to New York City, I placed an order with L.L.Bean for warm flannel-lined clothing that I would send to him. What I didn't know was that they would change his life.

Looking through the rustic-life catalog that came with the order, he completely fell in love with the outdoor American style, and the next thing I knew, he was building a new restaurant that he would call

Backwoods, designed to look like an old log cabin, with all the adornments and features that you would expect to find in one.

Gan-san's musical taste shifted. When I first met him, he was into Cuban music. Now he was all about country and western, and years later, when I went out to visit him in 2000, he was building a compound in the mountains above Tokyo, where he intended to create Japan's biggest country music club.

Visiting the Smoky Mountains with my mom once, I picked up a couple of local hillbilly records for him. He took one look at the cover, a picture of these old guys sitting out on a porch, and excitedly called people over. "Look! Look! That's the bit we could never get right!" A tiny detail on a hillbilly record sleeve had solved a construction problem that had been haunting him for weeks.

I renewed my friendship with the bands I'd met in the fall, Sheena and the Rokkets, Sandii and the Sunsetz, and others, and I went to some truly memorable shows as well, including a Yellow Magic Orchestra performance at the Budokan that was quite unlike any I have ever witnessed.

Now, the Nippon Budokan is huge. It was originally built to host the judo competition at the 1964 Olympics, and it can hold around fifteen

Yellow Magic Orchestra, Budokan, Tokyo, Japan, March 1980

thousand people. Every major rock act to visit Japan, from the Beatles on, plays the Budokan, and if you are big enough to play there, you're big enough to sell it out. The Yellow Magic Orchestra had a very different idea. What if, instead of playing the Budokan in front of 15,000 fans, they were performing at a 1920s cabaret in front of maybe 150?

And that is what they did. They built a club on the Budokan stage, complete in every detail, from a bar that served real alcohol (for some reason, they asked me to stand beside it) to a dance floor with real dancers, and tables and chairs arranged for their invited guests to sit at. That's who they performed for, and that's what all the thousands of people out in the audience watched.

I thought it was incredible performance art. But talking later with a friend who had been out in the crowd, he had not been impressed in the slightest, and I believe others felt the same way. For them it was more like a movie than a concert, and that's not what they had bought tickets for.

I was having a wonderful time, but again the money soon ran out. By June 1980 I was back in New York City, flying in the day before the Rolling Stones press conference at Danceteria, and just in time for the first-ever New Music Seminar.

An industry-wide showcase for new bands and performers, the New Music Seminar was destined to become a major part of my life

The Rolling Stones, Danceteria, New York City, June 1980

for the next decade or more, but this first year, the highlight for me was a keynote speech from Malcolm McLaren. He was just launching the band Bow Wow Wow, around the premise that people no longer bought records, because they could tape them from the radio instead. Their first single, "C30, C60, C90 Go," was even released on cassette, with the music on one side of the tape and the other side blank . . . presumably to tape other music.

Bow Wow Wow's record company refused to promote the record because the lyrics included a clear invitation to record songs off the radio instead of buying them.

Malcolm's speech was equally inflammatory, but it was intended as a warning that the music industry was about to face a major crisis from music piracy, and it needed to act to protect itself. He talked about what we now know as sampling, about bootleg cassettes, and also about how record companies had lost their way, in that marketing was suddenly becoming more important than music.

His talk was fascinating and prescient. In fact, as I left the room, I saw a little booth that was actually selling cassette recordings of the different speeches that had taken place. I bought one of Malcolm's and walked back into where he was sitting and handed it to him. He was beyond astonished.

Yoko called and told me there was a project coming up that she couldn't tell me anything about, but she wanted me to be ready and available for when they needed me. A month or so later, she called me to come to the Record Plant, where I discovered they were already deep into the sessions for a new album.

The sessions were very secret; only the musicians and the people who were actually working with them were allowed into the studio. Even David Geffen, the head of the label that would be releasing the album, wasn't allowed into the studio.

I was not summoned until the last day the full band was there, recording the last basic tracks for the album. John wore a jacket and tie to mark the special occasion. I sensed he was pretty tired that night but elated about a job well done. He'd been in the studio for a couple of

John Lennon and Yoko Ono (seated, far right) and the *Double Fantasy* band,
Mr. Chow's, New York City, August 1980

weeks, working hard to perfect all the tracks. We went to Mr. Chow's Chinese restaurant later that night to celebrate.

In spite of the strict security they told me to stop by the studio whenever I wanted. They were usually there through the night into early morning.

One night I went by with my friend Jonathan Takami. We were sitting in the lounge, when John came running out and asked if anybody had boots on. We were actually the only people in the room, and it so happened that we both were wearing boots. John called us into the studio and explained that he was making these little vignettes of sound to go between each track, and for this one he wanted the sound of a beggar asking for alms for the poor while people walked by and dropped coins into a cup.

He sat on the floor and placed a metal plate in front of him while we walked around in circles on a piece of plywood that he'd laid down to amplify the sound of our footsteps as we dropped coins onto the plate. Unfortunately, since I was part of the recording, I couldn't take any pictures, but I have a clear memory of John sitting on the floor acting out the part of a beggar while I made my recording debut.

We were talking about doing a photo session. We scheduled several dates and each of them, for one reason or another, ended up being postponed. In November, I showed up at the Dakota only to be put off one more time.

John was full of energy, but Yoko was all business and wanted to finish her work without distractions. "Why don't you boys go to the coffee shop and come back later?" Café La Fortuna was a short walk away and had a peaceful garden in the back. The owners always played quiet opera music, and John had become a regular. He could walk there, have a coffee, and read the paper or a book without people bothering him. In many ways, a trip to Café La Fortuna was representative of the changes he was making—acting less like an elusive rock star and more like a normal New Yorker. That day was the first time in a long time that we'd sat down together and really talked.

I told him about my apartment in Tokyo, and John told me about a trip he took to Bermuda, aboard a large sailboat he had rented, called the *Imagine*. He took an assistant and some professional crewmen to sail the vessel, and on the way, they found themselves in the heart of a raging storm. John had switched to a macrobiotic diet back in 1976, after a dose of the flu, and he swore it was the diet that saved his life on this occasion. The storm was so heavy that the entire crew got sick. He, however, was fine and put it down to the fact that while they were into hotdogs and potato chips, he ate rice and vegetables.

He was the only person who was well enough to guide the boat through the storm, pointing the bow into the oncoming waves, so that it would not capsize. His crewmates even dressed him in a bright yellow sou'wester and lashed him to the wheel, so he couldn't be washed away, and it suddenly dawned on him that the only thing missing were sea shanties to accompany him. Unfortunately, he didn't know any, so he sang Beatles songs until they had passed through the storm.

We also talked for a while about the new album, and John already had some thoughts about the kind of photos he wanted to promote it. He sketched a diagram on a napkin of himself and Yoko to illustrate his idea. In the drawing, John and Yoko stand on the sidewalk at dawn as people are hurrying to work. The sunlight would be coming up, he explained, and the image would convey him and Yoko starting out together on a new day. That's how he thought of the new album, as starting over. The song by that title would become the first single released from the album.

The difference in the studio, brought on by John's change of philosophy, was dramatic. Whereas, before Sean was born, the studio cooler was filled with tequila, cognac, six packs, and mixers, now it held sodas and fruit juices and one can of beer. The message was clear: "We understand people drink, and if you have an emergency and need a beer, it's here." Drinking was not being encouraged as before.

He put up two pictures in the studio to remind him of his new responsibilities. One was a photo of Sean, which was taped over the television to replace the distraction of the screen. The other was a picture of a very obese Orson Welles taped up on the wall, to show him the consequences of excess. He said the picture helped keep him focused and reminded him of the benefits of being healthy and living a more responsible life.

Sean came to the studio once, so John could show him what Daddy was doing. I took a picture of John with his arms spread out over the control panel with Sean looking on. People love it, because it looks like John's majestically introducing his son to the world of music.

That's not inaccurate, but there was more going on. What John was actually doing was showing me how this board worked automatically. In the photo, you can see that all the controls are set. Each one of the controls monitors the volume of one of twenty-four different tracks.

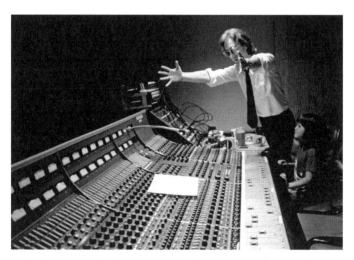

John Lennon and Sean Lennon, the Hit Factory, New York City, August 1980

Previously, in order to make a mix, you'd have to manually move the controls up and down and add a little more volume to one track at the same time you let up on another. Then the machines were combined, so there would be forty-eight or even seventy-two tracks. You'd have to have the engineer and the receptionist and everyone who happened to be around come in to help.

Finally, the whole recording process was computerized. The musicians could run through a song once and set the controls the way they wanted, then lock it, so that ultimately all the controllers were run by the computer.

I had never seen the device, and since it was new, John was pretty excited. "Watch this," he said, turning on a song, saying, "Ta-da!" spreading his arms as the whole apparatus began moving by itself. What a great moment for me and for Sean, to see John's demonstration and total enthusiasm for this new invention.

CHAPTER 29

NOW HE IS EVERYWHERE

John Lennon • John and Yoko • The Dakota

JOHN TURNED FORTY ON OCTOBER 9, 1980. I WAS at a birthday party for singer Nona Hendryx the night before, and I went straight to see John and Yoko at the recording studio. It was after midnight by the time I arrived, so technically it was October 9, John's fortieth birthday and Sean's fifth birthday. I'd taken a piece of cake from Nona's party, and I gave it to John so he could start his celebration off right.

Yoko gave John his gifts, which he excitedly showed off. Yoko used to knit a lot and had made a tie for John in his old school colors. She also gave him a pin of the American flag that was decorated with diamonds, rubies, and sapphires. John wore it proudly; the gift clearly meant a lot to him, although he managed to lose it within minutes of putting it on! He'd gone to the bathroom and I noticed the pin lying on the floor. I snatched it up before anybody—meaning Yoko—noticed it and met him in the bathroom. "Don't lose it again."

John Lennon, the Hit Factory,
New York City, October 9, 1980

I often dropped by the studio—they were now working at the Hit Factory—while John and Yoko were mixing their *Double Fantasy* album. John was very pleased with the way the work was progressing. One night, in a playful mood he picked up my camera and started running around taking pictures of everyone in the studio. When he turned the camera on me, I handed my other camera to someone nearby who took a shot of John taking a picture of me.

John Lennon and Bob Gruen, the Hit Factory, New York City,
October 1980 (photograph by Eddie Germano)

RIGHT PLACE, RIGHT TIME

Earlier, I'd given John the shirt he wore that particular night. I'd started spending time with a group called the Rockercisers, who wanted to teach people how to exercise in place—they pitched it as aerobic dance for future astronauts. As soon as I gave John the bright, loud shirt they'd designed, he took his shirt off and put the new one on. The Rockercisers were pretty happy when they saw the picture of John wearing their shirt.

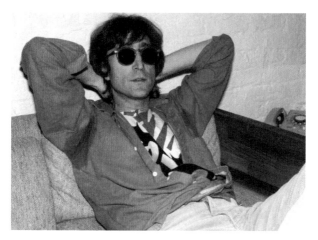

John Lennon, the Hit Factory, New York City, October 1980

John was very conscious of his appearance, always looking around to see what was new, what was different. He often bought new clothes. Once I visited John wearing my bright blue, shiny, vinyl winter parka. Vinyl clothing wasn't that popular yet, and I was proud of my unique, spaceman-like outfit. The very next day, John was wearing a similar jacket, but without a hood and in a darker shade of blue. I felt a twinge of competition between us that day, but I felt good that we had similar taste in clothes. Although I think my jacket was much cooler.

John talked openly and frequently about his relationship with Yoko in the many interviews he gave in December 1980. It was clearly uppermost in his mind, and the album *Double Fantasy* was very much a symbol of what John had been working to achieve for so long—a successful, meaningful relationship. *Double Fantasy* was a John and Yoko album, and the title was John's idea.

A double fantasy is a type of freesia John saw on his Bermuda vacation, a small bellflower with a sweet smell, and two colors on the same plant. John loved the symbolism of the different colors. To him, a double fantasy represented two people living together, having the same dream of a relationship, in the same way that the two freesia colors shared the same stem. That concept essentially was what *Double Fantasy* was all about. The album uses a simple back-and-forth format, as John and Yoko alternately speak of universal issues that people have in every relationship.

Most of the pictures of John and Yoko making the album show them very in touch with each other, physically. They acted as a tag team, so they could take charge of each other's work, and instruct the backup musicians or engineers as to what was needed, even if it wasn't technically their song. If one of them had listened to a track so often as to lose objectivity, the other would take over and keep the work moving. They had a shared vision.

John Lennon and Yoko Ono, the Hit Factory,
New York City, August 1980

Recording artists often rent out space surrounding their studios and fill it with their own furniture and comfort items; the homey touches close by make the long hours in the studio more manageable. John and Yoko rented the room next to their studio and brought in an upright

RIGHT PLACE, RIGHT TIME

John Lennon and Yoko Ono, the Hit Factory, New York City, August 1980

piano. This shot of them at the piano became the first publicity image released for *Double Fantasy*.

Mixing an album can be exhausting. There are often hours and hours of sitting and listening to the minor details that create the overall sound, and that can be very boring. Once when John and producer Jack Douglas were doing just that, I fell asleep on a couch right in front of the control panel. They kept hearing a sound on the recording that wasn't supposed to be there, and they listened to the recording again and again in an effort to isolate and eliminate the noise. Then they heard the sound as they were rewinding the recording and realized it was coming from somewhere in the room. They finally determined that I was the source, snoring away on the couch.

John, always curious, decided to see what would happen if I woke up to the sound of my own snoring. He and the engineer planned to rig up a microphone to capture my snore, and then play it back to me full blast. Unfortunately for them, I woke up as they were setting up the microphone.

John and Yoko had originally planned *Double Fantasy* as a double album, but now realized they would only have half of the album done in time to release it for the holiday sales in November. They decided to make the release into a single album instead of a double, and planned

John Lennon and Yoko Ono, the Hit Factory, New York City, 1980

to finish mixing and recording the second half that winter. (That would later become the *Milk and Honey* album.)

They were still in the studio when the single "Starting Over" was released; in fact, we'd been in there all night and into the following morning. We knew that DJ Scott Muni would be presenting the world premiere of the song on his show that morning, so someone tuned a little beatbox radio to WNEW.

The song sounded great on the radio, and everyone was excited, including Muni. As soon as the record ended, he said, "This song is so great, we're just going to play it again." John and Yoko were so happy they started dancing around the studio.

At the beginning of December, I got an assignment to submit several shots of John and Yoko for a *Village Voice* article. I told Yoko that I could probably use some of the pictures I'd already taken over the last couple of months and went to the studio so that she could choose her favorites, as I always did. Instead, she suggested I take some new photos. They were promoting *Double Fantasy* heavily, and more images were a good idea.

I took a few pictures in the control room and a few of John and Yoko posing in the hallway of the Record Plant studio. A huge guitar

was displayed behind a glass case there. Most people thought the guitar was just a random decoration, but John had actually had it made in 1971 as part of his and Yoko's *This Is Not Here* exhibit at the Everson Museum in Syracuse.

The piece was way too big to get in the door of an apartment, so he'd lent it to the Record Plant to store and display. Knowing the guitar actually belonged to John and Yoko, I suggested they pose in front of it. At first they stood in a normal kind of way, as a couple facing the camera. Then John pushed Yoko against the wall in a suggestive pose, saying, "Take this picture—this is what everyone wants to see."

John Lennon and Yoko Ono, the Record Plant,
New York City, December 1980

Before we left, John said that he'd just gotten a fancy new Yohji Yamamoto jacket embroidered in gold with spiritual sayings, and he wanted me to take pictures of him wearing it. He asked, "Can you come back tomorrow?"

I was back the next night, and they were working on Yoko's new song, "Walking on Thin Ice." Due to a technical delay, I ended up sitting on the studio steps with John most of that night, talking about his plans for the future.

Double Fantasy was selling well—it was in the top ten, and he was hoping it would reach number one. He was looking forward to a world tour that was set to launch in the spring, but he was especially pleased that Yoko's music was getting good reviews as well. "They're writing Yoko up as having the more interesting kind of music, and calling mine more M.O.R. [middle of the road]," he said. It didn't bother him, though. "I'm going right down the middle of the road to the bank." He was really proud of Yoko, too. "I worked with two of the world's greatest artists," he said. "Yoko Ono and Paul McCartney—and that's not a bad record."

John talked about his plans for an upcoming tour, and we discussed our mutual love of Japan and how we were excited to go there. We talked about which were our favorite restaurants in Paris or where we'd shop in Tokyo, what we'd do. The whole mood of the conversation was focused around how great life was, how everything was really coming together.

John sounded very grounded that night—clear and confident. He enjoyed talking about what he'd learned from raising his son and the joy that brought him. At the age of forty, he'd learned about the happiness that comes from delayed gratification—that if you don't get high every night, you get an even higher feeling when you see your child learn something. He talked about his ideas of living a responsible life, eating a healthy diet, thinking through your actions. In years past, he had chosen at times to momentarily numb all unpleasant feelings. He told me he'd learned now about the satisfaction that comes from working through those feelings, coming out of a slump through natural—rather than chemical—means.

Yoko didn't finish working on her track until six or seven in the morning. The sun was rising when we finally emerged from the studio. She was tired and ready to go home. "Forget the pictures," she said, "we'll do them tomorrow or next week." John then said, "But Bob stayed up all night waiting, and I brought my jacket." So, on the way out, we stopped on Forty-Fourth Street—the same place where I'd photographed them with Elephant's Memory, back in 1972.

I took half a roll of black and white and half a roll of color. In the morning light, the pictures looked just like the sketch John had drawn on the napkin at Café La Fortuna several months earlier. People were

**John Lennon and Yoko Ono, New York City,
December 6, 1980**

hurrying to work around them, and John and Yoko were standing confident and ready to face the world, to start another day.

Getting in the limo, John turned and said, "We'll see you later."

I talked to John two days later and told him I was going to come by the studio that night. Because John had been talking for a while about wanting to catch up with what other musicians were doing in their live performances, I'd lent him a videotape from my friend Don Letts, with footage of the Sex Pistols, the Clash, the Boomtown Rats, and the Slits performing. He said that he'd watched the tape and liked it. He told me he was going to leave it at the front desk of the Dakota for me to pick up.

On that night, December 8, I was developing the pictures of John and Yoko I'd taken Friday and Saturday morning. The *Village Voice* had given me a 2:00 A.M. deadline. To make it, I would have to finish developing the prints, drive up to the studio to show John and Yoko, and then drive down to the *Village Voice* offices. At around eleven that evening, as I was rushing to finish, my doorman rang up and asked if I had a television or radio on. "No," I said, "why?"

He told me he'd just heard John Lennon had been shot.

My first thought was that maybe John had gotten mugged after going out to get something to eat. I knew John rarely carried a lot of cash, so I thought maybe somebody had asked him for money and got mad when he didn't have any. Being shot doesn't mean dying, I thought. My phone started ringing. Toby Mamis called me from California to ask me what was going on.

"I have no idea," I said. "What did you hear?"

"I've got the TV on, and they're saying John Lennon is dead."

I slid down to the floor. It was the worst news I'd ever heard. Death is not negotiable, changeable, reversible. I started thinking, "How can I control this? How can I change this? How can I make it better?" My mind was reeling with the shocking permanence of the news and with how unbelievably wrong John's death was—this news out of nowhere, when so much positive energy was building around him.

My phone kept ringing, with calls from friends from all over the country. I suddenly realized that the whole world was watching, that people everywhere were going to be following the story. Everyone was going to be talking about it, and everyone was going to want pictures. And that was my job—to help John look good. I knew I had to get my pictures sent out. Almost as if I was sleepwalking, I started going through my files and pulling out pictures of John Lennon.

I called the *New York Post*, the *Daily News*, and the *New York Times* and told them I had pictures. After an hour or so, I went up to the Dakota. It was a scene, people crying and crowding around John's home. People were in shock and wanted to gather together for solace. There was a lot of hugging and hand-holding, and tape recorders playing John's music. I wanted to leave a message for Yoko that I was there, if there was anything I could do.

I remembered John said he'd leave Don's videotape with a copy of the new album at the reception desk. I worked my way through the crowd to the cops who were guarding the door. I said I needed to pick something up from the desk, and they let me through.

The Dakota has an outer gate by the street, then a driveway, and then stairs leading up to the reception desk. In the winter they have an

old-fashioned temporary wooden vestibule with windows that serves as a heat barrier. As I walked up, I saw a bullet hole in the glass window, which made me feel ill. The deskman looked as stunned as I felt. I asked if a package had been left for me. There the tape was, right on the shelf as John had said it would be, along with a copy of the *Double Fantasy* album. I asked the deskman to call into the office John and Yoko kept on the ground floor and left my message for Yoko. By the time I got home later that morning, I had calls from every major art director from every major media outlet in the world, all wanting pictures. I knew I had to start working, getting pictures sent out. I felt it was my job to share my pictures of John.

The day after the murder, when Yoko told Sean his father was dead, Sean said, "Now he's everywhere."

A day or two later, on Friday morning, Ron Delsener called to tell me about a memorial event planned for that Sunday. Yoko's wish was for ten minutes of silence in honor of John that everyone could participate in. It didn't matter where you were or who you were—everywhere around the world, at noon New York time, people could gather in their homes with their families and friends and be silent in memory of John. She wasn't organizing a formal gathering where the VIPs would be the only ones with tickets. John was a man of the people.

The city felt that a lot of people would want to gather at the Dakota, which would become a focal point. Rather than have thousands of people in the street, the city officials thought they should shift the inevitable gathering east to the bandshell in Central Park. They asked Ron Delsener to set up something people could focus on. Ron arranged some equipment to play John's music, and he asked me if I would supply a picture that would be enlarged for a centerpiece. I asked if he wanted me to bring some pictures to the office so he could pick one out. "No," he said, "you knew him. I know you'll pick a good one. Just pick it now. We have to get a big print made right away."

I gave a lot of thought to which picture I'd choose, because I knew hundreds—maybe thousands—of people would attend. One I considered was what I think of as the "rocker" shot, where John's playing his guitar onstage. So many people thought of him as a musician-hero, as a Beatle.

John Lennon, Madison Square Garden,
New York City, August 30, 1972

John Lennon, Butterfly Studio,
New York City, April 4, 1972

RIGHT PLACE, RIGHT TIME

But John was much more than just a rocker—he was an artist, a spokesman. Another image I thought about was a portrait from the Butterfly Studio. That photograph ran on the cover of the *New York Times* and showed John's quiet, intelligent, reflective side. But that photograph didn't seem quite right, either.

Yoko had taken a full page in the *New York Times*. Her message was, "Please don't blame New York for John's death—what happened could have happened anywhere." I agreed, and knew John was very proud of being a New Yorker. He died in New York because he lived in New York. He died going home. That's why I chose the picture of him wearing the New York City T-shirt.

John Lennon Memorial, Central Park,
New York City, December 14, 1980

I arrived in Central Park on the day of the service just as the silent period began. Thousands of mourners had gathered on the gray, cold day, and though it was quiet, you could hear people softly crying. That aside, it was so eerily silent that I could hear the sound of my own footsteps. John's music played before and after the silent period, and everyone listened without saying much or singing along. Every year on John's

birthday, fans still gather in Central Park at the Strawberry Fields area near the Dakota.

In the weeks before John died, he gave a lot of interviews, and in all of them he talked about how much he enjoyed his life—just like he'd told me on our last night together. He'd gotten rid of most of his bad habits and was clearheaded and disciplined.

John was a brilliant man and deep thinker. He spent almost five years in virtual seclusion, taking care of his son and learning what it was like to have a sober life. He emerged ready to talk openly about his new ideas of commitment and responsibility. It took him forty years to get there, and I've always wondered what would have happened if he'd had another forty years.

Not long after John died, I was downtown in a pretty bad neighborhood. Suddenly, I saw the words to "Imagine" written out on a wall. It

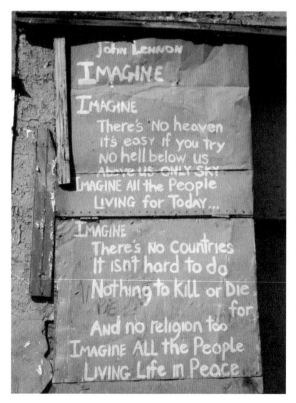

"Imagine" graffiti, New York City, 1981

was really powerful to see the lyrics written so simply, in such a rundown place. I sent that out as a Christmas card for several years. People kept it on their own walls forever.

It's hard to sum up why John means so much to so many people. Mainly I think John represented everyone's desire to better themselves and the importance of that struggle. Sometimes he fell short of the goals he set, but he was always open and honest about his failings. John Lennon always strived to do better, to be better, and encouraged people to imagine a better world.

I was in a total daze, I couldn't believe what had happened . . . my mind was in absolute turmoil, wracked by my grief. The phone was forever ringing with people needing pictures. They had lost a cultural icon, but we had lost so much more. Yoko had lost her husband. Sean had lost his daddy. I had lost a friend.

THE VIEW FROM HERE

John's Glasses • Yoko Ono and Sean Lennon • The Clash •
Green Day • Dad

ONE DAY EARLY IN 1981, YOKO ASKED IF I WOULD help her with an idea she had for the cover of her new album, *Season of Glass*. Much of the new record was an expression of Yoko's emotions, her account of how it felt to be suddenly a widow, to be suddenly without John. For the album's cover, she wanted to use the pair of glasses John wore when he was shot. His blood was still on them.

It was something she had to do, to share with people the horror of what had happened. I set up the lights, an old umbrella filter with two clamp-on reflectors that I'd picked up in a hardware store. We were both in tears as she opened a box and took out the glasses. Then Yoko arranged John's glasses on a windowsill that overlooked Central Park.

She also set down a glass of water that was half full, or half empty, depending on your viewpoint. The image shows Central Park through

the water glass, through the water, through John's glasses, through the window, showing how one reality exists in many ways simultaneously.

I set up the camera and handed it to Yoko. It was important to me that she take the shot herself. When she started looking through the viewfinder, I felt a little awkward just standing there watching, to suddenly be the assistant and not the photographer, so I picked up my other camera and took a picture of her taking the picture. Many years later, she began using her photo of John's glasses as a symbol of gun violence.

People were horrified when they saw the album cover and realized what it was. Seeing the glasses brought home a little bit of the horror and the anguish that Yoko was going through. If you could feel that upset just by looking at a broken pair of glasses, you could begin to understand Yoko's pain.

Yoko Ono, the Dakota, New York City, April 1981

On May 9, Yoko was in the studio completing *Season of Glass*, and I was at the Ritz for Tina Turner's comeback, the first big night of what would become her new solo career. Keith Richards was there, and it was a fascinating evening.

Yoko told me she'd be finishing the record, but I was busy with Keith and Tina till four in the morning. I called her at the studio, and she said

she was heading back to the Dakota, but I should meet her there because she and her musical director were going to have their first-ever listen to the final album, mixed and mastered.

The record was just finishing when Sean woke up. He came down the hall and joined us in the bedroom where we were listening; Yoko was in bed, and Sean just climbed in and snuggled up to her. It was natural for me to reach for my camera and take some pictures of them together. It was dawn on Mother's Day.

Yoko Ono and Sean Lennon, the Dakota, New York City, May 10, 1981

I showed the photos to Yoko a few days later, and she commented on how odd it was that she was now going to have to be the caregiver. People had never seen her that way before, and she'd never seen herself that way. John had been taking care of Sean while she was concentrating on their business. After years of being put down as a weirdo artist, she had become this sympathetic widow and mother. She said that there were many titles in life, but one thing she never wanted to be was a widow.

Five years later, on John's birthday, October 9, 1985, Strawberry Fields in Central Park would be officially dedicated as a memorial to preserve John's legacy. Yoko worked with the New York City Parks Commissioner and United Nations ambassadors to get it endorsed as a Garden of Peace by 121 countries, whose names appear on a bronze plaque near the memorial.

(Left to right) Mayor Ed Koch, Parks Commissioner Henry Stern, Yoko Ono, Sean Lennon, and Julian Lennon, Strawberry Fields, groundbreaking ceremony, Central Park, New York City, March 21, 1984

In the spring of 1981, the Clash came to New York City for an extended stay. They rented a loft in the West Twenties, where they spent their time entertaining friends, stalking the city, and silk-screening their own shirts and posters and things. That's when they came up with the idea of playing a week at Bonds.

Bonds was not actually a theater. It had been a department store in Times Square, just a big, open space on the second floor of a building with a linoleum floor and a low ceiling. The stage was a haphazard arrangement, the dressing room was an old storeroom.

But they found a promoter who was willing to take it on, somehow they wrangled the necessary permits and permissions, and that was it. The Clash was playing a week in New York City, and they sold out every night. In fact, the first night, it became apparent that the promoter had far oversold the show—meaning, he had sold more tickets than the place could hold.

Somehow, they squeezed everybody in, only for the fire department to show up and close the place down. So, the band held a press conference and announced that they were now going to play two weeks, and that everyone who had bought tickets for the first run of gigs could exchange them for one night in the following week.

They added all-ages matinee performances on both Sundays, and they recruited local acts, including a lot of rap artists, to open for them, including Grandmaster Flash and the Furious Five and Run DMC. Just as the Clash had done their best to introduce Bo Diddley and others to their audience, as their tribute to rock and roll's past, now they were offering the next generation exposure.

Again, the Clash asked me to play the bugle for them, although this time I would be opening the encore to give it extra emphasis, and that really revved up the audience.

It was during this period that the Clash appeared on Tom Snyder's TV show. They would be taping in the RCA building, where I had taken the Rollers to the roof, the best rooftop view in New York City. We were in the elevator riding down, and I was telling them about that session, and how we should go up there and take some pictures.

Joe agreed. "He lives here, we should listen to him!" he said. Topper, the drummer, had some other business he needed to attend to, but Mick, Joe, and Paul rode up with me to the observation deck and I spent just about ten minutes taking pictures of them, which have now been reproduced millions of times around the world.

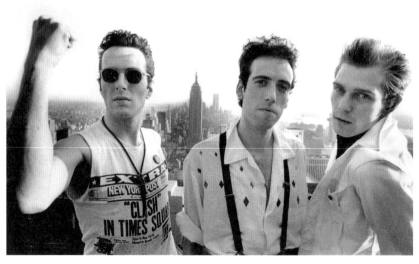

(Left to right) Joe Strummer, Mick Jones, and Paul Simonon—
the Clash, Top of the Rock, New York City, June 1981

When Green Day was in town for *Saturday Night Live* in 2009, I mentioned that we were in the same building where I'd taken that photo of the Clash with the New York City skyline and asked if they'd like me to take their picture there.

They immediately said yes; they were excited to do it. With the Clash, we simply took the visitor elevator to the roof. Now, we needed special permission for Green Day to leave the SNL stage even for a few minutes. Since the show is live, they insist that the talent must be on hand hours in advance.

We got the permission, but we still needed to be accompanied by NBC-TV's head of security—who later told me that he had a print of the Clash photo on his office wall.

(Left to right) Tre Cool, Billie Joe Armstrong, and Mike Dirnt—
Green Day, Top of the Rock, New York City, May 16, 2009

In early 1982, I reconnected with my old Justice League friend Tom Winer at his art and photo gallery uptown. We'd been talking about having him sell my photographs and arranging an exhibition since we first met the previous fall. Now Tom was helping me select suitable pictures for the show.

I'd had occasional exhibitions before. There was one at the Beacon Theatre, when Ike and Tina were playing, a series of 30 × 40-inch prints of them that I hung on hooks that I screwed into the walls of the theater. Every time I went to the Beacon in years to come, until they finally

remodeled the place, I would see the little holes I had drilled into those old walls.

A little later, I was part of a group exhibit at Westbeth, which landed me a review in the *New York Times*. I was in the lobby the following day and someone said, "Did you see our review?" I asked if it was a good one, and she said, "It was for *you*." Almost the entire review was about my work. I also had an exhibition at the Art Barn in Greenwich, Connecticut, in 1974, set up by Nadya's mom in an attempt to make me seem respectable, and one more at PS1, a converted school that is now a part of MoMA. A variety of New York photographers and graffiti artists were involved. I had two walls, one of rock and roll and one of John and Yoko. This exhibit at Tommy's gallery, however, was to be my first solo gallery exhibition.

I was making my way to the gallery one afternoon when I stopped to watch KISS shoot a new video at Studio 54, the famous disco. Talking with the club's publicist, Victoria Leacock, I mentioned the exhibition and she asked if I wanted to have a party at Studio 54 to launch it. I told Tom and he got very excited. He said we should definitely do it.

I agreed, but I wanted to do it on my own terms, which meant—no disco music. I wanted rock and roll, and I wanted to supply my own deejay, Scratchy Myers, who deejayed for the Clash. The club's manager agreed, but he had one condition of his own. Scratchy could spin until midnight. If he liked the deejay, the club would pay him and allow him to continue on through the night. If he didn't, there would be no money, and a regular Studio 54 deejay would replace him. I agreed.

Meanwhile, I was still trying to get the exhibition itself together. The lab I regularly used extended me credit to print more than 125 pictures; we needed them to be 16 × 20 inches, whereas my darkroom could only produce up to 11 × 14 inches. To save money, I used some of the prints I'd shown at earlier shows, and soon everything was together.

Studio 54, however, was making me nervous. I went there the day before the party, and absolutely nothing had been set up. The plan was that we would set up the entire exhibition at Studio 54 for the party itself, and then transfer it to the gallery the following day. Right now, though, the entire room was empty.

The following day, I watched as huge sheets of four-by-eight-foot foam-core boards were unloaded and taped together so they could be spread accordion style across the stage. I had an instant gallery.

I began arranging the pictures—I made three really big ones, 4 × 8 feet, which we placed in the lobby: one of John, one of John and Yoko, and one of Mick Jagger. Later, as the party started, Scratchy asked if I wanted to have people walking around looking at the pictures or if I wanted them to dance. I told him I wanted them to dance around and look at the pictures, and that was what happened. I was also very happy when I looked over at half past midnight to see that Scratchy was still playing.

That night was the first time I had ever rented a tuxedo, something I mentioned to Nadya a few days before the show. When she and Kris arrived, she had dressed him, too, in a tux . . . or, at least, an eight-year-old's version of one.

My father came along as well, and that made me especially happy because it was the first time he ever saw me as a success. He knew I made my living from photography, and that I was doing well at it. But this was confirmation that I hadn't wasted all those years taking snapshots of pop stars.

The other great thing about my father being there was that Ann and Nancy Wilson from Heart, who were there, loved talking with him—in fact, they spent most of the night with him. Even better, it turned out

(Left to right) Rudolph Gruen, Ann Wilson of Heart, Bob Gruen, and Kris Gruen, Studio 54, New York City, April 1982

Bob Gruen's exhibit, Studio 54, New York City, April 1982

that both Ann and Nancy, and their manager Kelly Curtis, were huge fans of the Beatles and, between them, they bought enough photos to cover my lab bill and leave me with a little profit. And they hired me for a photo shoot the following day.

Finally, to cap it all off, the next day I got a call from Jerry Rubin, asking if I could leave the pictures up for the party he was having at Studio 54 that night, so I did.

It was the success of the Studio 54 party and the exhibition that followed that started me thinking about other ways in which I could make money from my photography—thoughts that had been wandering around my head since I returned from Japan in 1980 to find myself broke.

Ginny was working as secretary to the director of Globe Photo Agency, which was one of New York City's most established old-school agencies. They did little in the way of rock and roll, but the appeal of rock and roll was becoming much more mainstream than it ever had been.

I talked to Ginny about her starting her own agency, specializing in rock and roll. She needed a little persuading, but she already had my library to work with and was growing more interested in the idea. Finally, she agreed. We found a couple of other photographers to add to the business, and that was enough to get us going. Ginny launched Star File in 1982 and it quickly became the premier photo agency for rock and roll in New York City, and it became a major part of my life as well.

Ginny was a natural. From the list of magazine names and contacts that I gave her, she promoted rock images in America and internationally. Over the next few years, Star File grew and grew, and as it expanded, so did the market for my work.

━━━━━━━━

CHAPTER 31

SEE YOU IN JAMAICA

Mick Jagger and Pete Townshend • The Clash • Mick and
David Johansen • Keith Richards and David • Yellowman

TWO OF MY ALL-TIME FAVORITE BANDS, THE CLASH
and the Who, were going out on tour together, six weeks of shows
that stretched from the middle of September until the end of
October 1982.

I didn't get to go on the whole tour. The Clash was under new
management and now they were flying everywhere. The first gig I saw
was the second stop on the tour, Philadelphia, on September 25. Mick
Jagger came with his daughter Jade, who was a big Clash fan, and he
also wanted to check them out.

The next gig I saw was at Orchard Park, near Buffalo. The best
shows for me, though, were spread over two days, October 12–13, 1982,
when the Clash joined the Who and David Johansen to play Shea Sta-
dium. My three favorite bands, all on the same bill.

Pete Townshend and Mick Jagger, John F. Kennedy Stadium,
Philadelphia, September 25, 1982

I met the Clash at their hotel and, while they piled into the Cadillac convertible that they had rented for the occasion, Don and I drove alongside in my car, with Don filming them all the way. He was making a documentary about the band. Watching it years later, one moment really leaped out at me.

We were driving across Delancey Street, heading for the bridge to go out to Queens, and Joe was in the back of the Cadillac with an Instamatic camera. He lifted it up and, in Don's film, you can see the flash go off as Joe took a picture of us, as we were filming him.

The Clash, Shea Stadium, New York City, October 1982

The Clash, New York City, October 12, 1982

I have always wanted to see that picture. I asked Joe a couple of times, but he had no idea where it was or what happened to it. He often would lose things when he was traveling. He took pictures more for fun than anything else, because I don't know if I've ever seen any of the pictures he took, and he took a lot of pictures.

One time when he was in New York City, he was fixated on hubcaps and, as we were walking around, he would suddenly run over to a car and lean down and take a picture of the reflection of the city in the hubcap. He did a whole series of pictures of cityscapes reflected in hubcaps that no one's ever seen. I don't know if he lost the film or never got it developed or if he was just having fun taking the pictures.

The Shea Stadium shows were really thrilling. The first day it was raining, but it didn't dampen anybody's spirits. The Clash rose to the occasion, as did David Johansen. I think it was the first time he played in a big stadium, but he was the hometown guy. So it was a fantastic show.

I wanted to see the Clash in Jamaica in November, where they were performing at the dedication of a new concert venue, the Bob Marley Memorial Performing Centre.

It was a three-day bash combining Jamaican legends like Peter Tosh and Jimmy Cliff on the same bill with groups as diverse as the B-52's, the Grateful Dead, and the Clash, a really eclectic lineup of musicians.

But it looked as though I wouldn't be able to go. Yoko had a trip to Europe coming up, and she asked me to go along. She would be doing

(Left to right) David Johansen, Mick Jones, and Joe Strummer, Shea Stadium, New York City, October 1982

some press, and she was nervous because of the English media. Word had gotten around that she had a new boyfriend, and while I knew he was more of an advisor and companion, that doesn't make half as good a headline.

We had stops first in Germany and France, and the United Kingdom was next, and all the while, Yoko was growing more and more nervous about how the press was going to attack her. Finally, on the second day in Paris, she suddenly decided we were all going to go home.

I'd been out that night. I happened to see a poster advertising a hip-hop show featuring Fab Five Freddy, Grandmaster Flash, and the Rock Steady Crew, promoted by my friend Rusa Blue. I went along and ran into Mick Jones, who played onstage with Fab Five Freddy. It was an exhilarating night, and we all went out for dinner afterward, so it was late when I finally returned to my hotel, to find a note on my bed telling me that we were going to go home first thing in the morning.

We weren't to tell anybody, not even friends and family, that we were coming home, which made things awkward for me because my then-girlfriend Jean, thinking I'd be away for ten days, had decided to completely renovate my loft with my assistant Karla Merrifield. Jean and Karla were going to completely reconfigure the place, to make room for more filing cabinets.

We had talked about her doing it for some time, and this was the perfect opportunity. So, while I was away with Yoko, Jean had basically taken the apartment apart. When I called her from the airport and said, "I'm back in New York, I'm coming home," the first thing she said was, "You can't." She explained she was in the middle of the major building project, and all I could do was promise I wouldn't stay too long.

In fact, I already knew what I was going to do—head down to Jamaica. The concert was still two days away, after all.

There was no space available on a direct flight. The best any airline could suggest was to make my way to Miami and try from there. So, I went to Miami and I was standing at the counter, just getting my flight booked when I suddenly heard someone call out, "Hey Bob!"

I turned around and there was the Clash riding by in one of those little golf carts they use to drive people around in the airport. "I'll see you in Jamaica," I called after them, then caught up to find out where they were staying.

I went to a big hotel across from the festival site and told them I had a reservation, even though I didn't. After some back and forth, the clerk told me there was only one room empty, and that was because it was flooded.

I didn't care. I was exhausted and still jet-lagged and just wanted to sleep. I was given the key and walked in to find the entire room two inches deep in water. I can't imagine what had happened, but I waded my way across it and felt the bed. At least it was dry, and I could sleep.

There were still no rooms available the next day, but the hotel let me check my bag, and I went across the road to the festival site. I spent the whole day there, going out into the crowd and buying a bag of pot for five dollars, and then coming across a little drink stand where they claimed to be selling rum.

It didn't really look like rum, and neither did the bottle they poured it from—it had "anti-freeze" written on the side. I realized from my first taste that it was obviously a homemade brew, and it was so good that I promptly bought another one.

Then I went in search of the Clash, backstage, where Joe was sitting looking very pleased with himself, clutching a bag of pot that was the

same size as mine. He was convinced he'd got a bargain, as well—all it cost him was the hundred-dollar wristwatch he'd been wearing!

I stayed for a few of the bands, but finally, when the Grateful Dead appeared, I headed back to the hotel. It was late, I was tired, and there still was no room for me. I walked down to the beach, flopped down on a lounge chair, and fell asleep. I awoke the following morning to find myself on a crowded beach, surrounded by vacationing families and playing children.

I rented a moped and made my way to Ocean View, that funky little place where I'd stayed on my first trip to the island, almost exactly ten years before, and I got a room there for the rest of my trip. That was the last time I ever saw the Clash perform.

(Left to right) Joe Strummer, Paul Simonon, Terry Chimes, and Mick Jones—the Clash, Jamaica World Music Festival, Bob Marley Memorial Performing Centre, Montego Bay, Jamaica, November 27, 1982

Another time I was hired to photograph Yellowman in Jamaica. It was a typically bitter New York City winter's day when I got the call; and I said yes I'd go to Jamaica even before I knew who Yellowman was—an albino black man who had part of his face removed as a consequence of jaw cancer.

It sounded challenging, but I was just happy to go to the Caribbean in January. I was scheduled to arrive on Friday night; a hotel had been booked, and I was told there would be somebody over to pick me up the following morning for the drive over the mountain to Ocho Rios.

I assumed that, being in Jamaica, we would be operating on "Jamaica time," which means nothing is ever done any sooner than it needs to be. I got up early, went down to the pool, got a cup of coffee, and I was stretched out in the sun when suddenly I hear an announcement. "Would Bob Gruen please come to the front desk." It was barely 9:00 A.M.!

I ran back up to the room, dressed, came down, and there was Yellowman himself, a tall, unique-looking guy with yellow hair and kind of a crooked face. He was a very nice, very outgoing guy. He was also very popular, one of the best-known deejays in Jamaica.

His driver, Red Bird, was with him, so we piled into their small compact and took off. Red Bird drove like many Jamaicans drive, which is at around ninety miles an hour on narrow two-lane roads that wind through the mountains, screaming around tight mountain turns. At one point I saw a cop car and I was sure we were in trouble. Instead, Yellowman just waved at them and the police shouted back, "Yo, Yellowman!" In fact, everywhere we went, everybody we passed was waving and calling his name. They loved him.

Yellowman, Ocho Rios, Jamaica, January 1984

We stopped a few times on the journey so I could take pictures, some by a waterfall, some with a mountain backdrop, and once we arrived in Ocho Rios we went to an open-air nightclub. I walked to the doorway and was looking out at the street, with my cameras hanging around my neck, when Red Bird grabbed me and said, "Don't go out in the street. You can't go out in the street. Come back in here." I hadn't considered how dangerous it was to walk around, especially with expensive equipment hanging from my neck.

We spent the whole day together, and then I spent the following day resting in Ocho Rios, lying on the beach. When I got back and checked my answering service, I discovered that I'd missed the opportunity to photograph Mick Jagger! Lisa Robinson interviewed him, and she had wanted me there. All I could think was, "Can't I just take one day off?"

The company wanted the photographs in a rush, because they had some kind of convention coming up. I stayed up late developing them, and delivered them to the label the following day; that weekend, the photos were being used at a convention in Hawaii, profiling the label's up-and-coming acts.

By this point in time, early 1984, I was coming up on fifteen years as a professional rock photographer—more than that, if you count the work of my early years at Newport and with Glitterhouse. Then it was closer to twenty years.

Two decades, and in all that time, the routine was simple. I would deliver the photographs and my invoice, and at some point—it might be immediately, it might be a month, it might be ninety days—I would receive a check.

That's how I worked, and that's how everybody worked. So you can imagine my reaction when Ginny, who was now my agent, called me up one morning to tell me she had just received a contract from the label for the Yellowman job, and that I wouldn't be paid until it had been signed, countersigned, and whatever they needed to do.

We read it together. Of course, they were asking for far too much. They'd made a low-priced deal to take pictures for publicity and to show at their convention. But, according to the contract, they wanted

the rights to use the photos for posters and for album covers and for any other use they possibly could think of without paying any more.

There was no way I was going to sign that. Ginny called and told them outright, "We can't sign the contract because you didn't pay enough to license all rights. You were only paying enough to cover using the pictures for publicity." The negotiations began.

And every week, they'd have a conversation, back and forth and back and forth and back and forth, until more than two months had gone by, and they were still talking and I still hadn't been paid. I was livid. I did this job practically overnight because they needed it in a rush, and now it was months later, and they're still talking about what rights they can get for what little money they can pay. I was at Ginny's office one day, on Forty-Fourth Street in Times Square, and the record company was just up the road, at Fiftieth Street and Sixth Avenue. I stormed over there, getting angrier and angrier, and went up to the office of the publicist who had hired me in the first place. "Where's my money?"

"You've got to talk to this guy." She brought me to the A&R guy, and he tried to calm me down. "Well, it's not like we're going to use your pictures and not pay you."

I said, "You've already used my pictures, and you haven't paid me. I want to be paid. You're still dicking around with this contract to see what extra rights you can get. You hired me to take the pictures to use at your convention. You used them at your convention. Now pay me."

I walked out. I was so angry that as we were walking away, the publicist said, "Oh, I'm so glad you didn't hit him." Of course I wouldn't have; I've never punched anybody in my life, but they didn't know that. I was still seething that evening, despite having one of David Johansen's Buster Poindexter shows to look forward to. Buster was a highly amusing lounge act that David had come up with. The show was at Tramps, a place I regularly went to have a good time, but because I was in such a bad mood, I didn't even take my camera with me.

So, when Keith Richards showed up with Jane Rose, his manager, and I overheard him talking to David about getting up onstage with him at the end of the second part of the show, I ran outside, leaped into a cab

home, raced inside, and got my camera, back into the cab and back to Tramps. It was cool to see Keith up there with David.

I developed the pictures as soon as I got home, and at 5:00 A.M. I was in a cab to the *New York Post* headquarters down by South Street Seaport, where I dropped them off. I realized my mood had completely changed. As I walked through the Seaport, a light rain began falling, and the city was totally still around me. I felt at peace.

(Left to right) Delbert McClinton, Keith Richards, and David Johansen as Buster Poindexter, Tramps, New York City, February 23, 1984

I got home around 6:30 A.M. and was sleeping soundly until the phone rang at nine. It was the guy from the record company. "We have your check ready if you want to come and pick it up." I went back to sleep. All was well with the world.

Contracts were now becoming a normal part of my business; it seemed that every job came with one. Ginny and I would always read them carefully, because they always asked for more than they were willing to pay for. We had to check the wording carefully. I once had to have a model sign a release for photos I'd taken. The release forms came in pads that you could buy at a camera store, and they were titled Standard Release Form. When I gave one to the model, she said, "The only thing standard about these is they're all different."

Whenever someone told Ginny, "This is our standard contract," she would always reply, "but we're not standard people." After a while, she took to using white-out to erase all the offending clauses, instead of simply crossing them out. We would sometimes return a three- or four-page contract with only a handful of clauses left visible. One day she met a lawyer at a party. They were introduced and he said, "Oh, Virginia from Star File, the one with the white-out."

Ginny Lohle, Star File office,
New York City, September 1994

CHAPTER 32

STARS IN MY EYES

Sean Lennon and Andy Warhol • Mark Ronson and Sean •
Chuck Berry and Phil Spector • Ronnie Wood and Richard
Lewis • Joe Strummer and Friends • Sheena and the Rokkets

SEAN LENNON TURNED NINE IN OCTOBER 1984, AND
Yoko threw a party to celebrate Sean's special day and to honor
what would have been John's forty-fourth birthday. She invited
artist and musician friends including Iggy Pop, Phil Spector, Roberta
Flack, Andy Warhol, and Keith Haring. There was an awkward moment
when Spector decided to tell Iggy that he really didn't like his music or
his band, and that it was no good.

So, Iggy kicked him.

"Why did you do that?" Phil asked as he rubbed his leg. Iggy just
looked at him. "You hit me twice. I only hit you once."

Of all the people at his party, it was Andy Warhol who seemed to
intrigue Sean the most. At one point in the evening, Sean made a little
drawing of a big heart saying, "Sean loves Andy," or something like that.

He signed it "Sean Lennon," gave it to Andy, and asked Andy to draw something for him. So, Andy drew a big heart and wrote "Andy loves $ean," with a big dollar sign instead of the "S" for Sean.

He added his signature, "Andy," and passed it to Sean, who promptly handed it back and said, "This could be Andy anybody. Sign 'Andy Warhol.'" I couldn't believe it. At nine years old, what a smart kid!

Following dinner, we all went into the living room where Yoko had a pair of expensive white vintage Art Deco chairs, and now Sean and Andy were drawing with Sharpies on napkins on the arm of one of the white chairs. Yoko noticed that some of the ink had gone through onto the arm of the chair. I can't imagine what she was thinking, but she turned away as though she hadn't noticed, and quietly asked me, "Is Sean making trouble?"

I looked over. Sean did not have a pen in his hand at that moment. "No," I told her. "But his friends might be." The fact is, I was very surprised to see Andy being so talkative with Sean. He usually didn't say very much at all. I mentioned it to Yoko, and she laughed. "Well, that's because Andy's finally found somebody on his own age level."

(Left to right) Keith Haring, Andy Warhol, and Sean Lennon,
the Dakota, New York City, October 9, 1984

I was getting closer to Yoko at this time. Many nights we would sit and talk for hours. One of the last things John Lennon told me was to always listen to Yoko, that she was always right, and I found that to be true. She was always busy with new art projects and her songwriting and recording. I became a regular visitor to her apartment in the Dakota. I would sometimes bring music cassettes for Sean. Yoko and her companion didn't know much about the history of rock and roll and blues, so I would give Sean all kinds of music that I thought he should know about, like Miles Davis, Fela Kuti, and various reggae records. He's grown into a fine musician who can play almost any instrument he picks up. Now he introduces me to people as his "uncle."

In 1984 Yoko took me along to Europe on some dates she played in Budapest, Ljubljana, and London. She played some big theaters and it was great to see a room full of young people who admired Yoko and enjoyed her music so much.

New Music Seminar had grown, and my involvement had grown alongside it in the years since that first event, when Malcolm was one of the keynote speakers. Now I was the official photographer, which meant I had to run around and photograph as many different bands a night as I could, with some four hundred bands playing at forty different venues in Manhattan. People coming from out of town were excited that there were forty clubs to go to, but I knew that these clubs were open all year and the only difference was that during seminar week most of the bands had a publicist.

Every day before I set out, I would plan my route, this band here, that band there, another band someplace else, and then back to the first venue for a different show before racing uptown for somebody else. And I had it down to a fine art.

I'd pull up outside the venue, double-park if I had to, and I'd run inside. My assistant would wait in the car in case it needed to be moved, and I'd shoot off as many pictures as I could in four or five minutes, then run out and we'd drive to the next place. Over and over again, ten or twelve times a night.

The choice of bands that I shot was largely made by the NMS music director, although I had free rein to photograph any artists that

I liked, and for a couple of years at the beginning of the 1990s, I had two extra pairs of ears to recommend bands, after Sean and his friend Mark Ronson joined me.

Sean was fifteen by now, and one day he called to ask if he and his friend Mark could ride with me and come in to see the bands and get to experience as much of the New Music Seminar as possible. They had already bought passes for the show but didn't want to wait on line, so I said yes and we piled into my car and off we went.

Today, Mark Ronson is one of the most well-known producers and deejays in the world, but at the time he was just fifteen, a kid nobody had heard of. I quickly discovered that, if there is such a thing as a music savant, it was Mark. Every show we stopped at, he not only knew exactly who was in the group, but who they'd played with before; he knew their music, he knew their story. A few times, he would ask if we could detour to see somebody that wasn't on my list, and every time, I was glad he did. Mark really did know what he was talking about. So when the following year's seminar rolled around and Sean again asked if he could tag along, I told him yes, "but only if you bring Mark."

Mark Ronson and Sean Lennon, New York City, July 1991

In 1986 the first annual Rock and Roll Hall of Fame induction ceremony was held at the Waldorf Astoria Hotel. In the early years, they were inducting people from the 1950s and early 1960s or bringing them

on as presenters. I saw many legends on the Hall of Fame stage; some were people I'd grown up listening to and others I had worked with, like Chuck Berry, Bo Diddley, Ike and Tina Turner, and the Shirelles.

For me, and I'm sure for many other people, the best part of the evening, in those earliest days, was the wild spontaneous jam that would conclude the event. The bandleader, Paul Shaffer, would call out a song title and everybody just jumped in, not only the current year's inductees, but any past members who happened to be there as well. Bill Graham was the emcee, and several times I saw him just reach out into the audience for some legendary artist who happened to be there, calling them up onstage to join in.

It was such a joyous celebration of the music, and it affected everybody in the room—including drunken executives who would suddenly get it into their heads that they should be up there as well, playing guitar alongside Eric Clapton. Bill would always firmly yet gently escort them off the stage. After all the formality of the awards ceremony itself, this was the moment when everybody could let their hair down, and they did.

For me, those were the golden years of the Hall of Fame, the first years, before it became the television special it is today, when the entire show is planned and rehearsed. Every year there is roiling controversy about who does and doesn't get inducted. Everybody reading this probably has their own list of favorites who they feel have been ignored by the Hall of Fame, dating back to the very earliest years of rock and roll. When I've visited the Hall of Fame Museum in Cleveland and witnessed parents explaining to their kids how music influenced their lives, I feel it's all worth it.

Another highlight of those earliest years was the after-party that Allen Klein would host with Phil Spector in the penthouse of the Waldorf. Allen always made certain there was a spread of great food, but I usually got there too late for the caviar. There were lots of drinks, and there was usually a music jam as well. One year, Phil and Chuck Berry were sitting at a piano together and they started playing a medley of songs. Soon, everybody in the room was joining in, and suddenly there I was, standing next to Peter Wolf singing along with Phil Spector and Chuck Berry!

Phil Spector and Chuck Berry, Waldorf Astoria, New York City, January 19, 1994

I was back in Japan in 1987, this time to work on a movie, *Tokyo Pop*. Earlier in the year, I went to a party at the building that used to be the Fillmore, where I ran into a woman named Fran Kuzui, who looked familiar to me, although I could not place her. While we were talking, I was trying to remember how I knew her, as she was telling me about the movie she was about to start work on. It was about a girl from New Jersey who moves to Tokyo and joins a rock-and-roll band.

Jokingly, I told her she should hire me, because I knew everything about girls from New Jersey, rock and roll, and Tokyo. She suggested we have dinner and talk about it. When we met I still had the feeling that we'd met before, and then I asked where she went to high school.

"Great Neck."

And what school did she attend? South, the same one as me. At exactly the same time. But she wasn't Fran Kuzui at the time, she was Fran Rubel. And I wasn't Bob Gruen . . . I was *Robert* Gruen. Fran said, "Oh my god, you were the AV guy!" A few days later, she called and hired me as the stills photographer. In March we flew to Tokyo to begin work.

Carrie Hamilton played the lead role, Wendy; much of the remainder of the cast, including the musicians, was Japanese. A few of my friends found themselves with at least a minor part in the film—Yuya's in it, Gan-san is in it—and I had a wonderful time, even though the work itself could be grueling. We would work from six in the morning until

(Left to right) Carrie Hamilton, Fran Kuzui, and
Yutaka Tadokoro, Tokyo, Japan, May 1987

midnight, at which point I would return to my hotel room to develop
film in the makeshift darkroom I'd set up in the bathroom.

I enjoyed the experience of working on a movie set so much that
when Fran called again, a few years later, to ask if I was interested in
taking stills for her next movie I didn't hesitate. We started working
on *Buffy the Vampire Slayer* in spring of 1992. Fran's plan was to start
shooting on a low budget but was sure that when a studio she was in
touch with saw how it was going they would back the film and we would
get a much bigger budget and union pay rates.

Hotel developing jars, Tokyo, Japan, 1987

She was so enthusiastic and confident, and her mood was contagious. Soon, I was driving around Laurel Canyon looking at properties and imagining myself leaving New York City forever and relocating to Hollywood, to launch a new career in movies. At the moment, I couldn't afford to rent even a single basement room in the houses I was looking at. But if I got in the union, I could see myself doing very well.

Fran did find a studio that loved the movie; they would distribute it around the world and the crew would all be admitted to the film union. She took me to one side and told me that there was a problem. Yes, she had a deal, but unfortunately, the publicist who would be handling the promotion had a boyfriend who was a movie stills photographer. And the way I heard the story, she effectively told Fran that, if her boyfriend didn't get the job, then *Buffy* wouldn't get her support.

Fran had no alternative. I was let go, and the movie went on without me. When it was released in 1992, I noticed that the vast majority of the promotional stills being used were ones that I had taken. I was furious when I heard the news. I had done all that work on the film, and my dreams of moving to Laurel Canyon were over. I hated the movie business.

All I wanted to do was get out of Hollywood and fly home. I planned a farewell dinner but couldn't bring myself to go out when suddenly the phone rang. I picked it up and it was Bill German, a guy I'd known for years, who ran *Beggars Banquet*, the best Rolling Stones fanzine of them all—the one that even the band members turned to if they wanted to find out what one of the others was doing at the time.

Ronnie Wood was hosting a Hollywood listening party for his new album, *Slide on This*, and Bill suggested that I go. I wasn't certain how I could get in. Hollywood is not New York City; people didn't know me there like they did at home. But I said I'd try.

We got there, and I must admit we did look the part—my date was even wearing a bright pink motorcycle jacket. We walked up to the guard at the gate and he was just about to ask whether we were on the guest list when his phone rang. Instead of telling us to wait, he simply waved us through.

Ronnie saw us as soon as we walked in and told me to "get clicking," so I took photos of him and his friends. In the midst of this, some guy

I'd never seen before sidled up to me and said, "If you want to sell any of those pictures, give my agent a call on Monday," and he handed me a business card.

I didn't even look at it. "No, if your agent wants to buy any of those pictures, tell him to give me a call; I'll be in New York City." I handed him my card; the guy looked at it and burst out, "Oh my god, you're Bob Gruen! My friend has sent me your photos as birthday presents for years."

He went on to explain that he had only two types of art in his house, Ronnie Wood's paintings and my photographs, and then he introduced himself—Richard Lewis, the comedian. So, I prepared a picture to send to him, and I added a xeroxed catalog of all my photographs, to see if there was anything else that he wanted.

There were, in fact, too many. Richard said, "I don't have the wall space for all the photos I want!" But he asked whether he could buy twenty 8 × 10s, which he would put in a fancy leather portfolio, so he could have his own unique, original Bob Gruen photo album.

Richard Lewis and Ronnie Wood, Los Angeles, March 1992

The Clash were no more, but Joe Strummer continued to play a major role in my life. He was spending more and more time in New York City, and whenever he was there, he would stay at my apartment. When he

was in town he would gather what became his usual New York posse—
Jim Jarmusch, Matt Dillon, and Josh Cheuse—and we'd end up having
adventures and staying out drinking all night.

When we went out with Joe for an evening, we always had to
remember to bring our sunglasses . . . you need sunglasses when you
walk out of a bar into bright morning daylight, as we often did.

(Left to right) Josh Cheuse, Jim Jarmusch, Matt Dillion, Joe Strummer, and Bob Gruen,
Milano's Bar, New York City, April 1994 (photograph by Elizabeth Gregory-Gruen)

In 1987, Joe was in town to film his part in Robert Frank's new
movie *Candy Mountain*. It was only a small role, but he took it seriously,
particularly Frank's insistence that he deliver his two lines in an authen-
tic New York accent. Joe turned to me for help. "What," he asked me one
day, "is a typical New York expression? Something that everybody says."

I thought for a moment, and then came up with "D'ya wanna bagel?"

Joe gave it a try. "Do you want a bagel?"

"No, too English."

He tried again. And then again and again and again. For the rest of
the week, no matter where we were or what we were doing, I knew that
sooner or later, Joe would turn to me and say, "Do you want a bagel?"

It was always entertaining to hang out with Joe. One time he told
me he found a lucky dime . . . then a little while later he said he just found
two dimes in his pocket and he was upset because he didn't know which

one was the lucky one. I explained that he just doubled his money and that was all the luck he could expect for ten cents.

In the late nineties Joe formed a band he called the Mescaleros. They were all great musicians, and his sets were a mix of rock, reggae, blues, and jazz. We saw a lot of great shows they played, including a week at St. Ann's Warehouse in Brooklyn. All these nights lasted past dawn.

The last night we were together, in November 2002, Joe found out the Clash had been voted into the Rock & Roll Hall of Fame. He said, "Wow, the Hall of Fame, just like Babe Ruth!" We ended the night celebrating by dancing on tables at a downtown restaurant.

(Left to right) Joe Strummer, Chris LaSalle, Linda Rowe, Edward Lee, Jennifer Senger, and Elizabeth Gregory-Gruen, New York City, November 2002

In the spring of 1988, the Japanese band Sheena and the Rokkets had decided to record their next album in New York City, and they asked me if I could make the necessary arrangements. I brought in a friend of mine, Jim Ball, to produce, and I found a studio on Bond Street that we could use, which coincidentally had been built by a famous Japanese calligrapher. His two sons were both into jazz, and when they moved to New York City, they bought a brownstone and converted one floor of it into a

calligraphy school and the second floor into a state-of-the-art recording studio, where they hoped to attract jazz musicians. There were living quarters upstairs, where the band could stay, and they remained in town for a month, recording what would become their *Happy House* album.

The band loved the studio setup and were especially excited that it was just around the corner from CBGB—the venue that nurtured almost every band they liked (their band was even named for a Ramones song, "Sheena Is a Punk Rocker"). Every night when they finished recording, the band would head there, and soon they were asking me if they could get a gig at CBGB.

I contacted Hilly, and he agreed to put them on. I called Ron Delsener, and he arranged a warm-up gig at a little club he owned uptown, on Eighty-Fourth Street. I was wallpapering posters for the CBGB show all over those parts of New York City that had a large Japanese population. Sheena and the Rokkets were, after all, huge back home. Nobody would want to miss seeing them in New York City, and that is how it turned out. The club was sold out that night, and the gig was a triumph. Hilly liked them so much he later brought them back for his twentieth-anniversary celebration.

Sheena and the Rokkets, *Happy House*, New York City, 1988

We also shot a video for one of the songs on the album, and I had high hopes of getting it on MTV. Unfortunately, I was not aware of the rules surrounding what we now call "product placement"—quite innocently, a few brand names appeared in the video, on cans and bottles, and while MTV did give me the option of re-editing the video to remove them, we simply couldn't afford it.

I first met Giorgio Gomelsky at Tramps. He was an older, professorial-looking, intellectual European who would come in and sit at the bar to watch the blues acts there. He was mysterious. Nobody seemed to know where he came from, and while he definitely had an accent, it was hard to place. He seemed kind of like a Russian mystic.

He knew a lot about everything, he had opinions about everything, and he loved to talk. There were rumors that he had something to do with the Rolling Stones, the Yardbirds, too. But again, he never said a word about it. When he did discuss music, his head was full of new bands that he'd met and was trying to help. Whatever they were doing, he wanted them to do more. He always wanted people to do more and go further.

This went on for a couple of years, until one day, when Lowell Fulsome was playing at Tramps, Mick Jagger walked in with Jimmy Rip, his guitar player. As soon as Mick saw Giorgio at the bar, he went over and the pair of them looked so happy to see each other, talking away. All the rest of us were standing around the bar elbowing one another, saying, "Look, he really does know Mick Jagger!"

Slowly, the story fell into place; how Giorgio was in Paris when his friend Serge Gainsbourg—we couldn't believe it! He actually knew Serge Gainsbourg!—suggested he go to London, to look at the music scene developing there. This was in the 1960s, just as a new generation of musicians was discovering the blues.

It was Giorgio who discovered the Rolling Stones and, when they went off with other management, he discovered the Yardbirds. The history of British rock spilled out of Giorgio's story, and French rock, too. His favorite band, with whom he worked for years, was called Magma, and when they came to New York City one time, he insisted that we all go with him.

I can't say I was impressed. They sang songs in a kind of made-up language while playing an impenetrable jazzy prog rock. But Giorgio loved them, so there must have been something there. Giorgio owned a building on Twenty-Fourth Street and he used to rent out rooms for young bands to rehearse in. He would throw the greatest parties, where you would meet a variety of eclectic people. At his sixtieth birthday in 1994, the entertainment was provided by a gentleman Giorgio introduced to us as the world's greatest saw player.

Now, I am no judge of such things—I don't believe I had ever even heard somebody play a saw before. But this guy held the room spellbound with a playbook of sounds that ranged from the spookiest horror effects to the most out-of-this-world sci-fi symphonies. He may well have been the world's greatest saw player.

HAPPY BIRTHDAY TO ME

*Birthday cakes • Michael Joo and Angus Fairhurst •
Michael Schmidt and Debbie Harry • Courtney Love,
Misstress Formika, and Evan Dando • Green Day*

IN THE FALL OF 1991, HILLY KRISTAL BOUGHT THE TWO buildings on either side of CBGB, one of which was a pizza parlor, where he hired musicians to prepare the food; the other side became an arts space. He was starting the CBGB gallery with an exhibit of rock-and-roll art and I was asked to be a part of it. The opening was scheduled for October 23.

When they told me the date, I said, "Oh, that's my birthday." I hadn't meant for them to take notice, but when I received the invitation, there was my name, in bold lettering on the list of other photographers whose work would also be on display, and underneath in tiny print, "It's Bob's forty-sixth birthday."

The place was full, and that led to an almost *Spinal Tap*–like moment, when the birthday cake that Ginny had ordered was delivered. She had asked for a three-foot cake but what arrived was barely ten inches. No way would that feed the club, so she raced to Veniero's Italian bakery nearby and bought six more of the biggest cakes they had, put candles on every one of them, and then rounded up different people to carry each one up to me.

A picture of Sean Lennon, accompanied by half a dozen pretty girls at the party, actually made it into the *New York Post* the following day, on the same page as a photo of Richard Gere talking to the Dalai Lama and another of Paul McCartney. Although it wasn't planned as my birthday party it was the start of a tradition that lasted the next twenty-five years.

(Left to right) Bob Gruen, Sean Lennon, Deborah Pope, Jenny Golden, and Ginny Lohle, CB's 313 Gallery, New York City, October 23, 1991 (photograph by Tina Paul)

Jesse Malin was the lead singer of the band D Generation when we met in the early nineties. They rehearsed at Giorgio's place on Twenty-Fourth Street and would throw monthly rent parties there. As they got more popular, he rented space on St. Mark's Place, by chance the same space where Glitterhouse got their big break years before. When the parties became a destination, Jesse made a deal and took over the whole building, and it became a rock-and-roll place, three floors of boundless fun he called Coney Island High. The Ramones played there, and D Generation, plus a regular schedule of local bands and great deejays.

I was standing at the bar there one night in 1993 when I saw Elizabeth Gregory crossing the room toward me. She had been the girlfriend of my friend John Spacely, and we had known each other for seven years by then.

I had always been very attracted to her but never said so, naturally, because she was my friend's girlfriend. By this point, John and Elizabeth were no longer living together. We talked all night. As we walked out to my car, I asked her if I could take her back to my place. She looked at me and said, "You can take me anywhere."

We went on our first proper date a few days later; I took her to a Stephen Sprouse fashion show at Studio 54, where D Generation was playing, and we've been together ever since. Elizabeth and I were married in October 1995, two days before my fiftieth birthday.

Twice a year, Elizabeth would travel to Europe for her fashion design job, and I started to go with her. She would work all day while I checked in with contacts and made evening plans for us with friends.

Joe Strummer had kept in touch, and we went to his wedding when he married Lucinda, and we sometimes visited them at their home in Somerset. On one of these visits Joe announced that we were going to visit Damien Hirst at his place an hour or so away. We arrived to find

Michael Joo, England, June 2001

Angus Fairhurst, England, June 2001

that he was hosting a lot of friends for the unveiling of sculptures by his friends Michael Joo and Angus Fairhurst. Our friendship with Damien grew, and on later trips he let us stay in several places he had in London.

There were so many new clubs operating in New York City in the late eighties and nineties. Pat Kenny, from Kenny's Castaways, opened the Cat Club on Thirteenth Street at Fourth Avenue in 1985, with Don Hill managing. A lot of the bands that played there were of the heavy metal genre known as hair bands; LA Guns and Poison both appeared there. There would be so many people spraying and teasing their hair in the restroom that it might have blown up if someone lit a cigarette.

Around 1993, Don moved on to open his own club, Don Hill's in SoHo, and it became a legendary haven for both local and visiting rock and punk bands. Another important place was Jackie 60, a weekly party held at West Fourteenth Street and Washington Street, in the old meat market district of New York City, at a time when there still was a meat market. Today, it's an upscale place with hotels and fancy stores, but back then it had a real character. You'd walk out of Jackie 60 in the early morning, and right next door, there was a poultry place, with crates of live chickens piled up on the sidewalk. A few doors farther down, there was a biker bar, with the inimitable name Hogs and Heifers, and we would often end the night there, if only for the contrast between the club and the bar.

Jackie 60 was run by DJ Johnny Dynell and his wife, the writer Chi Chi Valenti, and it grew out of another club where Johnny and Chi Chi worked in the mid-1980s, called Area. Johnny was deejay, Chi Chi usually ran the door.

Area was a terrific place because every month they had a different theme and they had window displays set into the walls, like little rooms with windows through which you would see fantastical tableaus. One time the theme was Fetish, with a bathroom set up in one of the displays and everything was covered with carpet tacks glued about half an inch apart: on the toilet, on the sink, on the faucet, on the walls, and on the floor. On Religious Night, they had someone dressed as Jesus with a cross tied to his back, and he crawled around the club.

Jackie 60 has been described as a gay bar, or a fetish bar. In fact, it was far more. As far as we were concerned, it was simply a people bar and an exotic cabaret. It didn't matter who, or what, somebody was; they were welcome at Jackie 60, and they would be entertained by some truly incredible acts.

Every week on Tuesdays Jackie 60 turned itself over to a single theme. One week, for example, it might be the Night of a Thousand Stevies, at which everybody was encouraged to arrive in some way dressed as Stevie Nicks. The next week, it might be Pooped-Out Party Girls, or Fiddler in the Hood (Hassidic hip-hop!). There would be monthly poetry events, called Verbal Abuse. Elizabeth and I went there as often as we could.

Another favorite haunt was Squeezebox, a monthly party that designer Michael Schmidt took to throwing at Don Hill's in SoHo. Like Jackie 60, it had a wild, uninhibited atmosphere, which is hardly surprising because many of the Jackie 60 regulars were at Squeezebox as well.

Debbie Harry and Michael Schmidt, Supper Club, New York City, March 1993

I'd known Michael for years, having met him when he first came to New York City from the Midwest to start a career in fashion design. Michael's fashions are mostly made of metal. He designed a form-fitting dress for Debbie Harry that was made completely out of razor blades, every one of which he had filed down by hand. He was also responsible for the metal cones that Tina Turner wore in *Mad Max*, and sundry metal clothes for Madonna, too.

Squeezebox was pure rock and roll; DJ Miss Guy played a constant barrage of the Dolls, Aerosmith, Kiss, and bands like that. Misstress Formika was the host who organized the live shows featuring acts like Dean Johnson and the Weenies, or Jayne County (another of the regulars), as well as Debbie Harry.

I first saw Green Day on television when they got in a mud fight with the audience at the 1994 Woodstock festival. The audience started it but the band responded enthusiastically and it was quite a scene. A few months later, their singer, Billie Joe Armstrong, came to a Squeezebox party and joined Misstress Formika, Courtney Love, and Evan Dando onstage.

(Second from left to right) Evan Dando, Billie Joe Armstrong, Misstress Formika, and Courtney Love, Squeezebox, Don Hill's, New York City, December 1994

Then, one day a few years later, in 1997, Jesse Malin mentioned that D Generation was about to go on a European tour with Green Day, and he suggested that Elizabeth and I come along for part of it. We took him up on it and went with them from London to Paris for four shows. We spent some time with Green Day and, by the end of it, we knew one another pretty well.

I couldn't believe how well the band connected with their audience. There is one part of the show where they pull someone from the audience and hand them a guitar to play along with the band to show the audience that they can do it, too. Some nights they even replace the drummer and bass player with a fan from the crowd.

It turned out that they were fans of mine, too. They had grown up with my pictures in the magazines and books that they devoured as aspiring young rock musicians and, whenever we met, they peppered me with questions about the groups I worked with. For my part, I thought they were the best live band I'd seen since the Clash, and one of the most grounded, as well.

Most bands, and particularly at the biggest shows, will have a backstage area filled with celebrities. I only once saw a famous person in their dressing room, and that was the tennis star Serena Williams, who told them she had been a fan since she was twelve.

Far more often, the group would be backstage alone and, if I happened to be around, I was often the only person they allowed into the dressing room. That privilege, and that degree of access, is a very rare and precious thing. I took advantage of the opportunity and went to see them every time they came around.

As they became a bigger and bigger headlining act, Green Day kept in touch with their roots by playing at secret small-club shows, where they billed themselves as Foxboro Hot Tubs.

At one of these parties in 2010, Billie Joe mentioned that they were about to go to Europe with Joan Jett opening for them. I said I would love to see that, and he said "Cool, we'll get you whatever you need."

I didn't take it too seriously until their personal assistant, Bill Schneider, came up and said Billie Joe had mentioned that I said I'd

like to see them in Europe. He also said, "We'll get you whatever you need . . . passes, tickets, whatever you need."

I said, "I don't think you understand, I need a plane ticket." Bill replied, "Whatever you need, Bob," so I went to London, Dublin, and Paris with Green Day. And in 2019 Abrams published a book of my photos of Green Day.

Green Day flying from Dublin to Paris, June 25, 2010

Joan Jett and Bob Gruen, Wembley Stadium, London, England, June 22, 2010

The Fuji Rock Festival, in the mountains of northern Japan, features eclectic bands and deejays from around the world. Some are well-known headliners, but there are also unusual musical surprise acts tucked in the forest surrounding the stages.

In the summer of 2001, Masa Hidaka, the promoter of Fuji Rock invited me to come to Fuji Rock to start the weekend with a dedication to Joey Ramone, who had just passed away that April. Patti Smith was on the bill, so her bandmate Lenny Kaye was there. I asked him to join me in the dedication, and he said exactly the right words: "Joey gave to the world with love and so the whole world loves Joey."

I spent a lot of time roaming the festival site that weekend, and I have to say, of all the major outdoor events that I have ever been to, Fuji Rock is the best-run festival and it is attended by the most respectful audience. There were more than fifty thousand people there, most of them camping out from Thursday to Sunday, and by noon on Monday there was not a trace of them anywhere. All those people left nothing but footprints, and you couldn't even see those.

I wanted to return at some point, but I didn't expect to be invited back just two years later, this time to dedicate the festival to Joe Strummer.

Joe had been a part of Fuji Rock when it started in 1997. He came as a deejay, but built an area just outside the main entrance dubbed "Strummerville," which had its own stages and bands and, like the area he had been creating for years at the Glastonbury Festival in England, there was a big bonfire for people to sit around.

There had been nothing wrong with him. The last time I spoke to him, a few days before he died, he was just Joe, happy to be living in the wilds of Somerset and thrilled with his life, talking about finishing a new album with his band the Mescaleros. Then, the Sunday before Christmas, after walking his dogs, he went to nap on a couch and never woke up. Joe was gone.

When Masa published my monograph *Rock Seen* in a Japanese edition in 2017 he brought me to Fuji Rock to promote the book. The festival had grown to more than 125,000 people attending. There was also an exhibition of my photos in Tokyo.

RIGHT PLACE, RIGHT TIME

Masa brought me back again when Bob Dylan was headlining Fuji Rock the next year, 2018, on a bill that also included Jack Johnson, whose bassist is Merlo Podlewski, whose mom I had known from the New York Dolls days. In fact, I'd known Merlo since he was four! Masa asked me to take a photo of him with Jack and also with Dylan. I went with him to the backstage area where their dressing rooms were next to each other. We said hello to Jack and Merlo and took a photo with Masa, then went next door to see Bob Dylan.

His road manager said he'd check with Dylan to see if he was available and asked us to wait. The way I figured it, there were three possibilities. One was that Dylan had completely forgotten who I was and why he hated me. Two, he remembered me and still wanted to beat me up. And three, my fantasy, he's heard of me and he knows I've become one of the top rock photographers and will be happy for me to photograph him.

Or four, the one I didn't anticipate, that Masa would stare hard at the back of the retreating road manager and announce, "I am the producer. I don't wait." And with that, he walked off, and I followed behind.

EPILOGUE

Supla • Photo exhibitions • Jean-Luc Le Dû • Birthday parties

I MET THE BRAZILIAN MUSICIAN SUPLA ONE DAY IN 1996 when Elizabeth and I stopped into Electric Lady studio, where Ric Ocasek was producing a new album for D Generation. Elizabeth's knee was in a brace from a ski accident, and we started talking to Supla because he'd had a soccer accident and he had the same knee brace as Elizabeth. We went to a performance he gave and found out he was very talented and very unusual. His show ranged from punk to bossa nova and a mixture of both—punkanova. We also soon found out he was one of the most well-known personalities in Brazil.

We were bumped from a flight and got a free plane ticket that we could use to go anywhere in North or South America. When I heard that Bob Dylan was opening for the Rolling Stones in Brazil, we decided to use our tickets to go there.

We mentioned to Supla that we were going to Rio de Janeiro and São Paulo, and he said we must stay with his parents in São Paulo. We felt a little unsure, but he told us they were really cool. I thought, "Whose parents are cool?" But Supla told us they had gone to college in the United

Supla, New York City, November 1997

States, in fact to Ann Arbor and Berkeley, when they were the hotbeds of the 1960s hippie demonstrations.

After returning to Brazil, Supla's parents then joined others to start the Workers Party and, by the time we met them, his father was a national senator, and his mom was running for governor. We stayed with them . . . and they were very cool. The senator is a truly dedicated politician, and we were lucky to meet them both.

A few years later, I sent them a copy of my John Lennon book, and they showed it to their friend Celita Procopio, president of the board of directors of FAAP University, the most prestigious and respected arts school in Brazil.

She thought of mounting an exhibit of my Lennon photos and talked to Supla to find out more about me. He suggested that they have an exhibition of all of my rock work, not just Lennon, and they agreed.

They contacted me, and after a year of planning, a vast exhibition of my photos opened there. Supla contacted the young architect Tito Ficarelli to design the exhibit, and he described his plan as "a park, if Salvador Dalí had made it." There were six distinct areas, each with its own soundtrack, and it was the first time we created a "teenage bedroom" installation.

As Supla and Tito and I were talking about the design, I mentioned that there should be something to show what the photos were taken for in the first place . . . for people to live with. We came up with the idea of making a room with my photos as reproduced in magazines, on record covers and posters, showing how teenagers would cover their walls with pictures of their heroes. This was so popular that I've had a teenage

Rockers exhibit, Fundação Armando Alvares Penteado (FAAP), São Paulo, Brazil, May 15, 2007

RIGHT PLACE, RIGHT TIME

bedroom in most of my exhibits since then. I even made a version of it for the Museum of Modern Art in New York in 2009.

When the exhibit opened on May 15, 2007, several thousand people came, including my ninety-four-year-old mother. By then, Supla's mom was the mayor of São Paulo, and I got to introduce my mom to her and to Supla's dad, who was in his third term as senator. I was very proud to introduce my mom, who had always been involved in politics herself, to my new friends, the mayor and senator. Walking through the enormous exhibit, I realized how much of an impact my photos have had and the importance of my archive as a record of the history of our time.

(Left to right) Mayor Marta Suplicy, Supla, Bob Gruen, Celita Procopio de Carvalho, Elizabeth Gregory-Gruen, Elizabeth Gervais-Gruen, Senator Eduardo Suplicy, and Kris Gruen, FAAP, São Paulo, Brazil, May 15, 2007 (photograph by Linda Rowe)

The success of this first exhibition led to more recognition in South America and to more exhibitions in Brazil and in Argentina. Exhibitions are now my main focus.

Around 2012, my friend Michael Dorf, owner of City Winery (a branch of which is just around the corner from me and Elizabeth) had an idea for the annual company convention, which that year was being held in Puerto Rico. Jean-Luc Le Dû, a James Beard Award–winning sommelier and very good friend of mine, was going to be hosting a wine tasting there, and Michael wanted to know if I would join him. There would be a screening of the Don Letts documentary about me, a free handout of copies of *Rock Seen*, and the following day, I would host a question-and-answer session.

I was happy to do it, but then Jean-Luc came up with an even better idea. How about a rock-and-roll wine tasting? I would talk about

Jean-Luc Le Dû and Bob Gruen, Brasserie 8½,
New York City, April 26, 2017 (photograph
by Elizabeth Gregory-Gruen)

RIGHT PLACE, RIGHT TIME

different artists with whom I'd worked, and Jean-Luc would then recommend the wine that was most appropriate for their music. For the Clash, a loud, explosive group for example, he suggested a particular wine that was grown on the slopes of Mount Etna. Tina Turner got a Champagne, of course, but Jean-Luc would explain which one was the best for her and why.

The presentation went down better than any of us expected, and the next thing we knew, Michael was booking us into the City Winery itself.

It snowballed from there. Somebody from City National Bank, a part of the Royal Bank of Canada, caught the act and asked us to put on a show for them in New York City. Then, when that was a success, there were further engagements over the next few years in Nashville and Atlanta. City National was just making plans for the biggest show of all, in Los Angeles in early 2018, when Jean-Luc died suddenly, that Christmas. It was a shock to us and to the world of wine.

The annual birthday bashes in New York were great while they lasted. Every year was bigger than the last, and about halfway through the run, a friend asked if his band could play, and that started another tradition of bands performing. One year, Bebe Buell played a set and ended the evening with both a management deal and a record contract. Another year, the comedian Tammy Faye Starlight brought along her Blondie tribute band—successors to, first, a Stones tribute called the Mike Hunt Band, and an elderly Runaways tribute called the Stay at Homes.

Debbie Harry was actually there the night of the Blondie tribute, but she didn't get up onstage with them; however, when Tammy came back another time with her New York Dolls tribute, Sylvain was soon up there playing "Trash" alongside them.

In 2014, we even had Alice Cooper! There was a benefit concert in town that Little Steven was involved with. I already had Jesse Malin putting together the musical side of things, and my son Kris's band was scheduled to play as well.

Initially, Little Steven called to ask if I could take pictures at the benefit; I told him that I couldn't, and explained why. Then I suggested that my party become the benefit's after-party as well. He loved the

(Left to right) Bob Gruen, Billie Joe Armstrong, Debbie Harry, and Jesse Malin,
R Bar, New York City, October 23, 2013 (photograph by David Appel)

idea, and so Billie Joe was there, Debbie was back again, and suddenly
Alice arrived with my old friend Toby Mamis, who has been working
with Alice for years.

It didn't look as though Alice was going to hang around; the moment
he walked in, he was surrounded by people, and when he got upstairs, a
very large, very tattooed woman began harassing him. I saw Alice make
eye contact with Toby, a "please get me out of here" look, and Toby dis-
appeared, presumably to get the car.

It was at that moment that Little Steven and Danny Fields showed
up, along with some other people that Alice knew and liked, and so he
started to relax. Which was a relief for us, because some of the musicians
had been rehearsing "Eighteen" for days, in the hope that Alice would
get up and sing with them.

Alice didn't know this, and I wasn't about to ask him. So, when the
sound guy came up and asked if Alice was going to do it or not, I thought
quickly. "Why don't you just ask him when he wants to play, not if? Does
he want to come on first, or does he want the band to warm up first?"

So, he asked, and amazingly, Alice just said, "Oh, I'll go on first."
I was thrilled and I felt even better when Toby returned to say the car
was ready, and Alice turned to him and said, "It's okay, I'm going to do

a song first; Bob and I go way back." The look of surprise on Toby's face just made my night.

I pushed through the crowd toward the stage with Alice, and as we got there, he turned to me and said, "I remember playing clubs like this."

"Recently?" I asked, and he laughed.

"No, I'm playing Madison Square Garden on Tuesday." And then he said, "I want you to sing backing vocals with Sheryl" (his wife).

It was my turn to laugh. "You really don't want to hear me sing." But he was determined. "If you want to hear me sing, I want to hear you sing."

The next year Handsome Dick Manitoba got up to perform a duet of "I Got You, Babe" with Debbie Harry, and then Debbie sang "Happy Birthday" to me. But now after twenty-six years, it didn't feel like my birthday party anymore. It was just another excuse for people to go out and get rowdy. I found I was standing in the middle of a huge room, surrounded by people who all seemed to be having a great time, but I realized that I didn't know most of them. As my next birthday grew closer, and people started pushing me to invite this person and offer an appearance fee to that one, I just said no.

The old place where the parties began had closed down. The people who made the parties special at the beginning, Ginny and Giorgio, and so many more, were no longer with us. So when Elizabeth suggested that if I didn't want a party we could instead go to Paris for a few days, I didn't hesitate. "What a great idea!" As luck would have it, we got to see the Rolling Stones play in Paris as well.

On October 23, 2019, just as this book was approaching completion, I turned seventy-four. I've seen and heard sixty years of rock. I've participated as rock and roll has evolved from being played in little clubs to theaters to gigantic festivals, becoming a multibillion-dollar corporate business, as each new generation reinvents it.

I was drawn to my work to share the freedom of rock and roll. The freedom to express your feelings, loudly, in public! For me it's about the moment when everyone is screaming "Yea!" and no one is thinking about paying their rent or anything else.

I no longer go looking for the newest, hottest thing in music. I'm looking for a good time. I don't take pictures as much as I used to, either. Now that taking photos is so simple—everyone takes photos at concerts and posts them online instantly—there's much less demand for the kind of work I did and many of the contacts I had in the business are retired.

I still go out most every night, but now mostly to art or movie openings, charity benefits, and dinners. I've quit cigarettes, and I don't drink anymore, except the occasional wine or beer at an event.

I've now been around long enough that my life and work have become a part of rock history. Most of my business now, as I'd hoped, is licensing images from my archives, organizing exhibitions, and telling my story.

In 2011, Don Letts made *Rock and Roll Exposed,* a four-part, two-hour documentary about me. My images have been shown at museums and galleries around the world, and I'm often asked to give lectures about the work. There is now a much better understanding of how integral rock and roll is to our culture—and how important rock photography is in documenting and defining that culture. I believe that my archive of thousands of photographs has become a unique treasure trove and historical resource.

In my personal life, I have discovered the many rewards of having a close family. In 2005, as I was turning sixty, my son, Kris, now a singer/songwriter, and his wife, Jaiel, an organic farmer in Vermont, had their first daughter, Jasmine, and five years later they had another daughter, Zinnia. I'm really happy in my role as a grandfather. Being with the kids is now my favorite thing to do.

In 2008, I got a letter from Toni, a daughter I had never met. She was born in 1966 and grew up in a very loving family in Brooklyn; like many adopted children, she wanted to know who her biological parents were. Eventually, she found her biological mother, who told her my name. Finding me was easy, and now we have a good relationship. She lives near Boston with her two daughters, Sierra and Alexa. After I introduced them, Toni and my son, Kris, and their four kids bonded as family.

Who would have thought it? When I first moved to New York City at the age of nineteen, I fully expected to live fast, die young, and leave a

good-looking corpse by the age of twenty-five. Instead, now I'm treated as a respected elder by younger generations.

Living an unscheduled, unpredictable life is scary. I wake up every day unemployed and have to figure out what to do to make the best of whatever comes up. I'm not wealthy—some months are good, and some are tight—but that's the life of a freelance artist.

Young people continually ask me how I became a success as a rock photographer. I think I've had a rich and satisfying career because I didn't wait at home watching TV, and instead went out and got involved in things. I do seem to have luck in being in the right place at the right time, but I also trusted my intuition and made the right decisions, so that most opportunities worked out well for me and whoever I was working for. I always tried to do more than I was asked, so I could beat out my competition and get hired again. I didn't do it by waiting around, I did it by going out every night. If you want to make things happen, you have to get out and live your life!

And please, go in peace, live in peace, and imagine peace.

Bob Gruen and Elizabeth Gregory-Gruen, Lincoln Center,
New York City, September 26, 2019

ACKNOWLEDGMENTS

I could not have finished this book without the professional writing of Dave Thompson and I thank him for all his good ideas and hard work.

And thank you to my editor, Michael Sand, for his patience and advice. And thanks to my agent, Paul Lucas, for finding Michael Sand.

I am very grateful to the many people who have helped me in my life and my career and to all the fantastic artists who have given me the opportunity to "capture the moment."

Thank you to: My mom, who taught me photography, and my dad, who encouraged me and was the first to call a selection of my earliest photos a "portfolio," showing respect for my work.

My wife, Elizabeth Gregory, for keeping me healthy and happy and painstakingly organizing my archive.

My first wife, Nadya Beck, for those early days, and more. To our son, Kris, for always making me proud, and my brother David, who always had my back.

I would like to thank my assistants, many of whom became like family, working closely with me at my Westbeth studio over the years, including: Jonathan Takami, my first assistant; Cindy Difford, who helped me until she left to marry a rock star; Karen Lesser, who also left to marry a rock star, but not before she found Karla Merrifield, who worked with me for ten years and created a system out of the chaos of my files which we still use today to immediately locate any photo in the archive; Jana Kaiser, who left to go back to her native Germany after the Berlin Wall fell; Linda Rowe, the brightest ray of sunshine and a darkroom genius who printed my photos for seventeen years; and Sarah Field, who adeptly turned my studio operation into more of a "proper" business.

I shall always be indebted to Virginia (Ginny) Lohle, who, as my photo agent, licensed my work worldwide for more than thirty years.

Thank you to Lisa Robinson (and her sister, Deane) for all the assignments we did together. And thank you to Susan Blond for all the jobs you gave me.

I've also had a lot of help from around the world:

In London: Sheila Rock, Don Letts, Joe Strummer and his wife, Lucinda, Malcolm McLaren, Patti Palladin, and Damien Hirst.

In Paris: Christian Lebrun, Philippe Manoeuvre, Bruno Blum, and Marc Zermati.

In Japan: Gin Satoh, Yuki Taira, Makoto and Sheena Auyakawa, Yuya Uchida, Kei Ishizaka, Gan Murakami, Sandii Kawauchi, Fumi and Toshio Goto, and Shegimi and Masa Hidaka.

In South America: Supla and his parents, Marta and Eduardo Suplicy; Celita Procopio and Fernanda Celidonio at FAAP University; Tito Ficarelli; and my current agents, Sebastian Alderete and Florencia Giordana Braun.

And thank you to those working with me today: Richelle DeLora, my ever-efficient studio manager; Hanna Toresson and David Appel, who make my photos look good; Mandi Newall, who helps with my writing; Carol Strauss Klenfner, the publicist who tells the world what I'm doing; and Lydia Criss, who has been keeping my accounts in order for many years.